Modern Portugal

MODERN
Portugal

EDITED BY

António Costa Pinto

The Society for the Promotion
of Science and Scholarship
PALO ALTO, CALIFORNIA

The Society for the Promotion of Science and Scholarship, Inc.
Palo Alto, California

© 1998 The Society for the Promotion of Science and Scholarship

Printed in the United States of America.

Published with the support of the Camões Institute, Lisbon, and
the Luso-American Foundation, Lisbon

The Society for the Promotion of Science and Scholarship is a nonprofit
corporation established for the purposes of scholarly publishing; it has special
interests in European and British studies.

Library of Congress Cataloging-in-Publication Data

Modern Portugal / edited by António Costa Pinto.
 p. cm.
 Includes index.
 ISBN 0-930664-17-5 (hardcover : alk. paper)
 1. Portugal. I. Pinto, António Costa.
DP517.M63 1998
946.9—dc21 97-45654
 CIP

Portugal has undergone a significant process of change over the last three decades. It has seen political change, marked by the end of forty-eight years of dictatorial rule and by the consolidation of democracy. It has also experienced a shift in the country's international relations with the delayed collapse of its colonial empire and its integration into the European Union. Economic and social change has taken place, with Portugal changing from a backward, socially underdeveloped country into a modern nation. The aim of this book is to present a panorama of that process of change and to examine it as part of the evolution of Portuguese politics and society in the twentieth century.

Following the consolidation of the liberal order during the second half of the nineteenth century and significant pressure for democratization during the first years of the twentieth century, democratic rule succumbed to a long period of authoritarianism with the consolidation of the *Estado Novo* under António de Oliveira Salazar in the 1930s. The Portuguese dictatorship, which, along with the Franco regime in Spain, survived World War II, was toppled only by Portugal's military in 1974. The first chapter of this book focuses on these events, providing a brief introduction to the social and political change that continued from the turn of the twentieth century until the 1970s.

Chapter 2, by Valentim Alexandre, addresses a key issue in twentieth-century Portuguese history: the colonial question. With the end of the Brazilian Empire in 1822 and the close of the nineteenth century in particular, the African colonial question became a central element in Portuguese politics, dominating the political arena until the transition to democracy and decolonization in the 1970s.

The colonial question also figures in Nuno Severiano Teixeira's discussion of foreign policy in chapter 3, given that it was undoubtedly the central issue in Portugal's foreign relations until the 1970s. In assessing Portuguese foreign policy, this chapter covers the period between Portugal's participation in World War I and its accession to the European Community in 1986.

The following two chapters, by Fernando Rosas and J. M. Brandão de Brito, respectively, trace the evolution of the Portuguese economy. Rosas focuses primarily on the political economy of the 1930s and 1940s. Brandão de Brito examines the economic liberalization of the 1960s, a process marked by the country's membership in the European Free Trade Association and its treaty of association with the European Economic Community.

Many of these chapters refer to the transition to democracy in 1974 as a watershed event in the process of national political change. Chapter 6, by Manuel Braga da Cruz, is therefore dedicated to its analysis. The process of transition itself, as well as the years 1974 and 1975, has been the subject of an immense body of academic work; this was also the period subjected to intense scrutiny by the media later in the 1970s. For this reason, it was deemed important to extend the analysis, exploring the process of democratic consolidation and the evolution of the Portuguese political system to the present day.

The military played a central role in the overthrow of the authoritarian regime and the construction of a new political order. Chapter 7, by Maria Carrilho, examines how the military was distanced from the political arena from the end of the 1970s on. It also analyzes the Portuguese population's attitude toward the military and defense matters.

With chapter 8, by João Ferreira de Almeida, the analysis shifts to a study of change in the structure and values of Portuguese society over the last twenty years, a change strongly marked by a qualitative leap in the process of urbanization and deruralization.

Chapter 9, by Virginia Ferreira, provides a general picture of the situation of women in Portugal, as well as the relevant social and political changes occurring from the beginning of the twentieth century to the present. Chapter 10, by Maria Ioannis Baganha, focuses on emigration, a key factor in Portuguese society, paying particular attention to the period after 1945.

The last three chapters are dedicated to the theme of cultural change, which is rare in books of this nature. Chapter 11, by Nuno G. Monteiro and the editor, focuses on a theme that has been very dear to key sectors of the national elite throughout this century, that of national identity. João Camilo dos Santos analyzes contemporary Portuguese literature in chapter 12.

It is curious that although it is traditionally taught at U.S. universities, and although some Portuguese writers, such as José Rodrigues Miguéis and Jorge de Sena, have lived in the United States for long periods of time, contemporary Portuguese literature is still little known in the Anglo-Saxon world, in contrast with continental Europe. Interest appears to be increasing, however, as witnessed by the recent wave of translations (of the poet Fernando Pessoa and contemporary writers José Saramago and António Lobo Antunes, for example). A number of publications on Portuguese literature and language have emerged, such as the *Luso-Brazilian Review* of the University of Wisconsin Press, the *Gávea-Brown* from Brown University, and the more recent *Santa Barbara Portuguese Studies* from the University of California, Santa Barbara.

Chapter 13, by João Pinharanda, examines twentieth-century Portuguese art from a comparative perspective. Apart from a few international exhibitions and a few Portuguese painters and sculptors who have gained international recognition, appreciation of Portuguese art outside the country has been only sporadic, and its hold has been tenuous. These are some of the reasons which led me to include chapters on these topics, in the hope that this book might be useful to a wider public.

Finally, Nancy Bermeo has written a conclusion and summary, in which she examines the transition to and consolidation of democracy in Portugal as part of the "third wave" of transitions to democracy in the world at large.

In some of the areas explored in this book, such as comparative politics, political economy, or international relations, Portugal already figures as part of the curriculum in North American universities. The same cannot be said of history or the humanities, however, from which Portugal is notably absent. In the last few years, however, new journals, study centers, and courses have focused on the Lusophone world and have contributed to the development of these areas of study. The *Portuguese Studies Review*, published at the University of New Hampshire by Douglas L. Wheeler, and the *Camões Center Quarterly* of the Camões Center at Columbia University, directed by Kenneth Maxwell, have been making important contributions to the study of Portugal and the other Lusophone countries in the United States and elsewhere.

The establishment in the 1980s of the Luso American Development Foundation (FLAD), an institution created specifically to foster scien-

tific and cultural relations between Portugal and the United States, has also strengthened the field. The number of Portuguese scholars at North American universities, particularly at the master's or doctoral levels, has increased significantly. Contracts and agreements with North American universities and research centers have also increased notably. Further evidence of a rapidly developing field of study is provided by the creation of exchange, teaching, and research programs, such as those opened at Brown, Berkeley, Stanford, and Princeton, and by the consolidation of a network of contacts with Portuguese universities and the establishment of bilateral programs between North American and Portuguese universities.

The project that led to the publication of this book originated in a conversation with Professor Peter Stansky at Stanford University during my stay as visiting professor in the Department of History in 1992–93. SPOSS was planning to publish a series of books on recent developments in various European countries, and a book on Portugal was thought to be necessary. Given the lack of books in English on contemporary Portugal, however, I felt it would be important to include an analysis of the twentieth century as a whole, rather than limiting the book to only the most recent developments in the country.

On my return to Portugal, I invited some historians, sociologists, political scientists, and specialists in arts and literature to participate in this collective work. I would like to thank them for their contributions to this volume. As is always the case, I regret not having been able to achieve all the objectives initially laid out; I think, nevertheless, that the topics developed in these chapters provide a good basis for further study by a wider English-language readership in the various fields and disciplines of the social and human sciences.

Of course, with a book of this nature, there are many people to thank. I would first like to acknowledge the support of the FLAD, which was efficient and lacking in bureaucratic delay, a rare thing in Portugal. Without its support, this work would not have been possible. I would also like to acknowledge the support of the Camões Institute for the services it provided to the publisher which, we hope, will permit the wider dissemination of this book. The help of Alexandra Barahona de Brito, who translated and edited the book, was also decisive, particularly in light of the time constraints under which we all worked.

I would also like to acknowledge the valuable comments and sugges-

tions of the outside reader. They were invaluable, not only for the revisions of some of the chapters, but also by enabling us to adapt the material for a nonspecialist readership with limited knowledge of Portugal. Last but not least, I would like to thank Nancy Bermeo and the Institute of International Studies, Princeton University, for the epilogue to this book, for the magnificent hospitality offered to me at Princeton, and for the excellent working conditions and the stimulating intellectual environment at the IIS, where I completed this project.

<div align="right">

António Costa Pinto
Lisbon, July 1997

</div>

Contents

xii Contents

Tables

Figure

VALENTIM ALEXANDRE is a research fellow at the Institute of Social Sciences of Lisbon University. His current interest is Portuguese colonialism in the nineteenth and twentieth centuries. He has written *Orígens do colonialismo português moderno* (1979) and *Os sentidos do império: questão nacional e questão colonial na crise do antigo regime português* (1993).

JOÃO FERREIRA DE ALMEIDA is a professor of sociology at the Instituto Superior de Ciências do Trabalho e da Empresa (ISCTE), Lisbon. He has written extensively on rural communities and social inequality, including *Classes sociais nos campos-camponeses parciais numa região do Noroeste* (1986), *Valores e representações sociais* (1990), and *Exclusão social: factores e tipos de pobreza em Portugal* (1992).

MARIA IOANNIS B. BAGANHA is a professor on the Faculty of Economics of Coimbra University. She holds a Ph.D. from the University of Pennsylvania, and her research interests are the economic and social dimensions of emigration. She is the author of numerous articles on this topic, as well as *Portuguese Emigration to the United States, 1820–1930* (1990).

NANCY BERMEO is an associate professor of politics at Princeton University. She holds a Ph.D. in political science from Yale University, and she has written numerous articles on the democratic transitions and consolidations in southern Europe, Eastern Europe, and Latin America. Her books include *The Revolution Within the Revolution: Workers' Control in Rural Portugal* (1986), and the edited volume *Liberalization and Democratization: Change in the Soviet Union and Eastern Europe* (1991).

JOSÉ MARIA BRANDÃO DE BRITO is a professor of economics at the Technical University of Lisbon. His main research interest is the political economy of contemporary Portugal. Among the works he has written and edited are *A industrialização portuguesa no pós-guerra (1948–1965): o condicionamento industrial* (1989), and "The Portuguese Response to the Marshall Plan," *Estudos de Economia* 10:4 (1990).

MARIA CARRILHO is a professor of political sociology at the ISCTE, Lisbon. She serves on the executive committee of the International Sociological Association and is currently a member of the Portuguese Parliament. Her research interests center on the military and politics. She has written *Sociologia della negritudine* (1973), *Portogallo: la via militare* (1975), *Forças armadas e mudança política no século XX em Portugal* (1985), and *Democracia e defesa* (1994).

MANUEL BRAGA DA CRUZ is a research fellow at the Institute of Social Sciences of Lisbon University, where he is editor of the journal *Análise Social*, and a professor of sociology at the Catholic University of Lisbon. His publications include *As orígens da democracia cristã e o salazarismo* (1980), *Monárquicos e republicanos sob o Estado Novo* (1986), *O partido e o estado no salazarismo* (1988), and *Instituições políticas e processos sociais* (1995).

VIRGINIA FERREIRA is a lecturer in sociology on the Faculty of Economics at the University of Coimbra, and a member of the editorial board of the *European Journal of Women's Studies*. Her research has focused on office automation and women's employment. Her most recent publications in English are "Women's Employment in the European Semiperipheral Countries: Analysis of the Portuguese Case," *Women's Studies International Forum* 17:2–3 (1994); and "Office Work, Gender, and Technological Change: The Portuguese Case," in *The New Division of Labour: Emerging Forms of Work Organisation in International Perspective*, ed. Wolfgang Littek and Tony Charles (1995).

NUNO G. MONTEIRO is a research fellow at the Institute of Social Sciences of Lisbon University and a professor of history at the ISCTE, Lisbon. His main research interests are the social history of eighteenth- and nineteenth-century Portugal. He is the author of several articles, as well as the book *O crepúsculo da aristocracia em Portugal, 1750–1832* (1997), and is co-editor (with Cesar Oliveira) of *História dos municípios e do poder local* (1996).

JOÃO PINHARANDA is an art critic for the daily newspaper *Público*, Lisbon. He holds a master's degree in art history from the New University of Lisbon, and he has written extensively on Portuguese contemporary art. He is co-author (with Alexandre Melo) of *Arte portuguesa contempo-*

rânea (1986), and editor of the forthcoming *Dicionário da arte portuguesa no século XX*.

ANTÓNIO COSTA PINTO is a professor of modern European history and politics at the ISCTE, Lisbon. He holds a Ph.D. from the European University Institute, Florence. He has written on fascism, political parties, elites, and democratic breakdown and transition in Portugal. In 1992–93 he was a visiting professor at Stanford University, and in 1996, he was a Senior Fellow at the Center for International Studies at Princeton University. He has recently published *Os camisas azuís. Ideologias, elites e movimentos fascistas em Portugal, 1914–1945* (1994), and *Salazar's Dictatorship and European Fascism: Problems of Interpretation* (1995).

FERNANDO ROSAS is a professor of history on the Faculty of Arts and Sciences of the New University of Lisbon. His research interests center on the economic and social history of the Portuguese *Estado Novo*. He has published several books, including *O Estado Novo nos anos trinta* (1986), *Portugal entre a guerra e a paz (1939–1945)* (1990), and *O Estado Novo (1926–1974)* (1994).

JOÃO CAMILO DOS SANTOS is a professor of Portuguese literature at the University of California, Santa Barbara, and the director of the Center for Portuguese Studies, where in 1994 he founded the journal *Santa Barbara Portuguese Studies*. He holds a Ph.D. in comparative literature from the University of Aix-en-Provence, and has written extensively on modern and contemporary Portuguese literature. His publications include *Carlos de Oliveira et le Roman* (1987), *Os malefícios da literatura, do amor e da civilização* (1992), and, as editor, *Camilo Castelo Branco* (1995).

NUNO SEVERIANO TEIXEIRA is a professor of modern history and international relations at the University of Evora and the current director of the Institute for National Defense, Lisbon. He holds a Ph.D. from the European University Institute, Florence. His writings on contemporary Portuguese foreign policy include *O ultimatum inglês. Política externa e política interna no Portugal de 1890* (1990) and *O poder e a guerra. Objectivos nacionais e estratégias políticas em Portugal, 1914–1918* (1996).

Modern Portugal

Twentieth-Century Portugal: An Introduction

ANTÓNIO COSTA PINTO

The "age of the masses" was inaugurated in Portugal without the upheavals affecting parallel processes of democratic regime crisis and overthrow in interwar Europe. On the eve of the twentieth century, Portugal, an old nation-state with political frontiers unchanged since the late Middle Ages, was the "ideal" state envisioned by Liberal nationalists. State and nation coincided in conditions of cultural homogeneity. There were no national or ethnocultural minorities in Portugal, or Portuguese populations in neighboring countries; similarly, Portugal had no religious or ethnolinguistic minorities. Dialects were rare, found only in some areas near the Spanish border. Portugal had no territorial claims in Europe. Thus, the historical and cultural variables so markedly present in other cases were either negligible or absent in the case of Portugal.[1]

Portugal's imperial and colonial past, however, is vital to understanding the country's history. From the seventeenth century on, Portugal was both an imperial power and a political and economic dependency of Britain. Indeed, Britain protected the country's vast colonial empire. Africa had been the stronghold of Portuguese colonialism since Brazilian independence in 1822, but at the end of the nineteenth century, Portugal's "historical rights" in Africa were threatened by other European powers.

Tensions with Britain increased dramatically in the 1880s, culminating in the British Ultimatum of 1890, which foiled Portuguese aspirations to what is now Zimbabwe. Britain forced Portugal to abandon its project

to unify Angola and Mozambique by threatening to invade the country. This episode gave rise to modern Portuguese nationalism; it provoked the first wave of anti-British sentiment, cementing what was to become the mainstay of Portuguese foreign policy until the 1970s: the defense of the colonial empire.[2] Indeed, "the identification of the colonial empire with nationalism in Portugal is a functional equivalent of [the] divisive nation-state issues" that plagued other contemporary European societies.[3]

Portugal stood on the periphery of the world economy.[4] Its own economy was backward, with a weak and sparse industrial base.[5] In 1911, Portugal had about 5.5 million inhabitants. The economically active population stood at 2,545,000. Of these, 58 percent worked in agriculture, 25 percent in industry, and 17 percent in the tertiary sector. By 1930, the active population in agriculture had decreased by 3 percent, the tertiary sector had increased by 3 percent, and the secondary sector had remained stable.[6]

Levels of urbanization were also low. Between 1900 and 1930, the number of people living in cities or towns with more than twenty thousand inhabitants increased from 10.5 percent to 13.9 percent. Of these, 8 percent lived in Lisbon. The second-largest city, Oporto, trailed far behind. These were the only centers of "urban political culture" in Portugal. Few of the country's cities were more than towns or large villages. Even considering concentrations of ten thousand as urban, the numbers do not differ significantly. The rural and village world dominated Portuguese society, accounting for more than 80 percent of the population in 1930. After the 1920s, urban growth was extremely slow and modestly paced. It was only in the 1960s that the growth rate picked up. Even so, in 1960, only 23 percent of the population was urban, and 77 percent was still rural.

Late nineteenth-century Portugal was a nonindustrialized country governed by a stable, "oligarchic parliamentarism." The dynamic of social and economic change was similar to that of other "semiperipheral" countries, which, according to Nicos Mouzelis, experienced "early parliamentarism and late industrialization."[7] At the turn of the century, however, Portugal's oligarchic and clientelistic Liberalism, based on the exploitation of the African colonies and on a timid import-substituting industrialization, began to come apart. The Republican movement, which mobilized large sections of the previously "politically excluded" urban middle and lower middle classes, heralded the regime crisis.[8]

From the beginning of the twentieth century on, the Republicans managed to erode the clientelist system based on monarchical "rotativism" through a strategy of populist electoral and social mobilization. The Republican Party's program was very flexible: it made successful use of nationalist, anticlerical themes, as well as advocating political participation and the right to strike, one demand of the feeble labor movement. On the eve of the 1910 Revolution, the Republicans were a mixed political group. At one extreme stood the moderate electoral faction; at the other, the authoritarian Jacobins. The coalition included secret groups of radical Republicans and anarchists, such as the "Portuguese Carbonaria," which had a strong popular base in Lisbon and which worked within local party committees.[9]

Although most armed forces units remained neutral during the October 1910 overthrow of the constitutional monarchy, the coup was led by Republican military officers, aided and abetted by civilians, as well as members of the Carbonaria (mostly sergeants and corporals). Portugal thereby became one of Europe's first republics, and Republican elites undertook a timid "mass nationalization," always conscious of the social and political hold that the rural areas still exerted on Portuguese society.

The First Republic: Dominant-Party Parliamentarism

When the Republicans overthrew the constitutional monarchy and began to implement their political program, Portuguese society did not entirely fulfill the economic, social, and cultural requirements for "the formation of a civil political culture." This is clear even without applying the more extreme theories that correlate economic and social development with democratic regime consolidation.[10]

The Republican elites adopted a program of universal suffrage, anticlericalism, and anti-British nationalism in defense of the colonial empire. Secularizing legislation was passed as early as 1910. It was accompanied by the emergence of a strong urban, anticlerical movement. These measures were modeled after those undertaken five years earlier by the French Third Republic, and they had a profound impact on the Catholic hierarchy.

The extension of universal suffrage, however, was not decreed as promised, because of the dangerous monarchical revolts that broke out in Spain.

The Democratic Party, successor to the Republican Party after the defection of key leaders in the wake of the Revolution, inherited the electoral machine of the Liberal monarchy and became the ruling party.

The political system became what Mattei Dogan, referring to Romania, has called a "mimic democracy."[11] The Portuguese system differs from Dogan's model in certain ways, however. First, the "political game" was not limited to the top of the social pyramid, as under the constitutional monarchy. Second, the landed gentry either lost access to the state or found new social and political mediators. Third, the state and the church were not mutually supportive. This created a new political cleavage between the secular and religious arenas. Fourth, the state became more vulnerable to ideological pressure, and began to transcend its previous role as "traditional tax collector." Fifth, "semitraditional" political clienteles changed. Finally, the urban world entered the political arena, destabilizing it.

The establishment of a parliamentary regime with the approval of the Constitution of 1911 was undertaken by a parliament dominated almost entirely by the Republican Party. According to the new constitution, the president was elected by Parliament and had no powers to dissolve Parliament. The Republicans still did not implement universal suffrage, arguing that *caciquismo* in the countryside made such a policy impossible. Indeed, pressures for universal suffrage were very limited, if not entirely absent, at the Republican Constitutional Assembly of 1911. Pressure "from below" was also very weak, both because of the "absence" of the rural world from the political arena and the antiparticipatory tendencies of the "active minorities" among the urban working classes.[12]

Curiously, it was the more conservative, dissident sectors of the Republican Party that occasionally debated the problem. Political participation was thus restricted to literate males, and the franchise of literate adult males was limited. The electoral laws restricted proportional representation to Oporto and Lisbon, the electoral fiefdom of the Democratic Party. Majoritarian rule governed the rest of country (see table 1.1).

The republic put an end to the two-party system of the constitutional monarchy, replacing it with a dominant-party, multiparty system. The Republican Party had been the first quasi-mass party under the Liberal regime. With the Revolution of 1910, dissident conservative members of the party created the Unionist and the Evolutionist parties. These, however, were never more than groups of notables.

TABLE I.I
Ratio of Eligible to Actual Voters, 1911–1925

	Electorate	Voters	Percent
1911	846,801	250,000[a]	—
1913	397,038	150,000[b]	—
1915	471,560	282,387	59.9
1919	500,000	300,000	60.0
1921	550,000	350,000	63.6
1922	550,000	380,000	69.0
1925	574,260	407,960	71.0

SOURCE: Lopes, *Poder político e caciquismo na I ª República*.
[a] Only 26 electoral constituencies voted.
[b] Only 28 electoral constituencies voted.

The electoral hegemony of the Democratic Party was immediately es-
tablished as it inherited the machinery of the Republican Party. It used the
state to become "the main provider of patronage."[13] Limited suffrage en-
abled the Democratic Party to work out a compromise between its urban,
petit bourgeois electoral base and key provincial notables, who guaranteed
its control of the system.

From the turn of century on, the Democratic Party acquired a strong
and stable electoral and political base (see table 1.2). It was the only truly
national party. Radical petit bourgeois and popular urban networks were
central to its survival, both at the ballot box and in the streets, when it
faced "extraparliamentary" or "presidential" challenges. The party comple-
mented the "legal" electoral system with violent attacks on monarchical,
Conservative Republican, and military opponents who operated in the
electoral as well as the extra-parliamentary arena.

The political articulation between the urban and rural worlds was en-
sured through the "governmentalization" of local administration. The dis-
trict governors sustained the clientelistic pacts that ensured the party's vic-
tory in rural areas. The Democratic Party thus acquired "a 'dual' structure
and a 'dual' clientele with noncompetitive yet asymmetric ideological ori-
entations."[14] Although this uneasy coalition between urban Jacobins and
rural notables ensured the Democratic Party almost permanent electoral
domination during the Republican period, it was not "sufficient to ensure
a genuine, permanent monopoly of political power . . . in the manner of
dominant parties in semi-Liberal politics."[15]

The Unionist and Evolutionist parties were both led by centrist or

TABLE I.2
Distribution of Parties in Parliament, 1910–1917

	1911		1913		1915	
	Seats	%	Seats	%	Seats	%
Republican	229	97.9	—	—	—	—
Independent	3	1.3	12	7.7	13	8.0
Socialist	2	0.8	1	0.6	2	1.2
Democratic	—	—	82	52.6	106	65.0
Evolutionist	—	—	36	23.1	26	16.0
Unionist	—	—	25	16.0	15	9.2
Catholic	—	—	—	—	1	0.6
TOTAL	234	100.0	156	100.0	163	100.0

SOURCE: Lopes, *Poder político e caciquismo na Iª República*.

right-wing parliamentary factions that had left the Republican Party in 1912. As key "system" parties, they lobbied in favor of electoral constituency reform, and they advocated moderation in church-state relations. They also sought clienteles in the provinces, where they established local fiefdoms.

Competition and rivalry between personalistic leaderships ensured that these parties overwhelmed antidemocratic coalitions without having to resort to other forms of institutional mediation. Left-wing opposition was insignificant. Indeed, until the onset of World War I, the Democratic Party suffered no left-leaning splits. Furthermore, the two parliamentary seats in the hands of the Socialist Party were Democratic Party "gifts."[16] As far as the Right was concerned, a semiloyal Conservative Republican opposition operated until the establishment of the Sidónio Pais dictatorship in 1918. As all attempts to reform the political system and to unify conservative forces electorally failed during the 1920s, however, conservative elites came to believe that they would never achieve power electorally or constitutionally.

Endemic Cabinet Instability

Electoral stability and cabinet instability characterized the Republican era. Between 1910 and 1926, forty-five cabinets were formed. Of these, seventeen were single-party cabinets, three were military, and twenty-one resulted from coalition governments.[17] The Democratic Party dominated cabinets between 1912 and 1917, but the Conservative Republican parties gained a foothold in some cabinets.

The first serious challenge to Democratic Party hegemony occurred in 1915, when the cabinet collapsed as a result of a military coup supported by the president and the Conservative parties. In January 1915, under military pressure, the president nominated General Pimenta de Castro as prime minister. Pimenta de Castro headed a cabinet with a strong military component. Pressures to suspend Parliament, to change the electoral law, and to convene elections were strong. Only months later, however, an uprising was led by armed civilians backed by key military units, which reinstated the Democrats, caused 150 deaths, and left 300 wounded.

In June 1915, the Democratic Party won the elections again and began preparing for participation in the Great War. From that time on, the party led successive coalition governments until the Sidónio Pais coup in 1917. The Conservative Republican parties supported these coalition governments. But whether they were led by conservatives, "neutrals," or a parliamentary Democratic majority, the coalition governments also proved unstable. Indeed, they experienced the greatest level of turnover and the lowest duration, lasting an average of 91 days compared with those of single-party governments, which lasted an average of 156 days.[18]

Although endemic throughout the Republican era, cabinet turnover peaked in the immediate postwar period. Postwar cabinet instability differed from prewar instability in two ways. First, economic policy issues, rather than issues of "political access," were the causes of instability, revealing the increasingly important role played by socioeconomic cleavages and interest groups in political struggle. A study comparing cabinets and economic policy to see whether the former favored industry or agriculture, urban consumers or social pacts, shows that the attitude of economic interest groups was a key to the formation and fall of cabinets. The same study also highlights the role played by the "extraparliamentary arena" in promoting cabinet instability.[19] Second, the postwar period was characterized by the increased fragmentation of the party system. Left-wing splits now afflicted the Democratic Party; prewar Evolutionists and Unionists failed in their attempts to establish a conservative electoral machine; and Sidonism emerged.

Key Sociopolitical Cleavages

The first post-1910 cleavage was religious. Secularization had been a central Republican propaganda theme, and during the first days of the

Revolution, an anticlerical movement swept Lisbon. Convents were closed down, and religious orders, such as the Jesuits, were expelled from the country. On November 3, a divorce law was decreed; a month later, a law was passed that made marriage "exclusively civil." Strict limitations were imposed on nonchurch religious ceremonies. All state religious rites in the courts, the universities, and the armed forces were abolished. By the beginning of 1911, approximately 150 priests were in prison, charged with various acts of disobedience.[20] When the church hierarchy reacted to the new curbs, the government forbade the reading of the pastoral letter. This led to the severance of Portuguese relations with the Vatican and of ties between bishops and the state.

The religious-secular cleavage became a focal point of Portuguese political life. It lasted until 1926, despite subsequent pacification measures. A new Catholic movement emerged from this conflict. It was authoritarian and closely linked to the hierarchy. The Catholic Center Party (CCP) naturally filled the "space" for a Christian-Democratic or "popular" party. Initially social Catholic, the CCP became corporatist and authoritarian and supported the Pais dictatorship in 1917.

The second cleavage of this period was the Republican-monarchical split, also known as the "regime question." It was expressed in the resistance to the Republican regime of a small but relatively strong nucleus of monarchists, who were not connected with the Liberal parties that had been dissolved in 1910.

In 1911 and 1912, two monarchical incursions, launched from Galicia, were led by a former officer of Caesarist leanings, Paiva Couceiro, who had led the African occupation campaigns at the turn of the century. Paiva Couceiro was accompanied by a number of young men who later, on their return from exile in 1914, would create the Integralismo Lusitano (IL) movement. The Integralist movement was based on the Maurrasian ideology that had guided Action Française. It also influenced the CCP.

The third major cleavage of the 1910s was the urban-rural divide. It expressed a struggle for political access to the state and governmental decision-making, particularly after the war. It centered on a conflict between the rural, latifundio-based "traditional elite" and the leaders of industry. The inability of successive cabinets to deal with these divisions was central to the breakdown of the regime. This is why António de Oliveira Salazar later reshaped the political arena to protect the "traditional sector" and prolong its social and political power. Indeed, the *Estado Novo* (New

State) used the political system, as well as state intervention and economic policy, to ensure the continued domination of the traditional sector.

Participation in World War I

The war had an immediate destabilizing impact on Portugal; it led to the destruction of the already fragile Republican edifice. The Republicans had unanimously supported participation in the Great War, in the belief that it would guarantee the safety of the African colonies. But because Britain seemed prepared to "give" Germany some of those colonies, the Democratic Party concluded that neutrality was dangerous, and became the greatest champion of military participation on the European front. The Democrats believed, furthermore, that Portuguese participation in the peace negotiations would consolidate the country's international position.

In supporting participation, however, the Democratic Party also pursued its own internal political objectives. Ensuring the safety of the African colonies did not, per se, justify action on the European front; Great Britain did not demand intervention on the basis of the Anglo-Portuguese Alliance. Intervention in Africa alone, an option defended by Conservative Republicans, would have been sufficient. But the Democratic Party aimed to consolidate its control over the political system through nationalist and patriotic mobilization. It hoped to force the other parties to cooperate in a *union sacré* of sorts, to legitimate greater repressive control over political dissidents and to tone down political and social cleavages.[21]

The Democratic Party's expectations quickly collapsed. The issue of intervention divided the armed forces, leading to the emergence of a faction that favored intervention in Africa alone. Not trusting the army, the government set up a special intervention force, the Portuguese Expeditionary Corps, led by loyal Republican military officers and manned by militia officers. In October 1914, however, a group of officers occupied a barracks and declared themselves against participation, foreshadowing the short-lived military government of 1915 and the coup led by Sidónio Pais in 1917. Despite the rebellion, the government was able to ensure participation in the war. In 1916 and 1917, approximately two-thirds of the army was dispatched abroad. Flanders received fifty-five thousand Portuguese soldiers and the colonies forty-five thousand. Of the former, thirty-five thousand were either killed or wounded.[22]

The Democratic Party took for granted the participation of the rest of

the Republican parties in its *union sacré*, but the Evolutionists, initially willing, soon abandoned the coalition. The Unionist Party, on the other hand, was opposed to intervention in Europe from the start. Both parties feared the social and political effects of participation, which had already led to riots in Lisbon and raids on shops because of food shortages, and had brought more strikes led by revolutionary syndicalist unions opposed to the war. In response to these events, the government declared a state of siege in Lisbon on July 12, 1917, and harshly repressed a general strike in September of the same year, arresting revolutionary syndicalists en masse.

An Authoritarian Interlude: The Pais Dictatorship (1917–1918)

Sidónio Pais put his military past at the service of his charismatic image, but his background was not really military; he was part of the Conservative Republican elite, a professor at the University of Coimbra, and a member of Parliament for the Unionist Party. He had held ministerial posts twice and had been ambassador in Berlin in 1916 when Germany declared war on Portugal.

The 1917 coup was initially planned with the support of Conservative Republican notables from the Unionist Party, and it owed its success to the rapid erosion of support for the war policy of the Democratic Party. Indeed, the military units that played a decisive role in the coup were preparing to leave for the front. An ambiguous coalition of groups adopted a position of "cooperative neutrality" vis-à-vis the coup. A delegation of unions visited Pais when he was directing military operations in the center of Lisbon, promising the future dictator their support in return for the release of political prisoners.

The Pais dictatorship was in some ways similar to other postwar dictatorships of a fascistic nature. Not long after coming to power, Pais exiled a good part of the Republican elite, broke with the Constitution of 1911, and proceeded with the institutionalization of a plebiscitary, presidentialist dictatorship.

Large crowds mobilized by the clergy proclaimed Pais the "savior of Portugal" during a triumphant tour of the provinces. Pais introduced universal male suffrage and became the self-elected president of the republic. He took control of the executive arm of the government, which the Conservative Republican parties had abandoned, and created a National Re-

publican Party (NRP), the only republican party contesting the elections. Apart from the NRP, only the monarchists and the Catholics were represented in Parliament. The monarchists supported the regime and were reinstated in institutions such as the military; the church supported Pais to the very end because he revoked the most radical anticlerical legislation and reestablished relations with the Vatican.

The new political system constituted an experiment with corporatist representation. The two-house system was maintained, but the new Senate included representatives of employers' associations, the trade unions, the industrial sectors, and the professions. It was not long, however, before the Senate was sidelined; Pais sent both houses into recess and governed alone, increasingly confident of his charismatic leadership.

In the face of war-provoked general shortages, Pais's political discourse was antiplutocratic. It emphasized the struggle against party oligarchies and propounded a messianic nationalism. Pais brought the monarchists and the Conservative Republicans together; he also effectively attracted the support of a group of young army officers.

In late 1918, Pais was assassinated by a former rural trade unionist. The dictatorship did not survive the death of its leader. The outbreak of a monarchical revolt in the north heralded the end of the regime. A local military junta in Oporto proclaimed the return of the monarchy, and an insurrection erupted in Lisbon.

In reponse, the Republicans mobilized in the cities, and several military units declared themselves neutral, permitting the victory of the Democrats and a return to constitutional rule. The Democratic Party promoted what was effectively its last popular mobilization in Lisbon against the monarchist revolt. Some military units handed out arms to party members, while others prepared to move north. By the end of January 1918, the provisional monarchical government in Oporto had been defeated. In Lisbon, rallies and demonstrations led to the dissolution of Parliament and the pro-monarchy political police. The government took refuge in a barracks. A few days later, the Sidonists resigned.

Thus the collapse of the Sidónio Pais regime further disrupted an army divided and politicized by participation in the war. Many of the officers who had fought at the front had been unhappy with Sidónio's "war abandonment" strategy. They had also resented the monarchist officers who had joined the dictator. Military juntas were therefore set up in a num-

ber of cities after the assassination, emitting diverse political pronounce-ments, which forced the government's hand. Monarchical, Sidonist, and Republican "military barons" made their first and last appearance during this period of crisis. Finally, the reemergence of the old "regime question" shattered the unity of conservative forces and almost threw the country into civil war.

This convulsive period was followed by several failed attempts to form a Conservative Party capable of opposing the Democratic Party in the elec-tions. The Democrats won the elections of 1919, gaining 53 percent of the seats in the House of Deputies, and reinstated the Constitution of 1911.

The Crisis and Breakdown of the Republic

Participation in World War I did not seriously damage Portugal's pro-ductive or social structure, as it did those in countries of Central Europe. Nor did it favor the emergence of groups able to form strong fascist move-ments. Portugal had suffered its war "humiliations" and the decimation of its frontline battalions midway through the Pais dictatorship, during which participation in the war had also ended. The Republicans had man-aged to mobilize many veterans who felt "betrayed" by the monarchists, who supported the war, and by the military regiments that refused to leave for France. But this reaction did not foster the emergence of a veterans' movement. Either veterans were rapidly absorbed into rural society, or they opted for emigration. The *vitoria mancata* was only moderately felt in Portugal, moreover, for the country had managed to safeguard its colo-nies and had no territorial claims in Europe.

In general, the prewar characteristics of the political system continued to prevail. Universal suffrage still was not implemented, and the formal political system remained basically unchanged. Some changes did occur, however. The Pais dictatorship and the state of near civil war that fol-lowed its fall led to the first pact among political parties for a revision of the 1911 Constitution and for the stabilization of the political system. This pact led to a first, important change: the Democrats in 1919 gave the presi-dent powers to dissolve Parliament after restricting the power of cabinets between dissolution and elections. This measure, however, established a direct channel for extraparliamentary pressures over the presidency.

A second important change was the demise of the historic leaders of the

pre-1917 period. Afonso Costa, the strongman of the Democratic Party, did not return from exile; António José de Almeida and Brito Camacho left the Evolutionist and Unionist parties.

A third change was an increasing fragmentation of the party system. The Democratic Party suffered left-wing and right-wing splits; small but highly ideological parties appeared in both the parliamentary arena (the CCP and the Democratic Left) and the extraparliamentary arena (the Communist Party in 1921 and the Sidonists from 1919 on).

In 1919, the Conservatives (including the Unionist, Evolutionist, and Centrist parties) united under the new Liberal Party banner. The Liberal Party became an embryonic electoral machine opposed to the dominant party. In 1921, for the first time in the electoral history of the republic, the Democratic Party was defeated and its monopoly on power jeopardized. The Liberal cabinets also fell, however, because of an insurrection led by the National Republican Guard to dissolve the 1921 parliament. After 1921, Conservative representation split again into several parties (*Governamentais*, *Nacionalistas*, and *Populares*), and authoritarian pressures increased.

Despite splits in the Democratic Party with the emergence of the *Reconstituintes* on the right in 1920 and the formation of the "democratic left" in 1925, the party maintained its dominant position. Nevertheless, its "asymmetrical," clientelistic machine caused it to suffer severe losses among urban voters. Manipulation and violence surrounding electoral activity increased dramatically. The lack of a well-defined party policy, resulting from two conflicting tendencies within the party structure, one moderate and another more left-wing, exacerbated divisions.

The Democratic Party survived the postwar economic and social crisis and the 1925 elections put it back in the seat of power. By this point, however, the main arenas for political battle were already outside Parliament. A new political actor emerged: a federation of employers' associations, the UIE, which supported a clearly antidemocratic platform but used elections and Parliament to sell its ideas (see table 1.3).

In the extraparliamentary sphere, the state, employers in urban industry, and the trade and service sectors viewed 1919 to 1922 as the years of the "Red threat." The "golden age" of the anarcho-syndicalist Confederação Geral do Trabalho (CGT) was marked by a wave of strikes, which affected a range of sectors. As the union movement declined in strength, terrorism emerged. Clandestine organizations such as the Red Legion were demon-

TABLE 1.3
Distribution of Parties in Parliament, 1919–1926

	1919–21		1921		1922–25		1925–26	
	Seats	%	Seats	%	Seats	%	Seats	%
Democratic	86	52.8	54	33.1	71	44.6	83	50.9
Evolutionist	38	23.3	—	—	—	—	—	—
Unionist	17	10.4	—	—	—	—	—	—
Independent	13	8.0	5	3.1	5	3.1	19	11.7
"Reconstituinte"	—	—	12	7.4	17	10.7	—	—
Socialist	8	4.9	—	—	—	—	2	1.2
Catholic	1	0.6	3	1.8	5	3.1	4	2.4
Liberal	—	—	79	48.5	33	20.8	—	—
Monarchist	—	—	4	2.5	13	8.2	7	4.3
"Dissidente"	—	—	3	1.8	—	—	—	—
Regionalist	—	—	2	1.2	2	1.3	—	—
"Popular"	—	—	1	0.6	—	—	—	—
"Governamentais"	—	—	—	—	13	8.2	—	—
Nacionalist	—	—	—	—	—	—	36	22.1
Democratic Left	—	—	—	—	—	—	6	3.7
UIE	—	—	—	—	—	—	6	3.7
TOTAL	163	100.0	163	100.0	159	100.0	163	100.0

SOURCE: A. H. Oliveira Marques, *A Iª República as estruturas de base* (Lisbon: Iniciativas Editoriais, 1975); Lopes, *Poder político e caciquismo na Iª República*, 1994.

ized by the conservative media. The Democratic Party opened up the electoral machine, which allowed the Socialist Party to win eight parliamentary seats in 1919. All attempts to integrate the working classes and the Left failed, however.[23]

The employers' associations, affected by these almost exclusively urban movements, strengthened their federations and dramatically increased their intervention in political life. By the end of 1922, the "Red threat" had been eliminated and labor confrontations were on the decline. Recent studies linking the politicization of employers' associations and the authoritarian takeover of power prove that intrabourgeois economic conflict was more significant than bourgeois-worker conflict.[24]

Conservative Republican parties and the groups of notables representing economic interests had become accustomed to using extraparliamentary means to gain power. The radicalization of the small Conservative Republican parties was a key factor in the fall of the republic; it led them to appeal to the military when the Democratic Party won the elections of 1925.

The most important factor unifying the new extreme Right in the 1920s

was the emergence of groups influenced by Italian fascism and the dictatorship of Primo de Rivera in Spain. A new generation of young Sorelian Integralists emerged, which "postponed" the republic-monarchy cleavage. Organizations such as the Nuno Alvares Crusade testify to this; it united Sidonists, Catholics, Integralists, and fascists. The Integralists received significant support from members of the armed forces, who played an important antidemocratic role in some conspiratorial groups.

The Integralists themselves played a key role in conspiratorial and propaganda activities, unlike the CCP, which was linked to the church hierarchy and was therefore more cautious. An important sector of the civilian radical Right had lent support to the 1926 coup. Charismatic leaders emerged who joined the small, elitist, extreme right-wing group supporting military intervention and the formation of organized groups inside the armed forces. Francisco Cunha Leal, a leader of the Nationalist Party, is an example. Leal had advocated military intervention since 1923, negotiating a *post factum* political arrangement with military factions. Such groups were instrumental in giving the military a political program that transcended a mere call for "order in the streets and in the government."

Military intervention in Republican politics predated the postwar period, as did persistent factionalism in the ranks. The main difference between the prewar interventions and the 1926 coup lies in three factors: the proliferation of "corporatist" tensions in the army as an institution, increasing tensions of the same kind in the government, and the growing unity of the military when intervening in the political arena.[25]

Tracing the roots of the 1926 coup to previous conspiracies and to personalistic military players is an *evenementielle* trap. Indeed, as one U.S. historian has said, Portugal had been living "in the kingdom of the Pronunciamento" since 1918.[26] It is therefore important to find other explanations for the 1926 military coup.

The situation between December 1918 and February 1919 had been particularly devastating for the army, with military juntas all over the country and the renewed "regime question," particularly in the wake of the proclamation of the monarchy in Oporto. In addition to monarchist officers, furthermore, the Sidonist regime had attracted an increasing number of young cadets and officers, all associated with the civilian radical Right, which was involved in various conspiracies throughout the early 1920s. The Democratic Party was thus confronted with a new army after the war.

This army had acquired a troop corps twice its 1911 size, with new, prestigious leaders who had returned from the battlefront. A new, militaristic ideology emerged.

The nearly two thousand supposedly temporary militia officers were a key problem. Elsewhere in Europe, officer corps had been demobilized; but in Portugal, the government had incorporated militia officers into the regular ranks. In 1919, this "political" incorporation had increased the number of regular army officers to 4,500. In 1915, they had numbered 2,600.[27] Whether this gesture was a response to the dangers of demobilization or an instrument of political patronage, it provoked tension between the army and the civilian government. This tension became particularly acute during a hyperinflationary period. The purchasing power of a captain's salary, for example, in 1919 declined to 60 percent of its 1914 value.

Its lack of trust in the army led the government to reinforce the staff and armament of the Guarda Nacional Republicana between 1919 and 1921. The number of GNR officers rose from five thousand in 1911 to eleven thousand in 1922. The GNR "was strengthened as an urban defender of the state" against the working class and the army; it "became one more element of the bureaucracy associated with the Democrats' control of the government."[28] A second source of tension was thus created. The prime minister was later forced to weaken the GNR, not only to discourage insurrections but also to calm the army down.

On April 18, 1925, a group of military officers carried out the first open coup attempt in the name of the armed forces, but resistance from some military units and the GNR aborted the insurrection. A few months later, a military court sent those involved back to the barracks. Appeals for a military interregnum had reached a fever pitch.

The key difference between this coup and that of 1926 lies in the rise of an "antisystem coalition." The military coup that put an end to the parliamentary republic on May 28, 1926, was more than a praetorian intervention. Republican Liberalism was overthrown by an army divided and politicized by participation in the war, and by Conservative Republican, Social Catholic, and Integralist factions operating within it. Fascist groups exerted a particularly important influence over young officers who had supported the dictatorship of Sidónio Pais.

The Rise of Fascism

The rise of fascism in postwar Portugal was characterized by the early adoption of the Italian fascist model and by fascism's feeble and fragmented party political expression.[29] Portugal's first fascistic political experience had occurred under Sidonismo. The Pais regime became a rallying point for young officers, intellectuals, and Republican right-wing students.

Many of the groups that emerged, however, were not strictly fascist. The concept of the radical Right is more appropriate to characterize them, in many cases. The composition of the Sidónio Pais Center Party in 1921 shows the rise of military participation in these groups: 19 of its 33 leaders were officers, mostly from the army. Many of the intellectuals involved, such as António Ferro, were active participants in the Portuguese futurist movement. Ferro later moderated his fascist ideas and served the Salazar regime as propaganda chief.

The first publications heralding "Portuguese fascism" emerged in 1923 when the first fascist party, Nacionalismo Lusitano, was founded. The NL was not just an ideological party; it was a mass militia movement. Integralismo Lusitano also developed fascist-type organizations. Rolão Preto, chief of the IL's "social" department, created a "syndicalist" party section and founded a newspaper called *Revolução* (1922–23). All attempts to establish fascist parties in Portugal, however, were condemned to failure. These parties disappeared after the first serious military coup attempt against the Liberal regime in April 1925.

Portuguese fascism was, nevertheless, ideologically and politically influenced by Integralismo Lusitano. Although the postwar crisis produced other movements that were not influenced by the IL, the movement's ability to present a new, reactionary ideological package was decisive. This package was, despite obvious foreign influences, legitimate in the Portuguese cultural context. The IL's ideological vigor and its capacity to permeate the elites thus conditioned fascist development and penetration in Portugal. As Herminio Martins has said, "At a time when Italian fascist and Nazi models assumed 'world-historical' importance, those most predisposed to learn from and emulate them were all grounded in the teachings and intellectual style of the IL." Indeed, almost all attempts to establish fascist parties—the last and most successful of which was National Syndicalism—were shaped by the IL.[30]

The IL created durable foundations for a new Portuguese reactionary nationalism. It reinvented the "tradition" of an "organic" and corporatist society based on a vision of medieval Portugal that had been destroyed by "imported" nineteenth-century Liberalism. The IL presented corporatism as the alternative to Liberalism, acting as a launching pad for the restoration of the monarchy. Efforts to legitimate historically and to develop the theoretical foundations of corporatism, however, were more than a reflection of the IL's anti-Liberalism. This is apparent in the hundreds of erudite studies published by its leaders.

The IL constructed a coherent political and intellectual alternative. Its dogma was codified into a political program. A vision of a nation organized hierarchically according to tradition was held up in opposition to the notion of popular sovereignty. The idea of universal suffrage was replaced by a vision of a corporatist representation of the family, the city and town councils, and the professions. Parliament was rejected in favor of an advisory national assembly representing "living forces." In response to the Liberal state's centralization, destruction of local community life, and uncontrolled urbanization, the IL advocated an anticosmopolitan, ruralizing decentralization to allow an "eminently agricultural country to fulfill its historical mission." Corporatist representation became the antidote to a Liberal economy and the "disastrous agitation of class struggle."[31]

Sociologically speaking, Integralism was a typical reaction to modernization, hence its ability to infiltrate the areas most threatened by modernization, particularly after the destabilization of the fragile Republican regime. The IL was elitist, centered in a small university network and restructured provincial monarchical circles.

Although it suffered fascist-leaning changes in the postwar period, the ideology of the IL's founders remained traditionally anti-Liberal. Its "historical" nationalism was the expression of a rural reaction to industrialization. Socialism and communism were seen as variants of Liberalism and democracy, undeserving of great attention. Masonry and anticlerical or Jacobin Republicanism were the great enemies.

From the time it was founded, the IL was embroiled in right-wing military conspiracies. In 1916, the pro-German IL took part in an antiwar uprising. Under Sidónio Pais, it forged closer ties with military academy cadets, the dictator's incipient praetorian guard. The IL was also supported

by young monarchical officers, but it did not trust this group because it was prone to the "restorationist itch."

Sidónio's downfall and the return of the Liberal regime, however, threw a good number of these officers into the orbit of the radical Right. The monarchist revolt sounded the death knell for further restorationist revolts, and the Integralists began to back all right-wing military candidates campaigning for the overthrow of the republic. Integralists acted as "civilian links" in a number of coup attempts, such as that of April 18, 1925. Widespread civilian participation in the coup attempt permitted the consolidation of contacts with the more radical "lieutenants" and with Manuel Gomes da Costa, the maverick general who led the uprising.

As he marched from Braga, in the north, to Lisbon, da Costa negotiated his new powers with the Conservative Republicans, headed by Admiral Mendes Cabeçadas. There was barely any military resistance to the coup; civilian mobilization was similarly absent. The legacy of the Liberal parliamentary republic and the outcome of its legitimacy crisis led to the establishment of an unstable military dictatorship.

Although the Integralists played an important role in the first phase of this dictatorship, the new political situation divided them. On the one hand, fascism was supported by a large part of the youth sector and by some military sympathizers. On the other hand, the IL's central junta hard-liners remained faithful to the monarchy and supported projects seeking to install a new and radically anti-Liberal corporative order. This group viewed Salazar's subsequent rise to power and the hybrid political institutions he created with suspicion. A good part withdrew into various fascist-oriented organizations, later forming the core of National Syndicalism (1932). Furthermore, many of those belonging to the so-called second Integralist generation supported Salazarism. Such was the case of Marcello Caetano, Salazar's eventual successor in the late 1960s.

The Transition to Salazar's 'Estado Novo'

The most appropriate way to analyze the fall of the Republican regime is to examine civil-military relations. Appeals to the military were a constant feature of postwar politics. By definition, the Republican political system did not have a "loyal opposition." It was obvious to political actors

that the possibility of achieving power through elections was virtually nonexistent.

The process of breakdown falls between the two patterns of democratic regime collapse that Juan Linz has indicated. The military coup of 1926 co-opted part of the Liberal regime's political elite (which, like many in the military, aimed for the establishment of a reformed constitutional order). The coup was also supported by what Linz calls the "disloyal opposition," which aimed to remove the dominant party from power.[32]

The military dictatorship rapidly eliminated the Republicans from the ranks of the regime, but it was unable to institutionalize itself. The lesser partners in this coalition, the fascists, were only briefly linked to the regime. The small, pugnacious workers' movement, under anarcho-syndicalist hegemony, frightened the ruling classes, who recalled the notorious failure of the Republican regime to incorporate workers into the political system. The role of the Portuguese *bienio rosso* in the overthrow of Liberalism should not be exaggerated, however. The old urban-rural and traditional-modern cleavages, typical of a "dual society" such as Portugal's, are more relevant than the divide between the bourgeoisie and the working class.

If the processes of the overthrow of democracy and the rise of fascism are indeed characterized by "the takeover of power by a well-organized disloyal opposition with a mass base in society, committed to the creation of a new political and social order, and unwilling to share its power with members of the political class of the past regime, except as minor partners in a transition phase," Portugal is notable for the absence of a fascist movement.[33] The crisis of Portuguese liberalism was a product of the complex relationship between fascism and the different political "families" that made up the Conservative bloc during the first half of the twentieth century. Clearly, the rise of fascism in Europe was possible because of the emergence of coalitions of factions, parties, and voters previously represented by a variety of Conservative parties. Yet this does not explain the distinct character of the two movements. As Martin Blinkhorn has stated, "It cannot seriously be denied that as movements, parties and political ideologies, conservatism and fascism occupied very different positions within the early and mid-twentieth-century European right, converging at some points and conflicting at others."[34]

It seems clear that the secondary role played by the fascists was par-

ticularly evident in countries such as those on the eastern and southern European periphery, with levels of economic development, social structures, and political systems similar to Portugal's. The nature of the crisis of the Portuguese republic in the postwar period highlights the difficulties fascist movements faced in societies where the "massification of politics" was at only an incipient stage and where competitors had already occupied the available political space.[35]

The presence of a right-wing reflecting urban-rural and traditional-modern cleavages was also important. The secularization cleavage was perhaps the most important one caused by the First Republic. The Portuguese case shows how, culturally speaking, the emergence of a "fascist intelligentsia" becomes very difficult when "the hostile response to modern society and the concomitant rejection of liberalism and democratization remain embedded in traditional religious forms, and reactionary or conservative politics is linked to the defense of the position of the church."[36] The church and the CCP constituted a powerful obstacle to the "fascistization" of the university and intellectual elites, playing a key political role in the antidemocratic reaction.

Another enduring cleavage, the monarchy-republic cleavage or "regime question," also had an influence. "Restorationism" inhibited the development of fascism; it curbed fascist tendencies within the Integralist movement and Sidonism's attempts at populist mobilization. The "regime question" also highlighted the understanding between Integralists and Social Catholics; both groups defended authoritarian corporatism as an alternative to liberalism.

Following the mobilization of the urban popular and middle classes, both increasingly distant from the Democratic Party, all traces of populist mobilization in the conservative countryside disappeared. The republic had not shaken the traditional structures of domination in the north; clientelistic pacts with local notables had been established. In the latifundia-dominated south, the rural unions had almost disappeared after brief periods of activity in 1910 and 1912. They were not part of the *bienio rosso* in the 1920s, and the social conflict that characterized the rise of rural fascism in Italy did not occur in Portugal. The nature of conservative political and social representation in the 1920s (mass parties had not yet emerged) and the existence of clientelistic relationships in the political system were decisive elements in the transition to authoritarianism.

As soon as the Republican regime was overthrown, the military dictatorship found punitive solutions for some of the problems worrying the Conservative bloc. The Democratic Party was ousted from power and its leaders exiled; the working class lost its right to strike, and the unions were legally restricted. Revolutionary action against the dictatorship was dominated by the Republicans. The only exception was the failed general strike in 1934, the year when Salazar established the corporatist system. The Catholic Church blessed the 1926 coup and, while suspicious of Republican officers and civilians in the regime, immediately volunteered secular supporters for ministerial positions.

Salazarism was born out of a military dictatorship beset by a succession of conspiracies, palace coups, and revolutionary attempts, signs of the battle for leadership within the vast, pro-dictatorial Conservative coalition. The consolidation of the authoritarian regime met with difficulties because of the political diversity of the Conservative bloc and its ability to penetrate the armed forces. Curiously, it was under the military dictatorship that the fascists gained some influence through the young officer class. They attempted to create autonomous organizations and played a role in driving out Republicans from the ranks of the military. This military-mediated "limited and self-devouring pluralism" was overcome only by Salazar.

The military regime has been characterized as a "dictatorship without a dictator." It did not present an alternative to Republican liberalism; it arose from a tentative, military-brokered compromise and experienced contradictory phases until the consolidation of authoritarianism under Salazar. Between 1926 and 1930, it failed to establish a firm hold on power. It was the target of several attempted coups d'état led by the pro-democracy opposition (the most serious on February 7, 1927), as well as by the far Right. The Conservative Republicans, the Catholics, and the far Right tried to convert young officers, who were a parallel power in the barracks; their position was strengthened by the appointment of officers to local administrative posts.

At the governmental level, a more cohesive group of conservative generals consolidated around General Oscar Carmona. In the wake of a major financial crisis, Salazar was named finance minister, subsequently gaining ample powers over the other ministries.

The National Union (NU) was legally established in 1930, an "antiparty

party" that aggregated the civilian forces supporting the new regime.[37] In 1933 a new constitution declared Portugal a "unitarian and corporatist republic," balancing liberal and corporatist principles of representation. The former, however, were eliminated through subsequent legislation, and the latter limited to the point of insignificance.

The result was a dictatorship headed by a prime minister and a national assembly dominated by the National Union through noncompetitive elections. To avoid any loss of power, even to a house dominated by the government party, the executive was made almost completely autonomous. General Carmona was made president to guarantee military interests. Censorship eliminated any suggestion of political conflict, and censors devoted their attention to the opposition, and to the fascist minority led by Rolão Preto in particular, a group that had initially challenged the new regime. The political police were reorganized and used with remarkable rationality.

All this was done "from above," without fascistic demagoguery. It was a process that depended more on generals and colonels than on lieutenants, and more on the Ministry of the Interior than on "the mob." By 1934, liberalism had been eliminated and the old Republican institutions replaced.

The most rebellious of the fascist leaders were exiled; a majority, however, were appointed to minor positions, particularly after the ominous onset of the Spanish civil war. The great Republican figures were forgotten in exile after the brief optimism generated by the Spanish Popular Front. One by one, anarcho-syndicalist leaders went to prison or died in Spain, leaving the leadership of the clandestine opposition in the hands of the small, youthful Communist Party.

The regime institutionalized by Salazar was admired by many on the fringes of the European radical Right, but above all by those of Maurrasian and traditional Catholic extraction, given its cultural origin. Its cultural identity was based on more than just an "order-promoting" program, but it did not have the "totalitarian," "pagan" elements of Nazi Germany or fascist Italy. Salazarism was thus based on radical right-wing and anti-Liberal Social Catholicism.[38]

The Salazarist Political System

The 1933 Constitution established the political institutions of the *Estado Novo*; it heralded an early compromise with the Conservative Republi-

cans. Its liberal principles were weak and its corporatist and authoritarian elements strong. Rights and liberties were formally maintained but were actually eliminated by government regulation. De jure freedom of association existed, but parties were eliminated through regulation. Formally, the National Union never became a single party, although it functioned that way after 1934.

A "Constitutionalized Dictatorship"

As president of the National Union, António Salazar nominated the party's deputies to Parliament. The constitution maintained the classic separation of powers, but the Chamber of Deputies had few powers and the Corporatist Chamber had none. The government was thus freed of any domination by Parliament.

Theoretically, the members of the Corporatist Chamber should have been designated by the corporations, but Salazar nominated most of them. The constitution maintained the presidency of the republic, elected by direct suffrage, as well as the presidency of the Council of Ministers; Salazar was answerable only to the former. During the early years of Salazar's rule, the president posed the only constitutional challenge to his authority. The president of the republic was always a general, given the legacy of the military dictatorship. This caused Salazar some problems after 1945. In short, to use a phrase of the time, the regime was a "constitutionalized dictatorship."

The merely "advisory" Chamber of Deputies and Corporatist Chamber constituted the regime's "limited pluralism," together with the single party. The division between those favoring a restoration of the monarchy and the Republicans, as well as that between Integralist and moderate corporatists, was reflected in both chambers. In the 1950s, moreover, different lobbies emerged to defend agricultural and industrial interests.

The *Estado Novo* inherited the repressive apparatus of the military dictatorship and strengthened it. Whereas censorship was established in 1926 and controlled by the propaganda services, as were the political police, the backbone of the system, the autonomy of the political police increased with successive decrees until they were answerable only to Salazar. Apart from repressing the clandestine opposition, controlling access to public administration was of central importance. Mechanisms to control the judi-

cial branch increased. Political crimes, for example, were placed under the jurisdiction of special military courts, and special judges were nominated. The political police, furthermore, were given ample powers to determine prison sentences.

In 1936, having completed the juridical consolidation of the system, Salazar authorized the founding of a militia, the Portuguese Legion. He also set up youth and women's organizations dependent on the Ministry of Education. A fascist choreography emerged more clearly.

One important problem remained: relations with the military. Throughout the regime, this was the institution that Salazar feared most, yet the movement to co-opt and control the military elite was central to the consolidation of Salazarism. The subordination of the military hierarchy to the regime was a fact by the eve of World War II, but the process was slow and fraught with tensions.

Salazar's speech at an officers' rally in 1938 symbolically marked the victory of "a civilian police dictatorship" over the old military dictatorship of 1926.[39] This process of establishing control lasted from the time Salazar entered the War Ministry in mid-1936 to the reform of the armed forces in 1937, which General Carmona resisted. After taking charge of the War Ministry portfolio, Salazar could have a final, albeit tentative, word on all high-level promotions and transfers. Despite the "temporary" nature of his position, Salazar was minister of war until the end of World War II; and it was in this post that he presented his reform bill for the armed forces in 1937. It was the most significant piece of legislation ensuring government control over the armed forces ever proposed in Portugal.

This reform provoked the most important reduction in the armed forces since World War I. The officers' corps shrank by 30 percent. Already significantly affected by resignations and by the transfer to the reserves of those implicated in the dozens of attempted coups and revolutions, the number of officers reached "the lowest levels registered since 1905."[40]

Besides this control "from above," a number of legislative measures were passed that strengthened ideological and police control over the armed forces. These measures heralded the political hegemony of the undersecretary of state, Captain Santos Costa, whose power went unchallenged until the late 1950s.

Salazarism did not affront the international order. Salazarist nationalism was based on a vision of the past and on Portugal's colonial patrimony.

The Anglo-Portuguese Alliance was never questioned, ensuring the British government's discreet support for the dictatorship. Geography, the evolution of the conflict, and Salazar's commitment to maintaining Portugal's neutrality, as well as its old system of alliances, kept the country out of World War II.

As for the political system, little or nothing changed, despite the profound alteration of the international order after 1945. The only concession was the opening for the emergence of a legal opposition—a month at a time every four years—for which no constitutional reform was necessary. After 1958, when a "scare" was provoked by the presidential candidacy of a dissident general, Humberto Delgado, the president was indirectly and "organically" elected by the National Assembly and the representatives of the municipal chambers.

A Strong Dictator

Many studies of modern dictatorships ignore the figure of the leader. In the case of António Salazar, it would be a mistake to do so. Salazar had a worldview; he designed the whole institutional framework of the regime. Once he became the unchallenged leader, very little legislation, important or trivial, was passed without his approval.[41]

Salazar played no part in the 1926 coup d'état. Nor was he listed as a candidate during the last years of the parliamentary regime. He was the son of a poor rural family from Vimieiro, a village in central Portugal. Salazar had a traditional Catholic upbringing and completed most of his intellectual and political education before World War I. He attended a seminary but abandoned the ecclesiastical path on the eve of the fall of the monarchy in order to study law at the University of Coimbra.

A reserved and brilliant student, he led the best-known Catholic student organization at Coimbra, the Centro Académico de Democracia Cristã. His friendship with the future cardinal patriarch Manuel Cerejeira dates from this period. He pursued a university career as a professor of economic law, and his only political activity under the liberal republic took place within the strict limits of the Social Catholic movement. He was one of the leaders of the CCP and was elected a deputy by the party in the early 1920s.

Salazar's expertise in finance and his membership in the CCP made him a natural candidate for the post of finance minister immediately after the

1926 coup, and it was in that capacity that he joined the military dictator-
ship in 1928. His rise in the government was possible because of the ample
powers he negotiated on arriving at the Finance Ministry.

The image Salazar cultivated was that of a reserved, puritanical, and
provincial dictator. It was an image that held sway until his death, and
one that he never attempted to change. As a young Catholic militant he
left Portugal only once, to take part in a Catholic congress in Belgium.
After taking power, he made a single trip to Spain to meet with Francisco
Franco. He ruled over a "colonial empire" but never visited a single colony
during the thirty-six years of his consulship. He never went to Brazil, Por-
tugal's "sister country." He flew only once and did not like it.

Yet it would be a mistake to assume that his provincialism reflected a
lack of political culture. Salazar was an "academic" dictator who closely
followed international politics and the ideas of the times. He was ideo-
logically and culturally traditional, anti-Liberal, Catholic, and Integralist
in a context of secularization and accelerated modernization. He was ultra-
conservative in the most literal sense of the term. He steadfastly defended
his rejection of democracy, favoring an "organic" vision of society based
on traditional, Catholic foundations. As the nation's leader, he was aware
of the inevitability of modernization, but also acutely aware of the threat
it represented.

The systematic, Cartesian nature of his speeches provides a good in-
dication of his political thought.[42] He always addressed the elite, never
succumbing to populist mass appeals. He was a professor of finance, and
had clear ideas about the management of a state's balance sheet. Portugal's
dictator rejected the fascist model of charismatic leadership for ideological
and political reasons, not for pragmatic reasons; even more for the nature
of Portuguese society, whose structure was not unlike that of societies
subject to a more fascist type of populism. As a "strong" dictator, he rarely
decentralized decisions, and he relied on a docile administration.

The National Union

The National Union was a variant of the political parties that Linz has
called "unified parties." Giovanni Sartori considers such parties "single au-
thoritarian parties," generally representing a "coalescence, from the top,
of various elements to create a new political entity," obliging other forces

either to integrate or to be excluded.[43] In some cases, such parties fulfilled a number of the functions of the single parties in totalitarian and fascist regimes. Their origins, ideology, organization, and relationship with both state and society, however, were different. The key determining factor is that these parties were created in an authoritarian situation, where political pluralism was already absent or severely handicapped.

The impetus for their formation came from the government, with decisive aid from the state apparatus. In general, their establishment entailed varying degrees of compromise on the part of other parties or pressure groups participating in the winning coalition.

In Portugal and Spain, parties of this type had precedents; they were modeled on those that had thrived under Sidónio Pais (the National Republican Party) and Primo de Rivera (the Patriotic Union).[44] Similar and more or less successful projects had also been promoted in the 1930s by authoritarian regimes in Austria, Hungary (the National Union Party), Poland (the Camp of National Union), and Spain.[45]

Indeed, a single party similar to Portugal's was the one led by Franco. In 1937, Franco forced various previously independent parties, members of the coalition that ultimately won the civil war, to unify under the banner of a single political party. He thus established an organization strictly controlled by him, but with distinct factions acknowledged by the party leadership.[46] The identity and preponderance of intraparty groups were reflected in the ministerial elite.

Unlike Portugal's, however, Franco's single party was initially closer to the Italian Fascist Party. In Portugal, the National Union merged with the state apparatus and depended on it to the very end. Its very existence was at times uncertain. This was, paradoxically, truest during the "fascist era," when its survival seemed most important.

Salazar created the National Union in 1930 when he was emerging as the dictatorship's main political leader. Its aims and membership criteria, however, were only vaguely stated. The government-led NU welcomed all the dictatorship's sympathizers, whether Republican, monarchist, or Catholic. For the first two years, the NU was completely dependent on the Ministry of the Interior.[47] The district governors were influential in the establishment of local committees; the minister of the interior was initially responsible for replacing local leaders, who normally depended on the district

governor.[48] Thus, the Constitution of 1933 represented a formal commitment to liberal principles of representation, reflecting the political weight of the Conservative Republican groups. The NU, on the other hand, took on the political task of gaining the adherence and support of Conservative Republicans at the local level.

State dependency marked the life of the party. Contrary to what one might expect, its lethargy was especially notorious in the 1930s. Once its leaders had been appointed, its statutes established, and its National Assembly representatives chosen, the National Union practically disappeared. In 1938, the dictator himself recognized that the NU's activity had "progressively diminished to near-vanishing point."[49] It was only just before 1945, when opposition mounted and disaster at the polls threatened, that the NU acquired visibility once again.

The NU's internal structure was weak. It lacked the propaganda, ideological, and cultural departments of most other authoritarian single parties. It also lacked socioprofessional organizations such as the Falange Española Tradicionalista (FET) in neighboring Spain. Salazar established state departments for propaganda, the Portuguese Youth, and the *Doppo Lavoro*, but these were not linked to the party. Only occasionally did the state turn to the party network, and then only to carry out limited tasks.

The single party was not important in the formation of Salazarism's political elite. It did, however, strengthen Salazar's authority and limit the organization of blocs and pressure groups, as well as allow for a certain "technocratic" pluralism.

The first parliamentary elections in 1934 had clear legitimating aims. Elections were held regularly, but were not organized to achieve 99 percent participation. Civil servants were mobilized and, despite the already restricted number of registered voters, electoral rolls were manipulated. The *Estado Novo* was never a "dual state"; Salazar governed over and through the administrative apparatus, relegating the truly "political" institutions to secondary positions. The National Union's key role was therefore to control central and local administration; to unify the diverse political factions that supported the regime; and to supply the system with political officials, especially in the provinces.

The Corporatist Machine

The *Estado Novo* was essentially corporatist. Corporatism was written into the constitution and given a central role in determining institutional structures, ideology, relations with "organized interests," and the state's economic policy.

Corporatism was also central to Italian fascism, but it is not specific to fascism. Generally speaking, the term has covered a wide ideological spectrum within the authoritarian Right since the beginning of the century. It is doubtful whether it can even be considered a characteristic of German Nazism.[50] It was, however, a key legitimating element for postwar authoritarian regimes in Austria, Spain, Vichy France, and Portugal.

Salazarism did not give the corporatist sector a monopoly on representation, despite pressures from the radical Right. Elections were held, but the Corporatist Chamber retained merely consultative status in a powerless National Assembly. The Portuguese corporatist edifice was never completed. Its influence on economic policy or its capacity to act as a buffer against social conflict, however, are worthy of detailed study. Although no "corporations" were created to represent the "organic elements of the nation" in the Corporatist Chamber, no intermediate organizations emerged, either. The distance between the constituencies and members of the chamber was maintained. The procurators were chosen by the Corporatist Council, which consisted of Salazar and the ministers and secretaries of state of the sectors involved, such as the Ministry of Economy.

The linchpin of the corporatist structure was the *Estatuto do Trabalho Nacional* (ETN) of 1933, along with the "industrial conditioning" law. Although tempered by the *Estado Novo*'s strong Catholic leanings, the ETN owed a great deal to Italy's *Carta del Lavoro*. The statute approved in September 1933 sought to establish a synthesis of the Italian model and the ideals of Social Catholicism. The founder of the Portuguese corporatist system, Pedro Teotónio Pereira, was a friend of Salazar's. He was a former Integralist who united young radical right-wingers as well as Social Catholic civil servants within his department (he was secretary of state for corporations).

Social engineering was undertaken only bureaucratically. The Rolão Preto fascists were explicitly excluded from the enterprise. Once the ETN was established and the appropriate control mechanisms created, the orga-

nization of labor was undertaken. The government gave the unions two months either to accept the new system or to disband. Substantially weakened after the 1926 coup, the unions accepted the new legislation, albeit by only a slight majority.[51] The most important unions were simply dissolved when they rejected the legislation. In January 1934 a strike took place to protest the so-called fascistization of the remaining unions; these were then re-created from the top down by officials from the corporatist apparatus.

The new unions were controlled by the National Institute of Labor and Welfare (INTP). Their governing statutes and prospective leaders were submitted to state approval. If they diverged from the ETN, they were summarily dissolved. Even members' dues came under official scrutiny. National representation was not permitted, so as to keep them weak and ineffectual.

The rural world was represented by the so-called *casas do povo*. The regime did not recognize social differences in a rural society overseen by "associate protectors," actually latifundistas. The old rural unions were simply abolished, particularly in the latifundia-dominated south. To ensure that the working classes were culturally provided for, the National Foundation for Joy at Work was created. It worked in tandem with the Secretariat for National Propaganda (SPN), organizing the activities of the *Doppo Lavoro*, an organization with Italian roots.[52]

The importance of the corporatist system becomes clearer when examining state economic intervention from 1930 on. The precorporatist institutions that could ensure smooth relations between the state and the emerging corporatist institutions, such as the Organizations of Economic Coordination, were maintained. According to official rhetoric, they were to disappear gradually over time as the corporatist edifice neared completion. In practice, however, they became central features of the regime, gaining total control over the *grémios*, or guilds, in the agricultural sector, the weaker industrial areas, and the agro–food export sector. Wheat, flour milling, wine-making and related businesses, olive oil, wool and wool products, and canned products, including fish, depended on the state for all decisions regarding production quotas, prices, and salaries.

The integration of the old employers' associations into the new corporatist system was asymmetrical, especially when compared with labor. Decrees governing the *grémios* sought to reorganize employers and the liberal

professions, but in a more moderate and prudent fashion. The employers' associations remained tentatively active. Although supposedly "transitional," some of them lasted as long as the regime itself. The *grémios* were led by the state in the name of "national economic interests." Economic intervention strategies, rather than corporatist coherence, determined their organization. Those in the more modern economic sectors enjoyed greater autonomy, but *grémios* in agriculture and associated trade sectors (wine, olive oil, and cereals), as well as milling and agro-industry, were rapidly forced to consolidate in the framework of the corporatist system.

Militia and Youth Organizations

Students of the *Estado Novo* have stressed the impact that the electoral victory of the Spanish Popular Front and the outbreak of the civil war had on Portugal. In response to the "Red Threat," the regime developed a new political discourse and symbology and set up two militia organizations. These steps have often been interpreted as the "fascistization" of the Salazar regime.

Until the Spanish civil war, Salazar had refused either to create a militia-type organization or to permit the "top-down" fascistization of the single party. During the military dictatorship, a number of attempts to create such bodies had failed. In 1934, Salazar had crushed Preto's National Syndicalism; in the same year, the first youth organization, the School Action Vanguard (*Acção Escolar Vanguarda*, or AEV), backed by the philofascist propaganda chief António Ferro, had been disbanded.[53] In 1936, however, the regime created a paramilitary youth organization, the Portuguese Youth, and permitted the formation of a fascist-style militia group, the Portuguese Legion (LP).

The LP was founded in September 1936 in the wake of an anticommunist rally organized by the "national unions." It emerged from the genuine "pressure" exerted by certain sectors that had recently joined the regime. Salazar authorized its formation and decreed its strict submission to the government. As was his custom, he moderated its declaration of principles and put the military in charge, avoiding the selection of officers who had been prominent in the radical Right and National Syndicalism.

Similar "pressures" led to the foundation of the Portuguese Youth (*Mocidade Portuguesa*, or MP). The Education Ministry had drawn up plans for

various projects aiming to unite different youth sectors in a paramilitary organization to replace the moribund AEV. Between May and September 1936, in response to the victory of the Popular Front in Spain, the MP indiscriminately accepted new members, including young people who were not students in schools. Membership was voluntary, and the children of the "lower middle class"—business people, white-collar workers, and laborers—could sign up. Thus, during its first months, the MP's social base "approximated that of the National Syndicalist Movement."[54]

The youth movement, however, was rapidly curtailed with the transfer of nonstudent volunteers to the Portuguese Legion. From then on, the MP accepted only school-going members. Participation became compulsory, and the MP became dependent on a strengthened Ministry of Education. In response to criticism from the Catholic hierarchy, the MP was rapidly "Christianized" and encouraged to interact with other, essentially Catholic, youth organizations.

Meanwhile, the Portuguese Legion was created as a voluntary, politicized militia. In 1935, a group of corporatist unionists and Preto dissidents had made a failed attempt to create a militia along the lines of the LP; they later became the driving force behind the LP.[55] The LP's inaugural rally was organized by the corporatist apparatus and supported by a number of former National Syndicalist dissidents. Salazar nominated Costa Leite (Lumbrales) president of the LP's Central Committee. Leite, a professor from the University of Coimbra, led the anti-Preto breakaway faction in 1933 with Salazar's support.

Relations between the LP and the other regime institutions were not peaceful. This was particularly true with the National Union. Salazar separated the MP from the LP and rejected all proposals to place it under the control of the NU. Meanwhile, the single party, ever suspicious of militia organizations, continued to dominate local administration and to constitute the principal channel of communication between the state and society. Yet there was no formal link between the NU and the MP.

After an initial shakeup, the respective positions of the church and the army were consolidated. The former maintained its organizations, "Christianized" the MP, and led the reform of the school system; the latter dominated the Portuguese Legion and sent an appreciable number of reserve officers into that organization.

Certain differences between the LP and the MP are worthy of note.

The MP was quickly depoliticized and Christianized, whereas the LP was vigorously politicized; its discourse, organizational structure, and social composition were more typical of a fascist militia. Both groups were more modest in scale and more dependent on the state apparatus than their counterparts in other European authoritarian and fascist regimes. Their presence on the political scene, moreover, was only fleeting; and in choreographic terms (that is, in terms of rallies, parades, and the like), they were never as fully developed. This holds true even when comparing Portugal with Vichy France, where the regime was ideologically and politically similar.

Salazar was pressured to maintain the LP after the Spanish civil war. The LP claimed that "there is still much to do for our patriotic reinvigoration, and the Legion thus believes that its mission should not be terminated."[56] Salazar did not dissolve the LP, but it went into irreversible decline nevertheless.

State, Politics, and Society

In 1933 the regime created the National Propaganda Secretariat (SPN), headed by António Ferro. Ferro was a cosmopolitan journalist connected to futurist and modernist circles who had admired fascism since the 1920s.[57] He enjoyed the dictator's confidence. Salazar ordered him to create a propaganda machine that, in the end, greatly exceeded the needs of Salazar's image management. Although he had little to do with the leader's provincial integralism, or perhaps precisely because of this, Ferro provided the regime with a "cultural project" that skillfully combined elements of "modern" aestheticism with a "reinvention of tradition."

The SPN coordinated the regime's press, ran the censorship services, and organized sporadic mass demonstrations, as well as leisure activities for the popular classes, in close association with the corporatist apparatus. It also organized numerous activities for the elites and promoted cultural relations with foreign countries. The SPN skillfully recruited intellectuals and artists, thanks to Ferro's "modernistic" links. Like other authoritarian regimes, Salazarism's cultural project sought the "systematic restoration of traditional values."[58]

The selective nature of censorship reflected the "organic" ideal of a conflict-free society. Because conflict had theoretically been abolished,

nothing was published that might testify to its existence. The censors were ruthless when it came to compulsory "social peace." The regime did not ban or systematically dissolve opposition publications; they survived throughout the 1930s. But they reached only an isolated or reduced intellectual readership, which was allowed to engage in debates about the social significance of art or the German-Soviet pact as long as such debates stayed strictly inside Lisbon's cafés and well away from the working class. Salazar did not have to worry about his rural and provincial bastions because he trusted traditional structures, such as the church, notables, and the bureaucracy. As he put it, "politically speaking, only what the public knows to exist, exists."[59]

The School System: "God, Fatherland, Family, and Work"

The *Estado Novo* was obsessive about education. This did not mean it wanted to modernize; modernization became an issue only in the 1950s. Illiteracy debates abounded. In 1933, Salazar expressed the opinion that the constitution of elites is more important than teaching the people to read. At issue was the primarily ideological reorganization of what had been the pride of the Liberal Republican elites: the secular, state-run school, particularly the primary school. Instead of promoting the modernization of the school system, the *Estado Novo* controlled what it had inherited. Government spending on education remained stagnant from 1930 to 1960, while ideological control over teachers and students increased. The *Mocidade Portuguesa* became an instrument for ideological training under the aegis of the Education Ministry; it trained youth in the high schools, to which, until the leap forward in the 1950s, only the urban middle class had access.

Salazarist ideology was based on the four-part doctrine of God, Fatherland, Family, and Work. It shaped teachers' lives. Mandatory school textbooks were issued and special classroom decorations were created. The values of resignation and obedience, as well as the concepts of an "organic" conflict and a politics-free society, dominated primary school teaching. Christianization was another official obsession that affected everything from classroom decorations to school rituals.

From the 1930s on, the official version of Portuguese history was rigidly codified. History was revised and relative pluralism eliminated, pursuant

to the slogan, "Everything for the nation, nothing against it." As early as 1932, the minister of education drew up a new policy that greatly strengthened "the family as a social cell," "faith, as . . . an element of national unity and solidarity," and "authority" and "respect for the hierarchy" as "principles of the social life."[60]

State, Church, and Society

It is difficult to comprehend fully the political system and the ideological foundations of the *Estado Novo* without taking into account the determining influence of traditional Catholicism. The church affected all major texts and institutions, including the Constitution and the declaration of corporatist principles. Its influence explains the weakness of the National Union and the paramilitary organizations, as well as the nature of the regime's propaganda. "Clerico-regime" definitions, also used to describe regimes such as those of Franco, Engelbert Dollfuss, and even Vichy, attempt to account for this power. All these regimes received important support from the Catholic Church; they also followed Republican secularization programs.

The Portuguese Catholic Church contributed to the Salazar regime's ideology. Not only did the regime use Catholic symbolism with the explicit approval of the church hierarchy, it maintained an actual policy of "Christianizing" institutions and the school system. This close association between church and state represented more than just a convergence of interests; it expressed a common ideological and political nucleus that was corporatist, anti-Liberal, and anticommunist.

Although the "Catholicization" of the *Estado Novo*'s institutions was a founding element of Salazarism, the church feared the totalitarian bent of some state organizations after 1936, as well as an eventual "forced integration" of its youth organizations into official, albeit Catholicized, bodies. This fear turned out to be groundless. The regime gave the church control over the symbolic and ideological training of large sectors of society, particularly traditional rural society, and opened up social space for the church's own organizations. The Catholic Scouts were not abolished, and they developed alongside the MP. Catholic Action organizations were linked to the corporatist system but allowed to maintain their autonomy. A significant Catholic private education sector emerged. The

church "defeated" Conservative Republican resistance and fascistizing tendencies with relative ease.

When the *Estado Novo* became institutionalized and the CCP was disbanded, Salazar gave the church hierarchy the task of "re-Christianizing" the country after decades of Republican and Liberal secularization. The Catholic Center was restricted to the social arena and barred from the political arena. In 1940, the Concordat was issued, crowning close church-state ties and establishing the norms for de facto cooperation. The divorce law, the last piece of Republican legislation to be abolished, was changed, prohibiting divorce in religious marriages. A subsequent constitutional revision made Catholicism "the religion of the Portuguese nation."[61] As Salazar himself stated, the *Estado Novo* gave the church "the possibility to reconstruct . . . and recover . . . its leading position in the formation of the Portuguese soul." Pope Pius XII held Portugal up as a model: "the Lord has provided the Portuguese nation with an exemplary head of government."[62]

When the regime's ideological vitality began to fade after 1945, the church gradually became an ideological haven, and the vitality of the Catholic organizations increased. In the early 1940s, Catholic Action organizations had almost seventy thousand members, mostly in the youth organizations; by 1956, membership had reached one hundred thousand.[63] Traditional Catholicism and the church were, on the one hand, the dictatorship's most powerful weapon; on the other hand, they limited fascistization, becoming the driving force of the "limited pluralism" of the *Estado Novo*.

Salazarism, Fascism, and Authoritarianism

Studies based on a typology differentiating authoritarianism from totalitarianism tend to emphasize the nonmobilizing nature of regimes such as the *Estado Novo*. If this is understood as synonymous with the absence of extensive mobilization and totalitarian tendencies, the definition is correct. Even during the "fascist era," the *Estado Novo* was deeply conservative, and relied more on traditional institutions like the church and the provincial elites than on mass organizations.

Salazar once said to Henry Massis that his aim was to "make Portugal live by habit."[64] This *maître-mot*, which so delighted his French supporter,

perfectly sums up the traditionalism of the *Estado Novo*. A functionalist might argue that Salazar's dictatorship did not undergo the totalitarian tension typical of fascism, given the nature of Portuguese society at the time. This interpretation does not wash; such tensions existed in societies just as industrialized or even less industrialized than Portugal. A better interpretation is that Salazarism was voluntarily nontotalitarian, and that it allowed most of the population to live normally as long as it did not get mixed up in politics.

It would be a mistake, however, to confuse Salazar's regime with a "pragmatic" dictatorship, particularly between 1933 and 1945. Salazarism officially instituted an "organic" vision of society and deployed all the ideological and social instruments of administrative, corporative, educational, and propagandistic control, as well as the elite, the state, and the church, to make that vision a reality. On the other hand, it reinforced the presence of the state in the economy, limited the autonomy of the economic elites, and disciplined them with an iron hand.

Culturally and ideologically, the dictatorships closest to Salazarism were those of Franco, Dollfuss, and Vichy. All were dominated by Maurrasian and Catholic thinking. In comparing the agents of the transition to fascism, the fall of liberalism in Portugal and the military dictatorship that ensued can be seen as an integral part of the authoritarian cycle of the 1920s. This is especially true of the transitions brought about by military interventions supported by right-wing parties, such as Hungary in 1919, Poland, Greece, and Lithuania in 1926.

Nevertheless, of all the European dictatorships that emerged in the 1920s, Salazar's *Estado Novo* proved to be the most thoroughly institutionalized and the longest lasting. Had severe international constraints not hindered many of those dictatorships on Europe's southern and eastern periphery, they would probably have survived with features quite similar to Salazarism. Piłsudski's regime in Poland or Smetona's in Lithuania, Dollfuss's in Austria, and Horthy's in Hungary encountered external, rather than internal, factors that froze the institutionalization of those regimes, leaving the process of "political engineering" unfinished.

All these dictatorships were established on the heels of traditional coups d'état; they represented a compromise between civilian and military conservatives; they set up single-party or hegemonic party political systems; and the fascist parties were either minor partners in the coalitions that

took power or were entirely absent. The elites and political movements that inspired the dictatorships were influenced by fascism to a varying degree, but the principles, institutionalizing agents, and types of dictatorships transcended fascism. They were "the typical response to the pressures of mass politics and modernization in most of Southern and Southeastern Europe during the interwar period."[65] They effectively became the dominant model for twentieth-century right-wing dictatorships.

Resistance After 1945

In the period following World War II, the *Estado Novo* defined itself as an "organic democracy" and endeavored, without much difficulty, to conceal its resemblance to fascism. The paramilitary organizations, especially the *Mocidade Portuguesa*, became "former-student" or sporting associations. The SPN's name was changed to the SNI, or National Information Secretariat, and its leadership replaced; it became more anodyne, a promoter of "tourism and information." The Portuguese Legion, downgraded after 1939 when Franco won the Spanish civil war, vanished from the streets and went into terminal decline. Institutional and decision-making changes were very limited. It was only after Salazar was replaced by Marcello Caetano in 1968 that a series of reforms took place and part of the political elite associated with the old dictator was removed.

Salazar's neutrality during World War II, his military concessions to Britain and the United States, and the rapid onset of the Cold War ensured the survival of his regime in an unfavorable post-1945 international climate. Portugal joined the United Nations (after an initial veto from the Soviet Union) and NATO within the next ten years.[66] But it was not easy for the regime to adapt to the new, U.S.-dominated international scene. The dictator had always feared and mistrusted the United States; this feeling was heightened as decolonization began and Portugal's colonial policies were subjected to international condemnation by the U.N.'s Afro-Asian bloc. The Salazar regime survived by cultivating an external image of a benign and aging authoritarianism that stood as an "anticommunist bulwark of Western civilization," and by efficiently controlling internal opposition.

After a period of internal turmoil in 1958, when the dissident general Humberto Delgado obtained significant results in the presidential "elec-

tions," members of the military establishment launched a coup attempt in 1961. Salazar neutralized the conspiracy and embarked "rapidly and force-fully" on the colonial war that eroded his regime and finally shattered it thirteen years later.

One of the classic themes explored by studies of Spain's transition to democracy has been the effect of the modernizing economic boom of the 1960s. Portugal also underwent a qualitative modernizing leap at that time, albeit more modestly. According to one historian, Portugal "ceased to be dominated by the primary sector; the tertiary sector took over, marking the passage from a peasant to a postindustrial society."[67] Economic policy was marked by a gradual liberalization, accession to EFTA, and increas-ing foreign investment in Portugal. Emigration to the more developed European countries from the rural interior increased. A new urban middle class emerged, with values that differed significantly from those of the regime. The "tourist boom" and emigrant remittances increased the pace of socioeconomic change and development. Meanwhile, the contradiction between these changes and official political ideology increased. Salazar's warning that "material life, economic development, and the unceasing rise in living standards" would "leave in darkness all that is spiritual in man" went unheeded.[68]

The process of change that led to the 1974 military coup and the tran-sition to democracy should not allow us to forget the durability and resil-ience of Portuguese authoritarianism.[69] Portugal lived under an authori-tarian regime for forty-eight years, making it the champion of right-wing authoritarian longevity in twentieth-century Europe.

The Colonial Empire

VALENTIM ALEXANDRE

The colonial question lies at the heart of modern Portugal's political life and of all fundamental national policy options. It has determined the fate of movements and regimes. Its weight is largely a product of the longevity of the Portuguese imperial tradition, initiated in the fifteenth century when the first trading posts and fortifications were established on the western coast of Africa. In the next century, the empire was based on Portugal's holdings in the Orient and India, and throughout the seventeenth and eighteenth centuries in Brazil. When the Brazilian portion collapsed in 1822 because of Brazilian secession, it was commonly held among Portugal's political elites that the country could not survive without an empire and would be absorbed by neighboring Spain if it did not possess one. In order to avoid this, it was thought necessary to create a "New Brazil" in Africa. The idea that the existence of the nation and its heritage would be guaranteed by the construction of a new colonial system left its mark on Portuguese nationalist thinking in the nineteenth and twentieth centuries.

It soon became apparent, however, that the task of creating a "New Brazil" would be more difficult than initially envisaged, given Portugal's scarce resources and the African territories' paltry trade relations with Portugal. The African colonies were dedicated mainly to the slave trade supplying Cuba and Brazil.

The African colonial project was formulated during the third decade of the nineteenth century, but it became a reality only in the late 1880s, when the African empires of the other European powers came into being. Colonial frontiers were definitively established after the successive conflicts and

negotiations of the decade following the 1885 Berlin Conference. The territory obtained by Portugal did not match the needs of a "New Brazil." It was a contiguous area stretching from coast to coast in Central Africa, including the area between Angola and Mozambique and a part of the Lower Congo.

Nevertheless, the empire embraced a vast area that far surpassed preexisting occupied enclaves. It included Angola on the western coast, which occupied more than 1.2 million square kilometers; and Mozambique on the eastern coast, which spread over 783,000 square kilometers. In addition, there was Guinea, a small territory of approximately 36,000 square kilometers south of Senegal; the Cape Verde Islands and São Tomé and Príncipe in the Atlantic; and the minuscule remains of the Oriental empire, including Goa, Damão (Daman), and Diu on the Indian subcontinent; Macao, the south of China; and Timor in *Insulíndia*.

The "Pacification" of Africa

With the empire mapped out, it became necessary to transform formal sovereignty into effective dominion. This task was central to Portuguese colonial policy for more than three decades, from the middle of the 1890s on. The policy consisted of a series of "pacification" campaigns of varying scope undertaken in all three of the African colonies.

Military activity was not, in and of itself, a novelty. The overseas administration of Portugal's territories had been traditionally entrusted to the military. Its presence in Africa was marked by innumerable localized conflicts, as well as a few occupation campaigns of greater or lesser importance, such as the Congo campaign in the 1850s and the Zambezi campaigns initiated in 1869. Military occupation was thus a natural extension of previous policy. Operations now became more systematic, however. Military means were boosted by initial success, particularly the victory over the feared N'goni Kingdom of Gaza in southern Mozambique in 1895. This culminated in the imprisonment of the N'goni ruler, who was subsequently paraded in the streets of Lisbon amid great patriotic fervor.

The leaders of the generation of 1895, António Enes, Mouzinho de Albuquerque, Paiva Couceiro, Aires de Ornelas, Freire de Andrade, Eduardo da Costa and Caldas Xavier, and other lesser personalities became national heroes. They left a strong imprint on colonial ideology in later

years. These men justified the use of force to subdue "backward" or "inferior" races on the basis of Social Darwinism, popularized in Portugal in the 1880s. Da Costa, considered the leading ideologue of the group, put forward the most elaborate theory for the domination of the colonial territories. In his view, expeditious means had to be used to ensure occupation; the peoples who dared to resist had to be severely punished; and the subsequently pacified zones had to be placed under a regime of "mitigated despotism," characterized by a total concentration of power in the hands of the colonial authorities, the absence of deliberative assemblies, and the use of summary military trials as means of administration.[1]

Variations notwithstanding, this theory predominated in works on colonial matters at the time. The peaceful penetration of the colonial territories and peaceful civil administration were a vision espoused only by a very small minority. The traditional aims of Portuguese colonial policy—tax collection and labor recruitment—generated tensions, which ultimately required the use of military force, such that the adoption of a peaceful path would not have been easy.

The process of occupation was characterized by a long series of localized conflicts punctuated by larger campaigns. The fragmentation of conflicts stemmed partly from the political pulverization of African societies, but also from the uneven pressure exerted by the Portuguese authorities and settlers. On rare occasions, conflicts would spread, affecting an entire ethnic group. They were sometimes provoked by a charismatic leader capable of uniting disparate populations. Such was the case of the revolt of the Ovimbundus on the Central Angolan Plateau in 1902 and the Bakongo revolt in northeastern Angola from 1913 to 1915. Regionwide economic pressures also contributed to wider conflicts. The Ovimbundus revolt, for example, was also provoked by the fall in the price of rubber, a trading commodity for the region.[2] In contrast, the endemic state of war that affected Zambezi (the central zone of Mozambique) can be explained by the persistent action of traditional war chiefs.[3]

Some of the larger conflicts originated in decisions of the Lisbon government to occupy rapidly certain areas considered particularly sensitive for external security. The campaign against the Kingdom of Gaza in 1895 is a case in point. Its conquest was considered necessary for the domination of southern Mozambique in the face of Cecil Rhodes's expansionism. The majority of the small campaigns did not involve more than a few

hundred men. In the Gaza conflict, more than 3,200 soldiers were deployed; approximately 2,700 of these were Europeans recently dispatched from Portugal. Mobilization continued over the following years as successive expeditions were launched. There were twelve between 1894 and 1901, raising the number of active soldiers in Mozambique to 7,000.[4]

The campaigns conducted both in Angola and Mozambique between 1914 and 1918 far outstripped these numbers. Approximately four hundred officers and twelve thousand men were sent out to the Angolan territories; more than nineteen thousand were dispatched to the east coast. The mobilization of auxiliary African soldiers also increased, as did the recruitment of carriers used for military transport services.[5] This effort was also successful in Guinea, if on a smaller scale. By the end of the second decade of the 1900s, "pacification" had been achieved in the three African territories under Portuguese sovereignty.

The Empire Under Pressure

Control over the empire as a whole was precarious, given that it was governed by a loosely structured, poorly organized military administration. As in the nineteenth century, the exploitation of the colonies after 1900 was ensured through the dominant trading circuits rather than by production itself (unless the limited, forced labor–based plantation sector is taken into account).

Once military occupation was established, the development and modernization of the colonies became the most urgent tasks of the 1920s, compelled mostly by external factors. The League of Nations defined the aims of colonization as the "civilization" of native peoples and the creation of wealth in overseas territories. Portugal consequently feared that poor performance in Africa would serve as an excuse for the League to partition Angola and Mozambique and eventually place them under the tutelage of more powerful countries. This fear led to the constitutional revision of 1920, giving the colonies greater economic and financial autonomy and permitting the nomination of high commissioners for Angola and Mozambique. The high commissioners were given vast legislative and executive powers and were charged with promoting the rapid development of their respective territories.

This policy was most fully implemented in Angola. After the trans-

atlantic slave trade ended with the closure of the Brazilian and Cuban markets in 1851 and 1866, respectively, the Angolan economy turned to the export of products from the interior, such as coffee, wax, and, from 1870 on, rubber. At the turn of the century, the plantation economy still consisted only of small areas of coffee and sugarcane cultivation. (The greater part of the latter replaced Brazil's production of *aguardente* destined for Angola's internal market.) Despite the abolition of slavery by law in 1869 and of servile labor in 1875, labor exploitation in this sector remained archaic and akin to slavery. Given the almost complete lack of roads and railways, the extremely onerous activity of the carriers took up much of the available manpower, with a detrimental effect on the development of agriculture.

This economic system went into crisis at the beginning of the 1890s, and was even more severely affected by the collapse of the Angolan rubber trade following the fall of international market prices in 1901 and 1913. Meanwhile, a prohibition on the manufacture of liquor damaged another important sector. These crises were only partially compensated for by the export of corn from the central plateau. Growing international pressure, moreover, made it increasingly risky to sustain forms of labor exploitation that resembled slavery.

It was against this background that General Norton de Matos, nominated high commissioner for Angola in 1921, appeared on the scene. The general had already governed the region once before, between 1912 and 1915. His plan was political: it aimed to reinforce Portuguese sovereignty over the territory. His efforts to replace the unstable and uneven military administration with a civilian one were undertaken in this spirit, aiming toward the organization of a "systematic, continuous, and constant administrative occupation," as did his policy of destroying the power of the "indigenous" chieftains.[6] The reinforcement of sovereignty entailed stricter control over the religious missions, particularly the foreign ones.[7] It also involved the encouragement of national "lay civilizing missions."[8] In the long run, however, the maintenance of a Portuguese presence in Angola was based on intensive colonization by families coming from Portugal, a process Matos sought to foster.[9]

None of these efforts would have been viable without the initially successful modernization of the Angolan economy. One aspect of modernization involved the elimination of all forms of forced labor, which Matos had already decreed during his first administration and which was subsequently

reinforced by further legislation during his rule as high commissioner.[10] The process of modernization was also based on a massive program of infrastructure construction, financed mostly by loans contracted with foreign companies active in the colonies. In Angola, this role fell to Diamang (controlled by the Belgian Société Minière), which had controlled the diamond exploration concession in the territories since 1917.[11]

The Matos plan was aborted immediately, however, killed by a lack of financial resources, galloping inflation, and the territory's inability to keep up with the debt payment. The plan left few traces of its existence, apart from an increase in the number of settlers from nine thousand in 1900 to forty-four thousand in 1930 and a first, limited, but nonetheless real boost to the construction of communications networks. Politically attacked both in and outside Angola, Matos was forced to retire in 1924. The modernizing path was short-lived. It could not overcome vested interests or the weakness of Portuguese capitalism, which could not sustain the voluntarism of the project.

In Mozambique, room to maneuver was more limited. High Commissioner Manuel Brito Camacho, who was nominated in 1921, had even less impact. Approximately two-thirds of the territory under his aegis escaped the direct control of the Portuguese authorities. These areas had been administered since the end of the nineteenth century by two chartered foreign companies: the Niassa Company, operating in the north, between the Lurio and Rovuma rivers; and the Mozambique Company in the central region, between the Zambezi River and the twenty-second parallel. Both of these companies lived off tribute and the recruitment of labor for the Rand mines and the Sena Sugar Estate, which had established plantations in the region of the Lower Zambezi River. As a whole, the Mozambican economy maintained only tenuous relations with Portugal. It was strongly linked to South Africa by the trade passing through the port and railway of Lourenço Marques or Delagoa Bay, as well as by the emigration of laborers to the mining regions of the Transvaal.

This system did not function without tensions, as witnessed by a variety of factors: the massive periodic exodus of people fleeing forced recruitment; the protest of white settlers against emigration to the mines, which robbed them of labor; South African pressures to control the Lourenço Marques port and railway and even to annex the whole of southern Mozambique. In this context, Brito Camacho attempted to negotiate stable

relations with South Africa. But he did not meet with success: in 1923, the South African government denounced the Convention of 1909 governing relations between the two regions. The question was left pending, but the Cape did not abandon its expansionist aims.

By the mid-1920s, it was becoming obvious that the colonies were not fulfilling their promise. Even the relatively more profitable islands of São Tomé and Príncipe in the Gulf of Guinea, where a nucleus of planters had settled during the previous century, showed signs of decline. The production of cocoa had decreased from plant disease, soil erosion, and falling prices. The bankruptcy of development plans, particularly those led by Norton de Matos, aggravated Portuguese anxiety over the colonial future.

The crisis revived the old specter of partition of the empire by the great powers. Apart from the South African threat to Mozambique (the most immediate and real one), it was feared that the colonial designs of Italy and Germany might lead to the redivision of the African continent, to the detriment of Portugal. A 1925 report by the U.S. sociologist Edward Ross, accusing the Portuguese authorities of permitting labor practices akin to slavery in Angola and Mozambique, further darkened the horizon. In Lisbon, the report was regarded as yet another example of the international conspiracy to deprive Portugal of its overseas territories. Yet another threat, whether real or imaginary, the rumor of white separatism circulated in Lisbon on a number of occasions throughout 1924 and 1925.

All this was more than enough to reawaken the most radical forms of nationalist sentiment among the Portuguese elites. That led to the establishment of a "Movement for the Defense of the Colonies," which united personalities from a great variety of political backgrounds. The themes of the movement were those that had dominated colonial ideology from the last quarter of the nineteenth century on: the sacred nature of the empire, the "historical mission" of Portugal, and national survival.

The colonial crisis and the nationalist upsurge it provoked were two of the decisive factors in the fall of the Portuguese First Republic with the military coup of May 28, 1926. The military dictatorship embodied the nationalist, centralizing reaction in the realm of colonial policy. The dictatorship promulgated a set of laws that aimed to make the colonial state machinery more consistent and efficient. The Organic Bases of the Colonial Administration (Decree Law 12.421 of October 2, 1926) limited the autonomy of the colonial governorships and reinforced the supervisory

and fiscal powers of the central administration. The Organic Statute for the Portuguese Catholic Missions in Africa and Timor (Decree 12.485 of October 13, 1926) gave overseas religious missions a free rein. As stated in the preamble, the aim was to combat the influence of foreign, particularly Protestant, missions, which were considered a threat to nationalization as well as potentially subversive. The other aim of the legislation was to gain the institutional support of the church for the exercise of an ideological control that the state had been unable to ensure.

The Political, Civil, and Criminal Statute of the Natives of Angola and Mozambique (Decree 12.533 of October 30, 1926, later reformulated by Decree 16.473 of February 6, 1929) juridically distinguished between "civilized" and "native" peoples, a distinction that characterized modern Portuguese colonial practice. "Natives" were to be governed by traditional customs and usages under the tutelage of the state, rather than by the rule of law. Finally, the extensive and critically important Native Labor Code (Decree 16.199 of December 6, 1928) abolished the legal duty to work. This was an obligation that had been consecrated in the previous legislation; its suppression eliminated the legal basis for forced labor. It was a tactical retreat in the face of pressures from the League of Nations and the International Labor Organization. As such it was also heavily criticized by the more radical elements of the regime. Those criticisms, however, were unwarranted: all evidence indicates that compulsory practices were only very briefly affected by legal reforms.

The "New State" and the Imperial Mentality

The four laws of the military dictatorship laid the foundations for colonial policy in the following decades. It was only under the *Estado Novo*, however, that policy was systematized. The state apparatus was placed at the service of the construction of a colonial empire. The symbol of the transition to this new phase was the Colonial Act of July 8, 1930, which was promulgated by António Salazar as interim minister of the colonies and became part of the colonial constitutional order.

The aim of the Colonial Act was political: solemnly and constitutionally to reaffirm Portuguese sovereignty overseas. Its purpose was thereby to make the law permanent and irrevocable at a time of growing tensions with the Society of Nations (SDN) over the question of indigenous labor

and the "internationalization" of the colonial territories. Hence the emphatic statement in the act's second article, "It is part of the organic essence of the Portuguese Nation that its historic function is to possess and colonize its overseas domains and to civilize the native populations contained therein." The issue of the defense of the empire, greatly popular among the Portuguese political elites, was thus taken up again.

The Colonial Act marked the beginning of a period in which the state actively pursued the creation of an imperial mentality among the Portuguese. It did this through an educational system at the service of the cause of the empire, and through organized events that had an impact on public opinion: conferences of colonial governors, the "Colonial Weeks," and various publications and exhibitions, all culminating in the visit of the president of the republic to the African colonies in 1938 and the Exhibition of the Portuguese World of 1940.

The Colonial Act, along with the Organic Charter of the Portuguese Colonial Empire and the Overseas Administrative Reform Act, also profoundly restructured the system of colonial power.[12] It centralized power, severely restricting the decision-making autonomy previously in the hands of the high commissioners (later replaced by governors) and concentrating a wide range of legislative and executive powers in the Ministry of the Colonies.

This new orientation was also reflected in the economic realm. The focus was on the "nationalization" of the exploitation of overseas territories. Strict control over foreign investment and the prohibition or renovation of concessions to foreign companies were implemented, involving a delegation of sovereign powers (Colonial Act, articles 11, 12, and 13). It led to the progressive elimination of the concessions that occupied a great part of Mozambique. In this case, however, "nationalization" also entailed the establishment of complementary links between the various parts of the empire, through the so-called colonial pact regime. According to this system, the overseas possessions were to supply Portugal's industry with the raw materials it needed and to reserve overseas markets for Portuguese products.

This policy contained nothing new. The use of differential rights to protect Portuguese exports to the colonies was a tradition initiated almost a century earlier, and reinforced in 1892 with the establishment of a highly protectionist system, particularly for wine and textiles. The earlier regime

was moderated somewhat in 1914, but the principle still applied at the beginning of the 1930s. The *Estado Novo* merely reaffirmed the system, fixing a 50 percent minimum level of tariff protection and updating duties that had been devalued by inflation.[13]

The persistence with which the Salazar regime attempted to control imperial trade flows was new, however. Successive measures of economic intervention were tried. One was the establishment of exchange rate funds in Angola (1931) and Mozambique (1932), which gave the state control over the distribution of funds available for foreign payments. Another, the 1936 application of the principle of overseas "industrial conditioning," made governmental approval necessary for the establishment of industries otherwise restricted or even entirely barred. In 1937, the establishment of the so-called economic coordination mechanisms aimed to control exports of a variety of colonial products.[14]

The objectives of this policy were not very different from those pursued by other colonial nations after 1929. For Portugal, moreover, the results were very limited, taking only the 1930s into account. Trade between the colonies and Portugal never exceeded 15 percent of the latter's foreign trade. The same was true for Portuguese exports to the colonies. In both instances, the figures were lower than those between 1890 and World War I.[15] It is important to note, however, the partial successes that were attained. The increase in textile exports to Angola and Mozambique was modest but real, as was the import of colonial products for consumption, including corn and sugar. (The latter had exclusive rights to the market in Portugal, as prices were fixed above world prices from 1930 on.)[16]

Perhaps the most important aspect of the imperial economy in the 1930s was the rapid growth of cotton cultivation in Angola and Mozambique.[17] Fostering the growth of this product had been a traditional aim of Portuguese colonial policy and had been unsuccessfully attempted on a number of occasions from the middle of the nineteenth century on. From the outset, the military dictatorship encouraged the cultivation of cotton, with the promulgation of a decree on September 28, 1926. The law followed the model already in use in the Belgian Congo. It provided for the division of the colonial territory into "zones of influence" under concessions that gained exclusive rights to buy cotton cultivated by the "natives." The real impetus for this policy, however, emerged only in 1932 after the fixing of minimum prices for cotton produced in the colonies for sale in Portugal.

Prices were fixed above international market levels.[18] In 1932, 2,378 tons of cotton were produced, and in 1936 the figure had risen to 7,048 tons.[19]

This system was based on the repression of African peasants, who were forced to cultivate a very low priced product grown to the detriment of subsistence crops or other more profitable products.[20] Forced cultivation was accompanied by more traditional forms of compulsive labor on the plantations or in the transport services, which were maintained despite their proscription by the Labor Code of 1928. It would be a mistake, however, to view Portuguese colonial society in the 1930s as a vast and uniform coercive labor camp. Depending on the economic situation, the pressure on labor varied from region to region (it declined overall in the 1930s, for example). That pressure also depended on levels of demand and on the level of efficiency of the still weak Portuguese administration of that period. For this reason, many African societies retained a dynamic of their own, as well as a significant ability to adapt to external economic factors.

The Economic Takeoff

World War II lent renewed impetus to the policy of the 1930s, once initial difficulties caused by the closure of various markets and the scarcity of transport had been overcome. With the reorganization of international trade circuits, rising demand for the main colonial products increased the value of Angola's and Mozambique's foreign trade. This reinvigorated domestic economic activity and increased pressure on the African peasantry through the forced cultivation of certain products or compulsory labor. At the same time, Portugal reinforced its control over imperial trade through specially established economic coordinating bodies. Control mechanisms already applied during the preceding decade were reactivated: protectionist duties, price tables for colonial goods (this time lower than international market prices), and fixed, compulsory quotas for the provision of the Portuguese market. Toward the end of the war, trade with the colonies made up approximately 20 percent of Portugal's foreign trade, and Portugal was Angola's and Mozambique's main trading partner.[21]

Overseas trade expansion lasted throughout the postwar period, benefiting from the high prices obtained for raw materials, as with the coffee boom in Angola. The intensity of relations between the colonies and Portugal peaked in this period, permitting the Portuguese state to achieve

some of its traditional objectives. In the 1950s, for example, cotton textiles represented nine-tenths of the imports of Cape Verde, Guinea, São Tomé and Príncipe, and Angola, and three-quarters of Mozambican imports. Wine exports, which represented about 80 percent of total exports, reached approximately 1,075,000 hectaliters per annum in the period between 1955 and 1959, in contrast with an average of 180,000 between 1930 and 1934.

Apart from these products, the range of Portuguese goods exported to Africa increased to include beer, canned fish, chemical products, tires, and machinery. On the other hand, a process of transferring industries to Angola and Mozambique was set in motion under the control of some of the most important Portuguese economic groups. From the mid-1940s on, these groups became interested in investing significantly for the first time, in trade and finance as well as in productive activities. They invested in the plantation economy, taking advantage of the retreat of foreign capital in the wake of World War II.[22] The state's capacity to invest public monies overseas was also a novelty. Relatively high sums were set aside for infrastructure projects through the First Investment Plan of 1953–58.

In addition to these trends, emigration to Angola and Mozambique increased. Between 1947 and 1960, emigration represented half of all previous demographic flows from Portugal. Large settlements of European origin appeared for the first time in both colonies. In Angola, the number of white inhabitants increased from 44,000 in 1940 to 173,000 in 1960; in Mozambique, the numbers for the same dates rose from 27,500 to 97,000. The sudden attraction of the overseas colonies can be explained primarily by their economic development, but it was also a product of the efforts of the *Estado Novo* to spread the "mystique" of the empire from the 1930s on. That promotional effort rid colonial life of the stigma of exile and death, which had traditionally characterized views of life in Africa. Apart from the obvious political importance of white colonization, the increase also contributed to the rapid growth of wine exports to Angola and Mozambique.

Until the end of the 1950s, the trading system between Portugal and the territories in Africa still followed the "colonial pact" model. The framework changed in the 1960s, however, with a new economic policy designed to create a single Portuguese market including Portugal and the overseas colonies, and to permit the free circulation of people, goods, and capital. The policy was intended to support the "national integration" consecrated with the constitutional revision of 1951. The evolution of the Portuguese economy, however, also rendered the previous model obsolete. The struc-

ture of industry was changing with the growth of the electrical, metallurgical, chemical, and petroleum sectors. Textiles, which had up to then constituted the backbone of the "colonial pact" regime, lost their weight and influence, becoming less and less dependent on the overseas colonies either as markets or as sources of raw materials.

The creation of the "Portuguese economic space" also aimed to respond to the tensions provoked by European integration. By joining the European Free Trade Association (EFTA) and inaugurating a development policy that integrated all the empire's various territories, the Portuguese government hoped at least to gain time to negotiate a stronger position with the member states of the European Economic Community (EEC).

Within the framework of this new policy (although not necessarily because of it), the Angolan and Mozambican economies experienced relatively high growth rates. This was particularly true for Angola, which grew at an annual rate of 7 percent between 1963 and 1973.[23] This allowed the colony greater access to the international economy under relatively favorable conditions. It also increased foreign capital investment between 1961 and 1965. The colonial war that began in Angola in 1961, in Guinea in 1963, and in Mozambique in 1964 did not have the negative economic impact that might have been expected. Except for Guinea, the armed conflict affected only marginal areas and left productive activities in Angola and Mozambique intact. In fact, the conflict had an indirectly positive impact on the development of both colonies: not only did it lead to the elimination of the archaic forms of labor exploitation, but it also increased civil and military state investment.

Growth did not lead to national integration, however. On the contrary, the ties between Portugal and the colonies were weakened. Angolan imports from Portugal fell by more than 40 percent of total imports during the first half of the 1960s, and again by 23 percent in 1972 and 26 percent in 1973. As for Mozambique, imports fell by more than 30 percent until 1967 and again by 19 percent in 1973. Portuguese exports overseas declined from 23.6 percent of total exports in 1968 to 12.6 percent in 1972.[24] These figures reflect Portugal's inability to absorb the increase in colonial production or to provide the colonies with the goods they needed.

The growth rate of the Portuguese economy accelerated, but its more modern and dynamic sectors (base metallurgy, chemicals, metal products, machinery, and transport equipment) did not depend on the colonies.[25]

The Political Crisis

The economic centrifugal forces set in motion with international trade liberalization and the internationalization of the productive process forced the Portuguese Empire to deal with an even greater political threat: the colonial crisis of legitimacy. It emerged in the wake of World War II, and it owed its origin to the reaffirmation of the principle of self-determination, the declining belief in the superiority of Western civilization, and the discrediting of the tutelary role of European nations over races once considered inferior or backward.

The colonial powers' immediate reaction to this new context was to modernize the system. More shocking forms of exploitation, such as forced labor, widespread on the African continent during the war, were eliminated, and greater rights of political representation were conceded to local populations. Portugal was no exception: its first references in parliamentary debate to the need to adapt the juridical and institutional forms governing the empire to the new postwar situation date from 1944. In 1945, the colonial minister traveled overseas to eliminate the legislative and administrative practices most obviously based on racial discrimination, and to get rid of forced labor.[26] Political concessions were minimal, however; they did not transcend a slight softening of the highly centralized regime.

Such limited reform was manifestly insufficient to respond to the crisis, which shook the very foundations of the colonial system. This was demonstrated in 1947 with the struggle against Portuguese sovereignty over Goa, Damão, and Diu, three small territories on the Indian subcontinent claimed by the new state of India. This issue dragged on, as Lisbon consistently refused to allow a referendum to resolve the dispute.

In the face of these pressures, and predicting the deterioration of the situation in Africa, the Portuguese government decided to change the institutional and juridical foundations of the system rather than the system itself. In 1951, a constitutional revision altered the imperial vision that had predominated between the two world wars and that had been enshrined in the Colonial Act. It replaced that vision with the idea of assimilation, through which the colonies became "overseas provinces" and parts of a single nation.

In the same period, the regime adopted Lusotropicalism as the new official doctrine. This was a theory formulated in the 1930s by the Brazil-

ian sociologist Gilberto Freyre. It was based on the idea that the relations established between the Portuguese and the peoples of the tropical regions followed a particular model, which emphasized understanding of and adherence to local values and which would give rise to a cultural and biological interpenetration, permitting the creation of an integrated whole—a veritable "Lusotropical civilization."[27]

The new juridical and ideological bases, however, barely affected the colonial political system. The Portuguese Organic Overseas Law, promulgated in 1953, only minimally altered overseas colonial administration. The Native Statute was maintained, countering the logic of assimilation. Although it was altered in 1954, the statute still deprived the overwhelming majority of the African population of access to Portuguese citizenship. The only exception to this rule were the "assimilated"—those who had adopted European values and lifestyles. But they were a minority that did not exceed 0.8 percent of the population in 1961, when the statute was finally abolished.

That percentage also reflects the state's inability and, to some degree, lack of political will to create elites capable of mediating between the colonial power and African society. Portuguese colonial policy toward the traditional African authorities, from the occupation campaigns on, had always been to eliminate them rather than to take advantage of them as intermediaries. The creole groups that had traditionally played that mediating role up to the nineteenth century, moreover, had lost all their influence in the political system, a result both of the influx of Europeans and of the discriminatory practices of the Portuguese administration. Thus, a vacuum was gradually created between the state, which aimed to be omnipresent, and the African peoples.

This situation left little room for political maneuvering, particularly from the second half of the 1950s on, when African decolonization accelerated. Pressure on Portugal reached a critical point only after the Belgian Congo achieved independence, in June 1960. The new state's geographical contiguousness with Angola and, more important, the shared ethnic identity of the people living in the border areas increased the likelihood that the conflict would spill over into Angolan territory. This is exactly what happened. At the beginning of 1961, a revolt erupted against forced cotton agriculture in the Cassang lowlands. It was fiercely repressed. An urban-based uprising broke out in Luanda in February, involving a frus-

trated attempt to liberate the regime's political prisoners. This event led to the indiscriminate persecution of the black population by the white militia. In March, the Congo insurrection infiltrated the northeastern part of Angola, accompanied by a massacre of white settlers and mixed-blood, or "assimilated," people. This insurrection marked the beginning of the Colonial War.

The explosion of conflict in Angola profoundly shook the *Estado Novo*. For the first time in his thirty-seven-year rule, Salazar faced the threat of being removed from power. A military coup attempt in April 1961 involved high-ranking officers, including the ministers of defense and of the army.

The insurgency was defeated. African policy was subsequently redefined along three key lines: the rapid preparation of a military counteroffensive in the insurrectional region of the Congo; the appeal to nationalist sentiment in Portugal; and the promulgation of a vast number of legislative measures. Among these were the abolition of the Native Statute and of forced cultivation and labor. Measures were taken to reinforce the colonial system so it could resist international pressures, and to rob the African movements of their social support.

Once again, however, alterations to the organization of colonial power were very limited. No new spaces were created for the population that had, up to then, been classified as "native." The native communities were regrouped under the *regedorias*, uniting "neighbors according to traditional law," directed by a *regedor* chosen according to local custom.[28] The new legal formula merely reaffirmed existing practices; the *regedor* continued to depend on the Portuguese administrative authorities. On the other hand, the reforms aimed to integrate the white settlers, who had long railed against centralism, by establishing elections both for the local administrative bodies and for the Legislative Councils of each "overseas province."[29]

This strategy was initially successful. The political and military situation in Portugal was normalized. The mobilization of more military forces to Angola permitted the occupation of the insurrectional areas once again. Once the first great shock had been absorbed, however, guerrilla war began, soon spreading to the territory of Guinea in 1963 and to Mozambique in 1964.

The long colonial war took place against a complex background of greater conflicts experienced during the 1960s and 1970s. The emergence of African nationalism in the struggle against the imperial powers was, on

a regional level, a battle between the "white bastion" of Africa and the countries of black supremacy. On a world scale, the African conflict was one of the most important of the Cold War. In this context, it was always possible for Portugal to garner military and diplomatic support to contain the guerrillas. Of all the Western nations, only the United States exerted real pressure on the Lisbon government to decolonize. But this pressure was short-lived; it was applied during the Kennedy administration and above all in 1961, the year the embargo on the sale of U.S. military supplies to Portugal was decreed. From then on, pressures diminished, and the embargo was avoided on a number of occasions. The strategic importance of the Lages base in the Azores (conceded to the United States for the first time in 1944 on a periodically renewable basis) prevented Washington from expressing its hostility toward Lisbon's African policy. Support from countries such as France and Germany, by contrast, was outright.

The majority of the African nationalist movements, on the other hand, sought support from the Communist bloc countries. Support and logistical bases allowed these movements to maintain a military presence in Angola, Mozambique, and Guinea for many years. With the exception of Guinea, however, they did not significantly affect the economic activities or even the daily routines of the main population centers.

Only a fundamental shift in Portuguese policy could have brought the conflict to an end. But the government of Marcello Caetano, who succeeded Salazar in 1968, made no change in policy. The "progressive autonomy" written into the constitution in 1971 did nothing but transfer powers to the sovereign colonial institutions. The overwhelming majority of Africans were still excluded from the political arena and the right of suffrage. Instead of opening a path toward a political solution for the colonial question, the constitutional reform of 1971 signaled the regime's inability to find one.

Meanwhile, the progressive disintegration of the bloc sustaining the regime was aggravated as a result of the economic development process itself. Economic interests with more links to the European market than to the "Portuguese economic space" emerged. Prolonged war cracked the edifice of the institutions that had been the great pillars of the system: the church and the armed forces. This process finally culminated in the military coup of April 25, 1974, which was accompanied by a popular uprising and a subsequent rapid process of decolonization.

Conclusions

The Portuguese colonial empire, dependent on a poor country that missed the Industrial Revolution of the nineteenth century, is usually seen by foreign observers as an abnormal case, one that escaped what appears to have been the normal course of history. Two temptations emerge from this view. The first, which reemerges periodically, is to see modern Portuguese colonialism as a simple conduit for the aims of the great powers, or a merely formal political sovereignty exercised in the name of outside interests. Portugal's semiperipheral status makes this theory particularly attractive. But nothing in the above account confirms the theory. The presence of foreign capital was always tolerated as a necessary evil, rather than actively promoted. Lisbon's colonial policy, moreover, was always defined in strictly national terms, often to the detriment of the economic development of the overseas territories.

The second temptation is to consider the Portuguese Empire as an anachronism, a survivor of the slave-trading era, its existence ensured by inertia. Again, analysis discredits this preconceived notion. As noted, the Portuguese Empire was constituted during the Scramble period, and it subsequently followed a path similar to that of the other European colonial systems in Africa: the consolidation of frontiers, military and administrative occupation, economic exploitation. The "archaic" forms of labor exploitation found in the Portuguese colonies, forced labor and cultivation, were also found in many French or Belgian territories in Africa, and were therefore not exclusive to backward Portuguese capitalism. From an economic point of view, the difference between the Portuguese Empire and the others is one of degree rather than of substance.

Another difference, although less obvious, is perhaps more important. It stems from the particular weight the colonial question held in Portuguese politics. For historical reasons, the imperial project was connected with the image of the nation itself, the "sacred heritage" of the Golden Age of the Discoveries and the country's own independence in relation to Spanish power on the Iberian Peninsula.

This view led to the "sacralization" of the empire, a process that reached culmination in the last quarter of the nineteenth century, casting a long shadow over the period to follow. It robbed anticolonial currents of any political space. These never acquired more than a tiny following in Por-

tugal except during the final years of the *Estado Novo*. Whereas nationalism in other colonial countries was divided into pro– and anti–overseas expansionist currents, Portuguese nationalism was, with rare exceptions, imperialist.

Hence the voluntarist nature of Portuguese colonial policy. It sought to mold the social forces and economic interests involved in the colonial process, in the name of national goals that were considered transcendent. This voluntarism peaked during the *Estado Novo*; it lay at the root of the creation of an "imperial mystique" in the 1930s and the tenacious defense of the colonial system in its final years, against the general trends of the times.

Between Africa and Europe: Portuguese Foreign Policy, 1890–1986

NUNO SEVERIANO TEIXEIRA

Portugal is both a European and an Atlantic country. As a small, semi-peripheral power with only one land border, it has always experienced an unstable geopolitical balance, caught between the devil of continental pressure and—literally—the deep blue sea. Geopolitical conditions, as well as the constant search for balance, have informed the strategic options and the historical characteristics of Portuguese foreign policy.

It would not be true to say that Portugal's foreign policy and diplomacy changed substantially at the end of the nineteenth century and during the twentieth century. Portuguese foreign policy principles were always marked by the constant search for a peninsular equilibrium and a concomitant balance between Europe and the Atlantic; in other words, between the weight given to relations with Spain, on the one hand, and extra-peninsular alliances and strategic options, a preferential alliance with the maritime powers, and a special emphasis on the colonial project, on the other. It was only with the advent of decolonization and the emergence of the "European option" that this historical framework changed.

From the diplomatic point of view, Portugal was still at the mercy of the power games and projects of the great powers. The country's diplomats sought to maintain a balance between Portugal's multiple dependencies and to adapt to new, evolving international circumstances with short-term policies subject to rapid alterations.

The Constitutional Monarchy

Throughout the first half of the nineteenth century and up to the 1870s, Portuguese foreign policy was unequivocally and forcibly dominated by the alliance with Britain. Initially, the primacy of this alliance was ensured in a direct and violent way by a political-military tutelage imposed after the French invasions, and by the economic hegemony ensured through the Anglo-Portuguese Treaty of 1810. Subsequently, it was imposed in a less direct and mitigated, albeit equally effective, fashion through the Quadruple Alliance, and through the integration of the peripheral and dependent Portuguese economy into the British economic system. Nevertheless, British hegemony over Portugal was sometimes visible during the first half of the century, notably during the emergence of Liberalism in 1834, the September 1836 revolution, and the Patuleia Civil War, which culminated in the Gramido Convention of 1847.

It was only with the unification of Germany in 1871 and the concomitant emergence of a new power in the international arena that an important alteration took place in the balance of power that had been in place since the Congress of Vienna in 1815. Although still dominant, Britain was no longer alone in the international sphere. Portuguese foreign policy thus had an "alternative." At the very least, mitigating the overwhelming hegemony of the alliance with Britain became a possibility. Portuguese diplomats attempted to make use of the German alternative when the first colonial conflicts with England emerged in the 1880s. The British Ultimatum of 1890 was a direct result of Portugal's attempt to decrease its external dependence. The ultimatum was a highly symbolic moment in Portuguese history, in both foreign and domestic political terms. It signaled the end of the monarchy.

Until the Berlin Conference of 1885, international public law governing colonial issues was based on a Portuguese juridical principle, the principle of historically established rights. Indeed, it was according to this principle that the first colonial disputes between Portugal and England had been settled through international arbitration. The Bolama Bay of Guinea question had been settled by U.S. president Grant in 1870, and the dispute over the Lourenço Marques Bay in Mozambique had been mediated by French president MacMahon in 1875.

Still, as interest among the European powers for the colonial territo-

ries increased, leading to the "scramble for Africa," the rising tension not only threatened the colonial territories Portugal claimed on the basis of historical rights, but also challenged the very juridical principle of historical rights in the international arena. The Berlin Conference of 1885 had a dual impact on Portuguese foreign policy. First, the partition of Africa forced Portugal to limit its sphere of influence on the African continent through the signature of two conventions in 1886: the Franco-Portuguese and the Luso-German, both limiting treaties. Second, Portugal was forced to occupy the territories it claimed by historical right through the rejection of the principle of historically acquired rights and the international consecration of the new principle of effective occupation.

Faced with Britain's explicit refusal politically or diplomatically to support Portugal's project at the Berlin Conference, and confronted with the emergence of Bismarck's Germany as an extra-European power, Portuguese foreign policymakers could not resist a rapprochement with Germany. They sought from Berlin the support on colonial matters that was not forthcoming from London. For Portugal, it was not a question of altering its policy of foreign alliances; instead, Portugal sought a diplomatic alternative and greater room to maneuver in relation to Britain's oppressive hegemony.

It was in this context that Portugal developed its "Meridional African Portuguese" project, famous from its cartographic embodiment in the "Pink Map." It was a project that linked Angola and Mozambique horizontally through the interior of the African continent. The Pink Map opposed British imperial projects aiming to link vertically the Cape of Good Hope with Cairo.

The combination of the rapprochement with Germany and the colonial dispute with Britain lay at the heart of the diplomatic conflict between Portugal and Britain that culminated in the British Ultimatum on January 11, 1890. London demanded the immediate withdrawal of Portuguese troops from the disputed area under threat of a break in diplomatic relations.

Faced with the ultimatum and strategically weaker than its opponent, Portugal gave in to the demand. Its initial diplomatic strategy was a vain attempt to mitigate the effects of defeat by appealing for international arbitration, as provided for by the twelfth article of the final act of the Berlin Treaty. Britain, however, did not accept the solution, nor did Germany accept a mediating role. Portugal then had no choice but to agree to direct

negotiations with Britain. After a year and a half of negotiations and the collapse of a first treaty on August 20, 1890, Portugal and Britain signed a second treaty in June 1891. It put an end to the conflict and drew what became the political map of Portuguese Africa until the era of decolonization began in 1975.

The treaty imposed onerous conditions. Despite a parliamentary debate on revising the country's policy of alliance, on possibly seeking German support for colonial matters, and on establishing an Iberian Union, the crisis of the ultimatum did not lead to radical changes. The alliance with Britain went unchallenged as the linchpin of Portuguese foreign policy. Another consequence of the ultimatum was more important: Portuguese nationalism became colonial. With nationalist sentiment affronted by the treaty and with part of the African territories amputated, the ensuing imperial project and Portugal's "African vocation" shaped collective political myths for a century after the ultimatum.

From then on, Portuguese foreign policy developed on two parallel but clearly interdependent fronts: the European front, centered on the alliance with Britain; and the colonial front, centered on the African Empire. During monarchical rule, Portugal's diplomacy was notable for a number of European state visits by King Carlos, and by visits to Portugal by King Alfonso XIII of Spain, King Edward VII of England, Kaiser Wilhelm II, and President Emile-François Loubet of France.

Portuguese historians have passionately debated the meaning of these state visits, as well as King Carlos's foreign policy. The monarchists have assessed the latter positively, even suggesting that Portuguese diplomacy had a formative impact on the establishment of the Entente Cordiale and the Triple Entente. The republicans, on the other hand, have minimized the political value of these diplomatic trips as mere tourist or technical visits. If it is unreasonable to attribute great weight to Portuguese diplomacy in the international political arena, however, it is equally exaggerated to rob the latter of any diplomatic or political meaning. The aim of these initiatives was to ensure the inclusion of Portugal in international politics and to influence the foreign policies of the great powers, whose interests and objectives affected Portuguese interests and aims in two regions, the colonies and Europe.

After the British Ultimatum, the alliance with Britain experienced a particularly critical period, culminating in the Anglo-German agreement

to partition the Portuguese colonies in 1898. The Boer War and international events, however, radically altered the situation, favoring an Anglo-Portuguese rapprochement. The secret declaration of 1899, inappropriately named the Treaty of Windsor, marked the renovation and reinforcement of the alliance with Britain. The British squadron's visit to Lisbon in 1900 was the first public indication of that rapprochement; its consummation was the visit of the newly crowned King Edward VII in 1903. The arbitration treaty of 1904, or the Second Treaty of Windsor, finally consecrated this shift. Relations with Spain were also normalized in the aftermath of the polemic over the Iberian Union and the difficult period of Iberianism.

With its relations with Britain and Spain thus improved, Portugal regained its traditional geopolitical equilibrium. After the critical period of the last decade of the nineteenth century, the first years of the twentieth were particularly favorable for Portuguese foreign policy.

In Europe, Portuguese interests conflicted with those of the great powers in the western Mediterranean and, more important, the Atlantic. The Morocco question polarized opinion. The Portuguese position was not a matter of indifference to the great powers, as evidenced by the visits of Kaiser Wilhelm and President Loubet to Lisbon precisely on the eve of the Algeciras Conference in 1905. France sought support, and Germany neutrality. The Portuguese position, as it was expressed in the instructions to the delegates from the Ministry of Foreign Affairs, was quite clear: the delegates were to vote with Britain without arousing German hostility. The results were highly beneficial for Portuguese diplomacy. Having supported the position of France and Great Britain, Portugal reaffirmed its international status in relation to the Entente Cordiale. On a regional level, Portugal stood by the powers with a particularly keen interest in Morocco, namely, France and Spain.

The Atlantic and the archipelagos of Madeira and the Azores were also fundamental to foreign policy. Portugal's Atlantic territories were strategic points because they permitted the establishment of a privileged logistical position, with control over maritime routes as well as the installation of submarine cables. These territories had been historically important for Britain, and they became critical for Germany when the latter began to dispute the former's naval hegemony.

It was in this context that Britain demanded preferential access to the islands after the secret declaration of 1899. Britain wanted formal guaran-

tees that these territories would not be handed over to a third power. After King Edward's visit in 1903, the Treaty of Windsor of 1904, and, above all, the Moroccan crisis of 1906, the British government redoubled its efforts to obtain such guarantees. Later that control would permit the establishment of military installations, including naval and airforce bases, in the Azores archipelago during the two World Wars and the Cold War. The bases were later handed over to the United States with the establishment of a tripartite agreement between Portugal, Britain, and the United States in 1917.

Although this favorable progress was made in Europe, Portuguese interests and strategic objectives came into conflict with those of the great powers in the colonies, putting Portugal's colonial project and its colonial foreign policy at risk. International stability depended in great part on the Anglo-German rivalry; to ensure the European balance of power, Britain was often forced to negotiate with Germany on colonial matters. The Portuguese colonies, in particular, became pieces of the negotiating currency.

International historians have long debated the role of the colonial question in Anglo-German relations. Were the colonies a strategic objective in and of themselves, or merely a tactical means to ensure appeasement and a bilateral rapprochement? Whichever the aim, for Portugal the result was one and the same: a threat to its African empire. The threat reared its head twice: in 1898, during the monarchy, and in 1912–13, during republican rule. On both occasions, the cause was an Anglo-German agreement to partition the Portuguese colonies.

The 1898 partition agreement must be seen in light of two distinct factors. The first is the international repercussions of the colonial situation in the second half of the 1890s, especially the imperial projects of Britain and Germany. The second is the difficult financial situation of the Portuguese state, which worsened progressively with the declaration of bankruptcy in 1892.

To sort out its public finances, Portugal proposed that Britain grant a loan, to be guaranteed by Portugal's colonial customs revenues. When Germany got wind of the proposal, it declared its interest in the operation to the British government. The situation was favorable for an Anglo-German rapprochement. The loan issue became the pretext for the opening of bilateral negotiations between the two countries, culminating in an agreement, which not only ensured that Portuguese colonial customs revenues would guarantee the loan, but also provided for the immediate sharing of cus-

toms revenues between Britain and Germany. Foreseeing the possibility of debt default on the part of Portugal, moreover, the agreement provided for shared German and British "zones of influence" in the colonies themselves.

Two conditions had to be met for the agreement to work. First, Portugal had to fail to service the debt. Second, both powers needed the political will to cooperate. Unfortunately, neither condition was met. Portuguese diplomats in London learned of the supposedly secret agreement, and Lisbon reacted by canceling the loan. On the other hand, although Germany wanted to see the agreement succeed, the same was not true for Britain. The latter was bothered by the obvious contradiction between the Anglo-German agreement and the obligations imposed by the Anglo-Portuguese alliance. A more ambiguous solution was desirable for Britain; it wanted an agreement that would neutralize Germany without alienating Portugal.

The unfolding of the Anglo-Boer conflict and the evolution of the international situation favored Portugal. Britain urgently required use of the Lourenço Marques port and railway line, situated in Portuguese Mozambican territory. It called for the diplomatic support of Lisbon and for the use of its colonial resources. Informed of the Anglo-German agreement, Portuguese diplomats took advantage of London's request to make a masterly move: they offered support, but on the condition that the British reaffirm the Anglo-Portuguese treaties of 1642 and 1661. Hence the secret declaration of 1899 and the Treaty of Windsor of 1904; hence, too, the period of cordial relations during the final phase of the reign of King Carlos.

The alliance with Britain was, however, the cause of new problems for Portugal's foreign policy during the last years of the monarchy, this time in Europe and the Iberian Peninsula. Since Alfonso XIII's accession to the Spanish throne in 1902, Portugal's neighboring power had abandoned its traditional isolationism and had initiated a diplomatic rapprochement with the Entente Cordiale, and Britain in particular. After Algeciras, Britain needed Spanish naval cooperation to ensure its position in the western Mediterranean. This reinforced a diplomatic rapprochement at Cartagena in 1907.

Cartagena became a specter for Portugal. Spain's extra-peninsular system of alliances, its relations with Portugal's old ally, and the reemergence of the "traditional threat" upset Portugal's fragile geopolitical balance and increased its vulnerability. Not only did it reduce Portugal's importance in the peninsula, devaluing its political importance compared with Spain,

but more fundamentally, it weakened the value of the alliance with Britain as a guarantee of national sovereignty.

Had Britain not already negotiated with Germany over the colonies? What was to stop it from doing the same with Spain? These were the fundamental questions that confronted Portuguese foreign policy toward the end of the constitutional monarchy. The similarity of the political regimes and the family connection between King Carlos and Edward VII mitigated the impact of the Cartagena meeting. The regicide of 1908 drastically altered the situation, however. Republican Portugal adopted the same foreign policy principles of the monarchical regime. It confronted the same difficulties and challenges, but now without the advantage of similar regimes and connected royal dynasties.

The Democratic Republic

During the period of antimonarchical propaganda, the Republican Party had no defined foreign policy. Its ideas were vague and diffuse, based on Iberianism, a legacy of traditional Republican ideology that combined republicanism, municipalism, and federalism. At the same time, they were also based on an exacerbated nationalism, which, because of the British Ultimatum, was Anglophobic and strongly linked with the colonial project.

Only with its gradual rise to power, and its concomitant shift from a tradition of oppositionist political culture to political realism, did the Republican Party abandon its Iberianist ideology and its Anglophobia. Indeed, even during the last days of the monarchy, Republican diplomatic policy was still based on traditional precepts. But the first official Republican ambassadorial missions to France and Britain—visits that aimed to prepare the international community for the formal recognition of the future republic—transmitted an already realistic, moderate message, conveyed within the historical framework of Portuguese foreign relations. In the name of the future regime, the Republican Party reaffirmed its commitment to previous international political and economic agreements, including the alliance with Britain and strict neutrality vis-à-vis Spanish domestic politics and the Iberian question.

While French foreign policy was conditioned by the Entente Cordiale, London's position was of critical importance. The Republican "embassy"

in London achieved a first diplomatic victory for the future republic. Republican leaders gained assurances, albeit unofficial, that the regime question in Portugal would be treated as an internal affair. The Foreign Office also implicitly assured the Republicans that the Anglo-Portuguese alliance was not between royal dynasties but between peoples. Britain's nonintervention and the survival of the Anglo-Portuguese alliance thus seemed assured. The path to an international recognition of the future Portuguese republic promised to be smooth. Nothing, however, could have been further from the truth.

The international situation was not at all favorable to the establishment of a republic—a republic that, moreover, seemed to be assuming an increasingly radical and Jacobin face. Europe at that time was dominated by monarchies. The only two republican regimes in existence could neither promise significant international support nor provide alternatives for Portuguese foreign policy. Switzerland was a small power with scant weight in the international arena, and France was diplomatically linked with Britain through the Entente Cordiale.

Although Britain stuck to its promise not to intervene in Portugal's internal affairs, when the monarchy was toppled on October 5, 1910, the new republic was received internationally with a coolness that quickly descended to hostility. Gaining official recognition was a difficult and complex process that involved three distinct phases, dragged on for ten months, and had a serious impact on Portugal's domestic and international situation.

The first wave of official recognitions occurred almost immediately, led by the South American republics, with Brazil and Argentina at the forefront. The second wave, between June and August 1911, was led by the United States and France. The delay in extending recognition was different in each case; the United States successively postponed it, breaking with the Monroe Doctrine, which traditionally advocated the automatic recognition of de facto regimes. Washington sought assurances as to the constitutional legality of the regime, so as to maintain a certain leeway when confronted with the recognition of the various Latin American dictatorships. France, on the other hand, was guided by the British attitude, being linked to Britain by the Entente Cordiale. Its recognition was conditioned by all the political-constitutional guarantees the British government demanded of the republican regime.

The last wave of recognitions was initiated by the British monarchy, followed by the other great European monarchies. London made recognition of the republic conditional on a series of demands, the fulfillment of which successively delayed the process. First, it demanded that elections be held and that the normal functioning of the Constituent Assembly be ensured. Once the assembly had been elected, it demanded that the head of state be elected. Once the president had been elected and was exercising his powers, Britain delayed recognition yet again. The cause of this delay was not the juridical-constitutional nature of the republic but the dispute between the Portuguese Republic and the Anglican Church in Portugal over the Law of Separation of Church and State. The problem was finally resolved only on September 11, 1911, when Britain and the remaining European monarchies finally extended their formal recognition.

Official recognition was undoubtedly an important step, but it did not by any means imply international acceptance of the regime. The establishment of the republic did not alter the orientation of Portuguese foreign policy or the strategic options of the state, which remained centered on the alliance with Britain and the African colonial project. The other threats and challenges persisted as well.

Despite its international isolation, the republic was still a part of the dynamics of international politics, in both Europe and Africa. Portuguese interests still intersected with those of the European powers in the Mediterranean and the Atlantic. British interest in the Azores continued, regardless of the change of regime. Although an Admiralty report of 1912 questioned the strategic value of Portugal on the Iberian Peninsula, interest in the Atlantic islands was maintained, and London renewed its request for guarantees of exclusive access to the islands whenever a new Portuguese foreign minister took office.

Portugal was a presence in the Mediterranean. It adhered to the Franco-German agreement of 1911, which put an end to the Agadir crisis. Portugal adopted an attitude of support for the Entente Cordiale powers, so it could not openly confront Spain, which had not resolved its differences with France. The difficult relations between the two peninsular states forced Portugal to engage in what turned out to be a successful diplomatic exercise involving a postponement of adherence to the 1911 agreement until the Franco-Spanish agreement of May 1912.

Despite the success of Portuguese diplomacy in this process, the rap-

prochement between Spain and the other powers of the Entente Cordiale raised the specter of Cartagena once again and gave renewed importance to the geopolitical balance between Spanish continental pressure, on the one hand, and the compensatory weight of the alliance with Britain, on the other.

The pro-annexation lobby in Spain was powerful and, although the idea did not reflect the position of Spanish foreign policy, Alfonso himself did not entirely reject it. Portugal's political instability facilitated the possibility. In this context, was the alliance with Britain an adequate diplomatic and military instrument to guarantee Portuguese security? This was a very delicate question. The British Foreign Office preferred not to intervene directly in the peninsular issue, favoring a bilateral understanding between the two protagonists. In the periods of more acute animosity, nevertheless, it was unable to abstain.

While London did not go so far as to accept Spanish military intervention and annexation of Portugal, it did demonstrate a special degree of tolerance toward Spain during the monarchical incursions. On two occasions, in 1911 and 1912, pro-monarchy troops marched into Portuguese territory with the knowledge and assent of the Spanish authorities, proclaiming their intention of restoring the monarchy. These incursions were military fiascos, but they aggravated the specter of the "Spanish threat" nevertheless. Portugal persistently tried to gain formal guarantees regarding the alliance from the Foreign Office throughout 1912 and 1913, but never received more than a verbal guarantee, because of the colonial question.

In a repetition of the events of 1898, a second Anglo-German agreement to partition the Portuguese colonies was signed in 1912–13. This agreement arose from the prevailing tension in the international arena, with the arms race and the increasing Anglo-German rivalry before World War I. It also stemmed from Portugal's own continuing postrevolutionary international isolation and domestic political instability.

In the wake of the total failure of the Haldane mission to Germany in 1912, the only way to maintain the dialogue between England and Germany was through the colonies. Compensating Germany overseas was the only means available to Britain to maintain the fragile equilibrium of European forces and to avoid conflict. The domestic and external vulnerabily of the Portuguese republic also favored an Anglo-German rapprochement. Therefore, in 1912, the two powers renewed the terms of the 1898 agree-

ment. The partition of zones of influence was renegotiated and, more important, the basis for legitimately intervening in Portugal's overseas territories was broadened. Like the first agreement, however, the second failed under autonomous but simultaneous pressure from Portugal and France. The Great War finally rendered it obsolete; yet one thing about it was certain: this instrument for international stabilization, which the British did not hesitate to adopt when it appeared to serve their interests and aims, constituted a real and concrete threat to Portugal's imperial project.

At the beginning of World War I, Portugal faced a threat from Spain in Europe and from Germany in its colonies. Its vulnerability resulted from British intransigence over Spain and the peninsular question and Germany's persistence with regard to the colonial question. These two factors were at the heart of Portugal's decision to enter the Great War.

Portuguese historians have usually explained the nation's participation in World War I on the basis of two distinct theories. One is the colonial thesis: it argues that Portugal entered the war to save the colonies. There is no doubt about this explanation. The Portuguese colonies were the object of economic and strategic interest on the part of the great powers; more important, they had already been twice used as "currency" in the negotiations between European powers. During the war, interest in the Portuguese colonies increased. Germany attacked them militarily and incited the population against Portuguese rule. Britain used them strategically as supply bases for wartime operations. Above all, there was no guarantee that Britain would not put the Portuguese colonies on the negotiating table, should that become necessary to resolve the conflict advantageously. The threat was real, as was the risk to Portuguese sovereignty over its colonies.

For Portugal, the colonial question was both a weighty consideration and a mobilizing factor. Indeed, it was the issue that produced a consensus in Portuguese society. The colonial issue in and of itself, however, is insufficient to explain the decision to enter the war. It cannot explain Portugal's active belligerence and military intervention in the European theater. Sovereignty and imperial integrity could have been assured by an undeclared neutrality and by a concentration of war efforts in the African theater.

The second explanatory theory is the peninsular European thesis. It argues that Portugal entered the war to ensure a place for itself in Europe and to ward off the "Spanish threat." There is no doubt about this moti-

vation, either. The country's international situation had been difficult before the war and did not change during the conflict. The "Spanish threat" was a de facto threat, all the more so when Britain warned Portugal that the alliance merely guaranteed the security of the colonies and Portugal's maritime coast, but not its landed frontier. Faced with Spain's neutrality, Portuguese belligerence on the side of the Allies, under the umbrella of the British alliance, constituted a double guarantee. First, it ensured a strong alliance with Britain by weakening the Anglo-Spanish link. Second, it increased Portugal's international status, affirmed its preponderance in the peninsular context, and thereby did ward off the "Spanish threat."

This second thesis doubtless explains Portugal's belligerence, but it, too, fails to provide a reason for military intervention in the European theater. To explain Portugal's entry into the European war, it is therefore necessary to take up a third explanation: the republican regime's lack of political consolidation and national legitimacy. Given the social cleavages and political instability of the new nation, only an external threat and military intervention in the central theater of war alongside the great powers could enable the regime to promote national unity and build support. Thus it simultaneously achieved both its foreign objectives and the consolidation and democratic legitimacy of the republic. Portugal entered the war on March 9, 1916.

Voluntary intervention was undoubtedly the safest way for Portugal to achieve all its objectives—safeguarding the colonies, warding off Spain, and consolidating the republic. Yet it was also the most difficult way, because it meant meeting more stringent conditions and it demanded greater means. That very voluntarism betrayed Portugal's realistic evaluation of the strategic situation. Not only did it fail to achieve the consensus and national unity the regime hoped for, but it actually aggravated internal cleavages, fostering a political movement that aimed to shift war policy. That movement led Sidónio Pais to power in December 1917. Voluntarism, furthermore, wrongly assessed the correlation between aims and means; in other words, the objectives were too ambitious compared with the economic, financial, military, and even political means available.

The results were plain at the Treaty of Versailles in 1919. Portugal paraded beside the victors under the Arc de Triomphe, but the Peace Conference left it far from attaining its war objectives. The colonial question

was not solved. Portugal's sovereignty over its colonial territories had de-
pended almost directly on its intervention in the war; but even the restitu-
tion of Kionga, the small territory on Africa's east coast that the Germans
had occupied since the end of the nineteenth century, was not part of the
war compensations. It merely represented the restoration of the interna-
tional legal order.

The aims of peace were different from the aims of war. They were related
to the imperious need to reconstruct the country's economy. Portuguese
foreign policy therefore concentrated on achieving financial objectives;
namely, war debt forgiveness and the right to reparations and indemnities
from Germany. Portugal's place in the "concert of nations" and the resolu-
tion of the peninsular question were still on the agenda.

If the economic and financial objectives were achieved, the same cannot
be said about Portugal's international position, now shaped by participa-
tion in the reorganization of the international system and in the League
of Nations. This is where Portuguese foreign policy suffered its greatest
defeat. Not only was Portugal's application for membership in the Execu-
tive Committee of the League of Nations not even considered, but more
important, Spain managed, despite its neutrality, to gain the position Por-
tugal's belligerence had failed to achieve.

In any case, during the final phase of the democratic republic, the
League of Nations became a reference point for Portuguese foreign policy.
Apart from bilateral relations based on the geopolitical balance of the
Lisbon-London-Madrid triangle, a new institutional arena for multilateral
relations had opened up, giving Portugal's foreign policymakers a wider
margin for diplomatic maneuvering and for diversifying the republic's for-
eign relations with Brazil, Belgium, and South Africa.

The colonial project was still Portugal's key strategic concern, albeit in
different international circumstances. In accordance with the dictates of
the League of Nations and the British Foreign Office, Portugal adopted
a new colonial political-administrative regime, institutionalized through
the establishment of high commissioners, giving the colonies greater au-
tonomy. The republic's treatment of colonial issues on an international
level had two further characteristics. First, the Portuguese presence was
ensured in the Permanent Commission of Mandates of the League of
Nations. Second, an active and versatile diplomacy was undertaken, some-

times in London and sometimes in Brussels, in defense of Portuguese colonial interests in Mozambique and Macao, where the issue of sovereignty was raised in 1921.

The military dictatorship that overthrew the democratic republic on May 28, 1926, did not alter Portugal's foreign policy. Overwhelmed by financial crisis and domestic political conflicts, the dictatorship sustained republican foreign policy. The colonial project and the alliance with Britain were dominant; the diversification of foreign relations, as well as multilateral initiatives in the "international assembly in Geneva" were maintained. The Financial Commission of the Council of the League of Nations was even involved in a foreign debt issue in 1927–28. It was only with the rise of the *Estado Novo* in the 1930s that Portuguese foreign policy underwent a significant shift.

The 'Estado Novo'

When António Salazar rose to power in 1932, his views on international politics were not known. In 1933, the year his regime was institutionalized, he gave an interview expressing his views on foreign policy matters. He protested openly and critically against the "international parliamentarism" of the League of Nations and declared his loyalty to the alliance with Britain.

This seemed to herald a return to the traditional precepts of Portugal's foreign policy. Indeed, Salazar's initial assessment of the country's international situation confirmed that tendency. First, he condemned "assemblyism" in Geneva, which he considered to be the center of continental politics. He countered it by affirming Portugal's Atlantic vocation and distancing the country from continental issues. Second, he reaffirmed the alliance with Britain, and third, he emphasized the reinforcement of an Iberian friendship. Finally, he intransigently defended the integrity of the colonies.

By 1935, the political objectives and the diplomatic principles that would govern Portugal's foreign policy during the Spanish civil war and World War II had been defined. Such was the importance of these two key events that Salazar personally conducted foreign policy from 1936 to 1947, directing the Foreign Affairs Ministry while acting as president of the Council of Ministers.

Indeed, the deliberate distancing of European affairs on the one hand,

and the affirmation of Atlantic Portugal and the African colonial project on the other, constituted Salazar's strategic options. Furthermore, the traditional balance based on the diplomatic triangle between Lisbon, London, and Madrid was revived; it became the central focus of Salazar's foreign policy throughout the 1930s and 1940s.

Between 1931 and 1939, Portuguese foreign policy was completely dominated by the "Spanish question." Salazar had a very particular understanding of the "peninsular friendship." Not only was it a desirable principle, it was an important way to achieve a geopolitical balance, albeit strongly conditioned by the political nature of the regimes in question. The size of the Iberian Peninsula, its division between two states, and the varying nature of the political regimes in each country all represented a menace to Portugal, especially to the survival of Salazar's regime. Indeed, between 1931 and 1936, Salazar saw the Spanish republic as a dual threat: in addition to the permanent Iberian threat, there was the danger of revolution. The specter of left-wing victory in Madrid loomed large in Lisbon. The triumph of the Popular Front in February 1936 heightened Salazar's fears of the incompatibility of two opposing regimes cohabiting in the peninsular space.

Given these concerns, Portugal's foreign policy during the Spanish civil war aimed to reconcile two imperatives. It continued to reaffirm the alliance with Britain, an instrument Salazar knew to be essential for safeguarding the African colonial project in a European context already dominated by the expansionism of nascent totalitarian regimes. It also worked discreetly but generously to support the Spanish nationalists. This support was considered indispensable to ensure the installation of a regime in Madrid that would not threaten the survival of the *Estado Novo*.

Despite the divergences and reservations that affected Salazar's negotiations with London, he always respected the alliance with Britain and coordinated his policies with the Foreign Office. Salazar participated in the London Commission for Non-Intervention in the Spanish Civil War; he agreed to the demand that Portugal's borders be monitored. He did not even officially recognize the Burgos regime until Britain had done so. On the other hand, he did not spare any effort in aiding Franco's nationalist troops unofficially. He gave them logistical and financial support and granted them safe passage into Portuguese territory, where they could find material support and mobilize volunteers.

The duplicity of Portugal's foreign policy succeeded throughout almost the entire civil war. It was only with the Munich crisis of 1938 that the conciliation of official and informal Portuguese policy was challenged.

The end of the civil war with Franco's victory created the conditions for the establishment of the "peninsular friendship" along the lines Salazar had espoused, initiating a period of good relations and political solidarity between the two authoritarian regimes. This solidarity found diplomatic expression in the signing of the Luso-Spanish Treaty of Friendship and Non-Aggression, or the Peninsular or Iberian Pact, in March 1939. The Iberian Pact, together with the alliance with Britain, constituted the basic diplomatic instruments that governed Portuguese foreign policy during World War II.

On September 1, 1939, immediately after the invasion of Poland and before Great Britain had declared war on Germany, Salazar hastened to declare Portugal's neutrality. He was undoubtedly moved to do so by the memory of the detrimental, ambiguous, and undeclared neutrality of the First Republic during World War I. Salazar, moreover, wanted to distance Franco's Spain from the Axis powers and to ensure its neutrality. The move also took account of the low degree of efficiency and readiness of Portugal's armed forces.

Between 1939 and 1942, Salazar's worries centered on Spain's possible entry into the war on the Axis side, which could have dragged Portugal into the conflict on the side of the Allies. The maintenance of neutrality and the concommitant establishment of conditions favorable for Spain's neutrality were therefore the key objectives of Portugal's foreign policy, buttressed by the alliance with Britain and the Iberian Pact.

Respecting the alliance with Britain and following the British example, Portuguese diplomacy insistently pressured Franco to comply with the policy of nonbelligerence and to fulfill the Iberian Pact, especially the Additional Protocol of 1940. Between 1940 and 1942, Portugal's neutrality effectively favored Spanish nonbelligerence.

The success of Portugal's foreign policy is undoubtedly attributable to Lisbon's political will and its diplomatic action. Things could have turned out differently, however, had it not been for a series of events that favored such a policy. In the first place, the great powers took an interest in the strategic neutrality of the Iberian Peninsula. Second, Nazi Germany shifted its military objectives, which, from 1940 on, focused on the Soviet Union

rather than on the British Isles and the Mediterranean. Third, the internal situation in Spain itself, the state of penury inherited from the civil war, aggravated by the economic blockade imposed by the Allies, destroyed the strategic reserves indispensable for conducting a war.

In the autumn of 1942, the strategic situation in the Iberian Peninsula changed significantly. With the Allied victory in North Africa and the opening of the fronts in Sicily and Normandy, the Iberian theater became peripheral. From 1943 on, Spain abandoned its nonbelligerent status, and the Iberian Peninsula as a whole became neutral. With peninsular neutrality ensured, Portugal was in a position to diversify its foreign policy objectives, and it now turned to the defense of economic interests and, above all, the integrity of the colonies. The controversy over Macao and the maintenance of sovereignty over Timor, which had been successively invaded by the Dutch, the Australians, and the Japanese, became a key concern.

In this context, Atlantic foreign policy and relations with the Allied powers were reinforced. Portugal, Britain, and the United States initiated tripartite negotiations for the concession of bases in the Azores archipelago. The talks culminated in the establishment of British and North American military bases on the islands in 1943 and 1944. As part of the same policy, Portugal ceased to sell wolfram to the Axis powers.

Although it maintained a formal position of neutrality, Portugal's foreign policy went through a period of "cooperative neutrality" or, as the British would have it, "continental neutrality." Portuguese historians have extensively discussed neutrality and Salazar's World War II foreign policy. The traditional thesis explains Portuguese neutrality on the basis of the "statesman" theory: neutrality was successful because of Salazar's political acumen. More recent hypotheses differ: they tend to relativize the importance of the "statesman" and to give weight to objective factors, such as the situation in Franco's Spain and, above all, the strategic evolution of the war. The strategic neutrality of the Iberian Peninsula, a geographic extension of neutrality on the western Mediterranean coast with Vichy France, served not only Portuguese foreign policy interests but also those of Britain and even Germany.

With the end of the war, Portugal, as a neutral country, was peripheral to the diplomatic efforts to restore peace and to reorganize the new international diplomatic system. Although the authoritarian regime survived the wave of postwar democratizations, the nation experienced a period of

international marginalization, and it lacked a defined foreign policy between 1945 and 1949.

The first sign of marginalization dates from April 1945, when Portugal was not invited to participate in the San Francisco conference for the foundation of a new international organization. Portugal was not a founding member of the United Nations, and the Soviet Union vetoed its first application for membership in 1946; it finally achieved membership in 1955.

The lack of a well-defined foreign policy reflected an inability to adapt to a new world order. Salazar appeared not to understand, or not to accept, the profound transformation that had occurred in the international sphere with the end of World War II: the bipolar division of power between the West and the Soviet bloc, the emergence of the two superpowers, the demise of Britain and the concomitant rise of the United States as the great maritime power. The shift was confirmed by the emergence of the North Atlantic Treaty Organization (NATO) in 1949.

Salazar also did not seem to accept the importance of the United Nations as the new world organization, or the demise of the Europe of old and of the European powers as protagonists in the world arena. The reconstruction of Europe was no longer possible on a national basis; it would have to be undertaken within a framework of international cooperation. Finally, Salazar did not comprehend that the two new superpowers were both anticolonial, albeit for different reasons. Indeed, the right to self-determination was a dominant principle of the United Nations, and, given the cooperation of many colonial peoples with the Allied war effort, decolonization was now an irreversible process.

The first moments of hesitation in the face of the new postwar reality occurred in June 1947 over the Marshall Plan. Salazar's limited understanding of the international situation and traditional distrust of the Americans led him to reject the North American offer of aid, thereby distancing Portugal from the so-called first exercise of the Marshall Plan in 1947–48. With the onset of the Cold War and the decline of Portugal's financial and exchange rate balance, the nation changed its stance and eventually applied for participation in the second phase of the Marshall Plan in 1948–49.

The Cold War clearly defined the new Soviet threat, the new Atlantic security framework, and, consequently, U.S. protagonism. The first sign of Portuguese acceptance of this new strategic order was the bilateral mili-

tary cooperation agreement between Portugal and the United States in February 1948. Unlike the agreement of 1943, the new agreement institutionalized the permanent nature of the North American air base on the Azores archipelago.

Salazar's hesitation regarding the Marshall Plan and concession in the Lages Agreement reveal two contradictory orientations in Portugal's foreign policy: one, a distancing from the process of European integration, and the other participation in the Atlantic security system. These, together with the intransigent defense of the colonial territories, were the strategic concerns of Portugal's foreign policy virtually until 1974.

In June 1948, faced with the Soviet threat and the need to define a new Atlantic security framework, the United States, Canada, and the European countries that had signed the Treaty of Brussels initiated negotiations with a view to creating a North Atlantic security system, the future Atlantic alliance. In December of that year, contacts were established with Lisbon to explore the possibility of Portugal's participation in the project. A complex diplomatic process eventually culminated in the signing of the North Atlantic Treaty in April 1949.

Portugal's accession to NATO immediately raised three fundamental questions. First, why had Portugal been invited to join? It had an authoritarian regime, it had remained neutral during the war, it did not yet belong to the United Nations, and it had been peripheral to the reorganization of the international system in the postwar period. Second, as far as Portugal was concerned, the question was why it had accepted the invitation. To do so meant a radical shift in foreign policy—the abandonment of a neutrality that had been constructed with such difficulty during the war and had been the crowning glory of the regime's propaganda. Given that drastic change, the third question was, naturally, how Portugal's membership in NATO would affect the country's future foreign policy.

The answer to the first question was simple: it was connected with geostrategic issues. The regime's political authoritarianism and its international situation were of less concern than the strategic importance of Portugal's territory in the new Cold War context. The Azores were particularly significant in this situation. An Atlantic security system based on two pillars, one European and the other North American, made the Azores bases a fundamental link for the articulation of the system and for the so-

called rapid reinforcement of Europe. The strategic value of the Azores and the Lages Agreement were thus confirmed and reinforced within a multilateral framework.

The answer to the second question was more complex. It derived from Portugal's reduced margin for political maneuvering and from the need to establish an alternative foreign policy in the context of the Cold War. When Portugal was formally invited to sign the NATO treaty, Salazar, distrusting the United States, looked on the proposal with suspicion. Deploying his usual negotiating tactics, he voiced some diplomatic reservations, as a way to gain some negotiating power and more decision-making time. He made two formal observations on the formulation of the treaty, concerning its references to democracy and to the United Nations. He also expressed three reservations of substance. He argued that the twenty-year period during which the treaty would be in force seemed too long; that the Spanish question—that is, the affirmation of the strategic unity of the Iberian Peninsula and the importance of Spain in the defense of the West—required the joint integration of Portugal and Spain in the alliance; and finally, that the geographical zone covered by the treaty did not include the Portuguese colonies. Salazar attempted to include the colonies as a means of guaranteeing the security and sovereignty of Portugal over its colonial territories through the fifth article of the treaty.

All Portugal's claims were rejected because none of them really affected the great powers. From then on, two contrary pressures were exerted on the Lisbon government. Invoking the Iberian Pact, Spain applied pressure on Portugal not to join NATO, or rather, to create the conditions for Spain itself to join. At the same time, the United States and Britain insisted on Portugal's adherence to the NATO treaty through diplomatic pressure exerted personally by the British prime minister and the U.S. secretary of state.

Despite Salazar's reservations and the divisions within the executive branch of the government, Portugal's alternatives were minimal. In a bipolar world, Portugal's refusal to participate could have created fissures in the Western bloc that would favor the Soviet Union. The responsibility was too great and, in the final analysis, Salazar did not want to shoulder it. Necessity triumphed over conviction. On April 4, 1949, Portugal became a founding member of the North Atlantic Alliance.

What were the consequences of Portugal's entry into NATO? Despite

Salazar's suspicions and reservations—one of the ironies of history—joining the alliance constituted a victory for the country's foreign policy. The regime could return to the traditional guidelines of Portuguese diplomacy, the Atlantic vocation and a preferential alliance with a maritime power. The novelty lay in the new choice of ally, the United States. In the Iberian context, the Western powers' refusal to accept Spain favored Portugal's position. Portugal's inclusion and Spain's exclusion reinforced Lisbon's position on the peninsula and turned Portugal into a privileged interlocutor.

Portugal's entry into NATO in 1949 thus initiated one of the most favorable periods in the foreign policy of the *Estado Novo*. It ended only when Portugal joined the United Nations. It was admitted in December 1955, together with a number of other countries, Spain among them. From then on, the international position of the Iberian countries underwent a reversal. Spain's entry into the U.N. put an end to the international isolation of the Franco regime. It also signaled the end of tolerance toward the *Estado Novo* and the beginning of international opposition to the regime's colonial policy.

Portugal's entry into the U.N. led to immediate confrontation with the anticolonialist spirit of the Afro-Asian and Non-Aligned Movement, which then dominated the General Assembly. Indeed, the colonial question became a dominant preoccupation in Portuguese foreign policy between 1956 and 1961. During this period, Portugal sought external support for the country's overseas policy; one initiative was a cycle of state visits begun in 1957 with that of President Juscelino Kubitchek of Brazil, in an attempt to create a Luso-Brazilian community. Subsequent invitations were accepted by the president of Pakistan, Queen Elizabeth II of England, President Sukarno of Indonesia, and Emperor Haile Selassie of Ethiopia. In 1960, the initiative was repeated with visits by the presidents of Peru, Nepal, and Thailand, culminating in those of the secretary general of the United Nations, Dag Hammarskjold, and, most significant, U.S. president Dwight D. Eisenhower.

Despite these attempts, the international attitude toward Portugal's colonial policy degenerated; and Portugal faced a military and diplomatic battle, first with India and later with the African liberation movements. The new state of India had already presented a diplomatic memorandum to Lisbon in 1950, which formally claimed Indian sovereignty over the ter-

ritories of Goa, Damão, and Diu and proposed negotiations to terminate Portuguese domination.

Salazar directly confronted the problem of decolonization for the first time. He had great difficulty accepting the principle of peoples' right to govern themselves. For that very reason, he could not accept its political consequences: self-determination and independence. Now, moreover, he was confronted with a concrete problem and not just a theoretical principle. If he accepted Indian sovereignty over Goa, Damão, and Diu, with what legitimacy could he then defend Portuguese sovereignty over its other overseas territories?

Salazar therefore intransigently defended the integrity of the colonies. His policy attempted to deprive the Indian Union of all political and diplomatic alternatives. It was based on the assumption that the explicitly pacifist position of Indian leader Jawaharlal Nehru would prevent him from resorting to military alternatives. If Nehru did militarize the conflict, Salazar believed that Portugal could count on the support of its closest allies. The calculation was doubly wrong. In December 1961, India invaded the three Portuguese territories; and not even the old ally, Britain, or the former colony, Brazil, supported Portugal. Franco's Spain had already established diplomatic relations with Nehru's India in 1956, a first sign of a break in the peninsular friendship. None of Portugal's NATO partners supported it. The international community generally looked on the events with indifference, and the U.N. General Assembly did so with some enjoyment.

Between 1961 and 1974, the international isolation of the *Estado Novo* and international hostility toward it increased. With the loss of the territories in India, the problem now centered on Africa. In 1961, the war in Angola began, and it was not long before Portugal became embroiled in three decolonization conflicts in three different theaters: Angola, Guinea, and Mozambique.

Right at the beginning, in April 1961, a group of military officers led by General Botelho Moniz unsuccessfully attempted a coup against the Salazar regime, with the knowledge and assent of the U.S. government. Their aim was to alter policy toward the colonies, to abandon the military path, and to seek a political solution to the conflict.

Later that year, after the failed coup, the Kennedy administration tried to promote an agreement between Lisbon and Washington with a view to negotiating a solution to the Portuguese colonial question. The U.S.

proposal suggested a third path, between Salazar's integrationism and complete independence for the colonies, as the U.N.'s Afro-Asian movement demanded. Salazar rejected the self-determination formula proposed, thereby rendering the agreement impossible.

Between the failed coup and the attempt to come to an agreement, the North American administration was able to elaborate a list of countries with which Portugal had the best relations, and which were therefore in a position to apply pressure on Lisbon to shift its position. These included Britain, Spain, Brazil, and the Vatican. All attempts by these countries, too, however, were in vain. Portugal resisted everyone. As it had in the Indian question, Britain distanced itself from Portugal over African decolonization. Spain distanced itself from Portugal on a number of occasions, under pressure from the Brazilian administration of Jânio Quadros. Even the Vatican abstained from supporting Portugal. Pope Paul VI received the liberation movements of the Portuguese colonies at the beginning of the 1970s, despite making his own visit to Fátima in 1967. Portugal's policy of "proudly standing alone" peaked.

Salazar regarded Africa as a natural prolongation of Europe. The colonies were seen as an inseparable part of the Old Continent and, both economically and strategically, as part of the defense of the Western bloc. Salazar had made this argument in vain when Portugal joined the North Atlantic Alliance.

Given the primacy of Atlantic policy and the wholehearted defense of colonial integrity, Europe had a merely secondary place in Portugal's foreign policy during this period. Salazar was always manifestly skeptical of, and frequently hostile toward, the process of European integration. Portugal's traditional distance from continental issues was compounded by its deep suspicion of processes such as integration, supranationality, and involvements that might threaten the survival of the authoritarian regime. Thus, when Portugal participated in European affairs, it did so less from adherence to the political ideal of constructing Europe and more for pragmatic reasons. Despite the weight of the United States in the Atlantic framework since Portugal's entry into NATO, Portugal's European foreign policy continued to follow closely the positions of its old ally, Britain.

With the second Marshall Plan, Portugal had participated in European economic cooperation through its membership in institutions such as the European Economic Cooperation Council (EECC). In 1957, Britain dis-

tanced itself from the negotiations that would lead to the Treaty of Rome and initiated talks for the creation of a European Free Trade Association (EFTA), of which Portugal became a founding member. Experience of Europe through EFTA led to the emergence of a pro-European current among the country's economic elites and characterized its foreign policy. In 1961, when Britain changed its mind and decided to request admission to the Treaty of Rome, Portugal also asked that negotiations with the European Economic Community (EEC) be initiated, with a view to the establishment of an association agreement; this was formalized in May 1962.

French president Charles de Gaulle's veto on Britain's accession necessarily slowed down negotiations with the other EFTA countries, Portugal among them. It was only in 1969, after the Hague Summit and the end of de Gaulle's rule, that Portugal asked the European Community to reopen negotiations. Begun again in May 1970, negotiations lasted for almost two years. In March 1972, after Britain had already gained accession, the trade agreement between Portugal and the EEC was finally signed. But a shift toward the "European option" had to wait for the transition to democracy.

The Transition to Democracy and the Democratic Regime

With the end of the authoritarian regime and the transition to democracy, initiated on April 25, 1974, Portugal's foreign policy underwent a profound redefinition, in accordance with the program of the Armed Forces Movement (*Movimento das Forças Armadas*, or MFA). The MFA's program was basically represented by the formula Democratization, Decolonization, Development. Although the MFA program declared and guaranteed the fulfillment of all of Portugal's international commitments, it became apparent that the two simple principles, democratization and decolonization, implied a reinterpretation of commitments and a profound change in the external orientation of the Portuguese state.

Negotiations for decolonization began in 1974. Indeed, decolonization constituted the first great foreign policy challenge for the new regime. Various ideological perspectives on the issue were debated. A first tendency, based on General Spínola's book *Portugal and the Future*, continued to insist on a federal option. A second one, inspired by Melo Antunes, leader of the moderate left-wing elements of the Armed Forces Movement, sought

to create an axis of nonaligned, Third World neutrality. Finally, Prime Minister Vasco Gonçalves supported a pro-Soviet tendency.

From a political perspective, these ideological nuances can be divided into two basic positions. The first argued that self-determination did not mean automatic independence, and it pugnaciously defended Portuguese sovereignty over the territories until a referendum could determine their destiny. The second position was based on a direct link between self-determination and independence; it argued for the immediate transfer of powers to the liberation movements as legitimate representatives of the colonial peoples.

The second position won the battle, in a complex process that had an important impact on domestic politics. While the cease-fire was being implemented on the ground, the Portuguese Foreign Office initiated the first round of diplomatic negotiations. Guinea-Bissau, which had already unilaterally declared its independence in 1973, became the first country to receive international recognition from its former colonial power, in August 1974. Between that date and January 1975, the same process of transference of powers took place in all the former Portuguese colonies.

While the process of decolonization unfolded, Portugal also established diplomatic relations with the Soviet Union, the Eastern European countries, and the Third World. Albania and China presented greater difficulties, and relations were established only in 1979.

Decolonization, the widening of diplomatic horizons, and the end of international isolation, however, were not, in and of themselves, sufficient to define the new foreign policy guidelines of Portugal's democracy. On the contrary; a silent battle over the objectives and strategic options of the country's foreign policy underlay the noisy struggles of the internal democratization process. Between April 1974 and January 1986, Portugal's foreign policy oscillated between two fundamental orientations, which also characterized two distinct phases: the transition to democracy, which corresponded to the preconstitutional period, dominated by the revolutionary process; and the consolidation of democracy, corresponding to the constitutional period, marked by the institutionalization and stabilization of the democratic regime.

The preconstitutional period was characterized by a battle over the strategic options the country should adopt, by the exercise of parallel diplomacies, and by a concomitant lack of foreign policy definition. Despite

the struggles, hesitations, and lack of clarity under the provisional governments, especially those dominated by the military, Portugal's foreign policy at this time was largely pro–Third World, favoring privileged relations with the new countries that had recently emerged from Portuguese decolonization. This was a replay of Portugal's "African vocation," which had been so dear to Salazar, only now it had a socialistic bent.

The constitutional period was characterized by the clarification of foreign policy and by the unequivocal and rigorous definition of the country's international position. Portugal fully assumed its role as a Western country, simultaneously European and Atlantic. The Atlantic dimension implied the continuation of the historical aspects of Portugal's foreign policy and played an important role both at the level of foreign policy orientation and at the level of internal political stabilization. On the bilateral level, Portugal's Atlanticism was embodied in the tightening of diplomatic relations with the United States and the renovation of the Lages Agreement in 1979 and 1983. With these agreements, Portugal extended the use of the Azores bases to the United States until 1991. In return, it was promised economic and military aid.

On a multilateral level, the Atlantic policy was expressed in the redefinition and renovation of Portuguese military commitments to NATO, which the African war effort had forced the country to abandon in the 1960s. The new commitments led to the organization in the army of the Independent Mixed Brigade (*Brigada Mista Independente*), later converted into the Air-Transported Brigade (*Brigada Aero-Transportada*), which replaced and reactivated the old Independent Army division and which essentially maintained its old objectives in NATO's missions in the southern flank of the Alliance. As for the navy and the air force, patrol missions were reinforced in the framework of NATO's IBERLAND and CIN-CIBERLAND, which a Portuguese officer was permitted to command.

The "European option," however, was the great novelty in foreign policy after April 25, as well as the greatest challenge for democratic Portugal. After conquering anti-European resistance, the authoritarian African option, and the Third World temptation of the revolutionary period, Portugal clearly adopted the "European option" from 1976 on. Now, however, it adhered to the political project, transcending the merely economic focus that had characterized the association agreements of 1972.

Portugal's rapprochement with the process of European integration

began in 1976 with the country's entry into the European Council and the signature of the Additional Protocols to the 1972 agreement, which constituted a first step toward accession. Following a cycle of negotiations in various European capitals between September 1976 and February 1977, the first constitutional government formally solicited accession to the European Community in March 1977. The formal request for accession signified the abandonment of hesitations concerning a Portuguese formula for integration (preaccession status or "privileged association"). It also signaled the firm establishment of the "European option." It was a strategic option that decisively marked the future of the country.

Two objectives lay behind this strategic option. First, entry into the European Community ensured the process of consolidation of democracy. Second, it permitted modernization and economic development. The request for accession was followed by a long and complex process of negotiations that lasted for almost a decade. The process culminated in June 1985 when Portugal signed the Treaty of Accession to the EEC. On January 1, 1986, Portugal became a full member of the European Community and signed the Single European Act.

Development of relations and ties of friendship and cooperation with other Portuguese-speaking countries was a continued preoccupation for Portugal from 1976 until the end of the 1980s. Both the government and the president spared no diplomatic efforts to improve relations with the Officially Portuguese Speaking Countries (*Países de Expressão Oficial Portuguesa*, or PALOP). The truth is, however, that Portugal's strategic option was now European. Without denying its Atlantic vocation, Portugal changed its place in the world and its historical destiny, shifting from Africa to Europe.

Salazarism and Economic Development in the 1930s and 1940s: Industrialization Without Agrarian Reform

FERNANDO ROSAS

Whatever the impact of key blockages generated by the dependent nature of peripherial European economies vis-à-vis the "developed center," it is empirically clear that international economic crises, spontaneous crises in the economic cycle, or crises arising from major political-military conflicts promoted attempts to initiate a sustainable "industrializing takeoff" in peripheral European economies at the end of the nineteenth and the first half of the twentieth century.[1] Portugal is a case in point.

"Opportunities for a Peripheral Country . . ."

The relatively dynamic industrial climate of the last decade of the nineteenth century, the small industrial spurt that followed the first postwar period, the doctrinal offensive undertaken by the industrial class, the industrializing impetus generated by the 1929 depression and sustained during the 1930s, and finally, the theoretical and practical successes of the policy of industrial promotion by José Ferreira Dias in the 1940s cannot be understood in isolation from foreign trade conditions created by international crises and wars.

It was after the crisis of 1929 that the first modern theory of Portu-

guese industrialization emerged. It focused on hydroelectric development, on the promotion of the internal market, import substitution, and protectionism, as well as on the development of "basic industries" and the exploitation, through monopolies or cartels, of national and colonial raw materials. This theory gained popularity with the First Engineers' Congress in 1931, the Great Exhibition of Portuguese Industry in 1932, and the Great Industrial Congress of 1933. Ferreira Dias developed and systematized his theory during World War II. It became the basis for the Law of National Electrification of 1944 (Law 2002) and the Law for Industrial Development and Reorganization of 1945 (Law 2001). Ferreira Dias wrote the "bible" of Portuguese industrialists, *Linha de rumo* (*The Guiding Line*).[2]

The Great Depression, the decline in foreign supply, and the proliferation of economic and financial obstacles to continued importing created both practical opportunities and a need to stimulate import-substituting industrial production. From these events sprang a concomitant theory of economic development, which advocated "industrial promotion" and "industry as the locomotive for modernization" and rejected the dogma of the "essentially agricultural country."[3] Engineers became the ideologues of developmentalist doctrine, a class of "true organic intellectuals" representing an economically weak, socially timid, and entrepreneurially primitive industrial bourgeoisie.[4]

The economic crisis provoked by World War II placed the industrialists in power. Their rise, however, resulted more from the intense pressure generated by the wartime economic blockade than from Salazar's decision to adopt an industrializing path.[5] Because normally imported goods were scarce, the government allowed Minister of the Economy Rafael Duque to promote Ferreira Dias to undersecretary of state for commerce and industry after 1940. Ferreira Dias was called on to foster the production of goods to which the country no longer had access. He turned the task into a true national development strategy.

For Ferreira Dias, industrialization was not an expedient, "an incidental product of difficult hours," but a "heroic reaction of a people seeking to remake themselves after a long and sad decadence."[6] In examining the economic literature of the 1930s and 1940s, it becomes clear that industrialists were well aware of the opportunities generated by the 1929 crisis and wartime bottlenecks. They clearly tried to take advantage of the situation. Hence the euphoria with which the depression of 1929 was heralded in the

Boletim da Direcção Geral da Industria, the mouthpiece of the Portuguese Industrial Association, and similar publications.[7] Ferreira Dias welcomed the war as "my ally in this campaign to teach the Portuguese the path of industrialization."[8] He implemented the first official policy of industralization under the *Estado Novo*, against fierce rural conservative opposition. During the first half of the 1930s, throughout World War II, and in the immediate postwar period, the Portuguese industrial bourgeoisie took up the national market, now free of competition from foreign products and capital. At the same time, the ideologues of industrialization designed an economic policy to achieve the aims of industrialization.

". . . And the Capacity to Take Advantage of Them"

Statistical data on industrial production indicate that no industrial "takeoff" occurred in the period between the early 1930s and the end of World War II. But it also cannot be said that industrial activities stagnated. World War II saw a series of favorable international situations that enabled the small modern industrial core in Portugal to emerge. This core was composed of the national Companhia União Fabril (CUF) as well as Belgian-and French-dominated chemical industries; modern metallurgical companies established at the end of the nineteenth and the beginning of the twentieth century; the Sommer cement industry, which emerged in the immediate postwar period; and the electrical and oil refining industries of the second half of the 1930s. Industrial production grew regularly by 5 percent per annum between 1939 and 1945, during both the depression and the war. The formation of gross fixed industrial capital tended to rise as well, despite the crisis of 1929 and the depression between 1930 and 1932. (This period was followed by a recovery, and later, between 1931 and 1944, by a renewed crisis with the war.)

The 1930s and 1940s witnessed the official sanctioning and creation of new industries (see table 4.1). Still, takeoff did not occur, despite the growing licensing of activities that aimed to promote new industrial enterprise. This period was marked by a renewal of entrepreneurial initiative, mostly a development of preexisting industrial activity. Between 1939 and 1945, 5,090 licenses for new factories were issued. Many of these did not actually entail the creation of new factories, but the sheer volume of requests and authorizations proves that the climate was favorable for industrial invest-

TABLE 4.1
New Industries Started in the 1930s

	Firm	Year
Fiber cement	Lusalite	1933
Lamps, electric motors	ENAE[a]	1934
Electric batteries	Tudor	1936
Bakelite	SIPE[b]	1936
Factory-made glass	Covina	1936
Oil refining	SACOR	1938
Amide	Amidex[c]	1939
Chloric acid, silicate solids	Soda Póvoa[d]	1939
Electric oven iron	CUF[e]	1939
Bicycles	Vilarinho e Moura	1939
Rotation oven iron, cement	Cimentos Tejo	1940

SOURCE: Fernando Rosas, *O Estado Novo* (Lisbon: Círculo dos Leitoros, 1994), 82.

[a] National Electrical Equipment Company.

[b] Industrial Electrical Product Society. Initiated production of bakelite articles for electrical equipment.

[c] Production of amide from corn and *mandioca* (cassava).

[d] Soda Póvoa was an older company bought by the Belgian firm Solvey. It began producing the above-mentioned products in 1939.

[e] Companhia União Fabril. These two attempts to initiate iron production did not result in the takeoff of this industry; that occurred only in the 1960s. These cases are examples of initiatives undertaken by two large industrial groups, the second of which launched the National Siderurgic Company. Iron and cement were produced according to the Basset method, in rotation ovens for Portland Cement.

ment. To the conditions already described that encouraged this growth can be added the new opportunities for export of primary goods, foodstuffs, and other products generated by the destruction of the Spanish economy with the civil war of 1936–39 (see table 4.2).

The relative rise of the economically active population in industry (in the extractive and transformative as well as transport and energy industries) between 1930 and 1950, from 21.8 percent to 27.8 percent, confirms this. The same indicators, however, fail to show a quantitative or qualitative industrial surge, capable of transforming the economic and social realities of Portuguese society.

In 1953, the share of industry, transport, and energy in the gross national product did not surpass 40 percent (it was 36 percent in 1938). The economically active population in industry in 1950 was still below 28 percent; it was only in the 1950s that average industrial growth rates rose by 7.4 percent per annum. In this period, the great hydroelectric projects, as well as basic industries in cellulose, paper paste, heavy metal mechanics, iron and steel, and fertilizers were still emerging. They began to develop toward the end of the 1940s and the beginning of the 1950s, and they took off even later. The cement, naval construction, modern chemical sub-

TABLE 4.2
Main New Portuguese Industries During World War II
(in numbers of new licenses)

	1939	1940	1941	1942	1943	1944	1945	Total
Foodstuffs	83	54	59	70	29	36	84	415
Wood products	52	56	137	71	72	111	225	724
Cork, related products	90	56	59	14	14	17	53	303
Leather	16	27	21	12	10	13	22	121
Chemical products	32	28	41	54	39	46	58	298
Explosives	6	5	—	—	—	—	—	11
Textiles								
Cotton	18	11	23	4	2	2	7	67
Wool products	38	7	5	23	12	26	24	133
Woven materials	14	9	13	9	3	9	13	70
Other	15	9	20	15	27	42	36	164
Rope	—	1	1	—	1	2	2	7
Metallurgy	61	14	179	57	23	18	90	442
Metal mechanics	96	48	115	68	50	87	273	737
Naval construction	—	—	1	1	2	1	2	7
Electrical products	5	9	10	6	8	4	11	53
Cement, lime, plaster	22	12	73	8	4	26	35	113
Ceramics	204	114	16	49	22	34	161	657
Graphic work								
(for publishing)	38	15	30	30	16	10	39	178
Hats	1	3	—	—	—	—	—	4
Shoes	3	—	1	1	—	2	5	13
Glass	5	4	1	5	2	8	4	29
Stonework	14	5	16	6	5	8	19	73
Goldsmithing	16	9	3	2	—	—	14	44
Paper	4	3	1	1	1	1	4	15
Other	—	22	47	69	95	54	81	412
TOTAL	875	512	862	755	438	557	1,262	5,090

SOURCE: Diário do Governo, 1939–45.

sectors, fertilizers, acid, gas for fuel, oil refining, and metal mechanical (equipment or consumption) sectors were islands in an industrial ocean dominated by traditional, family artisanal industries, surrounded by decrepit equipment, a workforce with little technical or professional training, very low levels of productivity, and very small average-sized industrial enterprises; 51 percent of industrial units registered between 1937 and 1939 had an average of only twenty workers.[9]

The favorable conditions of the 1930s and the war years permitted some industrial growth and diversification. They undoubtedly increased prosperity among industrial entrepreneurs of all sizes; but it was a prosperity created without a sustained technical and economic modernization of the productive apparatus, the social base connected with industrial activities,

or the primary and service sectors. The gap between prosperity and industrial modernization (as Ferreira Dias meant it, in the double sense of launching basic industries and of reorganizing and concentrating existing industries) was accentuated during the war and particularly in the postwar period, given the difficulty of importing oil, raw materials, and machinery. This gap (between capital accumulation and productive investment), however, had existed before the war, and outlasted it. The industrialization of the 1950s and 1960s never led to a sustained policy of direct or indirect state intervention, whether financial, political, or economic.

The withdrawal of private investment from industry did not stem from a lack of domestic or foreign capital. Indeed, during the war, capital was not scarce among the upper echelons of the landed bourgeoisie or the international and colonial trade elites. Nor were official stimuli lacking. In the early 1930s, the government lowered interest rates, created the *Caixa Geral de Depositos* to make credit available to industry, guaranteed low salaries, and ensured customs protection for the national and colonial market. It supported key industrial exports, such as canned fish, cork, and resin products. Industrial conditioning and the formation of corporate cartels should be seen as attempts to ensure the survival of industrial activity in a fragile industrial environment characterized by overstocks of equipment and excessive levels of production.

The difficulties facing industrial development in this period did not stem from state policies, which, for better or worse, aimed to promote industry. The explanation lies more in what the state failed to do with the agricultural sector. The structural relationship between industry and agriculture provides a fruitful explanation for the relative underutilization of Portuguese industry despite favorable external conditions or, in other words, for the inability to take advantage of these conditions to promote a real economic transformation.

Key structural factors, as well as certain domestic policies, predate these international circumstances, conditioning the action of economic agents. Why, then, did industry not make the leap in the 1930s and 1940s, when capital and state support were available? An attempt will be made to answer this question by examining foreign and domestic conditioning factors.

The Role of External Dependence

Until the 1930s, the Portuguese economy did not react dynamically to the stimuli of relative openness to the central economies of Europe (Britain in particular) and a relatively specialized and regionally concentrated export sector. GNP growth, technical training, sustained industrial development, and agricultural modernization did not occur according to the logic of the neo–free trade vision of the so-called new economic history.[10] On the contrary, Portugal seems to confirm in part the so-called Myrdalian effects on foreign trade structures.

This contradiction stems from the effect of the progressive devaluation of trade relations and the relative inelasticity of recipient markets for Portugal's main traditional exports. These factors prevented growth and diversification, as well as any theoretically admissible modernizing impact. Jaime Reis has tried to demonstrate that models of possible export specialization (such as cork and fish) could not have promoted a takeoff.[11] He also suggests that this might have worked for the wine sector, had added domestic and external structural or circumstantial conditions been present.

Whatever its merits, this hypothesis is doubtful, considering the social nature of the Portuguese exporting interests. These groups united agrarian and import-export interests and generally avoided industrial investment. They did so for reasons of profit and risk, and also because any attempt at import substitution contradicted the logic of their economic interests as it threatened the economic basis for accumulation and reproduction. Portuguese foreign trade was based on a network of interests that benefited from a situation they historically sought to resist economically, socially, and politically.

As far as imports are concerned, furthermore, the industrial products of the central European countries exerted a competitive blocking effect on local import substitution industries through local importers. They managed to do this despite the regular increase in customs duties and the successive financial and even fiscal limitations on importing goods and capital: namely, the financial and exchange rate crisis (1890–91), World War I (1914–18), and the depression. Until the 1930s, the efficacy of customs duties was dubious; inflation in the 1920s reduced the real value of import duties applied mostly according to weight and not value. Import duties obeyed fiscal rather than protectionist criteria. Those criteria, furthermore,

were selective, partly because of the ability of interested sectors to exert political pressure on the government, sometimes leaving strategic sectors unprotected. Naturally protectionist situations were unable to generate sustained import substitution until the postwar period, regardless of the industrializing impetus.

Thus, although the Portuguese economy benefited from administrative or natural protection, it lacked the domestic conditions to exploit it fully. Unable to substitute some of the essential goods it lacked, Portugal continued to import, despite increasing protectionism. The imports made it difficult to implant national enterprises and created something of a vicious cycle, fueled less by external dependence than by domestic dynamics.

It is important to note other factors that shaped the structure of foreign trade and also made the Portuguese economy vulnerable. One such factor was a chronic and structural deficit in the trade balance. Stability in the balance of payments depended on emigrant remittances, national capital invested abroad, and other "invisible currents," which made Portugal dangerously vulnerable to the external conditions that normally affect capital flows. It was through this door that the crisis of 1929 was ushered in. On the other hand, given the vital balancing role played by exports, concentration in the British market subordinated national exchange rate policy to the fluctuations of the pound, thus reproducing existing disequilibrium. This is what happened in September 1931, when, only months after adopting the gold standard, the Portuguese government was forced to respond to the devaluation of the pound.

It is also worth noting what appears to be a deviation from typical "Myrdalian effects." Throughout the end of the nineteenth century and the first thirty years of the twentieth, Portugal received a flow of capital investment from Britain, Belgium, and France that was quantitatively and qualitatively significant.[12] Although the amount is impossible to estimate accurately, this capital was directed at strategically important sectors: urban and railroad transport, telephone, telecommunications, chemicals, and cement, as well as the production and distribution of electrical energy, minerals, and consumer goods. Most of this investment had a positive impact on industrial employment, urban expansion, the creation of new activities, and technology transfer. But by itself, it was insufficient to generate a sustained multiplying effect. This is probably because the amount was too low; more important, perhaps, as industrialists at the time com-

plained, was that rather than stimulating national industry, this investment merely created new business for new foreign firms.

The problem, nevertheless, lies not in the presence of foreign capital but rather in the inability of Portuguese industry to satisfy a demand for sophisticated goods in conditions of price and quality competition. Clearly, pragmatic British and Belgian entrepreneurs would not buy more expensive goods from their countries of origin if they could have purchased them more cheaply in Portugal.

Yet again, the problem lies in limited diversification, in a lack of capital and know-how, preventing the proper use of new opportunities despite strong customs protection. This situation had intersectoral effects throughout the economy. It leads to the conclusion that the blocking effect of foreign economic dependence acted through the structural weaknesses of the Portuguese economy; in other words, dependent external economic relations produced blocking effects that acted through domestic economic bottlenecks. Even under conditions of declining foreign competition or the promotion of productive investment, takeoff difficulties persisted.

Dependence undoubtedly contributed to these difficulties, but it does not, in and of itself, explain them. Takeoff proved possible in other countries with identical economic potential and foreign trade structures. When political, economic, capital, and technological conditions emerged to launch import-substituting industries (phosphate fertilizers and cement), moreover, Portugal successfully warded off pressure from foreign and domestic import-export interests. Dependence was an obstacle that could, in certain circumstances, be overcome. What was lacking was the domestic conditions for the launching of isolated initiatives or, more important, of a process of sustained industrialization. It was therefore the absence of domestic conditions rather than the presence of external dependence that proved to be the Gordian knot. Which domestic conditions were these?

The Defeat of Agrarian Reform

Explanations for unsuccessful Portuguese industrialization based on unfavorable natural conditions (poor soil and climate, the "naturally poor country" variable) sustain a fatalistic discourse on economic underdevelopment.[13] This vision is too simplistic. Natural factors should be taken

into account, but it is important to know why countries facing similar conditions were able to initiate processes of modernization.

It is difficult to accept the determining weight of unfavorable natural conditions, furthermore, when throughout the first half of the twentieth century the exploitation of the country's natural wealth, its rivers, its minerals, the modernization of its land structures and cultural factors according to the "formula of Portuguese agriculture," had yet to take place. Throughout the 1930s and 1940s, the natural poverty argument was constantly used by rural conservatives as a counterargument against the voluntarist, statist, and authoritarian illuminism of the industrialists. It was essentially an ideological vision, which opposed change in general and the modernization of the cultural and land structure of agriculture in particular; a vision based on the "naturally agricultural and naturally poor" explanation.

Unfavorable natural conditions were raised to the status of dogma, preventing even their study and possible alteration. It was only in the 1940s, under Ferreira Dias, that subsoil or river current studies were initiated, and their systematic application began only a decade later. The delay aggravated problems of "latecomer" industrialization. Ideological and social factors are more important in explaining this delay than the relative poverty of natural conditions. Of course, taking advantage of natural conditions at the right moment would have been decisive for optimizing multiplier effects.

On the other hand, it is obvious that a lack of human capital, technology, or a small internal market had a great detrimental effect on industrial takeoff. But these problems derive in great part from another basic and decisive factor: the land question, the agricultural impasse, or the absence of agrarian reform. This is not the place to discuss which of the many models of agricultural or landholding modernization might have helped change the course of Portuguese industrialization. Such models range from that propounded by Joaquim Oliveira Martins to those put forward by the different neophysiocratic schools.[14] What is important to note is that, under the *Estado Novo*, Portuguese agriculture never decisively supported industrialization as a source of labor, as a market supplier, or or as a purchaser.

Social and political resistance to the modernization of agriculture prevented the emergence of conditions favoring industrialization or rapid

urbanization, not to mention a reduction or specialization of Portuguese agriculture. The perpetuation of old productive and landholding structures, politically prolonged by the *Estado Novo*, conditioned the country's economic future for a long time. It slowed the pace of industrialization in a tiny market whose agents sought an omnipresent state protection; it deprived industry of the advantages of integration with developed Europe, thus maintaining debilitating dependencies and vulnerabilities that might otherwise have been overcome.

Industrialization Without Agrarian Reform

The characteristics of Portuguese industry in the 1930s and 1940s, the socioeconomic profile of the country's entrepreneurs, the nature of the industrial labor force and its living conditions cannot be seen in isolation from the circumstances in which national industry developed in the twentieth century. First, as noted by Miriam Halpern Pereira, only a gradual industrialization was undertaken without the essential support of agrarian reform.[15] This explains industrial weakness in Portugal during the first half of the twentieth century. As a "latecomer" to the European industrialization process, Portugal implemented successive and increasingly protective measures to cover national and colonial markets for the benefit of the industrial sector from the last quarter of the nineteenth century on, but these steps were insufficient to generate industrial takeoff.

During the first half of the twentieth century, industry developed despite the absence of a large and prosperous rural middle class, which could have served as a pillar to sustain demand for industrial intermediary goods and equipment. The rural population did not have the purchasing power to sustain demand for consumer goods. Finally, the agricultural mode of production could not sustain industrial development in cultural, price, or productivity terms. All other weaknesses stemmed from this basic reality.

Those weaknesses led, first, to a typically peripheral economic industrialization, dependent on the opportunities created by world crises yet unable to take full advantage of these openings to induce sustained growth. Indeed, until the end of the 1940s, Portuguese industry grew in spurts, shaped by the domestic impact of four important international events favorable to import substitution industrialization: the crisis of 1890–91, World War I and the immediate postwar period, the depression of 1929,

and World War II. In all four cases, albeit for different reasons and in different ways, the withdrawal of foreign investment, the near-elimination of foreign competition and supply, and the material and financial limitations on continued importing created the conditions, as well as the need, to promote import-substituting industries.

Second, Portugal's industrial fabric was dominated by small, poorly capitalized enterprises with very basic technologies, very low productivity, and similarly low rates of production. Until the 1930s, the most advanced sectors (urban and railroad transport, telephone, telegraph, electricity, gas, and naval construction) were almost all in the hands of foreign capital.

A third consequence was that Portuguese industry developed in the shadow of a structurally determined, historical state protection that prevented autonomous development. The state protected and guaranteed the national and colonial market. It regulated, conditioned, or eliminated intra- and intersectoral competition by industrial conditioning through the creation of corporate cartels, administratively determined concessions or concentration, arbitration, and its own economic coordination agencies. The state promoted the search for, and then guaranteed the defense of, external markets. It ensured "social peace" and the low cost of labor by moderating the "excesses" of employers, fragmenting national trade unions, and deploying its police force. It financed fixed prices and production quotas and distributed raw materials.

The state was the omnipresent protector, arbiter, and banker. It was the authority that compensated for endemic industrial weaknesses, for lack of capital, knowledge, technology, and even imagination and creative initiative. This genetic submission of national industrialists to the political arena was drastically accentuated with the interventionism of the *Estado Novo*, a practice that marked ideology, attitudes, and practices in Portugal for a long time.

A fourth result of the entrenchment of agricultural production was that Portuguese industrialization was based historically on the exploitation of mostly semipeasant female, child, and illiterate labor, which lacked any technical formation and was deprived of the freedom to associate. Salaries were very low and working days very long. Together with the various measures of state protection, these factors permitted the development of traditional industries. Generally speaking, entrepreneurs in these industries were not interested in technological investment, the education of workers,

or the adoption of assistance schemes; they could survive and even prosper without these measures, protected as they were from competition and the demands of the workforce. Because of the low salaries, that workforce was largely obliged to ensure its livelihood by resorting to the land.

There is thus a great irony in Portugal's industrial history. Some of the most important traditional industrial sectors benefited from precapitalist modes of agricultural production. They contributed to the reproduction of rural conservatism and to the "blocking" of agrarian reform—the kind of reform on which, in the final analysis, industrial takeoff depended.

A fifth and final consequence was that the industrial bourgeoisie became the socioeconomic, ideological, and cultural expression of those structural realities. Indeed, the Portuguese industrial bourgeoisie of the 1930s and 1940s was dominated by an "entrepreneurial infantry," not very strong and with low scientific and technical qualifications. This class was far from constituting an "entrepreneurial culture"; investing in industry was still seen as a risky adventure.

With their begging hats held out to a state on which almost everything depended, the members of this "infantry" expressed an almost congenital fear of risk. They also feared competition and social agitation. They knew they could peacefully spend their profits to emulate the traditional wealthy through the purchase of farms, conspicuous consumption, investment in the London stock market, and buying and selling apartments for profit in Brazil or Lisbon.

All of these consequences marked the process of Portuguese industrialization from the 1950s on. The great hydroelectric and industrial enterprises launched in that period were governed by the protective measures mentioned above, as well as by monopolistic or oligopolistic conditions directly or indirectly ensured by the state. When, beginning in the 1960s, the moment for European integration could no longer be delayed, the Portuguese industrial economy entered a progressively liberalized market equipped with obsolete traditional industries, or other more recent ones based on foreign capital, which were competitive only because of low-wage labor. It was not long before the strategic sectors, which had been largely administratively created and maintained, began to suffer in the open market. The same can be said for the traditional sectors, which also were based on cheap labor.

The silent and immutable land provides the backdrop to all this history.

The mythical source of riches, security, and the permanence of things, the land was also the factor that decisively "blocked" industrialization and economic modernization. The laws of the market proved insensitive to the ideological values of a bucolic ruralism, which survived throughout this period and which finally prevented that market from truly developing.

The Portuguese Economy: From Salazarism to the European Community

JOSÉ MARIA BRANDÃO DE BRITO

This chapter consists of an analysis of the evolution of the Portuguese economy. It covers the period starting with the military coup of May 1926, which led to the military dictatorship and the period under the *Estado Novo* after authoritarian rule was constitutionalized in 1933, and ends with Portugal's accession to the European Economic Community (EEC) in 1986.

The period under analysis is divided into five phases. These are generally accepted by Portuguese historians as corresponding to critical periods in the development of the Portuguese economy. The first phase, which is only summarily examined, covers the 1930s. It corresponds to the period in which the regime and its corporative system were institutionalized and consolidated. At this time, economic strategies and projects were still relatively unclear.[1] In political-economic terms, two concepts would appear to define this period: financial housecleaning and order. Both became banners of the regime and were held up in contrast to the disorder that had prevailed during the turbulent years of the First Republic (1910–1926).

This period was essentially characterized by four key policies or measures: the 1933 National Labor Statute; the Wheat Campaign, which began in 1929 and lasted throughout the following decade; the policy of industrial conditioning, first decreed in 1926, formally established in 1931, and made law in 1933; and the Law of Economic Reconstruction of 1935, which represented the first attempt by the *Estado Novo* to implement a long-term

economic strategy. The aims of this law, however, were seriously affected by the outbreak of the Spanish civil war and by the belligerent atmosphere that reigned in Europe on the eve of World War II.[2]

Portugal's economic development throughout the first twenty years of the *Estado Novo*, and more precisely, until the passage of the Law of Industrial Conditioning, was marked by the confrontation between the defenders of rural or agrarian interests and the supporters of industrialization.[3] Indeed, this conflict and its long-term effects were among the hardest and most complex legacies Portugal had to deal with in the entire process of economic development. The conflict was a product of nothing less than the reaction of the agrarian sectors to the very idea of modern industry. On the one hand, it was clearly a clash between socially dominant groups, pitting farmers, landowners, and large-scale tenant farmers against industrialists and the supporters of an industrializing economic development. On the other hand, it was part of a wider struggle between radically different conceptions of the future and the evolution of Portuguese society as a whole.

The second phase of the country's economic development occurred during World War II. During this period, Portugal's economic policy and evolution underwent a decided shift. First, the war gave rise to the necessary conditions for industrial development.[4] Revealing the vulnerability of the Portuguese economy, it provided the supporters of industrialization with the opportunity to put their ideas into practice. Second, the war permitted certain industrial sectors to conquer the domestic market. Foodstuffs, textiles, rubber, nonmetallic minerals, metallurgy, and metal mechanics, whose previous development had been curtailed by the power and actions of the sectors connected with the import trade, finally gained ground.

This period was marked by two fundamental traits. The first was the important policy change just described. The second, a result of the first and of the foundations laid by the war, was the industrial offensive initiated in 1944–45, consolidated through a series of legislative measures and the doctrinal work of José Ferreira Dias and his followers.[5] World War II, in other words, aggravated the bureaucratization of the regime. It reinforced the interventionism of the central administration and, at the same time, postponed the normal development of a significant majority of industrial sectors. Nevertheless, the war was a decisive factor in removing persistent obstacles to the idea of industrialization.

The third phase in Portugal's economic development unfolded over the fifteen years following the end of World War II. This period was marked by the philosophy underpinning the Law of Industrial Reorganization and Support. A profound reformulation of economic policy was undertaken, based on the promotion of new sectors of the transformative industries, the restructuring of already existing industries, the protection of the internal market, and, above all, a clear policy of import substitution.

All these policies were implemented with three key aims in mind. First, they were meant to wipe out inflation, the scarcity of goods, and the unemployment caused by the war. Second, it was hoped that they would lead to a speedy national industrialization process. Third, they were intended to improve the country's living standards.

Economic Development Plans

It was also during this period that the government belatedly and rather shamefacedly accepted U.S. aid, in the form of the Marshall Plan.[6] As a framework for receiving that aid, the government was forced for the first time to formalize a medium-term development plan. This necessity seems to have been at the root of the First Development Plan. Although it presented a series of only vaguely articulated, large public works projects and partial investment programs, it nevertheless gave rise to an "era" of more or less global economic planning, which was crucial for public investment.[7] It also served as a guideline for private investment. It came to an end only in 1974.

The First Development Plan was initiated in 1953 and covered the following six years. Through it, the *Estado Novo* systematically attempted to implement innovative political-economic objectives. The fundamental preoccupations informing the plan were the need to increase labor productivity; the need to develop a guaranteed absorption of excess labor from the agricultural sector; and an increase in the qualifications of the economically active population to combat high levels of illiteracy.

Somewhat inarticulate because of poor preparation, the First Development Plan achieved only a 3 percent per capita per annum average increase in gross national product. Overall, it did not meet expectations. Even the official assessment recognized that "the First Plan was finally more of a plan for development works than a development works plan."[8] Other

development plans followed, however, which were increasingly sophisticated. They were applied until 1974.

The successive plans manifested the same central preoccupations and adopted the same key objectives Nevertheless, it is important to note that as the corporativist logic gave way to the logic of the market economy, the idea was reinforced that plans were imperative for the public sector and merely indicative for private sector investments.

It was in the middle of the First Development Plan that the Second Congress of Economists and the Second Congress of Portuguese Industry took place in 1957.[9] They signaled a new focus in economic policy and gave rise to the beginning of the fourth phase of Portugal's economic development. These important meetings provided a forum for an overview of almost all relevant aspects of Portugal's economy and society. New political-economic possibilities were sought, and solutions to the impasses already becoming apparent were discussed. Indeed, as far as the latter were concerned, the end of the war had led to the processes of integration and decolonization, which had thrown the dictatorial regime into a state of considerable perplexity.[10]

Despite the changes, it is not difficult to find continuity between the Second Congress of Economists and the first, which took place in 1933. It is possible to detect common elements in both events, even though they focused on different sets of problems. Both advocated industrial nationalism. Although the second congress was less radical in this regard, the concept of subordination of the agricultural to the industrial sector was present on both occasions, as was the idea of economic complementarity between Portugal and the colonies. Generally speaking, three key ideas emerged from various relevant speeches, the extensive and comprehensive reports, the communiqués presented at the congress, and, most importantly, in Marcello Caetano's inaugural speech.[11]

The first important concept was that economic growth policy had to be based on links between Portugal and its colonies. Particular emphasis was placed on intracolonial trade liberalization and on changing the location of industries processing raw materials in the colonies. The overall planning of economic development should permit the harmonious growth of all national sectors. The particular characteristics of each colony must be taken into account. At the same time, Portugal should not be excluded from European integration. The industrial conditioning regime should be

altered to apply to the country as a whole. Finally, the pursuit of technical education and the revision of the industrial credit regime were both important.

Second, the Congress' documents indicated that the demands of accelerated economic growth should be based on the dissemination of "an industrial way of thinking" and on the need to industrialize the country rapidly. Once again, the Law of Industrial Reorganization and Development was regarded as a linchpin for the reorganization of existing industries and the installation of new ones.

Third, the aim of adapting the Portuguese economy to the transformations occurring at the European level was indicated. Again, it was noted that the nation's high level of external dependence had to be kept in mind.

The conclusions presented at these congresses had an undeniable impact on subsequent political-economic developments. They influenced the Second Economic Development Plan (1959–64), which was already in preparation; they also had an impact on the negotiations that culminated in Portugal's accession to the European Free Trade Association (EFTA). Finally, they helped shape the process that ultimately created the Portuguese Economic Area.

The 1960s were characterized by the more or less programmed fulfillment of the political-economic model that had prevailed throughout the previous twenty years, albeit not without introducing some changes. The first of these was the gradual dismantling of the bureaucratic apparatus, the foundations of the "autocracy," and the concomitant institutionalization of Portugal's integration with European and world markets. Portugal became a founding member of EFTA; it was admitted to the IBRD/IMF in 1960; and it joined the GATT in 1962. The Portuguese government, furthermore, permitted a liberalization, albeit limited, in the terms for foreign direct investment.

The second alteration consisted of an effort to launch and consolidate the Portuguese Economic Area, uniting Portugal and the colonies. This project combined elements of the British Commonwealth and the European Common Market and was undertaken as Portugal pursued an open economic policy.

A third alteration aimed to reinforce a process of rapid growth and development based on the Second Development Plan, which pursued a slightly different path from its predecessor. Notably, it pointed to the ac-

celeration of the rate of economic growth, an increase in the level of productivity and living standards of the population, the reinforcement of professional education, the creation of new jobs, and the reorganization of industry and the balance of payments, as well as the shift in programmed investments, with approximately 50 percent allocated to the transformative and energy industries and 30 percent to the transportation and communications sector.

The 1960s were also marked by three developments that distinguished this decade in contemporary Portuguese history. These were the high rate of economic growth achieved, the outburst of the colonial wars of liberation, and social processes that led to a new wave of emigration.[12] The third trend caused the Portuguese population to decline by one percent, making Portugal the only member country of the Organization for Economic Cooperation and Development to experience a decline in its resident population in that decade.

The Interim Development Plan (1965–67) was unable to resolve the problems that arose from these processes, even though this plan was qualitatively better that its predecessors in both conceptual and metholodogical terms. Indeed, the Interim Plan was the first in the history of Portuguese economic planning that was to "attempt a global vision of the economy and pay attention to relevant aspects of the living conditions of the population."[13]

The plan's great objective, for example, illustrates this shift: "the acceleration of the rate of growth of the national product together with a *more equitable distribution of wealth*" (emphasis added). It should be noted that the inclusion of sums for health and housing in the plan actually represented a "shift in planning toward social needs."[14]

A New Regime

The end of the 1960s was an economically turbulent period. António Oliveira Salazar (1932–68) was replaced as president of the Council of Ministers by Caetano (1968–74). Meanwhile, disturbing symptoms appeared that the long-dominant economic model was finally exhausted.

Caetano initiated a liberalization process that provoked a climate of heightened expectations for greater social and political freedom. At the same time, the Third Development Plan (1968–73) came into force. Apart

from the usual objectives of acceleration of economic growth and a more balanced distribution of income, this plan aimed to correct regional economic imbalances, on the grounds that it should be "the instrument par excellence for the fulfillment of the policy of national economic unity toward which the country is working."[15]

Generally speaking, the economic model represented a final attempt to adapt to changing circumstances. The repeal of industrial conditioning was considered. An attempt was made to widen the sphere of influence of the market where transformative industries were concerned. The constitution was changed, and financial-economic groups as foundations of the economy were reinforced. Better conditions for foreign investment were created.

These remedies, however, were insufficient. Although growth rates were high, the agricultural sector seemed to have detached itself definitively from the process of development. Indeed, this separation constituted the greatest obstacle to further development. The first phase of industrialization, based on Law 2005 and on the policy of industrial conditioning, seemed to be reaching a point of exhaustion.

The new generation of politicians Caetano brought to power believed that the internal market was definitely incapable of acting as a pillar for a new industrial takeoff. As one observer noted, "the urban population represents a mere million and a half to two million in terms of purchasing power and living standards," compared with other European centers.[16] The industrialization model conceived by Ferreira Dias in the 1940s was, in effect, running out of steam. But Rogério Martins, the new secretary of state for industry and a self-proclaimed disciple of the old master, temporarily gave it renewed impetus. Ferreira's *Linha de rumo* was succeeded by Rogério Martins' *Caminho de país novo*.[17] A partial response to the process of "degeneration," moreover, emerged in the form of an industrial development policy that supported Martins' new industrial and economic ideas.

The new policy aimed to put an end to the previous autarchic and conditioned industrial system and to sustain the opening of the Portuguese economy to foreign markets. This shift clearly responded to the interests and strategies of the economy's more modern sectors. But in historical terms, and despite the introduction of a few innovations in Portuguese political practice, these solutions came too late. From a domestic per-

spective, the lack of balance between social forces did not ensure success. From an external point of view, EFTA was irreversibly weakened when the United Kingdom, Denmark, and Ireland joined the EEC in 1973.

Despite efforts to negotiate an association treaty with the European Community (fruitful only in 1972), furthermore, domestic and international economic conditions, specifically the deterioration of the national political climate and the first worldwide oil crisis, did not, for the most part, permit the development and fulfillment of the measures adopted.

The fifth and final phase of this historical process, between the revolution of April 1974 and Portugal's accession to the EEC in 1986, coincided with a particularly agitated economic climate. If the events of April 25, 1974, gave rise to a process of democratization and decolonization, they also threw the Portuguese economic system into a profound crisis, which coincided with a serious international recession. Portuguese macroeconomic variables, such as unemployment, inflation, and the public deficit, began to spiral out of control. Public and private economic agents, engaged in a deadly social battle, did not have the ability to reverse these negative tendencies. The economic system went into a serious decline.

The policy of nationalizing the main financial-economic groups and sectors in 1975 obeyed a revolutionary logic rather than a strategically consistent and sustainable economic policy logic. The agrarian reform carried out in the great latifundia in the south similarly occurred outside the confines of any economically coherent project. Socially relevant agrarian reform was nonetheless condemned to political and economic failure after 1975. These two great battles, trademarks of the April revolution, were waged immediately after the constitutionalization of the new regime. The revolutionary transformations could not survive, however, because of the adverse national and international conditions that emerged thereafter.

Reaching Toward the International Community

After the signing of the first agreement with the International Monetary Fund (IMF) to implement an economic stabilization policy in 1977, a new macroeconomic framework emerged.[18] It pointed toward normalization and represented an effort to rationalize the nationalized sector of the economy and to roll back state interventionism with the reinforcement of market mechanisms. It also heralded a rapprochement between Portugal

and the European Community. Indeed, Portugal's formal request for accession to the EEC was made in March 1977.

The path to full membership, however, stretched out for seven years. In the interim, Portugal became an economic laboratory of sorts, where a variety of different and frequently contradictory economic policies were implemented. The Medium-Term Plan (1977–80) was aborted along the way, leaving a series of difficulties for reestablishing balance in the system. Countercyclical policies were implemented. Efforts were made to improve international competitive capacity through an exchange rate policy based on discreet devaluations and the maintenance of the "crawling peg." Attempts were also made to increase productive investment and exports, to the detriment of domestic consumption and imports.

On a strictly formal level, and social considerations aside, the overall economic policy finally agreed on with the IMF can be considered generally positive. This is especially true given the major objective pursued by this policy, the reestablishment of equilibrium in the balance of payments. This objective was achieved in 1979–80. The battle against inflation also met with some success: inflation fell from 25 percent in 1977 to 16 percent in 1979. Productive activity was reinitiated, investment received renewed impetus, and the unemployment rate fell. Nevertheless, success was ephemeral. The measures adopted and implemented were too superficial.

After the electoral period of 1979–80, when an effort was made to present an artificially reasonable picture of the economic situation, the problematic international balance of payments entered a new, uncontrolled phase in 1981–82. The rise in the dollar, the new oil shock, the increase in international interest rates, and the industrial and agricultural national production deficit (which had just experienced two bad years) all contributed to this difficult period.

The new problems in financing the internal and external deficit indicated a need for another economic stabilization plan. A second agreement was reached with the IMF under the so-called *Bloco Central* government, which was a national coalition of the two major political parties, the Socialist Party and the Social Democratic Party. Given the economic situation, the government was obliged to submit the country to a strict stabilization policy that transcended even traditional IMF guidelines. It consisted of exchange rate, monetary, and budgetary restrictions, which pursued two objectives: reduction of the external deficit and cooling of domestic sources of expenditures, namely, consumption and investment.

A period of austerity followed, involving the rigorous fulfillment of criteria. The country emerged adequately, if performance can be judged coldly by the figures alone. The social and economic costs, however, were almost unbearable, particularly for many small businesses and for the lower middle and working classes of the population. It is true, nevertheless, that basic macroeconomic equilibrium was restored and, in some areas, expectations were even surpassed.

In the eyes of the international community, Portugal emerged as a "tidy and well-behaved" economy and as a nation that had rigorously fulfilled the measures imposed on it. Portugal seemed prepared at last to enter the European Community. In 1985, the end of a political-economic cycle seemed to have arrived. In January 1986, a new economic development cycle was initiated, this time with Portugal as a member of the European Community.

The Development of Portuguese Democracy

MANUEL BRAGA DA CRUZ

The Portuguese political system has undergone a series of phases from the period of transition to democracy to the present. The first, the revolutionary process, occurred between the military coup of April 25, 1974, and the promulgation of the constitution on April 2, 1976, and was punctuated by three key events. First, General Francisco Costa Gomes replaced General António Spínola as president of the National Salvation Junta and president of the republic on September 28, 1974. This heralded the acceleration of the decolonization process and the revolutionary transformation of political institutions and social structures.

Second, General Spínola's attempt to stem the tide of revolutionary change failed on March 11, 1975. The consequences of this failure were a reinforcement of socialization, with the nationalization of key financial and economic enterprises; the institutionalization of the Armed Forces Movement (*Movimento das Forças Armadas*, or MFA); and the reinforcement of the state's role in society.

Third, the slowdown of the revolutionary process began with the military coup on November 25, 1975, and particularly after the end of decolonization with the last, Angolan, declaration of independence on November 11, 1975. This led to the progressive dismantling of the "conquests of the revolution" and to the gradual institutionalization of a parliamentary democracy.

The second, or constitutional transitional phase, occurred under the tutelage of the Armed Forces Movement through the Council of the Revolution. It began with the promulgation of the constitution and ended with

the constitutional revision of 1982, which abolished the Council of the Revolution and distributed its powers among other newly created bodies. This period was characterized by conflict between the civilian government and the parliament on the one hand, and the militarized presidency and the Council of the Revolution on the other. In party political terms, this conflict was waged between the forces that defended an electoral legitimacy and those that affirmed a revolutionary legitimacy. This period was also marked by strong governmental and party instability, which favored high levels of presidential interventionism in governments established by presidential initiative. The period also witnessed a confrontation between a presidential majority and a governmental majority.

The third phase began with the constitutional revision of 1982 and ended with a full demilitarization of political life, with the election of the first civilian president in 1986 and the election of the first absolute single-party majority in 1987. This phase was marked by political and economic crisis, recession, and party instability. It was also profoundly shaped by Portugal's accession to the European Economic Community in 1986.

In 1987 a new political phase began, characterized by strong stability and political leadership as well as by economic development. That leadership and authority were bolstered by vast funds from the European Community. This gave rise to wide-reaching constitutional, economic, and social reforms that significantly altered Portuguese political life.

The Electoral System: From Consociationalism to Improbable Majorities

The Portuguese electoral system was born before the political constitution itself. Indeed, it can be said that the electoral system *is* the political system, because it conditions the political system structurally as well as politically.

The first electoral legislation passed after April 25, 1974, led to the emergence of a system of proportional representation, or the plurinominal list based on the de Hondt method. It also approved universal suffrage for everyone over the age of 18, including illiterates, and it institutionalized mandatory voting registration.[1]

The adoption of proportional representation was justified on the grounds that it permitted a greater margin of expression for the various

organized political tendencies that previously had been excluded. The aim was to represent fully the new panorama of democratic forces in the country. Criteria of legitimacy trumped those related to governmental efficacy; full representation was a greater preoccupation than ensuring stability and governability. Nor was the creation of an electoral system conducive to solid majorities, which might make it a priority to govern in a durable way. Instead, the aim was to favor the establishment of minority consociational governments, governments based on coalitions or formed through negotiation. This systemic bias was reinforced because positive or explicit parliamentary approval of government programs was unnecessary; instead, the law required only nonapproval, or negative approval. (The propositional system also ensured that a government could be brought down only after two censorship motions.)

A durable single-party system, which had been sustained by a system based on an electoral minority list, had created an aversion to any formula not based on electoral proportionality and governmental power sharing. This radical change in the electoral system, however, coexisted with the traditional electoral circles based on districts. This had significant repercussions for party organization at the district level. The system of representation and the de Hondt system of converting votes into mandates were actually incorporated into the text of the constitution.[2]

The first legislature, in 1976, was characterized by government instability. The emergence of successive governments (the first a minority government, the second based on a coalition, and subsequent ones "presidential") led to an impasse, which forced the dissolution of the parliament and the holding of interim elections in 1979. It also led to the first attempt to change the electoral law. The center-right parties proposed that the system of electoral circles be reformed. The Social Democratic Center (CDS) proposed the creation of a national circle alongside the district circles, which would elect half the parties' deputies. The Social Democratic Party (PDS), on the other hand, called for the formation of nondistrict electoral circles, which would correspond to "groupings of local authorities." The aim was to promote more socioeconomically and culturally homogeneous electoral circles, as well as to mitigate the difference in the number of deputies for each circle. The PDS also proposed that voting be made mandatory rather than optional. These proposals were finally rejected by the parties of the Left. The electoral legislation of 1974 thus remained unchanged.

A further attempt to reform the electoral law failed during the first constitutional revision of 1982. The aim of the proposal put forward by the Democratic Alliance (AD) on that occasion was to deconstitutionalize electoral law in order to make it more flexible.

Despite the impasse, criticism of the system increased, even within the Socialist Party, essentially because it did not permit the necessary proximity between representatives and represented. The German solution, based on a majoritarian and uninominal correction of the proportional system, gained supporters even within the Socialist Party, but the party's position remained unchanged.

The growing awareness of the need for change led the first government of Aníbal Cavaco Silva to nominate a commission in 1986 to study the reform of the electoral code. Among the proposals put forward in the commission's project, it is worth noting the call to circumscribe electoral circles by establishing a national circle to coexist with other partial circles. Another alternative proposed dismantling the more populated circles of Lisbon and Oporto and regrouping the least populated. A further proposal pointed to the augmentation of local electoral circles on a par with a national circle, making the former correspond with uninominal circles.

During the presidential campaign of 1986, Diogo Freitas do Amaral defended the adoption of a two-round majority system. Mário Soares, on the other hand, recognized the imperfections of the system but advocated a "reform without rupture."

The growing wave of criticism and the growing consensus regarding the deficiencies of the system led the Socialist Party to support the creation of a national circle and a reduction in the number of deputies, in an agreement for the constitutional revision of 1989. This was also the position defended by the Right, except that the Socialists made their support conditional on maintaining the same weight of electoral circles in the interior of the country. The objective was for the national circle to favor small parties, which could take advantage of "leftovers" in local elections.

The bill for electoral reform presented by the government in 1990 did not win parliamentary approval, however. It advocated the creation of a national circle and the division of the more popular circles, which would have favored the bipolarization of the party system and a greater proximity between representatives and represented. With the inauguration of a new legislature in 1991, the government again presented a reform bill.

The Socialist Party proposed the introduction of the preferential vote, the admissibility of independent candidates, and the new idea of determining the boundaries of electoral circles by regional administrations. Because the Social Democratic Party opposed any form of regionalization, however, the two parties again could not reach an agreement.

Today, the view is widely shared that the system is responsible for citizens' distance from and decreasing participation in political life, as evidenced by increasing abstention from electoral participation. The need to find solutions that will bring the elected and the voters closer together is urgent, so that representatives are held accountable not by their party machines but by their constituents. The crisis of Parliament's low public credibility is not only a product of the erosion or government usurpation of parliamentary competencies—a tendency apparent in all democracies; it is also the product of the distancing of citizens from political institutions and the excessive weight of political parties in political life.

Although the Social Democratic Party has twice gained an absolute majority under the rule of Cavaco Silva, it is widely acknowledged that the system does not facilitate the formation of majorities. This was apparent in the elections of 1995. It is also widely believed that the need to guarantee governability through stable solutions that are not consociational demands a reform that will ensure all three factors: legitimate representation, the efficacious functioning of institutions, and publicly accountable representatives.

The Party System: From Fragmentation to Polarization

Proportional representation led to a situation of limited fragmentation right from the start. Of the twelve parties that participated in the elections of 1975, six gained parliamentary seats. Two of these, the Portuguese Communist Party and the Portuguese Democratic Movement, gained seats as a result of a preelectoral coalition.

The parliamentary scene until 1979 was dominated by two large center parties, the Socialist Party at the center-left and the Popular Democratic Party at the center-right, which gained approximately 60 percent of the votes and more than two-thirds of the parliamentary seats. The Portuguese Communist Party and the Social Democratic Center were more marginal yet had significant weight, together gaining more than 30 percent of the

votes and almost one-third of the seats in Parliament. Beyond these two groups, two other left-wing parties with much less political relevance were represented nationally: the Portuguese Democratic Movement and the Popular Democratic Union, which had only one deputy each.

The party system established with the constituent elections of 1975 was reinforced with the first legislative elections in 1976. It was, in the words of Marcelo Rebelo de Sousa, an imperfect multiparty or "dominant party" system because of the electoral and governmental domination of the Socialist Party. It became a multiparty system without a dominant party at the end of 1977 with the establishment of the governing agreement between the Socialists and the Social Democratic Center.[3]

From 1978 on, however, with the rise of presidential governments, the party system weakened and fragmented. It weakened because presidential interventionism and the Council of the Revolution gained in strength to the detriment of the parties and the parliament, which were relegated to a secondary position. It fragmented because of internal party divisions.

Both the large center parties underwent processes of internal fragmentation, which divided their parliamentary representatives during the first legislature. The Socialist Party underwent two successive splits. The first, led by Lopes Cardoso and Aires Rodrigues, culminated in the creation of the Left Union for Socialist Democracy and the Workers Party for Socialist Unity. The second split was led by Medeiros Ferreira and António Barreto, who formed a group of reformists. The Social Democratic Party, on the other hand, suffered a split centered around the slogan "Immediate Choices," which had long-lasting repercussions for the party's parliamentary group.

The emergence of the Democratic Alliance and of the first government majorities in 1979 and 1980 reinforced the party system and created a situation of "imperfect or partial bipolarization." The Right and center-Right of the political spectrum, which gained a majority in parliament, were dominated by four parliamentary groups: the Social Democratic Center, the Social Democratic Party, the Popular Monarchic Party, and the Reformists. On the other side of the political spectrum, the Left remained divided; it was distributed among two coalitions, the Republican Socialist Front and the United Peoples' Alliance (with the Socialist Party generally gaining double the votes and seats of the Communist Party). The Left was also divided into five parliamentary groups: the Independent Social

TABLE 6.1
National Assembly Electoral Results by Party, 1975–1995
(by percentage)

	PS	PSD	PS+PSD	CDS+PCP
1975	37.87	26.38	—	—
1976	34.67	24.38	59.2	39.3
1979	27.33	45.26	—	—
1980	27.76	47.59	—	—
1983	36.12	27.24	63.3	30.6
1985	20.77	29.87	50.6	25.4
1987	22.24	50.22	72.4	16.5
1991	29.13	50.60	79.7	13.2
1995	43.80	34.00	77.8	18.1

SOURCE: Ministério da Administração Interna, *Eleições para a Assembleia da República* (Lisbon, 1975–95). Parties: PS = Socialist; PSD = Social Democratic; CDS = Social Democratic Center; PCP = Communist.

Democratic Association, the Socialist Party, the Left Union for Socialist Democracy, the Portuguese Communist Party, and the Popular Democratic Union.

This situation changed with the formation of the Central Bloc in 1983. It weakened the two center parties, the Socialists and the Social Democrats, and reinforced the marginal parties, the Social Democratic Center and the Portuguese Communist Party.

The collapse of the Central Bloc two years later and the emergence of the party led by General Ramalho Eanes in 1985 aggravated the tendencies already present in the party system. General Eanes' Democratic Renovating Party gained almost 18 percent of the vote and the third-largest parliamentary bloc in Congress. This acted as a brake on bipolarization, reinforced the center, and helped perpetrate the fragmentation of the party system. In 1985, there were still six parliamentary groups.

The 1987 elections changed the party panorama significantly. For the first time, a single party gained an absolute majority, both in terms of votes and of parliamentary representation. The Democratic Renovating Party gained only 5 percent of the vote, and the Socialist Party regained its previous leadership as the main opposition party of the Left, once again at the expense of the Communist Party. The 1991 elections reinforced the tendency toward polarization: they renewed the absolute majority gained by the Social Democratic Party, increased Socialist Party representation to almost 30 percent, and reduced the representation of the marginal Communist Party and Social Democratic Center to 8.8 percent and 4.4 percent,

respectively. The emergence of the National Solidarity Party, which gained one seat in Parliament, did not reverse this trend.

The vote for the two large center parties thus evolved from 59.2 percent in the first legislative elections of 1976 to 79.7 percent in the elections of 1991 (see table 6.1). The marginal parties, on the other hand, saw their share of the vote decrease from 39.3 percent in 1976 to 13.2 percent in 1991. The 1995 elections, however, partly reversed this trend, increasing the marginal parties' share and concomitantly decreasing the share of the large center parties.

The Governmental System: From Bonapartist Semipresidentialism to "Presidentialism of the Prime Minister"

The system of government established with the 1976 Constitution was characterized by a dual legitimacy, based on universal suffrage in electing the parliament and the president of the republic and on the government's dual accountability to these two offices. For this reason, it has been called a semipresidential system.

At times more parliamentary and at other times more presidentialist, the Portuguese system of government has oscillated between a visible presidency and a more discreet one. The president has sometimes been a leading figure in the political arena, even dominating the executive branch through a loyal prime minister; at other times playing the role of an opposition; and sometimes acting merely as an "influential magistrate." Some observers hold that although the system was created as semipresidentialist, it has since evolved into a rationalized parliamentarism, given the decline in presidential powers after the constitutional revision of 1982. Others argue that declining presidential powers, along with the emergence of consociational or majority situations, make the present system nothing more than a "presidentialism of the prime minister."[4]

The failure of the parliamentarism of the First Republic, as well as the dictatorial presidentialist model of the Estado Novo, led constitutionalists to adopt an intermediate solution, so as to avoid the errors of the past and respond to the historical call for greater political participation by an increasingly vocal opposition and public. This demand was translated into a call for free and direct parliamentary and presidential elections.

Apart from historical factors, there was a systemic justification for di-

rectly electing the president: the need to rationalize the electoral system and the system of government. The system of electoral and party representation had to be proportional and therefore fragmented; the system of government was meant to be consociational or coalitional rather than majoritarian, and therefore required only the parliament's passive nonreproval of government policy. The social and political weakness of a system that was fragmented and lacking in strong institutional mediators reinforced the need for an elected presidency.

Finally, another, more conjunctural factor led to the adoption of a semi-presidentialist model: the need to give political legitimacy to a military-led transition to democracy. The normalization of Portuguese society and of the armed forces and, more concretely, the military's retreat from political life and its disciplined return to the barracks demanded a strong authority, not just for strictly military but also for political reasons. Thus the commander in chief of the armed forces acquired a dual authority, becoming also the elected president of the republic. Given all these variables, the program of the Armed Forces Movement provided for the direct election of both the parliament and the president of the republic.[5]

It should be noted that before the Second Pact, or the second agreement between the parties and the Armed Forces Movement, of February 1976, other attempts had been made to solve this problem. The first openly presidentialist solution was proposed by then prime minister Palma Carlos to the Council of the State on July 8, 1974. The second proposal, a parliamentary one, was part of the program of the First Pact signed by the parties and the MFA in April 1975.

Some commentators thought the direct and universal election of the president of the republic represented a "sublimation of military influence over the development of the regime."[6] Others held it even to be an "implicit military clause," which created a situation whereby "the first elections for the head of state would make a military officer president" and "the officer elected president of the republic would be the chief of the armed forces."[7] This proved true, because General Eanes, the winner of the 1976 presidential election, was the commander in chief of the armed forces and also the victor in the coup of November 25, 1975. The reform was undoubtedly prompted by a desire to reinforce electorally the legitimacy of the commander in chief and to raise him to the rank of head of state.

Presidentialism therefore was introduced into the system of constitu-

tional government not because the members of the constituent assembly or their parties wanted it; it was the military that wanted it, and the parties that subscribed to the pact of 1976 tacitly complied. It became an expedient solution to reaffirm the Bonapartism of the constitutional transition.

The absence of majority governments, penalized by the electoral and governmental systems, and the concomitant existence of a presidential majority encouraged the increasing protagonism of the presidency. This protagonism has been characterized as Bonapartist because it was based on an electoral as well as a military legitimacy. The president was not only elected but was also the commander in chief of the armed forces who had emerged victorious in November 1975.[8]

The affirmation of the presidency was gradual, and it culminated in governments appointed by "presidential initiative." The naming of these "presidential governments" aimed toward the constitution of a "presidential majority" in the absence of a parliamentary majority. In practice, it meant that the system of government was dominated by a presidential, rather than a parliamentary, logic.

The replacement of Prime Minister Mário Soares in 1978 made it clear that the government, with its dual accountability, needed presidential backing as well as parliamentary support. The event paved the way for a discussion of the nature of that accountability, whether it was institutional or political, and whether the president's constitutionally guaranteed powers should be revised. It also led to a discussion of the power and intervention of the presidency; whether it was executive or merely representative, whether it played a moderating or a guiding role.

President General Eanes (1976–85) nominated "presidential governments" and frequently intervened in national politics. He turned the presidency into a second executive of sorts; he acted on the basis of a political understanding of the presidency's responsibilities, which led him to play a guiding role. Many in politics supported the alternative of an extension of presidential interventionism or the creation of a "Gaullist" presidency (emulating that of France's Charles de Gaulle). The establishment of a parliamentary majority through the creation of a presidential party elected to power through anticipated elections was another option favored by some. Others advocated supporting a constitution proposed by the president.

The protagonism of the presidency between 1976 and 1979 evolved from a "mitigated presidentialism" toward a "more active intervention-

ism."[9] At the beginning of 1980, presidential power was significantly reduced by the first Democratic Alliance governments, but it increased again after the presidential reelection of that year.

Meanwhile, the victory of the Democratic Alliance in the legislative elections of 1979 heralded the decisive and growing affirmation of the government, as compared with the presidency. After the elections of December 1979, the government was formed without presidential intervention. The president was informed but not consulted about its composition. For the first time, moreover, the military, normally close to the president, was not part of the government. A civilian was appointed to the Ministry of Defense.

A year later, after another victory in the legislative elections of October 5, 1980, Francisco Sá Carneiro did not run for the presidency. He reaffirmed that his legitimacy as head of the government was parliamentary and based on the vote, once again, of a majority. A growing "parliamentary" affirmation, in comparison with the "presidentialism" of General Eanes, gave rise to an opposition movement against Eanes. The day after the elections, Sá Carneiro launched the slogan for a new order, in preparation for the presidential elections in December of that year: "A Government, a Majority, a President." The Democratic Alliance presented its own presidential candidate against Eanes, and the latter was forced to seek the support necessary for reelection from the Socialist Party.

The Socialist Party exacted a high price for that support. It demanded that Eanes sign a new agreement, a pact that was as important as the previous armed forces–party pacts because it was also constituent, relevant in constitutional terms. The presidential election of December 1980 was therefore particularly important because it heralded constitutional reform.

With the agreement of November 1980, the Socialist Party committed itself to support Eanes for president and not to diminish the semipresidentialist nature of the system in subsequent constitutional reforms. General Eanes, on the other hand, was obliged to stand as a civilian. Once elected, he was forced to abandon his position as commander in chief of the armed forces, to abstain from presenting his own project for a constitutional revision, and to refrain from supporting a referendum as a way to overcome the constitutionally determined limits on constitutional revision. Eanes was also compelled to respect constitutional norms governing the nomi-

nation of governments and the admissibility of minority governments, and to respect the role of political parties under democracy.

With this pact, Eanes effectively renounced a good part of his military base of legitimacy. He accepted "civilianization" and the abandonment of his command of the armed forces. He also renounced a good part of his powers to intervene, because he did not present his own constitutional reform project. He gave up, furthermore, on a referendum, on his idea of the need for parliamentary majorities, and on the need to "take" governmental initiative.

Nevertheless, Eanes' victory and his reelection marked "the end of the 'parliamentarist' period" inaugurated on December 2, 1979."[10] It gave rise to continued presidential interventionism and a concomitant "institutional guerrilla war" between the president of the republic and the Council of the Revolution, on the one hand, and between the government and the parliament, on the other. That is because the political projects of Eanes and the Democratic Alliance were antagonistic. Eanes continued to intervene, working to prevent the bipolarization that the Democratic Alliance had introduced into the system and to foment a consensus for the formation of a Central Bloc uniting the Socialist and Social Democratic parties, between which Eanes hoped to position himself. Eanes also attempted to counteract the government in key areas, such as foreign policy and defense, the revision of the law on public and private enterprises, and the majority decisions to reform the constitution and to pass the Law of National Defense and the new Law on the Constitutional Tribunal.

The victory of Mário Soares in the Socialist Party permitted the establishment of a de facto majority for a constitutional revision, which, according to Rebelo de Sousa, culminated in "the relative reinforcement of the Legislature and in the decreased importance of the president of the republic."[11] Soares triumphed against the former secretariat of the party that had signed the agreement with Eanes.

The constitutional revision of 1982 significantly altered presidential prerogatives, both directly and indirectly. Directly, it limited the president's ability to dismiss the prime minister and the government, thereby reducing the government's accountability to the president of the republic. That accountability accordingly ceased to be political and became merely institutional. Indirectly, the revision reduced real and formal presidential

prerogatives with the suppression of the Council of the Revolution. As president of the council, Eanes lost much power as the council's role of determining constitutional legality and advising the presidency, and its jurisdiction over military legislation and nominations, were distributed among new bodies.

The National Defense Law of 1982 further reduced the powers of the president by withdrawing the president's right to nominate members of the Supreme National Defense Council. The new law stated that the military chiefs were to be nominated by the president of the republic, but only from a list proposed by the government in accordance with the constitution. Thus the armed forces became subordinate to civilian power. The Supreme National Defense Council was henceforth composed only of the ministers, the commanders in chief, and two deputies.

Many observers interpreted the reduction in presidential power as an authentic regime change. According to André Gonçalves Pereira, the regime ceased to be semipresidentialist and became a rational-parliamentary system.[12]

A presidential party became the means to ensure presidential intervention. It was a tactic that responded to the parliamentary nature of the system and to "the shift in constitutional powers." The Eanist party was created in response to a "systemic question" and, as noted by Joaquim Aguiar, to implement a "strategy for constitutional revision."[13] It sublimated military revolutionary interventionism in the party and political system. Unable to intervene in politics through the presidency and the council, the military sought new institutional, party-political mechanisms to prolong its revolutionary legitimacy. The entry of the "political military" into party-political life also contributed decisively to the demilitarization of politics and to the "depoliticization" of the armed forces; in other words, it aided in the subordination of the military to civilian power, a subordination that was legally enshrined by the Law of National Defense.

The presidential elections of 1985–86 also wrought important changes in the presidency. They definitively "civilianized" it, because they extinguished the last remnants of military legitimacy. Mário Soares became the first civilian president elected by direct, universal suffrage in Portuguese history. Indeed, he was elected in the wake of the most contested and polarizing presidential elections to date, and then only after a second

round and with a tiny margin over his opponent, who had won with a wide majority in the first round.

Faced with a divided country and a two-month-old minority government that had refused to resign with the inauguration of his presidential mandate, Soares decided to calm tensions by declaring, on the night of his victory, that the "presidential majority" that had brought him to power was extinct from that moment on. He did not dissolve the legislature, nor did he call for anticipated elections, as François Mitterrand had done in France; instead, he tacitly confirmed the government in power.

Soares rose to the presidency under a minority government that was threatened in parliament by the fighting between various factions struggling for leadership. This reinforced his role as arbiter of the system and contributed to greater links between the presidency, the government, and the parliament, the survival of the latter two depending on the former. Soares thus ruled at the top of the systemic pyramid because of his power to dissolve and dismiss governments and parliaments. The vetoing of parliamentary decrees was a rare occurrence, however. On very few occasions did the president refuse to promulgate texts emanating from the government.

With the fall of the government in the parliament and the concomitant crisis of 1987, the president had a chance to put all his powers of parliamentary, party, and governmental intervention to use. Soares dissolved the legislature and called for anticipated elections, thus contributing decisively to the formation of a new parliamentary majority and to the polarization of the party system. In doing so, however, he also contributed to the weakening of his own capacity to intervene. With the creation of a new majority, the parliamentarization of the system of government became increasingly accentuated, which led inevitably to the governmentalization of the political system. It must be said that this did not contradict Soares's own "parliamentary" conception of the semipresidential system.

Apart from being the first civilian elected to the presidency, Soares was also the first party leader to become head of state. Although his candidacy was not a party one, he was the first president with a clear party-political identity, whose electoral majority, moreover, did not coincide with the government's.

The achievement of an absolute majority in parliament in 1987 weak-

ened the role of the president. He came under increasing attack for his abstentionism.[14] His supporters called for a more active presidency.[15] Some believed that Soares's parsimonious behavior stemmed from his narrow victory in the elections of 1986. Soares admitted that "a president with a great national base of support can force governments of all stripes to look at him with the respect, care, and attention that the votes gained merit, because it is the vote which governs life in a democratic country." He made it clear that, had he won a greater electoral base of support, he might have behaved differently. This, indeed, is what he did during his second mandate.

Despite the accusations, it is clear that President Soares did exercise his right of veto, particularly when the interests of the armed forces, the church, or the trade unions were at stake. He sought, above all, to exercise what he called a "magistracy of influence," mediating between social and local interests on the one hand and decision-makers on the other. For Soares, the "magistracy of influence" meant acting as an arbitrator, a moderator, and a "power of last resort." In his view, the presidency was "particularly well placed to exert a profound influence over society and the state, calming tensions and divisions and generating the necessary national consensus."[16]

Soares sought to avoid what he considered the two contradictory and negative excesses of the system: a "merely symbolic" presidency or a "mere representation of the state" on the one hand, and an "executive" president who "intervened excessively" on the other. In his view, the role of the presidency was to "moderate the system" and to "guarantee constitutionality"; it was not to compete with the government, to which it owed an "institutional solidarity."[17] Soares confessed his opposition to "governments of presidential initiative." He felt that the presidency could be "perhaps more interventionist" in certain areas, such as foreign policy, but never "against the government but rather at its bidding."[18]

In reality, however, relations with the government were not entirely free of tension. Initiatives were proposed, both by the government and the presidency, that partly aimed to create trouble for one or the other. Nevertheless, Soares's first presidential term was characterized by a moderate interventionism and by a balanced coexistence.

This cohabitation, unlike the much tenser relationship between François Mitterrand and Jacques Chirac, can be explained by the difference in the Portuguese system, in which the president of the republic does not

have executive powers. Thus the jurisdictional boundaries between the various organs are clearer. Soares and his prime minister, Cavaco Silva, furthermore, did not harbor competing projects. Soares did not intend to return to the head of the government, and Cavaco Silva did not plan to dispute the presidency.

The "departyization" of Soares's mandate and the balanced and close relationship established with the government, along with the absence of competing candidates (the PSD decided to back Soares to ensure that the Socialist Party would not be alone in reaping the political dividends of a predictable victory), made Soares's reelection almost "fated."[19]

With his legitimacy reinforced by an overwhelming majority and now free of the need to conquer more votes from the Social Democratic Party for reelection, Soares's behavior in relation to the government changed, especially when the government won an absolute majority in Parliament in the summer of 1991. Although Soares had announced that this would not happen, that his interpretation of the constitution regarding the powers and functions of the presidency would remain the same, and although he had promised to act in solidarity with Parliament and the government whatever the outcome of legislative elections, the relationship with the government did undergo a shift.[20] Cohabitation became more conflictive and new heights of "institutional guerrilla warfare" were reached, reminiscent of the struggles during the first mandate of Ramalho Eanes.

The elections of 1995, however, paved the way for a new political cycle. The Socialist victory in the general elections made António Guterres prime minister; and in the presidential elections, Jorge Sampaio became president of the republic at the beginning of 1996, defeating Cavaco Silva. For the first time in modern Portuguese history, the government and the presidency were "controlled" by the same party, which, although a minority, had wide latitude for action.

The previous instances when the presidency and the government coincided were not a product of party-political confluences. Eanes and the governments of presidential initiative did not have their own party support. Only with the 1995 elections has the same party won the two institutions under a single-party banner, thus realizing Sá Carneiro's slogan from the beginning of the 1980s, "A Government, a Majority, a President."

Conclusions

The sweeping and general analysis of the Portuguese political system undertaken here reveals, in the first place, a historical tendency toward the "civilianization" of the presidency. This led to an inevitable weakening of the institution, with a decrease in its legitimacy (which became exclusively electoral) and with the reduction of its prerogatives and real areas of competence. This also led to a greater "partyization" of the presidency, especially as it ceased to be a military office.

It is relevant whether or not the presidential candidate emerges from a party. If not, the "vacuum" can favor the inclination to create a party base of support, disturbing the party system if the candidate is successful. This was the case with the reelection of Eanes and the subsequent formation of the Democratic Renovation Party. If the candidate does emerge from an existing party, this can affect the parties as well, although the nature of the impact will depend on whether victory or defeat ensues. Cases in point are the impact of the Movimento de Apoio a Soares Presidente (MASP) on the Socialist Party and the defeat of Freitas do Amaral on the relationship between the Social Democratic Party and the Social Democratic Center.

The preoccupation with winning additional support for reelection can wreak important changes on the political orientation of the president during a second mandate. Both Eanes and Soares received varying levels, as well as different types, of support during their first and second mandates. The shift in their base of support led to a shift in the behavior of both presidents. Secured or still-to-be-secured party support is therefore not irrelevant to the behavior of presidents.

The "partyization" of candidates can also have important effects on party organization itself, leading to what has already been called a process of "presidentialization." This manifests itself in the institutional adaptation of parties to presidential elections, and in the influence of elected presidents over the parties that support them.[21]

The second tendency this analysis reveals is the propensity toward a balancing of powers, with the prolongation of situations of cohabitation between the president and the government; in other words, the tendency to counteract the formation of majority governments by electing a president of alternative, if not opposing, political colors. The stabilization of cohabitation weakens the president's role, which normally increases when

there is no parliamentary majority. The president's powers, of which the most important are the exceptional powers to dismiss and dissolve government and Parliament, are diluted when cohabitation occurs during a parliamentary and governmental majority. The relevance of the presidency increases in situations of crisis and emergency; indeed, it is the prospect of an emergency situation that widens presidential powers. The dilution of presidential capacity to intervene therefore provokes changes in the political regime itself. Adriano Moreira notes, for example, that this happened after 1987, with a shift toward a "presidentialism of the prime minister."[22]

The way the president of the republic is selected becomes another relevant question in this context, because of the clear gap between the position's level of legitimacy and its scarce prerogatives. Now that the need electorally to legitimate the military leadership of the revolution has passed and the need to reinforce the democratic legitimacy of military power is over, one might wonder why a formula that generates such a flagrant contrast between the great latitude of authority and the weakness in the capacity to intervene should be maintained. Real as opposed to merely formal presidential powers, furthermore, depend more on the president's relation to the party system than on the institutional framework per se.

The powers of the president do not, in effect, depend exclusively or predominantly on the direct legitimacy of elections. Electoral legitimacy gives presidents acting in parliamentary governments not so much the capacity as the authority to influence political developments. Consequently, the power of the president has to be sought within the system and the dynamic of relations established therein.

The real powers of the president, be they to nominate or to dismiss the government, to dissolve the parliament or to veto legislation, effectively vary according to the relations between government and parliament. As Maurice Duverger has observed, such powers depend, first and most decisively, on the emergence of stable and cohesive majorities; and second, on the president's attitude toward those majorities and toward the minorities.[23]

Over the past twenty years, the Portuguese political system has been marked by what can be called a process of progressive "rationalization." An initially revolutionary source of legitimacy was progressively replaced by an electoral one. Today, elections are the only effective source of political legitimacy. The dilution of revolutionary legitimacy implies a loss of

efficacy in the mechanisms intended to exorcise the remnants of the previous regime and the mechanisms that symbolically commemorated the democratic regime. At the same time, an exclusively electoral legitimacy depends increasingly on a pragmatic rather than an ideological assessment of the efficacy of government policies. The practical rationality of the political process thus seems most directly to condition sources of political legitimacy.

This rationalization, however, has also occurred at the level of electoral behavior, with repercussions for the party system. Faced with an electoral system that is not highly conducive to government stability, the electorate has taken it on itself to correct this condition by voting for two consecutive "absolute majorities" and by favoring an increasing party-system polarization, which, although it facilitates alternation in power, does not prevent the extreme left and right from gaining votes and seats.

Finally, rationalization has occurred in the system of government. It has been expressed first in the mitigation of a fragmented parliamentarism through presidential intervention. The instability provoked by that interventionism has been reduced through the reinforcement of the government's political direction to the detriment of the president's intervening capacity.

This rationalizing tendency within the political system is not, however, matched in legal or juridical terms. Hence the urgent need to reform the electoral law, as well as the need to reform parliament, and even to introduce some changes to the constitutional system of relations between the organs of sovereignty. The beginning of a new political cycle will bring these issues to the center of the institutional debate in the coming years.

The Armed Forces and Democracy

MARIA CARRILHO

The military intervention of April 25, 1974, was led by a military move-ment, the Armed Forces Movement (*Movimento das Forças Armadas*, or MFA).[1] It marked the beginning of an international cycle of democratiza-tion that Samuel Huntington has called the "third wave" and that spread from southern Europe to Latin America and, later, to Eastern Europe.[2] The Portuguese transition is unique because the authoritarian regime was overthrown by the military, who paved the way for political and social liberation. The leading role played by the military, together with the weak-ness of the political parties, led to the former's involvement in the political sphere and turned the period of democratic consolidation into an intensely disputed process.

Military Protagonism and Institutional Change

To understand better the armed forces' role in the process of democra-tization, that process can be divided into three main periods. The first, the revolutionary transition period between 1974 and 1976, was characterized by military participation and intervention in politics. It was accompanied by significant institutional turbulence in the armed forces. The second, from November 25, 1975, until the constitutional revision of 1982, con-sisted, on the one hand, of the consolidation of democracy, in which the political parties played a leading role under the tutelage of the Revolution-ary Council; and on the other hand, of the institutional normalization of the armed forces. The third period, from the promulgation of the Armed

Forces and Defense Law in December 1982 to the present, was character-
ized by the subordination of the armed forces to civil-political control.

The Revolutionary Transition

For the military, the revolutionary transitional period led to the dis-
mantling of the organizational framework that had presided over the colo-
nial war effort. It also led to questioning the old, seemingly eternal values
that had sustained hierarchy and discipline.

Despite the support of a large core of officers, the MFA did not perme-
ate the whole of the armed forces. From the beginning of the revolution-
ary period, certain sectors of the officer corps did not support it. Indeed,
in the first days following the military coup, these sectors became the tar-
gets of purges, or *saneamentos*, in the form of forced early retirement. A
number of officers at the command levels of the various branches were re-
placed, and the generals and officers most closely associated with the old
regime were removed.

During the summer of 1974, the Continental Operational Command
(*Comando Operacional do Continente*, or COPCON), led by Brigadier Gen-
eral Otelo Saraiva de Carvalho, and the so-called Fifth Division appeared
on the political scene, armed with a strategy to strengthen the mechanisms
of military control over the political situation. The COPCON was given
an important role in maintaining public order, and the Fifth Division was
charged with psychological action and public relations, as well as "cultural
dynamization" activities and "civic action" campaigns. Both these organi-
zations had prominent, albeit controversial, roles during the revolutionary
period. Indeed, both embodied organizational conceptions and views on
the role of the armed forces that contradicted the prevailing trends in other
democratic European countries at the time.

Other important measures adopted before the end of 1974 included the
abolition of the General Staff Corps and the lowering by four years of the
retirement age for passage into the reserves. This reduced the number of
commanding officers and permitted the "rejuvenation" of the officer corps.

The removal of General Spínola after the military crisis of Septem-
ber 28, 1974, heralded a leftward shift in the military. The MFA proceeded
with institutionalization. The Delegates' Assembly of the MFA (AMFA)
was central to this process. Convened for the first time in December 1974,

it became a forum for military, economic, and political issues. Only after Spínola's failed coup attempt of March 11, 1975, which gave rise to the "hottest" period of the transition process, did the formal institutionalization of the MFA take place. The key issue then became the constitution of the Revolutionary Council.

This was also the period in which, according to the MFA's previous timetable, elections to the Constituent Assembly were supposed to be held. These were to be the first elections to take place in almost half a century, and no statistical data were available to forecast the results. The potential results therefore worried everybody. Each of the political parties feared that it would not be favored at the polls, while the MFA feared that a strong vote for the parties of the Right would reverse the process of disengagement from Africa.

To limit the uncertainties, the Constitutional Platform Agreement, better known as the MFA-Parties Pact, was signed by all the most important parties and by representatives of the MFA in April 1975. Elections were held on April 25, leading to the victory of the Socialist Party. The Communists had an unpleasant surprise: the polls demonstrated far weaker support than they had supposed. The revolutionary trend continued nevertheless, shaping the formation of the provisional governments.

The idea that democracy should penetrate the organizational structures of the armed forces themselves also gathered steam during this period. Commissions of soldiers and sergeants were formed. An Army Dynamization Office, along with Regional Dynamization Offices and Unit Delegate Assemblies, was created. This trend created a parallel hierarchy of sorts, which, as stated in the MFA bulletin, proclaimed a "new conception of discipline and of the exercise of command."[3] Although they arose from professional complaints that were clearly justifiable, the soldiers' and sergeants' movements quickly became enmeshed in the activities of political groups and parties.

The agitation in the military at the beginning of the summer of 1975 increased with the publication of the *Guia-Povo-MFA*, or MFA People's Guide.[4] With it, the movement distanced itself from many of the ideas put forth by other political-military sectors. The document called for the "progressive takeover of power by the people's organs," such as the mixed civilian-military local assemblies.

That summer, it became obvious that different allegiances existed

among the officers in the MFA. A group of nine MFA officers published what came to be known as the "Document of the Nine." It warned against the risks of radicalization and called for a political and military redefinition conducive to "normalization." Agitation peaked with the emergence of the SUV (*Soldados Unidos Vencerão*, or United Soldiers Shall Win) and with the declaration of an important military unit in Lisbon, the *Regimento de Artilharia de Lisboa*, better known as RALIS, which swore allegiance to the revolutionary flag.

On November 12, 1975, a street demonstration culminated with a crowd surrounding and besieging the Constituent Assembly. The armed forces were apparently unable to guarantee the safety of the deputies. A complex maneuver ensued, involving the parachute troops. The result of the military action in the streets was the victory of the moderates, under the command of General Ramalho Eanes, in the assembly, and the defeat and removal of the radical officers. The officers of the Revolutionary Council itself later played a key role in the reorientation of the armed forces according to Western standards.

Guided Consolidation

After November 12, 1975, it became apparent that the military would return to its traditional configuration, and that military intervention in the political arena would gradually dissipate. Indeed, this was the aim of Law 17/75, published in December 1975. With it the MFA ceased to be "a persistent movement in the political-military arena," becoming instead a merely "inspiring" force. For the first time, the principle of subordination to civilian political power was explicitly stated, as was the aim of depoliticizing the armed forces.

In early 1976, the Second MFA-Parties Pact was negotiated, confirming the increasing strength of the parties. It also recognized the military's role as guardian of the democratization process, but it limited the powers of the Revolutionary Council.

When the constitution came into force in April 1976 and the protagonism of the parties in the process of democratic consolidation was confirmed, the military authorities placed the armed forces under a regime similar to that found in other NATO countries. The creation of the first Independent Mixed Brigade in Santa Margarida was very important in

this context. This brigade became a large unit with up-to-date equipment, which operationally linked the Portuguese army to NATO.

Meanwhile, the relative autonomy of the armed forces permitted speedier decision-making on matters of military reorganization necessary for adapting to the postcolonial epoch. In April 1977, the new Codes of Military Justice were published, together with the new Military Discipline Regulations. In May, the army's territorial organization was changed, which reduced the number of units in the other branches. The army's officer promotion system was also reformed.

To ease the tensions that lingered from previous conflicts among the officers, a law promulgated in November 1979 granted amnesty for criminal and disciplinary infractions of a political nature, especially those linked to the events of March 11 and November 25, 1975.

During the last two years of its life, the Revolutionary Council proceeded with the study and approval of a great deal of legislation on the reorganization of the armed forces. Among other arrangements, the General Regulation for Army Service (II) of July 1980 deserves special mention. It established general command principles and revealed a significant degree of reflection and modernization. With it, discipline and subordination to the hierarchy were seen not as an end per se but as an indispensable condition for command and cohesion.

The constitutional revision of 1982 put an end to military participation in politics. It heralded the Revolutionary Council's exit from the scene. The officers who had constituted the council were given no further duties, and their withdrawal from military service was eased two years later with early passage to the reserves.

Civilian Control Confirmed

The political system and the Portuguese armed forces thus came to resemble those of other European democracies. The new constitution provided a general framework governing the armed forces and defense matters, both of which were soon the objects of specific legislation with the passage of the National Defense and Armed Forces Law. Although the law was approved by a majority in the legislature, it was vetoed by the president of the republic, General Eanes, because it appeared to make the Ministry of Defense a true ministry of the armed forces. Ultimately, however, a

majority again approved the law in December 1982. The struggle over passage of the Defense Law reflected continuing competition among military and party elites, which peaked as each sought to forge the future course of the nation's political class.

From then on, the Defense Law constituted the key legal point of reference regarding the military. A critical element of the law was the redefinition of the concept of national defense. The law put an end to the broader defense concept expressed in previous legislation. It clearly rejected the notion of an "internal enemy" typical of Latin American security doctrines. With the new law, the president of the republic, the government, the Superior National Defense Council, and the Superior Military Council became responsible for national defense. The armed forces essentially became an integral part of the Defense Ministry, and the selection of military chiefs of staff from a list proposed by each branch fell to the government.

The functions of the newly created Superior National Defense Council consisted mainly of "institutional repair work" involving the presidency, the government, and the military chiefs of staff. It played an advisory role in "matters relating to national defense, as well as the organization, functioning, and discipline of the armed forces."[5] The president of the republic presided over the council, and its members included the prime minister and the deputy prime minister, the ministers of defense and foreign affairs, the head of the chiefs of staff, and the ministers responsible for internal security, finance, planning, industry, energy, transportation, and communications, as well as the chiefs of staff of the navy, army, and air force. The so-called Superior Military Council was an additional, specifically military advisory body that worked alongside the Ministry of Defense. It was presided over by the defense minister and composed of all the military chiefs of staff.

The Defense Law laid solid groundwork for a profound reorganization of the armed forces, although this process did not unfold either quickly or all at once. The law also provided for a more precise definition of civil-military relations specific to Portuguese democracy.

Of the legislation subsequently passed, the Information Systems Law of the Republic, the previous Military Information Service Law, the military programming laws, and those regulating states of siege deserve special mention. The declaration of a state of siege is the responsibility of the president of the republic and is contingent on a government hearing and

authorization by the parliament. Institutionally, civilian-political domination was strengthened in the realm of civil-military relations. More specifically, judicial limitations were imposed to reduce the jurisdiction of the military tribunals in accordance with constitutional principles.

The Armed Forces and Democracy at the Turn of the Century

The military as an institution and a force is supposedly tailored to meet the defense needs of a nation in an international context. In Portugal, the general framework governing the armed forces is defined by the strategic concept of national defense. Among its objectives, the following are worthy of note: the strengthening of Portugal's position in the international community; participation in NATO, "with special attention to the preservation of transatlantic links"; participation in the consolidation of European integration and in European security and defense; and the improvement of relations with other Portuguese-speaking states.[6]

In line with the above principles, an institutional redefinition has occurred in the armed forces over the last few years. It is a process linked to changes in civil-military relations. It has also given greater weight to public opinion on defense and security issues through periodic opinion polls.

Civil-Military Relations

A significant aspect of the redefinition relates to the actual "construction" of the Ministry of Defense. When World War II came to an end, António Salazar created a ministry of defense, which operated under his authority; but actually it neither was a formal ministry nor possessed any staff. In the aftermath of the events of April 25, 1974, the officers in revolt against the authoritarian regime's excessive control over military matters attempted to ensure that the armed forces retain autonomy in relation to the government. A new ministry of defense was established that was not free from the military dictates; until 1980, defense ministers were selected only from the ranks of the military.

The Defense Law of 1982 gave the Defense Ministry a legal framework in which to develop, although with the political instability between 1982 and 1985, its development was slow. Indeed, legislation dating back to 1982 became law only as recently as 1993. Perhaps this is because the pres-

tige and status of the military suffered a devaluation once its subordination had been achieved in 1982. Those who held power in the civilian government, on the other hand, may have believed that caution was necessary to gain time and strength before passing measures that would be unpopular among some sectors of the military.

Among these measures was a reduction in the number of military personnel in active service. In the aftermath of the colonial war and decolonization, there was obviously an initial, sharp decline in active service personnel. While most of the conscripts and noncommissioned officers were sent home, however, the professional officer corps remained almost numerically intact until the early 1980s. But between 1985 and 1993 the officer corps shrank by almost 30 percent. Downsizing affected the army in particular, leading to a loss of influence in comparison with the navy. This resulted from two territorial concerns. One was the renewed attention given to the "strategic triangle" of continental Portugal, the Azores, and Madeira. The other was the increasing importance of Portugal's maritime resources following the international agreement that defined the nation's large Economic Exclusion Zone (EEZ).

Clearly, from the perspective of civil-military relations, this reorganization and concomitant reduction can be considered an affirmation of the power of civilian political authorities. When considering the relative weight of the military institution in the structure of the state, furthermore, it is important to examine defense budget figures. Predictably, in the period immediately following the end of the colonial war, a drastic reduction in military spending occurred. It declined from 31.7 percent of the national budget and 6.9 percent of the gross national product in 1974 to 12.4 percent of the budget and 3.7 percent of the GNP in 1976. Thereafter, military spending continued to decrease gradually until 1985, when defense expenditures leveled off at 2.4 percent of the GNP, a percentage similar to that of other NATO countries, such as Belgium, Norway, and the Netherlands.

Examining the 1992 distribution of defense expenditures in other NATO countries, however, it is possible to conclude that Portugal is the country that spends most on personnel (79 percent) and least on equipment (6.4 percent) and military operations. At the other extreme lies the United States, where, in the same period, personnel expenditures absorbed only 37 percent of the military budget and equipment accounted for 22.1 percent. (The figure for 1991 was 27.3 percent.)

Thus it is possible to say that the reduction in military spending was related to the relatively lower priority accorded the military institution by the Portuguese state. Budgetary allocations reflected the heightened importance of personnel and were, perhaps, a legacy from the period of the colonial war, as well as a consequence of the economic difficulties facing a country struggling to reach the same pace of development of the other countries of the European Union.

Women in the Ranks

The most significant new recent personnel policy has been the admission of women to the military academies and the enlisted ranks. It should be noted that the first women to be admitted to the Portuguese armed forces served as paratroop nurses in Africa during the colonial war. This precedent, however, was not repeated after the war.

It was only in 1986 that "the issue of women in the armed forces" really emerged. After debating the question of military service in general, Parliament pronounced itself in favor of the draft and simultaneously dispensed women from military service obligations. The absence of clear and specific legislation on the matter, however, was overcome by the process of women's social emancipation, as well as the military's own needs. Young women began to press for admittance to military academies and to compete for specialized officer-level posts, such as medical doctors, thereby militating against the exclusion of women, with the support of constitutional principles against discrimination on the basis of religion, race, or sex.

In 1988, the armed forces' pilot course was the first to change, accepting two young women students. From then on, the number of women in the forces grew, spreading to other branches and areas of specialization. An interesting aspect of this process is that women gained access to the most prominent and valued positions. In 1991, legislation was finally passed admitting female volunteers to military service. By the end of that year, 56 recruits out of 239 candidates were admitted to the air force as military service volunteers. In March 1992, the army admitted 34 women to its ranks for the first time. In December of the same year, the navy recruited a group of 80 women. By the beginning of 1994, more than a thousand women were serving in the Portuguese armed forces.

Comparing the number of male and female volunteers, it is clear that they all come from similar geographical backgrounds; the Lisbon district

predominates, representing more than one-third of the total. The women's educational levels are somewhat higher than the men's.

A 1991 poll showed that the large majority of Portuguese citizens (76.7 percent) were in favor of female volunteers. It is still too early to evaluate the impact that the admission of women has had on the armed forces; it has, nonetheless, clearly opened a larger field for military recruitment, as well as an additional career path for young women. Problems that have emerged in other countries, such as unequal promotion policies or sexual harassment, have not, thus far, been reported by female members of the military in Portugal.

Public Opinion on Defense and Security Issues

Access to information on the military has been difficult to obtain for decades. During the Salazar regime, the social and political sciences did not even exist. During the transition and consolidation periods, the issue of the armed forces was passionately debated but was generally considered too hot a topic by academic researchers and the political authorities. Similar worries prevented public opinion consultation on military issues. In 1991, however, the Institute of National Defense of the Ministry of Defense began to promote research on these issues. The following are some of the issues most frequently discussed in these polls.

Tasks of the armed forces in peacetime. All polls undertaken between 1991 and 1994 showed that peoples' main concern regarding defense and security matters was related to the new vulnerabilities arising from the nature of modern societies. Ecological disasters caused more worry than the risk of war, except on the occasion of the Gulf War in 1991.

A significant finding was that the Portuguese easily accepted the involvement of the armed forces in different tasks, some of which have little to do with the institution's real capacities. Of the proposed jobs for the armed forces in times of peace, the one most supported was cooperation in forest fire prevention activities (91 percent). A close second, with 83 percent support, was helping to police the streets, followed by offshore patrolling activities to protect fishermen (80.5 percent), and finally the construction of schools and roads. To date, however, the tasks have all been ones the armed forces could carry out. It is rather surprising that military assistance to the aged was supported by a greater number of re-

spondents (48 percent) than the 43 percent who believed that such a task should not be a job for the armed forces in peacetime. Cross-tabulations revealed that the categories of people who felt most vulnerable were the most likely to agree with this kind of idea; namely, the lesser educated, the aged, and housewives.

Military recruitment. Of all the questions posed in the polls, the one over which opinion was most divided was the system of recruitment. A slight majority more recently believed that military service ought to be voluntary. Considering the data from the 1991 and 1992 polls, furthermore, the tendency was toward increasing support for a voluntary system. This trend becomes even more significant considering that it was inversely correlated with the number of people supporting conscription. Indeed, the figures indicated both an increase in those favoring a voluntary system (47.9 percent in 1991, 51.9 percent in 1992, 52.3 percent in 1993) and a decrease in opinion favorable to compulsory military service (46.4 percent in 1991, 45.8 percent in 1992, 42.7 percent in 1993).

The main opinion cleavages were generational and educational. Far and away the most favorable toward voluntary service (77 percent) were the better educated. Of the 18-to-24-year-old group, 72 percent of either sex pronounced themselves in favor of an all-volunteer service; in the 25-to-34-year-old group, a clear alignment in favor of a voluntary service (61 percent) was apparent. On the other hand, support for conscription predominated among the most elderly (56 percent in the 55-to-64 age group) and among those with lower levels of education (65 percent).

Worthy causes. The defense of democracy and liberty was highly valued in the opinion of the majority (58 percent), followed by the defense of continental Portugal (45 percent). Relatively less important was the defense of the Azores and Madeira; barely 23 percent of those canvassed on the continent thought that the defense of either of the two autonomous regions was worth risking one's life. The youngest group, between the ages of 18 and 24, tended to think even less of defending the Azores (17 percent) or Madeira (16 percent) but placed greater-than-average emphasis on the defense of continental Portugal (47 percent).

The geographic distribution of opinion on this issue deserves particular attention. Generally speaking, the Azoreans seemed to attribute greater importance to the defense of every last bit of national territory. Support for the defense of the Azores islands themselves was apparent, with 68.3

percent of respondents from that region in favor of it. The numbers sup-
porting the defense of continental Portugal, however, also were greater
than those registered on the continent itself (61.4 percent), and the same
was true for the defense of Madeira (53.5 percent).

Unlike the Azoreans, however, in Madeira the Portuguese were much
less receptive to the possibility of an "extreme" defense of the national ter-
ritory, be it the autonomous regions or the continent (favored respectively
by 40 percent and 43 percent). The Azores appeared even less worthy of
personal sacrifice in case of invasion: only 33 percent of the respondents
in Madeira supported the idea of defending them. As for the defense of
liberty and democracy, the idea was accepted only with difficulty in the
Azores (38.6 percent) and in Madeira (31 percent).

Military alliances and United Nations missions. In general, the Portu-
guese seemed to think that in case of war the country could not defend
itself alone.[7] They were therefore relatively open to international alliances
for military defense purposes. NATO was still considered necessary by
a majority of respondents (57.5 percent), although the numbers declined
somewhat in later years. The idea that the countries of the European Com-
munity ought to create a common military force, however, was even more
popular (73.5 percent). On the other hand, the data also showed that a ma-
jority of respondents considered the two options not as mutually exclusive
but as complementary.

Young people most readily supported Portugal's participation in inter-
national alliances. Cross-tabulation showed that this was particularly true
for those who had been to college and for those belonging to the upper-
middle and upper classes. The population of the Azores and Madeira also
favored international alliances. NATO was supported by 51 percent of re-
spondents from Madeira and 64.4 percent from the Azores. The formation
of a common European defense force received particularly high support in
the two autonomous regions: 80.2 percent in the Azores and 75 percent in
Madeira.

The 1991 and 1992 polls showed a relatively ready acceptance of partici-
pation in international missions. In the 1992 poll, the missions deserving
the support of the great majority of citizens were peace missions carried
out under the auspices of the United Nations. Similar missions under
NATO were not looked on nearly as favorably. The reason for this may
be that the U.N. was clearly linked to the idea of peace (or peacekeeping),

while NATO was identified more with military defense. Also notable was the alignment of Portuguese public opinion with the objectives of international missions. Almost 55 percent agreed that the Portuguese armed forces, operating under the auspices of the United Nations, "ought to participate in the pacification of Yugoslavia"; 85.3 percent believed that they "ought to participate in support of Portuguese citizens in Angola"; and 87.3 percent thought that they "ought to offer support to the people of East Timor." It should be noted that "military support" was not mentioned, under the assumption that such missions always take place under the control of the United Nations.

The evolution of the data from 1991 to 1993 revealed a number of trends. Opinions favorable to Portuguese participation in the pacification of Yugoslavia increased, from 37.9 percent in 1991 to 43.9 percent in 1992 and 54.8 percent in 1993. There was what might be called generalized support for participation in situations in which Portuguese citizens were at risk (Zaire in 1991, Angola in 1993). The situation of the people of Timor continued to "bother" the Portuguese, who approved of Portugal's participation in any international "support" initiative. Cross-tabulations revealed that the young agreed most with Portugal's participation in U.N. missions, and that opinion in the islands matched that on the continent.

Possible explanations for the evolution of opinion on matters pertaining to international relations and defense suggest the influence of certain amply documented events, among them the devastating and prolonged interethnic war in former Yugoslavia. Portuguese citizens' vague awareness of a country about which they had heard little and which belonged to "another world" has been replaced by the conscious recognition that what is happening is taking place in Europe and is much closer than previously thought. On the other hand, the weakness of the European Community as an effective power wielder on an international political level has been laid bare. Furthermore, despite the hopes pinned on NATO in a context of international uncertainty, the organization has revealed its inability to come up with satisfactory solutions. The importance of a concerted defense on a common European scale thus emerges as desirable.

The importance of European cohesion can also explain the increase relative to 1992 (10 percent) of opinions favorable to common defense-related decision-making (involving the national government and the European Community). This is particularly so in the wake of the drop in confidence

in the capabilities of Europe registered between 1991 and 1992 (less than 40 percent). Debates on the Treaty of Maastricht (1992) and the result of the Danish referendum, as well as the ongoing debate on the possibility of a similar referendum in Portugal, explain this shift in public opinion.

As for opinions on defense issues, a majority of Portuguese have supported the idea that the armed forces could take public service tasks in peacetime. The legitimacy of the armed forces has been confirmed, as has the perception that a number of institutional gaps have existed, affecting certain collective and personal vulnerabilities. The cause most worthy of extreme sacrifice appears to be liberty and democracy, followed by the defense of continental Portugal. This may indicate a broad notion of defense, based more on political than on territorial considerations, with liberty and democracy a priority.

The Portuguese perceive that the country needs military alliances to defend itself. A majority supports strengthening European Union military defense, as well as NATO's continued existence; and these are not seen as incompatible. Finally, the participation of professional Portuguese soldiers in missions undertaken under the auspices of the U.N. is positively accepted.

Conclusions

Portugal is an interesting case of armed forces participation in a transition to and consolidation of democracy. The armed forces led the liberation movement of April 25, 1974, and promoted the end of the war in Africa. This might lead to the assumption that the normalization of civil-military relations and the subordination of the military institution might have been easy in Portugal.

Military activity, however, along with weak parties (the Communist Party was strong, but its role far outweighed its actual electoral support), led to military involvement in the nation's political life during the revolutionary transition period. The armed forces were at the center of the struggle to define the new regime and to create a new political class. The military tended to emphasize social justice over pluralism; this should come as no surprise, given the military's centralized and hierarchical organization. This tendency caused friction with the majority parties, however, as they played their dominant role in the consolidation of democracy. Con-

solidation in Portugal was characterized by a military and political party agreement brokered to guarantee democracy under the broad tutelage of the Revolutionary Council.

Greater autonomy in relation to civilian political power, another result of the April revolution, enabled the armed forces to progress with decolonization and to withdraw from Africa. After 1975, this allowed for a speedy military reorganization. For the consolidation of democracy, however, it was a double-edged sword: it guaranteed a certain distance from party interests, but it also made military subordination to democratically elected civilian political elites far more difficult.

The 1982 constitutional revision and the dissolution of the Revolutionary Council were concluded peacefully and consensually, nevertheless. The National Defense and Armed Forces Law of 1982 caused some controversy in the military but affirmed civilian dominance of military policy matters. Subsequent legislation brought the Portuguese armed forces closer to conformity with other Western countries.

As in other democratic countries, the development of a ministry of defense that integrated the armed forces and was governed by civilians closed the cycle of military-political influence. Meanwhile, military service was expanded to include women, who are found today in the ranks as well as in the army, navy, and air force academies.

Public opinion on the armed forces in Portugal is essentially similar to that in other EU countries. Key democratic social and political issues, however, are not yet resolved. Thus, the issue of obligatory military service and the representation of professional military interests are still pending matters.

Society and Values

JOÃO FERREIRA DE ALMEIDA

Social values are structured systems of preferences. Attitudes toward work, leisure, religion, politics, the family, or any other relevant aspect of life distinguish social groups from one another. It is possible to identify the values that are particular to a group through an understanding of what the members of that group do or say. What is true for small groups of people, furthermore, can be true for larger units. In other words, it is also possible to identify values that are specific to wider or more heterogeneous social units, such as countries or nations.

For the individual, values work as systems that establish individually internalized preferences. Preferences result from life experiences and condense these experiences. They entail a selection, perhaps unconscious or implicit, of the references and justifications for behavior. On a collective level, values are essentially an integral part of symbolic-cultural social life; they constitute a vast collection of resources, which create alternatives but which retain their instrumental nature with regard to action.

On both levels, the nature of existence shapes the formation and development of values. It is necessary to carry out an empirical analysis on a case-by-case basis to establish how existential conditions shape the value mechanisms, as well as the degree of freedom and choice, in the development of values. Systems of preferences undoubtedly have social roots that partly explain them, whether they relate to an individual, a group, or a society.

The aim of this chapter is not to establish systemic or explanatory relationships between the nature of Portuguese society as a whole and the

values that prevail within it. Nor is it to attempt an impossible registry of the structured preferences of the Portuguese. More modestly and realistically, this chapter will examine a few examples of what appear to be strong values cutting across a variety of cleavages in contemporary Portuguese society. To begin with, it is worth recalling a number of recent social indicators that, *grosso modo*, have shaped Portuguese society.

The Aging of the Population and Changes in Spatial Distribution

In the 1980s, population growth in Portugal stagnated. Some positive natural growth took place, but it was on the order of less than 4 percent and almost entirely compensated for by increased levels of emigration. Indeed, the great emigration to France and Germany of the 1960s and the immigration in the 1970s were followed by a period of negative growth. Such negative growth has been a structural feature of Portuguese society for some time, although it has become less pronounced in the 1990s than has historically been the case.

The aging of the population, however, is perhaps one of the most salient features of overall demographic change. Between 1981 and 1991, the number of people over the age of 65 increased by two percentage points. By 1991, this group represented 13.5 percent of the total population, close to the European Community average. The Alentejo and the northern and central regions of the interior have been most affected by this trend. On the other hand, over the last ten years, the number of young people has declined by 5 percent. To date, people under 15 years of age represent less than 21 percent of the total population, compared with 18 percent for the rest of the European Community.

The decline in the number of young people, however, has not, so far, affected the economically active population or the number of economically dependent people. Although the number of old people has increased relative to the number of the economically active, the decline in the number of people under 15 has amply compensated for that increase.

What of regional population trends? The only large region that has experienced significant growth is the Algarve. The north, as well as Lisbon and the Tejo Valley area, have almost stabilized. The subregions that have experienced the greatest growth are the Setubal Peninsula, the Cavado, the

Ave, and the Entre Douro and Vouga regions. Variations in population growth, a result of the processes of natural growth and net migration, confirm the pronounced tendency for people to move to the coastal regions, where approximately three-quarters of the population has settled. The interior of the country, bled dry by the migratory hemorrhage of the 1960s, has been, with few exceptions, unable to recover from the cummulative push-pull effect responsible for previous migratory flows.

Apart from the tendency to settle in the coastal regions, urbanization has also occurred, although Portugal is still far behind Europe, where approximately 70 percent of the total population is urban. Over the last decade, Portugal's urban population increased by 9 percent.[1] The urban population now represents almost half of the total. The number of people living in cities with more than ten thousand inhabitants and those in cities of more than fifty thousand have both increased. Dispersed population centers, on the other hand, have decreased in size. Part of the movement away from these centers has benefited nearby cities, even in the interior. In 1991, however, dispersed settlements still represented one-third of the total population.

The stabilization of the population as a whole, the fall in birth and fertility rates, the "double" aging process, migration trends, and the tendency to settle in coastal and urban regions are at once effects, symptoms, and factors shaping a wide variety of social changes. That these demographic trends are products of various other social factors can be illustrated by migratory movements. On the one hand, these stem directly from a push-pull dynamic, a set of conditions that shape life at the point of departure and arrival. On the other hand, they are a product of the differing plans, assessments, and values migrants develop in response to those conditions.

The decline in fertility rates is linked to a variety of changes that affect social structures, including those that shape ethics and dominant values. The recomposition of the Portuguese population is one such factor, as is the rapid decline in agricultural employment. In the agricultural sector, the cost of educating children has risen while the short-term value of education for production has declined, and so has its medium-term value as a means to safeguard the livelihood of aged and economically dependent parents.

The combination of these trends has gradually permitted agricultural workers or peasants to adopt urban values, such as birth control and family

planning, and the education and social promotion of a smaller number of children. The gradual transformation of their livelihood, together with their declining weight in the total population, therefore constitutes a partial explanation of the decline in fertility rates in Portugal. Again, these variables are effects, on the one hand, and symptoms and factors, on the other. They are indicators of social change, but are also elements contributing to that change.

Aging that stems from declining fertility rates, or "bottom-up aging," appears to indicate that the southern European countries as a whole, and Portugal in particular, are losing their capacity to promote generational renewal. Fertility rates in southern Europe are already only about 1.5 children per woman. Political measures designed to encourage higher birth rates, such as those adopted in Norway, may counteract this trend.

Top-down aging, on the other hand, also has repercussions for various aspects of social life, such as the length of intergenerational family life.[2] It also affects patterns of consumption, leisure activities, job opportunities, community organization, and voluntary work, insofar as communities contain more people who are not economically active. It has an impact, too, on the embryonic welfare state, through increased pressure on material resources and on the social security system. Finally, it can lead potentially to intergenerational conflicts over values and, above all, over the appropriation of scarce resources.

The Restructuring of Society

It is worth briefly mentioning aspects of what can be called the restructuring of society in Portugal, given that changes in values both originate in and derive from this process. First, the economically active population has been increasing since the 1960s. This increase results from the very pronounced growth in the registered activity of women. In 1960, 13 percent of women were economically active. In 1970 the figure had risen to 19 percent, by 1981 it stood at 29 percent, and in 1991 at 41 percent.

Second, the evolution of the active population by sectors confirms a process of economic tertiarization. In 1960, a mere 28 percent of the economically active population worked in the tertiary sector. By 1992, the percentage had increased to 55 percent of the active population.

The importance of the primary sector, on the other hand, diminished

from 44 percent to 12 percent between 1960 and 1992. Between 1979 and 1989, the one million or so individuals in domestic units dedicated to agricultural production ceased to exist as such. Since 1985, more than thirty thousand people have abandoned this sector, which is based overwhelmingly on family and microenterprises. The population active therein is, moreover, very aged and lacking in educational capital. This sector is also affected by other indicators of economic decline and a lack of intergenerational renewal. The agricultural exodus is therefore even faster than the rural exodus. Simple abandonment has been the key remedy for the lack of economic viability in agricultural activities. Taking on various jobs or searching for other sources of income have been other choices. The seasonal migration of family members or emmigration to other European countries has also been notable.

In the industrial sector, there has also been a tendency toward decline, albeit of a more limited nature. Over the last ten years, this sector's relative importance has declined from 39 percent to 33 percent. The industrial sector is the only one in which participation according to sex is still very uneven and male workers predominate.

The educational system also has had a role in societal restructuring. The 1980s saw a decline in the number of active students in the countries of the European Community, a consequence of declining birth rates. A recent trend, moreover, is to prolong studies, with young people staying in the system for longer periods of time. Educational levels in Portugal were very low at the beginning of the 1960s. It is therefore not surprising that the number of students has doubled every decade since then, at both the secondary and the university and other higher education levels.

In 1991, 65 percent of the Portuguese people had a basic level of education. Of these, 22 percent had been through secondary school and 8 percent through higher education institutions. Still, more than 20 percent of the population was illiterate. It is also important to note that more education does not mean better education. Thus, high dropout and illiteracy rates, along with the notorious lack of standards in experimental education, are causes of worry.

Despite the social effects and weaknesses of the system, however, the numbers are positive. Whereas in 1960 the number of students at the university level stood at 24,000, by 1989 it had risen to 130,000. In 1992, the portion of the population above the age of 20 who had completed

university studies reached 5.6 percent. In 1981, the figure was only 2.5 percent. Above all, it is significant that the desire to have an education and to acquire higher qualifications is now widespread. A few years ago, this was true only in the large urban centers. A society that was still strongly marked by peasant values and economies in the middle of the twentieth century once regarded a prolonged education as not only useless but even dangerous and counterproductive.

Social class indicators have also changed.[3] Rural salaried workers once represented 28 percent of the total economically active population in rural areas; but by 1992, this figure had declined to 2 percent. Nonremunerated workers are a residual category, even among the peasantry. The percentage of independent producers has declined from 11 percent to 6 percent over the last ten years, despite the relatively greater capacity of family-based agricultural production to resist change.

The middle classes, by contrast, have definitely increased in number. The proportional weight of the independent petite bourgeoisie, including self-employed workers, has almost doubled over the last ten years, and currently represents 13 percent of the total active population. The petite bourgeoisie engaged in dependent forms of employment, including salaried workers in trade, administration, and the service sector, reached 27.5 percent in 1992. Finally, the development of the "technically" skilled petite bourgeoisie, namely salaried workers engaged in scientific and intellectual work and intermediary technical tasks, has probably increased most and has exerted the greatest social impact. In 1960, this group represented 2.6 percent of the total. In 1970, the figure stood at 4.9 percent. In 1981 this had risen to 7.9 percent, and in 1992 to 16.8 percent.

This technically skilled group lives mostly in urban settings and possesses a relatively high cultural capital. It is highly visible and influential, and for that reason absorbs and amplifies the impact of changes in social values to a significant degree. This group is not homogeneous; yet through its internal divisions and differentiations, it largely defines dominant social values and plays leading roles in Portuguese society.

New social values and leadership roles are expressed by and rooted in a series of processes: the rapid "feminization" of the economically active population; the even faster feminization of attendance in and completion of higher education; the growth of the middle class, and its urban sector in particular, which is the relatively best equipped sector in terms of cul-

ture and education. Similarly important leadership roles are played by the heterogeneous entrepreneurial class, high-level administrators in the state or private enterprise, and by the liberal professions. Over the last decade, the last group has increased its weight from 4.4 percent to 7.8 percent of the economically active population.

Values

The dissemination, reproduction, and use of socially relevant values in Portugal is conditioned by a number of different factors. First are factors predominantly connected with the internal dynamic of symbolic configurations. Values and social representations evolve with a sort of built-in inertia that is often closely linked to long-term regional or local developments. Such inertia can be found, for example, in the "cultural regions" in Portugal, distinguishable by their different ethical, religious, and even political choices and behavior patterns.

The development of symbolic configurations, however, is far from static. Contagion is the rule rather than the exception. Ideas travel with ever greater ease and speed because of mass communications (television in particular) and their ever greater accessibility to wide sectors of the population. It is clear that Portugal's communication with the outside world is much greater today than it was thirty years ago. The timid opening of the 1960s, which affected only a few thousand emigrants and a few intellectuals, has, at the end of this century, widened to include everybody.

Apart from the role played by the media, this opening is facilitated by other developments. Among the most important is the political situation that emerged after the revolution of April 1974. Greater cultural receptivity and increasingly dense social contacts have also developed with progressive urbanization and interregional exchange.

A second group of factors that, although external to the cultural-symbolic dimension, influence the configuration of values are institutions or social groups with a high level of visibility, a capacity for leadership, and the ability to sustain and disseminate ideas that cut across social or other barriers. The family and the church are examples of institutions that, however heterogeneous and however various their levels of action and influence, have a distinct presence and serve as strategic centers for the production and dissemination of values. As for social groups, those already

noted, namely the declining peasantry, the concomitantly increasing petite bourgeoisie, and the increasing share of women in the workplace, have all been fundamental. These social changes undoubtedly are linked with equally important changes in values and patterns of behavior.

Also external to the symbolic arena is the wide and diffuse gamut of demographic, political, economic, and "geostrategic" conditions that both act on and reflect Portuguese society. All of the above-mentioned elements constitute the background and the framework within which constraints and opportunities develop. They act on the symbolic arena and, in particular, on the development of social values.

The 1980s saw an improvement in the living standards of the Portuguese in terms of income, consumption patterns, and access to services and material goods. The gross national product increased in volume by approximately 25 percent between 1985 and 1990. This period also saw an increase in the real salaries of dependent workers. The feminization of the economically active population is even more significant in this context, given that it has doubled the income of many family units, providing them with a level of financial security otherwise impossible to achieve. The consumption patterns of families confirm a tendency, already observed at the end of the 1960s, toward a decrease in the percentage of income spent on food. This is a common indicator of generally improved living standards.

Social Asymmetries and Vulnerabilities

Certain observations are in order regarding the changes reviewed so far. Together with other improvements, they have an obvious impact on social values. These improvements are strongly asymmetrical. Portugal is a country with a history of poverty and economic hardship affecting wide sectors of the population, expecially the family- and subsistence-based agricultural sector. Patches of urban and suburban poverty also persist. Today, moreover, Portugal suffers from the "new poverty" that has arisen in areas undergoing severe industrial crisis or reconversion. The spatial distribution of poverty situations, measurable according to the presence of the more vulnerable population categories, is consistent with other indicators for regions that are in decline and at a disadvantage relative to the country as a whole.

Negative social asymmetries of this kind create social exclusion, under-

stood in the wider sense of various forms of deprivation. Processes of pau-
perization are often accompanied by a learning process whereby social dis-
qualification, stigmatization, and loss of faith in the possibility of change
are internalized. In other words, empoverishment is often accompanied by
the formation of a "culture of poverty," which only reinforces the objective
difficulties of improvement or recovery.

Among the social categories vulnerable to this effect are the aged,
pensioners, low-income farmers, salaried workers living on the minimum
wage, workers in precarious situations in the informal economy, certain
ethnic minorities, young people with few qualifications seeking a first job,
the unemployed, and workers whose wages have not been paid. The evo-
lution or improvement of some of these groups is very difficult to foresee,
even over the short term, given that, among other things, they are so de-
pendent on the health of the economy as a whole.

Official unemployment figures, which are always underestimated, re-
veal marked fluctuations in employment levels. The figure for 1986 was 10
percent and for 1990 only 5.5 percent. The tendency today is toward a re-
newed and sharp increase. Factors such as the difficulties facing the social
security system may contribute to a speedy and negative development.

Experience indicates that reversals in the economic cycle, a threat with
direct or indirect repercussions for social life, usually have an immediate
impact on the system of values, overturning what previously appeared to
be firmly rooted values. It is worth remembering, to cite but one recent
and relatively mild example, the negative reaction in Italy and Norway,
two countries known for their traditions of openness and social convivi-
ality, when faced with larger migration flows.

Preoccupations and Shared Values

The peoples of Europe are different in the traditions, values, behavior
patterns, and goals they adopt and aspire to. A number of concerns are
shared nevertheless, reflecting a degree of convergence both in living con-
ditions and in modes of assessing the present and the future. Indeed, some
issues and problems emerge repeatedly in the studies and surveys carried
out since the beginning of the 1970s.

The problem of peace is one of these issues. Responses confirm Euro-

ropean citizens' continuing fear of armed conflict, even since the Cold War. The physical proximity of intense, cruel, and long-lasting wars makes these fears understandable. Human rights are also a relevant issue. Questions related to citizenship are accorded the greatest importance. The theme of social exclusion is repeatedly mentioned; it can be seen as an extension of the concern over citizenship, considering that social exclusion is a denial of citizenship of sorts. Sociocultural diversity is another important issue.

European attitudes can be divided into two general categories: defensive attitudes, which border on the xenophobic; and attitudes that support intercultural and interethnic coexistence. Europeans know, however, just how fragile and changeable the dividing line between these two can be, subject as it is to sudden changes in circumstances, such as economic crises or unemployment.

An additional dominant concern shared by Europeans as a whole is the environment. Although it developed relatively recently, awareness of this issue has become so widely disseminated that social movements have been organized around it and political agendas have made it an indispensable item.

It may seem a little odd that an explicit reference to economic problems does not emerge among the list of Europeans' central preoccupations. As noted above, however, the links between shifting circumstances and value systems are very quickly established. If current economic difficulties in Europe are perceived as being more than transitory, it is highly likely that "material" values will eventually become a more explicit part of the general concerns of Europeans.

The concerns voiced by Europeans are also present in Portugal. Given the sociocultural specifics, however, the importance accorded to each issue varies. Before summarizing and giving examples of trends in Portugal, it is important to remember a number of general factors. First, the concerns discussed are not universally shared. Second, they coexist with other, contradictory tendencies. Currents and countercurrents coexist and shift according to changing circumstances. Confidence can give way to fear, solidarity can be replaced by egocentricism, and social harmony can give way to confrontation. Finally, values do not always cut across all social cleavages, because they are characterized by the diversity of their support groups. Even on a macrosocial level, values always reflect diversity. That

which can be legitimately labeled a tendency is the preference that appears dominant and durable, perhaps because it has been appropriated and disseminated among the more visible, influential, and powerful social groups.

On the basis of an already significant number of studies and surveys, the values that can be called dominant in Portuguese society, generally speaking, stem from a series of positive circumstances. Democracy, economic development, and European integration have elicited more positive expectations and confidence than rejection and discredit.

The results of Euro-Barometer testify to this. In 1992, the overall assessment of life was positive for 72 percent of the Portuguese people. More important, the way democracy was working satisfied 69 percent of the population, which compares favorably with 47 percent for the European Community as a whole. As for social attitudes, only 13 percent of the Portuguese felt that antisubversive measures were a priority in 1990. The figure for the rest of Europe was double that, particularly among the more conservative sectors.

In 1992, the set of indicators referring to the European Community and to the process of integration were also overwhelmingly positive, optimistic, and well above the European average. A total of 80 percent favored the European Union, and 65 percent considered membership in the EEC to be a good thing. A further 75 percent felt that Portugal had benefited from integration, and 55 percent were in favor of the single market.

Pro-European optimism has persisted since 1986, and its effects extend to the national sphere. Indeed, although the responses for 1992 showed a slight decrease in satisfaction, a clear majority of respondents felt that "next year would be better than this year." It is significant that studies on the values of the Portuguese carried out from the mid-1980s on have all been affected by the positive set of circumstances referred to above.

Four general, dominant, and widespread trends in values that indicate a shift with regard to past attitudes are examined in the following sections of this chapter. Among the most important carriers of those values are groups whose leadership, influence, and potential are most prominent in Portugal. Essentially this is the economically active, urban population, particularly the more youthful sectors, which are culturally and educationally above average.

Immediate Satisfaction

One tendency that seems increasingly widespread and that cuts across a variety of cleavages is what can be called, for want of a better term, the fulfillment of personal or individual desires. With it comes the conscious priority of developing strategies and projects that most directly further personal goals.

The dominant model of behavior in rural and peasant societies centered on the family or the village, which used to be at the heart of social life. The prudent behavioral norm in such societies included a collective protection against threats and the uncertainties of old age, as well as a readiness to suffer great sacrifices in the present to protect the family from unpredictable events in the future.

Changing circumstances, however, have led to a shift in these values. The marked process of deruralization, the introduction of new ways of thinking and different sets of constraints, have led to an increase in strategies based on the refusal to postpone the fulfillment of personal desires or objectives. Even savings rates, very high in Portugal relative to the rest of Europe, have been falling very quickly as a result of this shift.

Affective relations and the family still occupy a central place in the hierarchy of values, even among the urban population. The symmetrical family model, however, is already preferred by the great majority of Portuguese people; that is, the model in which both the man and the woman are professionally active and share responsibility for raising children and domestic chores. The model of autonomy, in which family harmony is based on the satisfaction of the members of the unit, is preferred among the active urban population over the fusion model, in which individual sacrifices are admitted for the attainment of family harmony.

Another example, this time in the professional arena and predominantly among young people, concerns pleasure and vocation; what might be called the intrinsic value of work. The latter ranks first in the priorities of an active life; therefore, individual strategies concentrate on postponing as little pleasure as possible. This reflects what Louis Roussel has called the "impatience of happiness."[4] It is a tendency that suggests the emergence of a mild individualism rather than a narcissistic, self-centered, or extreme form. There is evidence, however, that forms of solidarity are neither dead nor moribund. Lack of interest in traditional forms of social and political

participation has undeniably become more widespread, but not all forms of social and political participation have been affected. Nor does any evidence indicate a decline in the strength of a professional ethic that values cooperation and collective projects.

The "Second Disenchantment with the World" and Pragmatism

In contrast to projects for the future, a second set of values that appear to be gaining ground in Portuguese society is based on a general skepticism toward systemic objectives and final or closed social models. It is apparently a second wave of what Max Weber a century ago called a "disenchantment with the world." Today this process seems to be linked to a loss of faith in a rational, moral, and linearly progressive world. The more favored, dominant classes have lost confidence in the durability of their status. The faith of the dominated or lower classes in the possibility of improving their situation has also been shaken.

At the same time, these values reject global, grandiose, and heroic objectives. Pragmatism seems to be gaining ground. It affects views of the capacity of social mechanisms to resolve conflicts, and it focuses on the attainment of more visible, controllable, and limited objectives. The best way to face the future therefore appears to be through short-term control of the present reality. The siren song of the more distant future is best ignored, as it is too uncertain to constitute a sufficiently reliable guide for action.

This historical victory of means over ends has various social manifestations, among them is the crisis, although not the death, of the great ideologies. Another aspect, highlighted by a variety of surveys directed mainly at young people, the urban, economically active population, is that affective relations and the family are ranked first among things considered relevant in life. Social and political participation is repeatedly ranked lowest. This devaluation also colors attitudes toward political institutions in general and political parties in particular. On the other hand, some evidence shows that people are prepared to engage in other forms of social intervention. Thus this process of distancing from traditional forms of participation also reflects a refusal to accept grand objectives, a lack of faith in the processes and institutions that seem most to represent or embody the rhetoric of unfulfilled promises.

Whatever emphasis is placed on family relations, the lack of faith in

the objectives and institutions outlined here does not lead exclusively to withdrawal into the protective space of the private sphere. Work and professional life, for example, are still strongly valued. There is no reason to believe, moreover, that new or partly new forms of involvement in collective action inevitably result in indifference.

The Peaceful Coexistence of Values

A third and increasingly dominant tendency shows a greater coexistence between distinct existential models and values. This is partly a result of the consolidation of democracy and the collective internalization of the value of tolerance, an adaptation to and coexistence with accepted differences. Such tolerance extends even to values that can be more rigid, such as those of a moral, religious, or political nature.

The diversification of lifestyle options and models, stemming from the increasing complexity and openness of postrural society, is confirmed by the most superficial of observations. Various studies have demonstrated that only small minorities retain rigid value judgments, particularly among young people. This is the case, for example, with attitudes toward affective and family behavior patterns. The general rule is that premarital sexual behavior, divorce, abortion, and contraception are all calmly seen as part of the personal sphere and therefore a choice for each individual.

Sociopolitical, moral, and religious values that are less rigid, more arbitrarily distributed, and more horizontal have contributed to this new flexibility. Political choices or ethical divisions between believers and nonbelievers obviously are less predictable than they used to be. Therefore, if Catholics and non-Catholics have ceased to think that everything in life places them in opposing camps, they must also have ceased to view each other as "negative" reference groups.

The harmonious coexistence of different values, however, does not necessarily imply greater relativism or a wholesale decline in normative values. What is happening is that, on the one hand, normative pluralism is accepted in certain spheres. Thus, each group accepts that other groups can act differently without feeling that it actually has to change its own values. The values that are upheld, on the other hand, are no longer applied as rigidly. Circumstances are taken into account when applying norms, and the latter are molded and adapted according to the nature of the former.

The Craftsmanship of Ideas

Having mentioned the increasingly flexible attitudes of citizens and groups toward norms and social relations as a whole, it is possible to return to a tendency affecting values: the crisis of the great ideologies. Ideologies are organized systems for interpreting the world, which serve as reference points for action. They explicitly or implicitly represent and interpret social processes. They also have a normative dimension, containing sets of values and behavioral prescriptions.

There is no point in linking ideology with false consciousness or attributing systematic distortions to ideological beliefs. There is little point in subscribing to Napoleon's view that ideology is the opinion of our enemies. There is also no reason why the end of ideology should be decreed, as prophets repeatedly do. The great ideologies of the modern age that have had an impact on society will obviously undergo changes and adaptations as a result of the natural course of events. Indeed, what is surprising is their capacity to resist change and their overall stability.

Where change is most apparent is in the use the Portuguese make of the great ideological systems. Adherence to or rejection of these systems was previously undertaken wholesale or en masse. Today, the tendency has been reversed; each citizen and group vindicates autonomy when selecting, as well as combining and managing, symbols. Clearly, in the long term, the Portuguese will transform the ideological systems themselves through the practice of seeking only that which is useful in any given system. Their unhesitating combination of elements from various systems and their remixing of parts of programmatic and cognitive schemes previously considered incompatible will also have an impact on those systems.

Returning to religion for an example, it is notable how many Portuguese Catholics make do without the more ritualistic aspects of their religion while not actually ceasing to be Catholic. It is, however, not just a question of going without a normatively ordained religious practice. It is rather a privatization of spirituality and faith, a refusal to accept the influence of religion in the public sphere or the mediating role of the priesthood. These are postures that obviously coexist with more traditional attitudes. Yet this process, which some have already called the "Protestantization" of Catholicism, is compatible with the continuing vitality of religious values. It shows, furthermore, that tendencies toward autonomy

and the recentering of options around the individual can appear in a domain that is normatively very powerful.

Another example can be drawn from the political field. In Portugal, to side with the Left or the Right a few years ago not only defined options and patterns of behavior in the strictly political field, but also affected the sphere of one's ethics, one's way of life, and even one's religious values. To adopt or discard one of these dimensions was normally seen as a wholesale adoption or rejection of a set of articulated values and patterns of behavior. Things have changed significantly in this regard, and the options have become more diverse.

These cleavages make traditional forms of categorization increasingly difficult, diffuse, and unreliable. Certain theories are based on the idea that values and patterns of behavior are systematically "leveled" by the manipulation and omnipresence of the mass media. Whatever the case, the overall result of this in Portuguese society seems to be the predominance of the "made to fit" over the "made to think," an affirmation of a new craftsmanship of ideas.

Final Caveats

Whatever their ability to cut across cleavages, the values outlined here are rooted in specific Portuguese social groups. Although the growth of these groups is apparent, and although they have been accorded a particularly high degree of visibility and influence, they must coexist with other social sectors whose values, choices, and behavior are more or less different.

The second caveat is more important. Values are the product of a vast and diverse set of constraints of a symbolic and extrasymbolic nature, which operate at the national and international levels. They are therefore reversible. Imagine, for a moment, that the unemployment crisis were to deepen, interregional inequalities were to become aggravated, situations of poverty and exclusion were to crystallize; that sudden waves of immigration should occur, or that a combination of these factors were to arise. If this came to pass, tensions in Portuguese society would undoubtedly increase over the short term. An increase in levels of social conflict would have a reverse effect on the tendencies that are dominant today. The first value to give way would be that which permits the coexistence of different values.

Engendering Portugal: Social Change, State Politics, and Women's Social Mobilization

VIRGINIA FERREIRA

In 1972, the writer Isabel da Nóbrega stated, "If by pressing a button I could pass a law that would suddenly give Portuguese women all the rights and responsibilities they have been deprived of, I would not do it. Simply because I know that such a sudden 'coming of age' would be isolated, apparent, and false, merely another illusion."[1] Only two years later, however, someone pressed that button. The military coup, or the "Revolution of the Carnations" of April 25, 1974, ended the rule of the *Estado Novo* and gave rise to a period of marked turbulence and social creativity that profoundly altered Portuguese society. The state reform that ensued aimed to create a democratic society and abolish institutional, social, and sexual inequalities.

The promotion of women's rights did not come out of the blue. Many women had participated in the courageous fifty-year struggle against the dictatorship. It is also true, however, that no important mobilization in defense of women's rights took place during the prolonged period of resistance to the regime. Thus, the juridical-institutional enshrinement of sexual equality was legislated "from the top down." It was part of the package of measures deemed necessary for the construction of a modern state, which was to be as advanced, if not more advanced, than its European counterparts. The way equality was institutionalized left deep marks on the social situation of women in Portugal. As one prominent activist

stated recently, "In Portugal there is a missing link, perhaps because the law changed before we emancipated ourselves."[2]

Portuguese women confront a misogynistic barrier much stronger than the one found in more advanced countries: the assumption of their inferiority. The institutional-juridical order that governed women's lives until the 1970s defended that assumption, and was based on it. That order, furthermore, was not gradually corroded by the rise of new values or by changes in social practices associated with urbanization and industrialization, as it was in other countries. Portugal historically has had a relatively low urban population (even today, just over a third of the population lives in settlements of more than ten thousand inhabitants). Industrialization was diffuse; indeed, it can be characterized as a process of industrialization without modernization.

These characteristics precluded the spread of individualistic lifestyles, as well as the emancipation of women. Family ties were not cut; on the contrary, as the country became industrialized, the limited public coverage of childcare and other social support systems intensified family, kinship, and neighborhood support networks.[3] The massification of consumption, increased access to the educational system, and the growth of the middle classes all have been very restricted. Social dualism is therefore still profound, and the distance that separates the economic, political, and social elites from the rest of the population characterizes contemporary Portuguese society.[4]

The position of women in Portugal today is marked by this context of juridical equality imposed from the top down, of a weak individualization of lifestyles, and of pronounced social and economic elitism. This chapter will seek to show how key social realities affect the rights of women and their capacity to organize autonomously in Portugal. It will refer briefly to the socioeconomic dimension of the life of women in Portugal, with particular attention to patterns of employment segregation. Next, it will review the most important legislation on sexual equality passed over the last century. Finally, the social and political changes of the past twenty years will be analyzed, with the following questions in mind: How to explain the egalitarianism that informs the new juridical order established by the democratic regime in Portugal? Why did the women's movement in Portugal not gain the public visibility typical of other countries in southern Europe, such as Italy, France, and Spain? The position of the state regard-

ing policies of equal opportunity relations between the state and women's organizations will also be examined.

The Feminization of the Workplace and Patterns of Sexual Segregation

A recent study of Portuguese society in the last twenty years states, "the large-scale insertion of women in the professional sphere constitutes one of the most significant and profound changes that Portuguese society has undergone over the last decades, even though there is not a very clear public awareness about this."[5] The entry of married women into the labor market has contributed signficantly to this trend. Employment is interrupted less and less by the birth of children, and the latter are increasingly few.[6]

The intensification of women's incorporation into the labor market was initiated in the 1960s, in an ideological context marked by the social doctrine of the church, or in other words, by the more traditional, family-based values, based on male-dominated social relations. The official discourse of the *Estado Novo* on the separation and complementarity of the sexes inexorably promoted a domestic focus for women's lives. Hence the argument that the dynamic of female employment developed somewhat autonomously from state policies.[7] The qualifying "somewhat" is important. Although the official discourse that predominated until April 1974 emphasized the duties of domestic life, it did not fit entirely with the government's legislative initiatives, which indicated a progressive acceptance of female employment, particularly after the death of António Salazar in 1968.[8]

Nevertheless, it was necessary to wait until after the demise of the dictatorship for women to enter the labor market in a decisive way. The process of incorporation occurred speedily and had very particular characteristics. It is not the task of this chapter to analyze these peculiarities systematically; this has been done elsewhere.[9] The objective here is to present the general characteristics of the feminization of the labor force and the sexual segregation of employment.[10]

Industrialization, Terciarization, and the Precariousness
of Female Employment

A combination of various factors in Portuguese society directly affected
the availability of labor during the 1960s. In the first place, the male work-
force was depleted by the colonial war and, above all, by strong emigra-
tion to other European countries. Second, employment expanded in the
process of industrialization. Industrialization had become the increasing
international focus of the economy because of the partial *revocation* of the
Law of Industrial Conditioning and the opening to foreign capital that
came with Portugal's accession to EFTA and agreements with the Euro-
pean Economic Community (EEC). The industrial leap was significant.
Industrial policies focused predominantly on increasing exports of finished
consumer goods. They gave rise to work-intensive industries, important
agents in the recruitment of female labor. The coastal urban centers that
supplied the internal market grew, promoting the growth of the service
industries as a whole. Consequently, the rate of feminization of the active
labor force increased from 18 percent to 26 percent.

The evolution of employment in the 1970s was characterized by the
explosive growth of the terciary and public administrative sectors, particu-
larly after April 1974. Concomitantly, the feminization of the labor force
was reinforced. In 1974, the terciary sector represented 36 percent of the
professionally active population; by 1991, the figure was 56 percent. Ter-
ciarization, however, occurred mainly at the cost of the primary sector.
In 1974, the primary sector employed approximately 30 percent of the
population; by 1991 this figure had halved. By 1991, therefore, the rate of
feminization of the active population had reached 40 percent.[11]

Unlike what happened in the majority of countries in the Organization
for Economic Cooperation and Development (OECD), where economic
crisis resulted in the stagnation of economic activity and declining em-
ployment opportunities, in Portugal there was no decline in available jobs
during the 1970s. The huge public sector investments made in the wake of
the nationalizations of 1975, as well as the expansion of consumption by
the administrative public sector, contributed significantly to this situation.
State intervention measures included policies to maintain available jobs,
to ensure the economic viability of many enterprises, and to make changes

in wage rates; these had a strong impact on the dynamic of job creation and suppression.[12]

The economic policies of the 1970s were essentially informed by a redistributive logic and a preoccupation with wage levels. The policies aimed to establish Fordism in Portugal, a policy already in crisis in the rest of Europe.[13] The establishment of a minimum wage, employment subsidies, a ninety-day maternity leave, and other pregnancy, maternity, and family assistance rights had a direct impact on levels of female employment. Pregnant women were permitted to leave work to visit the doctor without a loss of benefits or remuneration, and a fourteen-week maternity leave was established without a concomitant loss of service time, remuneration, or benefits. Women could also take off two hourly shifts per day for breast-feeding until children were one year old. They could miss up to thirty working days per year in case of child sickness, and up to two years unremunerated leave in special cases.

The Portuguese economy's capacity to absorb these changes, however, was very limited. Thus the female-dominated informal economy increased, as did the parallel market and especially the more precarious forms of employment. A study on atypical employment in Portugal at the end of the 1980s showed that it was mostly women who suffered from the delayed payment of salaries, clandestine work, and casual labor. This means they were the workers most affected by such labor practices as part-time work, short-term contracts, subcontracting, unremunerated family work, domestic work, underemployment, and even atypical employment in the public sector.[14] The net effect of government policies, the growth of public services, and the informalization of the economy was a great expansion in female employment.

In the 1980s, economic policies continued to favor employment, even at the cost of reduced wages. Rigid labor laws made the firing of both public and private sector workers with permanent contracts virtually impossible before 1989. For this reason, business owners and employers opted for more precarious forms of employment (such as short-term contracts) and more flexible wages (the declining weight of wages as a part of total remuneration). The large public sector established with the nationalizations of April 1974 "supported" underemployment over the long term and prevented an uncontrolled rise in unemployment. Nationalized enterprises,

however, also emphasized the quantity of employees over the quality of employment.[15]

The development of the labor market in Portugal over the last twenty years has some particular characteristics. On the one hand, certain elements of the "virtuous circle" that developed in other postwar European societies emerged, such as wage increases, the welfare state, and public services. These developments led to the massification of consumption patterns and the growth of the internal market. On the other hand, the economic climate in which consumption patterns changed, unlike that of other European countries, was affected not only by world economic crisis but also by more particular factors, such as the loss of investments in the former colonies and the return of hundreds of thousands of ex-colonials (former soldiers, immigrants, and entrepreneurs who abandoned their businesses to escape political persecution).

Still another factor was the financial effect of politically determined wage increases on businesses whose competiveness was based on low salaries. The deregulation of the economy in the 1980s reinforced the integration of women into the labor market through an increased demand for workers who were not unionized, whose labor was cheaper, and whose relationship with the labor market was less stable. The need to multiply sources of family income also contributed to feminization as increased consumption came under attack from high inflation rates, which were controlled only in the 1990s.

Patterns of Sexual Segregation in the Structure of Employment

Portugal is an exception to the rule that levels of sexual segregation tend to be higher in countries with higher rates of female employment.[16] The patterns of incorporating women into the labor market are therefore specific to the Portuguese context.[17] In Portugal, levels of female employment are very high (in 1994, 45 percent of the economically active population was female), and levels of sectoral and professional segregation are relatively low, as shown in table 9.1.[18]

As the table shows, the figures for professional segregation are higher than those for sectoral segregation. The percentages for the former (column 2) range from 22.1 to 48; for the latter (column 1), they range from

TABLE 9.1
*Index of Differentiation of Sectoral and Professional Employment and Percentage
of Female Employment in Selected Professions, OECD Countries, 1990*

	Sectoral (ID)	Professional (ID)	Technical-Scientific (%)	Professional-Technical (%)	Administrative (%)
Japan	17.7	22.1	41.9	11.2	26.8
Portugal	20.9	26.5	54.4	10.7	15.2
United States	27.4	36.2	50.3	18.0	27.3
Holland	30.1	37.6	61.4	23.8	24.2
Spain	30.2	39.4	47.0	12.9	16.4
Denmark	30.5	42.2	62.9	31.3	25.6
Nigeria	32.5	31.5	23.7	4.1	2.7
Norway	33.9	42.3	56.5	28.0	17.8
Finland	34.6	43.5	61.4	31.0	22.4
Philippines	36.3	34.9	63.2	9.8	5.9
Venezuela*	36.4	48.0	55.2	21.9	20.6

* 1989 data.
SOURCES: IDs calculated from data published in International Labour Office, *Year Book of Labour Statistics* (Geneva: U.N. International Labour Organization, 1991). For the calculation of professional segregation, the International Standard Classification of Occupations (ISCO, 1968) standard of sexual segregation in seven groups of professions was used. Groups 0 and 1 were fused into a single category, as were groups 7, 8, and 9. The information for sectoral segregation was also based on the ten groups (including the category of ill-defined activities) employed by the International Standard Industrial Classification of all Economic Activities (ISIC, 1968).

17.7 to 36.4. This reflects the tendency toward a distribution of women throughout different sectors and toward their concentration in some professions. Both indicators change, however, in the same direction; thus, in countries where sectoral segregation is lower, as in Portugal, professional segregation also tends to be lower.

It is the view of this author that the high rates of female employment and relatively low rates of segregation are products of a constellation of factors, particularly "a highly interventionist (though economically weak) state, incipient technological and economic development, a great flexibility evidenced by families in the allocation of the labor resources of their members, a rigid social structure, and weak family geographical mobility."[19] Apart from these, the level of activity and segregation is also a product of low wages (in 1994, the minimum monthly salary was approximately US$340, and the average was not far above US$530). Low wage rates (at 74.4 percent, the third-lowest in the countries of the European Union, where the average is 82.3 percent), the weak development of the service sector (at 56 percent, the second-lowest of the EU, where the average is 61.4 percent), and the weakness of part-time work (only about 5 percent

of workers are employed part-time) all characterize the Portuguese labor market.[20]

The profound elitism of Portuguese society can be seen in various indicators: the number of women employed in service activities that require no qualifications, such as cleaning services (19 percent of female workers are maids or porters), in subsistence-level agricultural activities (11 percent), and as unskilled industrial workers (25 percent). On the other hand, technical-scientific professions absorb approximately 11 percent of economically active women and administrative professions 15.2 percent (see table 9.1). These figures, the lowest in the European Union (the average in Portugal is 19 percent and in the EU 30 percent), testify to the deficit in intermediary social positions, typical of less-developed societies. This is also apparent in table 9.1.[21]

The high rate of female activity, especially among mothers (above 70 percent), in a country with scarce social and family support infrastucture and the longest workweek in the European Union (more than 40 hours), is achieved not by a greater sharing of family responsibilities by men, but rather through the activation of support networks and the mobilization of unqualified female labor to undertake domestic work.[22] In this way, women from the higher social classes have been able to embrace a professional career without their social gender relations actually changing. They can resort to very cheap domestic help.

The high rate of feminization of the technical and scientific professions in less-developed countries such as Portugal has been the subject of some controversy.[23] This is also true in other countries with highly interventionist states, such as the Nordic and Eastern European countries. In Portugal, this phenomenon is not new; in 1981, women already occupied 51 percent of the employment in the technical-scientific professions.

The feminization of the scientific professions is not isolated from the social and educational context in which it has occurred. Higher university education since the 1960s has shown exceptionally high rates of feminization compared with other countries. In the academic year 1990–91, for example, women represented 29.6 percent of students studying engineering, one of the professions traditionally most resistant to women. The figure for Great Britain was 12 percent and for Ireland 4 percent. In total, women represented 55.5 percent of matriculations and 65.8 percent of graduations.[24]

The educational system is indeed the least socially discriminatory be-
cause it is perhaps the only one in which merit, an essential element of
Western social values, effectively works as a criterion for selection. The
feminization of university education has worried the government, which
has set up a commission for reforming the rules governing university ad-
missions, a measure also undertaken in other countries, such as Canada.[25]

In this author's opinion, this phenonemon is the product of two in-
fluences. The first is the social structure: "the more elitist societies are,
the more they tend to value elite womens' higher qualifications."[26] The
educational system is extremely selective; in 1991, only 8.4 percent of the
total population above 17 years of age had attained middle- or higher-
level education. Thus the primacy of recruitment is based on social rather
than gender relations. Social class is more relevant than gender categories;
"class relations seem to supersede gender relations."[27] The low level of eco-
nomic, social, and political individuation and the concomitant strength
of family ties makes the recognition of individuals attendant on family
and social connections. This relationship is linked to the weakness of the
middle classes, which, in turn, is connected with the low level of entre-
neurial modernization. The middle class is unable to dynamize technical
and administrative support services as their counterparts in more advanced
societies do.[28]

Second, women's presence in the scientific and technical professions is
a product of Portugal's low level of economic and technological develop-
ment. Technical and scientific activities here are not as competitive or as
remunerative as they are in more advanced countries. These professions
are therefore more receptive to female labor, on the one hand, and less at-
tractive to men, on the other.

Despite these particular trends, the evolution of female employment in
Portugal over the last two decades in some ways parallels that of the more
developed countries. Most notable is the increase in female employment
despite the profound crisis that struck the European economies. The idea
that women were in the job market as a part of the industrial labor reserve
and that, for this reason, they would be the first to go in times of recession
has definitely been questioned. Women have fought to preserve their jobs
because they value their economic independence, because they are increas-
ingly alone, or perhaps because they cannot rely solely on men's wages to
ensure the survival and maintenance of their families.

Of course, there is no automatic correlation betweeen an increase in female employment and a change in attitudes toward women's place in the family or at work. Ideology clearly exerts a mediating effect on demographic and economic processes, on the opportunities for employment as well as on women's rights.[29] Female employment has therefore been relatively exempt from state policies.

The Legislative Construction of Equality Between the Sexes

The first European woman to vote (in the twelve member countries of the European Union at the end of the 1980s) was a Portuguese physician, Carolina Beatriz Angelo. She cast her ballot in 1911, in the first elections for the Constituent Assembly after the fall of the monarchy. She was a suffragette, the founder of the Associação de Propaganda Feminista. A widow and a mother, she took advantage of the technicality that the law did not expressly exclude women from the right to vote. In fact, the law in question referred to "Portuguese citizens over the age of 21 who can read and write and who are heads of family." After a series of vicissitudes, the courts finally allowed Angelo to register to vote on the grounds that the generic "Portuguese citizens" referred to both men and women.

This unique episode is worth noting not only as an example of the typically erratic and casuistic nature of Portuguese politics, but also because it shows that Portuguese women have benefited from a legal status while remaining frequently unable to enjoy their rights. Another example is that the Salic law was never adopted in Portugal.[30] Republican women mobilized in the struggle against the monarchy, but the Republican leaders, once in power, frustrated women's expectations. One year after Carolina Beatriz Angelo was allowed to vote, the regime hastily changed the electoral law, restricting the right to vote to men.

From Suffragette Feminism to the "Domestication" of Women Under the Estado Novo

During the First Republic (1910–1926), women maintained a tense and contradictory relationship with the government. On the one hand, the regime actively promoted the rights of women. Coeducation was established, and both sexes were obliged to attend school between the ages

of 7 and 11. New marriage and filiation laws were decreed, according to which women ceased to owe obedience to men. Divorce was legalized, with equality of treatment for both sexes. New employment opportunities were opened up for women; public service jobs became available. All-male schools were also opened up. A two-month maternity leave was instituted for all workers, both married and single. Carolina Michaelis de Vasconcelos became the first woman appointed to a university professorship.

On the other hand, an attempt was made to bar women from certain professions. The discourse of the regime, furthermore, emphasized women's domestic duties.[31] The regime therefore adopted a "Salerian" strategy.[32] It promoted women's access to new professions, yet it made sure that these jobs were poorly paid and inferior. In other words, it ensured that only limited professional opportunities became available.

During the fifty years of the *Estado Novo*, Portuguese women were governed by a regime that restricted or annulled the few rights they had gained in the preceding twenty-five years. Maternity leave was reduced to thirty days, and employment subsidies became optional. Divorce for religious marriages (70 percent of marriages, even today) was also curtailed. The regime also put an end to co-education and gave husbands the right to force wives to remain in the home.

The Constitution of 1933, which Michael Harsgor has described as one establishing "a subdued Lusitanian, Catholic version of a Fascist regime," declared the equality of citizens before the law "except for women, when Natural differences and the Family Good are at stake."[33] Based on a similar concept of equality, the Civil Code of 1967 established that families were headed by the husband, who was responsible for decisions affecting married life and children. As for the right to work, women were subject to their husbands' authorization. The code stipulated that husbands had a right to denounce contracts signed by their wives without their prior consent. Married women were therefore dependent on their husbands' veto power in the world of work.[34] This was also true for other aspects of life. Women could not leave the conjugal home or cross national borders without their husbands' consent. The Civil Code also stated that married women had to take care of the home. Domestic work became legally compulsory.

The legal framework that restricted the lives of women also set the limited margins of social freedom. Portugal was obsessively controlled by various police forces. Regime opponents were persecuted, political

parties were prohibited, and the media were censored.[35] Access to information was extremely limited, and available information was filtered. Contraception was prohibited. Abortion was harshly penalized, subject to up to eight years' imprisonment. Maternal and child support was almost nonexistent. Infant mortality rates reached nearly 50 percent. The public schools were weak, and illiteracy levels were very high. Illiteracy today still affects 15 percent of the population. In 1973, when the regime was nearing its end, Portugal's per capita gross national product was the same as Great Britain's in 1929, Germany's in the 1950s, and Italy's in 1960.[36]

The concept of progress is strongly ingrained in Western society. The Western vision of progress assumes that the establishment of legal rights and the creation of legal subjects are irreversible processes. In Portugal, nothing could be further from the truth. The *Estado Novo* restricted or annulled previously recognized rights. In terms of rights and development, the *Estado Novo* was a glacial era of sorts, during which the few social conquests previously achieved were lost.

From Dictatorship to Democracy: The Promise of a Universal Citizenship

After the military coup of 1974 and the end of the dictatorship, a brief "revolutionary crisis" occurred.[37] Boaventura de Sousa Santos describes the two years that followed the coup as producing

the widest and deepest social movement ever witnessed in postwar Europe. This movement was socially complex but headed by the urban working class (particularly from the Lisbon industrial areas), the salaried petty bourgeoisie in the large and medium-sized cities and by the rural workers of the Alentejo. The popular movement had an impact on various aspects of life: local administration, urban housing, the administration of businesses, education, culture and lifestyles, agrarian reform, power relations in the rural areas, etc.[38]

During these two years of social turbulence, organized political forces were often obliged to "follow" popular demands. The state often acted as an ad hoc legislator, making laws under the pressure of events to legitimate popular initiatives, such as the occupation of houses, factories, and lands and the purging of civil servants or professors linked to the ancien régime.

Successive provisional governments emerged from complicated negotiations and constantly shifting political alliances between the Portuguese

Communist Party, the Socialist Party, and the Social Democratic Party. The governments tried to reform the juridical-institutional order with new legislation. The framework of the new democratic regime was established in this period and later consecrated by the 1976 Constitution, passed by a Constituent Assembly dominated by deputies from the Socialist and Communist parties (representatives of those parties held 146 of the 250 seats). All parties except the Christian Democrats from the Social Democratic Center voted in favor of the preamble to the new constitution, which stated that it was the "decision of the Portuguese people . . . to forge the path toward a Socialist society." The first article of the constitution stated that Portugal was a "sovereign Republic, based on the dignity of the human person and on the popular will to create a classless society." The *acquis revolutionnaire* was thus confirmed by fundamental constitutional laws, by democratic institutions, and by economic and social changes.[39]

The political-juridical framework governing the lives of women suffered a radical change. According to many analysts, Portugal's became "one of the most advanced juridical orders in Europe."[40] Article 13 of the 1976 Constitution universalized the principle of juridical equality. It eliminated the myriad discriminations inherited from the outgoing regime, paving the way for a reform of the legal order, putting paid to discrimination against women. Professional prohibitions were eliminated; equality of rights and duties of spouses was established. The Concordat of 1940 with the Catholic church was revoked, and divorce was permitted for all forms of marriage. De facto unions were granted the same legal status as marriages. The notion of "illegitimate" children disappeared. Political rights, such as the right to vote, were universalized; social rights, including the right to social security and free universal health care, were granted, as were workers' rights, such as the right to strike, security of employment, unemployment subsidies, paid holidays, a minimum national wage, and maternity leave.[41]

The effects of the revolutionary crisis lasted a long time. They shaped the climate of opinion indelibly, such that certain political views and options became unacceptable. Socialism became the official ideology and remained so for some time. The Council of the Revolution, which the 1976 Constitution had established as the guarantor of the regime, was abolished only with the constitutional revision of 1982, and only in 1989 did the Social Democrats, in power since 1985, manage to liberalize the labor laws of this period. Fear of a return to the conditions of the dictatorship

had made the 1976 Constitution very rigid. Because it uniquely enshrined a wide array of social rights, it was prone to immobility. An overregulated system can asphyxiate social mobilization.[42] It is important to emphasize, however, that the revolutionary crisis also fostered a climate that encouraged the questioning of social responsibilities, which in turn shaped state policies.

Legal changes were made without opposition. For this reason, women did not have to mobilize. In 1975, divorce and contraception were legalized without so much as a rumor of opposition, in a country where the overwhelming majority of people claim to be Catholics.[43] The political elite acted as though the principle of equality were nothing more than a natural part of the process of democratic modernization: first, as an inevitable part of the path toward socialism, and later in the 1980s, as a necessity for Portuguese integration into the European Union. Because of the revolutionary crisis, and in contrast with what happened in Spain, the authoritarian political system was dismantled without need for negotiations with representatives of the previously dominant oligarchy. There was no need to make the new and old legal orders compatible. The mere "shame" of a fifty-year dictatorship seemed sufficient to give lawmakers total freedom.[44] The preambles of the first legal texts published after April 1974 on women's right to diplomatic, local administrative, and judicial posts spoke of the "reparation of a historical injustice," a vague and moralistic statement that effectively robs women of the merit of nomination.

Another reason for the sudden, "top-down" nature of these changes is the interest shown by men in the elites. Divorce is only the most obvious example.[45] Contraception is another. As far as the prohibition of diplomatic or judicial careers is concerned, and without falling into an explanation based on the functional needs of the system, it is possible to say that it became necessary to widen sources of recruitment, given that traditional sources had been tainted by association with the previous regime.

The Rights of Workers versus Equality of Rights

The rhetoric used by the state to reform the legal order has varied over the past twenty years. References to the reparation of historical injustices suffered by women and to the need to harmonize institutions with international norms disappeared with the end of the revolutionary crisis. During

this period, the principle of equality was placed in opposition to the rights of workers, as witnessed in the debates in the Constituent Assembly. The Portuguese Communist Party favored a constitutional article on women's rights based on the premises, "Women have the same rights and duties as men and can therefore not be the object of discrimination in any sphere of economic, cultural, or political life" and "The basis for the equality of rights and duties of women is the right to work and to an equal wage for equal work." The Communists defended this article according to the logic of the rights of workers. The Socialist and the Social Democratic parties rejected it on the basis of a logic of universal rights.[46]

The constitutional article that consecrates legal equality thus cites sex alongside race, political or religious creeds, and social class. Ordinary legislation, however, has utilized the logic of the rights of workers. The granting of maternity leave is one such example: according to the preamble to Decree Law 112/76 of February 7, 1976, the concession was based on the need to "improve the living conditions of the less favored."

After the publication of the law governing equality of opportunities for men and women at work (Decree Law 329/79 of September 20, 1979), legal change was based solely on the argument that constitutional principles establishing the equality of citizens' rights before the law had to be made a reality. This has given rise to a number of legislative initiatives. The most common of them deprive women of previously enshrined "special protection." Recent examples are the lifting of restrictions on night work (except during pregnancy and maternity) and the leveling of the age of retirement. Until 1993, women retired at 62 years of age and men at 65. Today, both retire at 65. The government declared itself in favor of equality and argued that "this differentiation in terms of retirement age was all wrong."[47]

Enmeshed as they were in the rhetoric of equality, the trade unions and women's organizations hardly reacted to this measure, despite the prevailing climate of job insecurity and redundancy. These trends can be seen in other countries. Catherine MacKinnon notes the example of the United States, where the greater part of the Supreme Court's jurisprudence on sexual inequality has resulted from proceedings initiated and won by men.[48] These are the traps of believing in a formal equality in a society without real equality. Also frequent is the assumption that men equally share the burden of domestic and family responsiblities. This is apparent in Article 68 of the 1976 Constitution:

1. Parents and mothers have the right to social and state protection when carrying out their irreplaceable task of child-rearing and education, being ensured professional guarantees as well as the conditions for participation in the civic life of the nation.

2. Maternity and paternity are socially eminent values.

3. Women workers have a right to special protection during and after pregnancy, including leave from work for an adequate period of time without a loss of wages and benefits.[49]

The 1976 Constitution, on the other hand, mentioned only the irreplaceable child-rearing role played by women and the socially eminent value of motherhood. The constitutional revision of 1982 thus placed maternity and paternity on an equal footing, consequently attributing the same weight to the obstacles to professional and civic participation encountered by mothers and fathers.

Clearly, only a small minority of men participate in childrearing activities or domestic tasks.[50] Formal equality is not complemented by family support structures, and effectively aggravates material inequalities between the sexes. It can therefore be said that while the legal order established in the 1970s is based on a universalist concept of citizenship, it effectively reinforces unequal and unfair social practices by considering men and women equal producers and reproducers.

A brief review of the legal rhetoric on social relations between the sexes suggests that the "defense of the rights of women workers" was dominant in the ten years from 1974 until the law protecting maternity and paternity was passed in 1984. The impetus for this came from the Communist Party, which emphasized the elimination of social and not sexual inequalities. After 1984, a rhetoric of "equality between the sexes" became dominant. Legislators worked on the assumption that economic, childcare, and domestic equality between men and women either already existed or would soon be realized, although it has often been acknowledged that social and institutional practices often fall far short of the law. This touches on a fundamental issue: the enormous discrepancy in Portugal between law on the books and law in action. As noted by Boaventura de Sousa Santos and as referred to above, this situation has resulted because "the law preceded emancipation." In other words, change was imposed from above.[51] Despite social contestation and the fierce social struggles of the revolutionary crisis, battles did not center on the issue of sexual equality.

The "Carnivalization of Politics" in a Dual State

The gap between legal reality and social practices is also a result of the dual nature of the state. After April 1974, the state was able to survive practically intact, evincing "a general and durable administrative paralysis in the midst of acute social struggles."[52] The functioning of state structures frequently depended on the recruitment of new agents capable of implementing new policies. This led to the emergence of a dual state: on the one hand, a state dominated by traditional administrative structures, practices, and ideologies; and on the other hand, a state undergoing the key institutional transformations required by a new policy orientation.[53]

State dualism is an essential part of what Sousa Santos has called the "carnivalization of politics": the assimilation of the practices of developed countries without a concomitant internalization of durable and coherent political practices.[54] This ambiguity permits an understanding of otherwise incomprehensible practices, such as the nonapplication or selective implementation or even instrumentalization of the law. Examples abound, apart from the abortion law. In 1990, the Committee of Ministers of the Council of Europe announced the Social Measures on Violence in the Family.[55] In 1991, the Portuguese National Assembly approved the creation of a system of prevention and support for women who are victims of crimes of violence, although to date, this law has not been applied.[56] There is still no emergency commission, there are still no police departments that can attend to women who have been the victims of violence, even though the law contemplated such departments.

Similarly, on International Women's Day 1993, the Athens Declaration justifying parity of democratic representation was approved by the Portuguese parliament. In January 1994, a group of Portuguese women deputies organized a parliament with an equal number of men and women representatives. It was a symbolic act: men and women debated the "glass ceiling" that prevents women's accession to centers of power and decision-making. On both these occasions, various statements on the need to change things were made, as were solemn promises to implement the necessary changes over the short term. Nevertheless, contrary to what happened in almost all other European countries, where party lists reinforced the presence of women, in Portugal their presence actually declined. The penultimate legislature had three women deputies; the number was reduced to 2 in the

last one. At 12 percent, this number represents the lowest rate of feminization of all the European parliaments.

In 1994, the International Year of the Family, the government felt obliged to undertake some initiative to mark the event. It published a resolution with a series of recommendations to promote equality of opportunity and responsibility between men and women. Not a single concrete measure was proposed. Each minister was left to define initiatives and to find the means to carry them out. As far as the author is aware, to date none of the ministries has undertaken any initiatives.

As for the state institutions responsible for implementing the law, many examples can be found of the lack of concrete application of the principle of equality. The sentences passed in crimes against individuals reveal that judges have a different attitude toward women. In 1989, the Supreme Court rationalized a light sentence for a man convicted of rape on the grounds that girls in Portugal should know that they live in the "hunting ground of the Iberian male" and should therefore take the necessary precautions (such as not accepting rides), so as not to excite the male libido, which is "sometimes difficult to control."[57]

Although the days are over when husbands' criminal responsiblity was attenuated if wives were adulterous, penal law clearly reveals the masculinity of the "intimacy" it protects.[58] The crime of sexual harassment does not exist in Portugal. When such cases occur, men are accused of "attacks on modesty." The fragmented and contradictory nature of the legal order is particularly clear in these matters; the incomplete fulfillment of the spirit of the law is most frequently apparent in these kinds of cases.

Clearly, though, the nonfulfillment of the law is not systematic. In some cases, the courts' intervention has been important, as well as pedagogic. Recently, for the first time, a husband was tried and sentenced for raping his wife. In other situations, the state faces resistance from social forces and acts as a modernizing agent. The development of programs to promote equality of opportunity at work is a case in point. Portugal's integration into the European Union has been highly positive in this sense: the primacy of EU norms means that European directives and recommendations create a framework in which national policies and legislation must be elaborated.

It is important to note, however, that the "carnivalization of politics" does not affect the state alone. The Socialist Party, the largest opposition

party during the rule of the Social Democrats and now the party in power, established an internal quota system at the end of the 1980s that provided for a 25 percent representation of women in the lists, yet to date, this has never led to any change.

The imitation of European examples by members of the elite puts the upper class into a world far removed from typical social practices and daily economic conditions. Meanwhile, the state's lack of resources often prevents it from carrying out the policies to which it is committed, and citizens of both sexes feel a great alienation from power. According to recent polls, the division between rich and poor is perceived as the key factor in social differentiation. These surveys portray a society that favors a democratic regime and rejects the dictatorial past; but they also reveal a society that is alienated from the democratic state. In terms of the individual capacity to intervene and shape society, one-fourth of those surveyed revealed their sense of impotence, stating that they had no capacity to shape outcomes. The percentages that claimed to read a daily newspaper (only 13 percent, compared with the 46 percent European average) or to belong to an association (only 18 percent, again far below the European average) also reveal this sense of alienation.[59]

It is possible to conclude, therefore, that Portuguese democracy is poor, both politically and economically. The cleavage between men and women is not consciously felt as a relevant aspect of social life for a majority of people. All of the above partially explains the absence of autonomous women's organizations in Portugal.

Portuguese society is characterized by a large gap between the elites and the masses, by a great distance between the governing and the governed, by pronounced socioprofessional segmentation, and by acute inequalities in income and capital, as well as inequalities in formal education.[60] Legal equality, in a society suffering from the impact of these economic deficiencies and these social structures, is unlikely to be reflected in social practices. Therefore it is manifestly insufficient to adopt a universalist model of citizenship; instead, it is necessary to create the conditions for the model's implementation. Otherwise, social realities will distort the desired effects, and inequalities will be aggravated. Formal equality has the effect of demobilizing women because it designates no institution to which demands can be addressed. It is more difficult to make demands of society. Legal

equality is thus a key difficulty confronting autonomous women's organizations. It is, however, not the only one.

Pressure from Party Organizations and the Central Position of the State

It is commonly held that women's organizations did not and still do not exist in Portugal, with the exception of those that emerged in the first decades of the twentieth century during the so-called first wave of Western feminism, or the suffragette movement.[61] Some writers have insisted, however, that the mobilization and collective action of the Campaign for Abortion in the 1980s was a true feminist movement, "albeit a heterogenous one, constituted by small groups, fragmented, with little political influence, and differentiated strategies and organization."[62] Leaving this question aside for the moment, the women's organizations that have appeared in Portugal have raised some other important issues.

Party Organizations in a Reduced Public Space

The first feminists of the early 1970s were linked mostly to the parties of the Left or extreme Left. The organizations associated with the Portuguese Communist Party had firmer structures and were more deeply rooted in the population. Women participated actively in the political struggle against the regime and fought for their rights as citizens, workers, or consumers. But the struggle was an antifascist struggle, not a struggle for equality between the sexes. Thus, the links with the political parties were sometimes problematic and conflictive.

The book *Novas cartas portuguesas*, published in 1972 and written by the so-called Three Marias (Maria Isabel Barreno, Maria Teresa Horta, and Maria Velho da Costa), came to symbolize the feminism of the 1970s.[63] The authors were very critical of marriage, sexual relations, and the place of women in society: "A woman's only role is to give birth and to remain stillborn herself."[64] (Of the three, only one still declares herself a feminist.) One month after the coup of April 25, 1974, one of the Marias published an essay titled "Portuguese Letter from Myself Alone to the People Still United."[65] In it she stated,

I am one of the so-called Three Marias. . . . I do not like what was done with that book. I do not like what has been done with me in relation to it. When it was written it was a book. Today, they say it is a feminist book. . . . I am in company better than that of feminism, however democratic and transatlantic bourgeois it may be—[I am in the company of] the two thousand people who went out onto the streets on May 1, who did not know any law other than their own and that of the Armed Forces Movement.[66]

This public declaration lays bare the major arguments against feminism that emerged in the period immediately after April 25, 1974. It reflects the traditional left-wing attitude, which inspires women to demand world peace and to remain silent about the sexual violence to which their neighbors are subjected. It also conveys the key role attributed to class and the secondary role given to social relations between the sexes.

This way of thinking prevented the emergence of autonomous women's organizations in Portugal. The weak efforts to establish organizations always met the opaque resistance of groups politically mobilized by the parties. Not long after the April Revolution, the Movement for the Liberation of Women (MLW) was organized. It brought together women from the extreme Left, some of whom had been militants in similar organizations in France or Italy. On January 13, 1975, the MLW organized a demonstration to celebrate the International Year of the Woman and to demand the right to sexual freedom and abortion. The plan was to burn the garments of the key symbols of femininity: the housewife, the bride, and the femme fatale. The initiative was distorted in the press and was advertised as a public bra burning. It elicited an extremely violent reaction. Men gathered at the site of the demonstration to protest the event, and the protest degenerated into verbal and physical aggression against the women.[67]

No demonstration had ever provoked such anger in Portugal, and this proved to be the first and last time a feminist women's demonstration was held there. Between 1979 and 1984, feminists participated in a number of demonstrations to demand the legalization of abortion, but always as part of a wider group uniting almost all women's organizations. At a symbolic level, these events marked the narrow limits of the debate, as well as the initiatives and autonomous organization, of women in Portugal.

The largest organization, the Democratic Women's Movement (DWM), was founded in the early 1960s as a feminist section of the

Communist Party. It never protested the suppression of the MLW demonstration, however. It was very influential in the trade unions and the so-called Unitary Women's Commissions, which were supposedly independent but were in reality obedient to the Communist Party. The MLW blocked demands for free abortion in these organizations because the issue was considered too controversial and because it did "not help to liberate the country."[68]

This type of organization was modeled on the traditional organizations of Communist parties, according to which various, apparently autonomous fronts serve as means of communication for the party to deal with specific issues. Like the party itself, these organizations tend to emphasize structural class inequalities to the detriment of internal organizational democracy.

It is therefore possible to say that one of the biggest obstacles to the development of autonomous women's organizations in Portugal was the domination of women's organizations by the political parties.[69] The main reason is that these women's party organizations occupied almost all public "space," in the Habermassian sense; namely, by concentrating public opinion and regulating all democratic participation.

The repercussions of this "over-occupation" are especially detrimental in a country such as Portugal. For one thing, the public arena is very reduced and very elitist. It is important, furthermore, to take the developments of the 1970s and 1980s into account. Toward the end of the 1970s, the Communist Party captured an average of 20 percent of the vote in legislative elections.[70] Once it had been removed from power in 1975, it was systematically ostracized and excluded from governmental and parliamentary alliances. This exclusion led it to civil society, the only arena where it could intervene as an opposition force. The instrument it used for political struggle was essentially the trade union movement, although it also tapped other social, political, economic, and cultural associations.[71] This clearly reduced the margin for autonomous action by these organizations.

This said, it is also important to note that women's organizations had to confront the misogyny of conservative right-wing political sectors. The social and cultural traditionalism of those sectors is, moreover, shared with other sectors of the population. It is expressed in surveys on the kind of behavior considered suitable for women. According to these surveys, the majority of respondents would not forgive women any infidelity and

would strongly disapprove of women dressing badly, smoking, or drinking alcohol.[72]

Beyond the influence of the parties, the centrality of Portugal's state apparatus also has an impact on women's nongovernmental organizations. Understanding the dependency of the latter on the former is fundamental to understanding what is happening in Portuguese society.

Relations Between the State and Women's Organizations

During the 1980s, the state emerged as the great protagonist, galvanizing the organization of private interests. After Portugal's integration into the European Union in 1986, the process of economic restructuring and institutional modernization led to the emergence of various economic and social interests. The state played a strong intervening role in the preparation of a political "space" for these social agents. They became the social "legitimating partners" of the state in support of the new model of political development and modernization.[73]

According to European Union rules, the implementation of European Community programs frequently demands the participation of women's organizations, which can act as project partners or as representatives of civil society. Because these organizations did not exist, the state became their promoter. This opened up opportunities for the most "competent" organizations. Such is the case of the Portuguese Association—Studies on Women. The PASW was established in 1991 after a series of meetings organized by the Commission for Equality and Women's Rights (CEWR). The CEWR itself recognizes its active role in this process. The annual brochure it publishes on the situation of women states that the CEWR "also promoted the organization of a National Network of Studies on Women and subsequently the creation of the Portuguese Association—Studies on Women (PASW)."[74]

It is important to note that this initiative was undertaken after the Committee of Ministers of the Council of Europe launched the European Network of Women's Studies in March 1989. The European Commission, furthermore, had also promoted women's studies by creating a database called Grace, linking researchers and institutions in the framework of its Third Program for Action on "Equality of Opportunities for Women and Men." Given the dominant role of the state and its own lack of funds, the

PASW still does not have its own headquarters, and it continues to depend entirely on the CEWR. In light of this example, the autonomy of these kinds of organizations is either very limited or nonexistent. Most of them depend on state funding, and their relationship with the state is therefore a dependent one. Their lack of autonomy makes the state a key point of reference.

It is in this context that the weak organizational expression of women's studies in Portugal can be understood. The discipline faces the same problems as do those involved in the mobilization of funds and individuals. The CEWR has organized the majority of women's studies meetings, the first of which took place in 1983. In 1985, two large conferences were organized by the two largest Portuguese universities; but these conferences were, in the view of this author, more of a voluntaristic act than a real reflection of an increase in research or teaching about women at those universities. The proof is that after 1985 nothing further happened. The last women's studies meeting took place in 1993, also organized by the CEWR.

Again, the central position of the state explains the weakness in this development. The social sciences began to develop fully only after April 1974, given the authoritarian regime's reluctance to see its workings laid bare. Sociology, for example, was considered to be a potentially subversive science. It was linked with socialism, and its teaching concomitantly was restricted to the universities. Because of their weakness, women's organizations did not set in motion a demand for this type of study, as occurred in other countries, such as the United States. Nor were social problems addressed separately from the struggle for power as a whole.

University administration, furthermore, was centralized until 1991, when the law governing university autonomy was passed. This meant that it was difficult to introduce new areas of study: any curricular or course alteration, or the elimination, substitution, or introduction of new disciplines was subject to ministerial approval. This imposition made the system almost immobile and uncompetitive, because opportunities to present new courses were scarce. The development of women's studies was therefore blocked in the places most receptive to the introduction of those studies. Protecting the universities from competition, moreover, has also been pernicious: they have not been forced to seek a public to ensure financing, and this has resulted in a lack of innovation.

To cap all these difficulties, private education is very weak. Given its

ideological origins, the 1976 Constitution gave private education only a secondary role. It is only recently that change at this level has become visible.[75] The few initiatives that have emerged, however, have arisen from the public universities, at the research and postgraduate study levels. Most of these initiatives are driven by the voluntarism of a few researchers and teachers rather than any institutional policy. This brief description helps explain why the PASW has encountered great difficulty in independently validating its interests and in gaining public legitimacy. The same can be said about the majority of other women's organizations.

Concluding Remarks

With the foregoing analysis as background, let us briefly reexamine the debate on the rise of a feminist movement in Portugal. The absence of important factors promoting the rise of social movements, as listed by Neil Smelser, explains the obstacles to the rise of autonomous women's movements in this country.[76]

The first factor is society's structural "conductibility." When certain social and political arenas are not socially regulated, there is greater margin for social mobilization. In Portugal, the extremely regulated nature of social relations between the sexes is constitutionally enshrined, creating rigidity, immobility, and resistance to social movements. In this sense, Portuguese society is therefore not a good conductor for social mobilization.

The second factor is structural tension. In Portugal, sexual inequalities are not, according to the latest surveys, perceived as indicators of social inequality. They exist, but they are not actively acknowledged. It cannot be said, therefore, that a structural tension exists in this arena. The third condition is based on the idea that social movements develop as a result of the dissemination of a certain ideology; it is necessary that certain beliefs become widespread in society. In Portugal, the only feminist ideology that has become widespread is a diffuse or official type of feminism. There is no public debate; and when discussions do arise, most of the participants emphasize, "I am not a feminist, but. . . ."

Curiously, it is usually the "femocrats" who admit to being feminists in these media debates. There are no theoretical schools, as in Spain or Italy, for example.[77] This is obvious even at the level of women's studies. Clearly, in a country where the social sciences as a whole are still under-

developed, this area does not have great opportunities for development. The Portuguese therefore participate in international debates by bearing witness to the peculiarities of the social situation in Portugal, and not by contributing original theoretical perspectives based on a study of those peculiarities.

The fourth condition derives from events that launch the movement into action. In Portugal, the only issue that has precipitated action is abortion. The trial of women accused of the crime of abortion mobilized support and solidarity movements, which led to the dismissal of the cases. After those trials, the Campaign for Abortion was initiated. This was a movement involving collective action and expressing the anti-institutional rupture that, according to Alain Touraine, is characteristic of the first phase of a social movement.[78] But that is as far as it went.

The fifth condition arises from the need for a group to coordinate and organize action. In Portugal, organizations were ephemeral; they got lost in interfactional or interorganizational rivalries and divided by doctrinal or organizational splits. Identification with a group is very strong, but the content of that identification has never been very clear. In Spain, for example, womens' organizations established a National Coordinating Commission and held meetings with thousands of participants.[79] Nothing like this has ever happened in Portugal. On the other hand, a lack of resources and weak mobilization prevented these organizations from establishing their own publications, which are necessary for regular communication among members. The few publications that emerged were short-lived; for some organizations, only a single issue was ever published.

The sixth and final condition mentioned by Smelser is the state's response to the process of social contestation. The state can either adopt measures to change the conductibility of the system or transform the conditions causing structural tension. In the latter case, it can become less receptive to collective action. The difficulties created by the emergence of a legal order imposed "from above," particularly one that became "one of the most advanced and progressive" in the world, are apparent in this case.

The functionalism that underlies Smelser's scheme does have its pitfalls. Social movements can erupt without "justifiable" systemic structural characteristics. In the second condition, for example, it is easy to see that one of the important roles played by women's organizations has been precisely to reveal the existence of previously unrecognized conflict. Smelser's

scheme has therefore been used here merely as an instrument to highlight the questions discussed in the chapter and to reiterate the point that the women's movement was not socially relevant in Portugal. The movement did not show the aggressive qualities that, according to Touraine, characterize anti-institutional ruptures; nor did it mobilize or attract significant parts of the population. The demands it presented were also very limited, given the weakness of the middle classes in Portuguese society.

Thus, numerous social conditions, such as the one indicated above, permit an understanding of Portuguese society as a whole. Although this chapter has focused only on selected aspects of social change, such as state intervention and the mobilization of women, the aim has been to permit a discussion of Portuguese society from a wider gender perspective.

Portuguese Emigration After World War II

MARIA IOANNIS B. BAGANHA

The northern Portuguese landscape is dotted with old houses that are architecturally exotic, with plenty of small, picturesque towers and innumerable decorative elements. One also finds new houses, architectually reminiscent of northern European cottages, with black roofs and large windows. Then there are expensive suburban houses, which their wealthy owners have covered with colorful tiles. A significant number of these are currently being built or enlarged.

These are the houses of former or present-day emigrants. The older ones are known as Brazilian houses and the more recent as French houses. Seemingly out of context, they dot the traditional landscape and constitute the most obvious material evidence that emigration has been a constant feature of modern Portuguese life.

Although Portuguese emigration took people to the United States, Venezuela, Germany, and Luxembourg (to name just a few of the countries where sizable Portuguese immigrant communities have settled historically), the labeling of these houses is rooted in the country's migratory experience. Up to the 1950s, Brazil received more than 80 percent of Portuguese migratory flows, and France approximately half from that period on.

The objective of this chapter is to present a general overview of the Portuguese migratory experience from World War II to the 1980s. It is, however, important to emphasize that Portuguese migration has been a significant historical process for centuries, one that has changed not only the country's landscape but also its way of life and its people's mentality.

The analysis presented here is based on the assumption that Portuguese emigration is essentially an international labor flow, which has changed according to demand for labor in the international market and within Portugal's geographical area. Its evolution has depended not only on the potential migrants' assessment of available rewards for labor abroad, but also on the political sanctioning of the "recipent" nations and the strength of the migrant network active at both ends of the trajectory.

Migration Policies: The Legal Framework

The Marshall Plan gave Western Europe the means with which to launch its postwar economic recovery.[1] Southern Europe and other peripheral regions covered the initial labor shortages resulting from war casualties, and later substituted native labor in the so-called dirty and low-paid jobs. Thus, between 1958 and 1973, the six countries of the European Economic Community issued eight million first work permits to facilitate a mass transfer of labor from the peripheral south to the industrialized north of Europe.

It was only from the 1960s on that Portugal began to participate substantially in this intra-European transfer of labor. This can be shown with an analysis of foreign arrivals in France between 1950 and 1974. France was a major destination for migration in this period and the preferred destination for Portuguese emigrants. In 1961, Portuguese arrivals began to exceed 10,000, representing 10.5 percent of all foreign arrivals, which in that year numbered 160,000. Previously, immigration to that country had consisted mainly of migrants from Italy and Spain. Between 1950 and 1959, Italians represented more than half of the total foreign inflow. In 1960, Spaniards equaled the number of Italians entering France, with each of these nationalities contributing 30,000 migrants to a total of 72,600 arrivals. The Spaniards replaced the Italians as France's main suppliers of foreign labor from 1961 to 1965, and were in turn replaced by the Portuguese from 1966 to 1972. From 1962 on, Portugal's share grew constantly. In 1970 and 1971, Portuguese migration peaked. Total arrivals numbered 255,000 in 1970 and 218,000 in 1971. The Portuguese contribution represented 53 percent (136,000) and 51 percent (111,000 migrants) respectively.[2]

The Portuguese did not simply replace the Italians and the Spaniards numerically; they also took up job vacancies in public works, construction,

and the domestic and personal service sectors, as well as in agriculture.[3] An analysis of the structure of the active native and foreign labor force in France also suggests that the labor market was segmented, with certain jobs specifically taken up by foreign laborers in the public works and construction sectors.[4]

The oil crisis of 1973–74 and the restrictive immigration policies of receiving countries halted the influx of foreigners. Up to then, however, the major recipient European countries had "open door" immigration policies. The same cannot be said of Portuguese migratory policy. Indeed, until 1974, individual freedom to emigrate was subordinated to the economic and imperial aims of the state. According to Article 31 of the 1933 Constitution, "The state has the right and the obligation to coordinate and regulate the economic and social life of the Nation with the objective of populating the national territories, protecting emigrants, and disciplining emigration." The *Estado Novo* tried to attain three key goals with this policy: to meet the country's own labor needs, to satisfy its interests in Africa, and to benefit from emigrant remittances with a supervised export of labor.

In 1944 the issuing of ordinary passports to any industrial worker or rural labor was interdicted; in 1947, after a temporary total ban on emigration, a special government agency, simultaneously dependent on the Foreign and the Interior ministries, was created to regulate and supervise emigration. The Junta da Emigração aimed to implement a quota system that defined the maximum number of departures by region and occupation, after taking into account regional labor needs and the structure of the active population.

According to the same logic, several bilateral treaties were signed in the 1960s with the Netherlands, France, and the Federal Republic of Germany. These treaties, which explicitly aimed to maximize economic returns from emigration to these countries, were accompanied by an order to the Emigration Services to allow a maximum of thirty thousand legal departures a year, and by a total ban on the legal departure of those engaged in specific occupations.[5] The combined effect of these policies was to ensure a migratory flow that the state considered beneficial to the country's labor supply and to its economic development.

The rationale behind such government policies was based on two notions: first, that the excess labor supply could be profitably exported without endangering the country's labor needs; second, that with the aban-

donment of the initial policy of labor-intensive traditional industries in northern Portugal, an increase in rural output would favor the creation of a leading modern industrial sector in the Lisbon area. This industrial sector, along with the banking and insurance sectors also centered mainly in the Lisbon area, came to absorb the majority of skilled or highly skilled workers and professionals. Neither of these groups was particularly inclined toward emigration.

On the eve of the 1974 Revolution, the state was ready to promulgate an unprecedented liberal law, justified on the grounds that emigration was highly beneficial for Portugal because it promoted gains in productivity and the rationalization of production methods. The law concluded with the following statement: "Emigration, which acts as a positive factor in modernization and the rationalization of labor, contributed greatly to the progress and development of the country."[6] Individual freedom to emigrate and return were finally written into the 1976 Constitution. By that time, however, most European countries had shifted to a "closed-door" policy.

The Evolution of Migration Flows

Between 1950 and 1988, the Portuguese Emigration Bureau, the Secretaria de Estado de Emigração, registered 1,375,000 legal departures.[7] Of these, five countries absorbed 82 percent (see Table 10.1). This official picture should be compared with French and German sources, which state that the number of Portuguese migrants during this period was actually closer to 1,259,000.[8] Even considering only Portuguese emigrants to these two destinations, emigration between 1950 and 1988 totaled at least 2,152,000. This means that during this period, at least 36 percent of Portuguese migrants left the country illegally.[9]

No systematic study has ever been made of clandestine migrants. The study of illegal Portuguese migration in other historical periods, as well as available information on illegal departures to Europe after World War II, however, indicates that clandestine flows differ significantly from legal ones. Illegal Portuguese migrants tend to be isolated and unskilled males in their prime; this increases the likelihood that legal flows do not accurately reflect actual migratory flows between 1950 and 1988.[10]

One corrective for the discrepancies in the figures is to examine the rela-

TABLE 10.1
Principal Destinations of Portuguese Legal Emigration, 1950–1988
(in thousands)

	Legal Departures	Percentage
France	347	25.0
Brazil	321	23.0
United States	193	14.0
Germany	135	10.0
Canada	138	10.0
Other	241	18.0
TOTAL	1,375	100.0

SOURCE: SECP, *Boletim anual*, 1980–81, 1988.

TABLE 10.2
Principal Destinations of Portuguese Emigration, 1950–1988
(in thousands)

	Legal Departures	Percentage
France	1,024	48.0
Brazil	321	15.0
United States	193	9.0
Germany	235	11.0
Canada	138	6.0
Other	241	11.0
TOTAL	2,152	100.0

SOURCES: see Table 10.6.

tive attraction of the principal recipient countries. According to French and German records, we can correct the distribution in Table 10.2. Table 10.1 shows that the two preferred European destinations (France and Germany) attracted 35 percent of the total between 1950 and 1988, and that the three overseas destinations (Brazil, Canada, and the United States) attracted 47 percent. Table 10.2, by contrast, indicates that the two key European destinations accounted for 59 percent of the total, and the three overseas destinations for just 30 percent, in the same period.

We can also correct the yearly totals by destination (see Table 10.6, pp. 204–05), which helps to obtain a better sense of the evolution of the "true" Portuguese migratory flow. The first remarkable change indicated in Table 10.6 is the intensity of growth of the total migratory flow. The annual average number of departures jumped from 33,000 in 1955–59 to 55,000 in 1960–64, 110,000 in 1965–69, and 134,000 in 1970–74. The average declined drastically to 37,000 in 1975–79, the same level of average annual

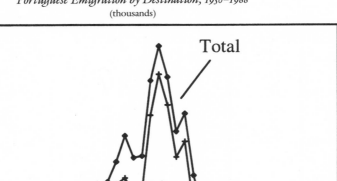

FIGURE 10.1
Portuguese Emigration by Destination, 1950–1988
(thousands)

SOURCE: Table 10.6

departures attained in the initial period (1950–54). Numbers decreased even further to 17,000 average departures between 1980 and 1988. This intense and sustained growth in the 1960s and early 1970s can be attributed to the Portuguese migratory flow to Europe, particularly to France, which absorbed 60 percent of the total migratory flow in this period.[11]

The data from Table 10.6 can be visually summarized in Figure 10.1. Both Table 10.6 and Figure 10.1 show that Portuguese emigration grew constantly and substantially from 1950, when departures numbered 22,000, to 1970, when departures numbered 183,000. It declined from 1971 to 1988, as departures dropped from 158,000 to 13,000. The peak years of Portuguese emigration after World War II occurred between 1965 and 1974, when the annual average number of departures was 122,000.

It can also be inferred that three major changes in preferred destinations took place between 1950 and 1979. In the first decade (1950–59), the overseas flow was clearly dominant. Indeed, of the 350,000 departures, 327,000 (93 percent) went overseas. A single country, Brazil, absorbed 68

percent of the global total of departures. In the following decade (1960–69), the overseas flow lost its relevance. Europe attracted 68 percent of the total number of departures, with France absorbing 59 percent of the global total. This shift occurred in 1962–63. In 1962, total departures numbered 43,000, of which 24,000 went overseas (57 percent) and 19,000 went to Europe (43 percent). In 1963, the total number of departures numbered 55,000, of which 22,000 (41 percent) went overseas and 33,000 (59 percent) to Europe. Europe clearly dominated between 1963 and 1977, but from then on, overseas destinations became dominant again. The European share fell from 56 percent in 1977 to 43 percent in 1978 and 39 percent in 1979. In the last period, 1980–88, overseas destinations accounted for 51 percent of all departures.

The change in the relative weight of migratory flows overseas is not the only noticeable shift. Although they tended to decrease in absolute terms, overseas flows did not register any dramatic change before 1979. They did, however, register a major change in the absolute and relative weight of the receiving countries. In the early 1960s, the contraction of the flow to Brazil was quite dramatic: the average annual number of departures to that country fell from twelve thousand to three thousand between 1960–64 and 1965–69. The United States and Canada took Brazil's place during this period; the annual number of departures to the United States rose from three thousand in 1960–64 to ten thousand in 1965–69, and to Canada the total rose from four thousand to six thousand.

Lack of information on illegal migrants usually creates a bias, increasing the relative weight of gender, age group, and marital status. Origin and distribution by activity are meant to be the characteristics least affected, if not in absolute at least in relative terms. This analysis will therefore focus on the more reliable factors. Table 10.3 shows the distribution of Portuguese emigration by region of origin.

Because the contributions of the islands and the mainland are quite different in terms of their respective shares in total flows, their direction, and the characteristics of their migrants, they will be treated separately. Between 1950 and 1988, the islands' migratory flow accounted for 21 percent of the total, and was overwhelmingly directed overseas. The Azorean flow went to the United States and grew markedly during the 1960s and the 1970s, after the United States passed the 1965 amendments favoring family reunification in the concession of U.S. immigrant visas and revised its

TABLE 10.3
Percentage of Portuguese Emigration by District, 1950–1988

	1950–59	1960–69	1970–79	1950–79	1980–88
Aveiro	10.74	6.62	7.32	7.84	10.93
Beja	0.18	1.08	2.04	1.13	0.45
Braga	6.04	9.31	6.24	7.63	4.01
Bragança	6.32	3.78	1.81	3.85	1.06
C. Branco	1.43	5.17	1.94	3.33	1.15
Coimbra	4.80	2.84	3.78	3.59	3.65
Evora	0.10	0.38	0.73	0.41	0.24
Faro	2.25	3.69	2.45	2.98	1.28
Guarda	6.76	5.80	2.29	5.04	2.22
Leiria	3.98	7.66	6.88	6.53	4.95
Lisbon	2.17	8.10	12.14	7.78	18.91
Portalegre	0.15	0.37	0.31	0.30	0.20
Porto	10.47	8.55	7.73	8.79	7.76
Santarém	1.94	3.79	3.42	3.23	3.50
Setubal	0.32	1.75	3.08	1.77	5.19
V. do Castelo	4.64	5.63	2.97	4.63	3.52
Vila Real	5.54	3.88	3.98	4.32	4.21
Viseu	10.59	4.73	5.39	6.37	3.26
Total mainland	78.41	83.12	74.51	79.51	76.50
Azores	6.14	11.17	19.30	12.23	21.21
Madeira	13.75	5.63	6.17	7.80	2.29
Unknown	1.70	0.08	0.01	0.46	0.00
TOTAL	100.00	100.00	100.00	100.00	100.00
Total number of emigrants	342,928	646,962	392,517	1,382,407	89,562

SOURCE: SECP, *Boletim anual*, 1980–81, 1988.

national origin quota system, in place since 1968. These measures increased the share of southern European migration and the Portuguese quota of entry with it.[12] Madeira's flow contracted markedly after the 1950s, when Brazil ceased to be a major destination, and has remained at a relatively low level since.

The flow from the mainland in the period 1950–88 represented 79 percent of the global flow. It was essentially directed toward Europe, particularly to France and Germany. It is possible to conclude from Table 10.3 that three regions of the mainland—the Lisbon interior, the Alentejo, and the Algarve—were not major sources of emigration. Together these three regions supplied a total of 111,000 migrants between 1950 and 1988. This figure is lower than the total of any of the other five regions considered individually. The heaviest suppliers of the period were the coastal regions, always contributing more than half the total migrants. The northern coast alone provided 305,000 migrants (26 percent of all the mainland flow).

An analysis by periods shows that the most remarkable change is in the numbers leaving from the Lisbon coastal region. In the 1950s, this region had only 8,500 emigrants. The number rose to 64,000 and 60,000 during the 1960s and 1970s, respectively, when France and Germany became the preferred countries of destination. The Lisbon coastal region became the country's main migratory area between 1980 and 1988, representing 24 percent (22,000 migrants) of mainland total legal flows.

This change seems to be connected to a major difference between the composition of migration flows overseas and to Europe. When directed overseas, migration was essentially from rural areas, both on the mainland and on the islands. When directed to Europe, it was linked to the most urban and industrial areas. Current trends show an even clearer intensification of this pattern, as documented by the growth of the Lisbon coastal region.

Key Migrant Characteristics

An analysis of the economic characteristics of the legal migrants will reinforce this point. Table 10.4, which summarizes legal migrant characteristics between 1955 and 1988, indicates that of the economically active migrants who left the country legally, 26 percent in 1955–59, 38 percent in the 1960s, and 50 percent in the 1970s were engaged in the secondary economic sector. Equally relevant is the increase in the annual number of departures from this sector. It rose from 5,000 in 1955–59 to 10,600 in 1960–69, clearly pointing to the greater attraction that European labor markets exerted over the urban and industrial sectors.

As noted earlier, sex-, age-, and marital status–based assumptions are risky. Nevertheless, Table 10.4 permits two conclusions. First, the flow overseas that was dominant in the 1950s was more male dominated and tended less toward family reunification than the European flow. Second, the European flow constituted a first wave in the 1960s, a flow dominated by isolated departures of single or married males in their prime, followed by a second wave in the 1970s, consisting largely of family reunification flows, as suggested by the growing share of children under 15 years of age and the number of married migrants.

French sources confirm this change in composition. Between 1960 and 1971, workers represented 68 percent of the Portuguese arrivals to that

TABLE 10.4
Characteristics of Legal Migrants, 1955–1988

	1955–59		1960–69		1970–79		1980–88	
	No.	%	No.	%	No.	%	No.	%
GENDER								
Male	96,357	60.35	378,080	58.44	210,347	58.79	50,253	56.11
Female	63,300	39.65	268,882	41.56	147,455	41.21	39,309	43.89
AGE								
–15	37,376	23.41	171,434	26.50	99,757	27.88	21,695	24.22
15–64	120,104	75.23	468,994	72.49	254,163	71.03	66,165	73.88
65+	2,177	1.36	6,534	1.01	3,882	1.08	1,702	1.90
MARITAL STATUS								
S	93,066	58.29	307,161	47.48	166,593	46.56	39,545	44.15
M	63,608	39.84	329,594	50.94	185,894	51.95	47,789	53.36
Other	2,983	1.87	10,207	1.58	5,315	1.49	2,228	2.49
ECONOMIC SECTOR[a]								
1ary	43,634	56.43	140,730	50.05	54,175	32.39	6,157	16.86
2ary	20,245	26.18	105,908	37.67	84,101	50.29	23,421	64.15
3ary	13,448	17.39	34,539	12.28	28,969	17.32	6,932	18.99
TOTAL ACTIVE	77,327	100.00	281,177	100.00	167,245	100.00	36,510	100.00
INACTIVE	52,425	40.40	240,399	46.09	163,155	49.38	53,052	59.23
TOTAL	129,752		521,576		330,400		89,562	
TOTAL	159,657	100.00	646,962	100.00	357,802	100.00	89,562	100.00

SOURCE: SECP, *Boletim anual*, 1980–81, 1988.
[a] Emigrants aged 10 or older.

country. From 1972 to 1979, on the other hand, they represented only 37 percent, and from 1980 to 1988 just 36 percent.[13] Both Portuguese and receiving country data also indicate that after 1970, a growing number of Portuguese immigrants either decided or were forced to return to Portugal.

Return Migration

The myth of the return is deeply embedded in Portuguese emigrant culture. It plays a role in the decision to leave, and it is an important reason why, before World War II, men migrated while women stayed, even though many men never returned.[14] Portuguese emigration to Europe in the 1960s initially fit this traditional pattern. After a decade, however, family reunification became a new trait of Portuguese emigration because of the proximity of the host societies, new means of transportation, and labor opportunities for women in the receiving areas.[15] Yet even then, the desire to return was not abandoned.

The number of returnees, their sociodemographic characteristics, their social reintegration, and its economic impact are perhaps the most researched topics in recent migration studies.[16] From these studies, it is possible to make several observations. After ten to fourteen years of working permanently abroad, the objectives that led a significant number of men to leave Portugal, and later to call their families to join them, apparently were attained. Various factors, moreover, seem to indicate the culmination of a cycle of family migratory projects. For example, the number of yearly returnees grew: seven thousand in the 1960s, thirteen thousand in the 1970s, and fifty-two thousand in the 1980s.[17] Among the returnees, 25 percent in 1970 and 32 percent in 1980–81 were between the ages of 1 and 19. And 86 percent of returnees were already married when they first emigrated.

Predictably, returnees were mostly male (71 percent of the total). This was because migratory flows were male-dominated until the 1970s, and because family reunification and second-generation educational prospects in host societies made staying there appear more favorable than returning to an uncertain future at home.[18] Most returnees were originally connected to agriculture in Portugal, and 90 percent returned, if not to agriculture, at least to their communities of birth. More than half were over 45 years

old, and one-third were older than 56. Of those who went to France, 56 percent worked in construction and public works.

Returnees followed a dominant economic trajectory. Before emigration, 45 percent worked in agriculture and 18 percent in construction. As emigrants, 37 percent worked in construction and 32 percent in manufacturing.[19] On returning, 38 percent worked in agriculture, 18 percent in construction, and 17 percent in small trades or catering. It is important to note that only 59 percent of returnees opted for an active life, and that the majority of those working in agriculture or small businesses were self-employed.

For the majority of these returning migrants, emigration was a success story.[20] A house, major appliances, a car, a small trade or restaurant, the opportunity for wives to stop working, the return to the region of departure, and a varying, but frequently reasonable, level of savings all guaranteed upward mobility.

As far as the Portuguese economy is concerned, however, returnee contributions are debatable. The overwhelming majority of returnees either are illiterate (12 percent), have no formal schooling (24 percent), or have attended only primary school (56 percent). New skills acquired have not been easily transferable; nor are former emigrants interested in taking up the same jobs they had abroad. They have used their savings primarily for consumption rather than productive investment. It is undeniable, however, that they have made a major contribution to regional development, and that with more adequate policies, their contribution could increase.

In demographic terms, the impact of emigration between 1960 and 1979, the heaviest period, represented 47 to 55 percent of the country's natural population growth. Yearly migration rates during that period varied from 5.3 to 6.1 migrants per thousand inhabitants, while the annual average number of departures was 82,419. In the same period, returns are estimated to have been between 30,000 and 37,000; Portugal's annual natural population growth was 95,693. Thus, net migration can be estimated at between 45,400 and 52,400. Based on the 1970 census (total population 8.569 million), the yearly migration rate between 1960 and 1979 must have oscillated between 5.3 and 6.1 migrants per thousand.[21] For intercensus periods the numbers were as shown in table 10.5.

These figures do not account for total impact, because migration caused a significant part of the country's demographic potential to go unfulfilled.

TABLE 10.5
Demographic Evolution, 1951–1981
(in thousands)

	Natural Growth	Effective Growth	Net Migration
1951–60	1,090.8	410.0	−680.8
1961–70	10,720.6	−282.6	−1,355.2
1971–81	838.7	1,284.1	+445.4

SOURCE: 1981 Census; SECP, *Boletim anual*, 1980 and 1981.

In economic terms, between 1973 and 1979, emigrant remittances represented 8.22 percent of the gross domestic product; between 1980 and 1989, the number rose to 10 percent. As a percentage of the GDP, remittances varied between 5.6 in 1975 and 12.1 in 1979, according to the Instituto Nacional de Estatística. Considering the relative weight of remittances in relation to the country's exports, the figures are even more impressive. Remittances increased from 13 percent of the country's exports in the 1950s to 25 percent in the 1960s and 56 percent in the 1970s.

These crude indicators illustrate the impact of Portuguese emigration on the country's economy and demography, but they do not tell whether that impact was beneficial. The latest econometric simulations to measure the trade-off between emigration and remittances suggest that "past emigration had positive welfare effects, which means that the positive effects of remittances dominate the negative welfare effects of depopulation. However, the annual growth of domestic production has been slowed down by about half a percentage point."[22]

Changes in the 1970s

With or without state permission, by the mid-1960s and early 1970s, the Portuguese were leaving the country in increasing numbers. Sociologists and historians working during those years stressed the duality of Portuguese society and the imbalances of the country's economic structure as the main factors driving a growing number of migrants out of the country.[23] Economists prefer to emphasize pull factors, and they name the wage differential between Portugal and the receiving countries as the main factor shaping Portuguese emigration.[24] According to one recent study, changes in the productive structure in the 1960s created high natural rates of unemployment and chronic underemployment in the agricultural and

family craft sectors, thereby giving a growing number of Portuguese men in their prime strong reasons to migrate to improve their lives.[25]

The push-pull factors analyzed in these works were obviously important, but for the most part, they ignore the condition that if international labor flows are indeed demand-oriented, the response of each individual does not depend on the evolution of the labor market in the host country alone. Indeed, the evolution of migration after 1974 clearly reflects the impact of other factors, namely, the political sanctions of the recipient nations and the strength of migrant networks active at both ends of the trajectory. Without taking these factors into consideration, how can the extremely low migratory flows of the period be explained?

Economic recession in most of the Organization for Economic Cooperation and Development (OECD) countries after the mid-1970s, and conditions in Portugal in the aftermath of the 1974 Revolution, were aggravated by the forced return of four hundred thousand Portuguese from the former African colonies, along with one hundred thousand troops. Emigration was abruptly halted by the receiving societies in the early 1970s, which aggravated the economic situation. All these factors, plus the legal prohibition of firing and dismissing employees, led the private sector to avoid new permanent labor contracts. This change, in turn, brought about major changes in the national labor market.[26]

Unemployment jumped from 86,000 in 1974 to 222,000 in 1975, and continued to grow. In 1980 the number of unemployed was 340,000, and by 1983, the figure had reached 446,000 thousand, or 10.5 percent of the active population. Furthermore, as economists José Barosa and Pedro Pereira note, "[measured] unemployment does not tell the whole story, as a survey of the Ministry of Labor found 95,000 workers in 1983 to be wageless."[27] As they also point out, the labor market began to show signs of recovery in 1979, after new legislation in October 1977 gave the private sector flexibility to hire workers over a fixed period. Unemployment finally decreased, dropping to 8.5 percent in 1985, to 7 percent in 1987, and to 5.7 percent in 1988. Even today, an increasing number of the new jobs are still based on short-term contracts.

As noted earlier, Portuguese migratory flows to Europe peaked in 1970 and tended to decrease thereafter, but it was only after the oil crisis of 1973–74 that great and sudden reductions were observed. The drop in migrant laborers was even greater, at least until 1986. For France, the data

indicate that laborers dominated the migratory flow to that country until 1971. Between 1972 and 1977, their relative share fell but remained significant. From 1978 to 1985, the flow was overwhelmingly composed of families. For 1987–89, the three last years for which information is available, laborers were dominant, although less than before; they represented 74 percent of the 17,000 immigrants arriving in France.

Deteriorating economic conditions and mass return migration from the former colonies undoubtedly increased migratory pressure in this period; annual average departures, however, fell from 122,000 per year between 1968 and 1975 to 22,000 per year between 1976 and 1988. Economic factors alone cannot explain the contraction in flows in the latter period. Restrictive migratory policies in the traditional recipient countries and the lack of sizable migratory networks functioning in other destinations left potential migrants temporarily without alternatives.

Portuguese scholars wrote the obituary for Portuguese emigration to Europe in 1985 at an international meeting called "Portugal and Europe: The End of a Migratory Cycle."[28] It was too soon, however. Indeed, Portuguese emigration to Europe is, once again, a significant phenomenon.[29] It should come as no surprise if in some years' time, we see the Portuguese landscape enriched with a new set of houses, perhaps labeled Swiss houses. When they appear, they will once again give evidence of Portugal's most constant modern historical phenomenon: emigration.

TABLE 10.6

Portuguese Emigration by Destination, 1950–1988

	Brazil	USA	Canada	Total Overseas	France	Germany	Other Europe	Total Europe	Total	%
1950	14,143	938	—	21,491	319	1	81	401	21,892	1.83
1951	28,104	676	—	33,341	418	2	254	674	34,015	1.98
1952	41,518	582	—	46,544	650	4	209	863	47,407	1.82
1953	32,159	1,455	—	39,026	690	—	246	936	39,962	2.34
1954	29,943	1,918	—	40,234	747	4	205	956	41,190	2.32
1955	18,486	1,328	—	28,690	1,336	—	121	1,457	30,147	4.83
1956	16,814	1,503	1,612	26,072	1,851	6	167	2,024	28,096	7.20
1957	19,931	1,628	4,158	32,150	4,640	5	99	4,744	36,894	12.86
1958	19,829	1,596	1,619	29,207	6,264	2	127	6,393	35,600	17.96
1959	16,400	4,569	3,961	29,780	4,838	6	130	4,974	34,754	14.31
1960	12,451	5,679	4,895	28,513	6,434	54	158	6,646	35,159	18.90
1961	16,073	3,370	2,635	27,499	10,492	277	304	11,073	38,572	28.71
1962	13,555	2,425	2,739	24,376	16,798	1,393	435	18,626	43,002	43.31
1963	11,281	2,922	3,424	22,420	29,843	2,118	837	32,798	55,218	59.40
1964	4,929	1,601	4,770	17,232	51,668	4,771	1,905	58,344	75,576	77.20
1965	3,051	1,852	5,197	17,557	60,267	12,197	1,467	73,931	91,488	80.81
1966	2,607	13,357	6,795	33,266	63,611	11,250	3,868	78,729	111,995	70.30
1967	3,271	11,516	6,615	28,584	59,597	4,070	2,461	66,128	94,712	69.82
1968	3,512	10,841	6,833	27,014	58,741	8,435	2,037	69,213	96,227	71.93
1969	2,537	13,111	6,502	27,383	110,614	15,406	2,269	128,289	155,672	82.41

Year										
1970	1,669	9,726	6,529	22,659	135,667	22,915	1,964	160,546	183,205	87.63
1971	1,200	8,839	6,983	21,962	110,820	24,273	1,418	136,511	158,473	86.14
1972	1,158	7,574	6,845	20,122	68,692	24,946	1,785	95,423	115,545	82.59
1973	890	8,160	7,403	22,091	63,942	38,444	5,255	107,641	129,732	82.97
1974	729	9,540	11,650	25,822	37,727	13,352	3,958	55,037	80,859	68.07
1975	1,553	8,975	5,857	19,304	23,436	8,177	1,569	33,182	52,486	63.22
1976	837	7,499	3,585	14,762	17,919	5,913	598	24,430	39,192	62.33
1977	557	6,748	2,280	14,826	13,265	4,835	750	18,850	33,676	55.97
1978	323	8,171	1,871	16,307	7,406	4,509	636	12,551	28,858	43.49
1979	215	8,181	2,805	17,532	5,987	4,400	807	11,194	28,726	38.97
1980	230	4,999	2,334	15,281	5,200	4,000	692	9,892	25,173	39.30
1981	228	4,295	2,196	14,498	8,600	3,100	409	12,109	26,607	45.51
1982	187	1,889	1,484	9,420	17,900	1,900	285	20,085	29,505	68.07
1983	197	2,437	823	6,242	6,300	1,500	166	7,966	14,208	56.07
1984	121	2,651	764	5,747	4,600	1,400	116	6,116	11,863	51.56
1985	136	2,783	791	5,842	4,000	1,600	109	5,709	11,551	49.42
1986	91	2,704	983	5,024	1,800	3,100	280	5,180	10,204	50.76
1987	28	2,643	3,398	7,757	400	3,100	158	3,658	11,415	32.05
1988	21	2,112	5,646	8,934	600	3,600	198	4,398	13,332	32.99

SOURCES: France: 1950–79, "Statistiques de l'immigration", 1988, ONI, in Antunes, "A emigração portuguesa des de 1950: Dados e comentários," *Cadernos GIS*, no. 7 (Lisbon, GIS, 1973), 14; Stahl et al., *Perspectivas da emigração portuguesa*, 61. Germany: "Statistiches Bundesant" 7-B, 182, in Stahl et al., 63. All other countries: SECP, *Boletim anual*, 1980–81, 1988; *Systéme d'observation permenent des migrations* (Paris, OECD) 1980, 1986, 1988, 1990.

NOTE: The special legalization from 1963 to 1968 was deducted.

Cultural Myths and Portuguese National Identity

NUNO G. MONTEIRO AND
ANTÓNIO COSTA PINTO

Most European states fixed their frontiers and became autonomous political entities only in the nineteenth or twentieth century, but the redefinition of preexisting territorial frontiers has occurred throughout history. The 1990s can be seen as the continuation of a cycle of boundary redefinition interrupted for almost half a century, with the international recognition of a significant number of new states after the collapse of the Eastern bloc. The nineteenth century witnessed the unification of various territories under different political units; the twentieth century, on the other hand, has seen the logic of fragmentation prevail.[1]

Britain, France, and Spain are European states whose autonomous political existence was established long before the nineteenth century. Both before and after the French Revolution, however, significant tensions and conflicts emerged almost everywhere, even in regions that had enjoyed political and institutional autonomy before their incorporation into larger state boundaries. These states subsequently preserved strong cultural and linguistic identities.

The above points are fundamental to understanding why, until recently, the theme of national identity has been virtually absent from Portuguese historiography. The explanation for this is simple: Portugal is a political entity that has maintained stable frontiers since the thirteenth century. Its existence as an autonomous kingdom from the twelfth century on was

interrupted only for little more than half a century (1580–1640). Portugal, moreover, has never confronted problems of linguistic diversity. All historians, not just those of a nationalist-corporatist bent, have generally taken the nation's existence for granted.

Modern political nationalism, which first emerged during the Liberal Revolution (1820–1834), never once questioned the existence of the nation and its unity; the central political question in Portugal has always been the "decadence" of the nation. The image of past grandeur associated with the Middle Ages and the maritime discoveries of the fifteenth and sixteenth centuries has permeated erudite culture, as well as national visionary currents of thought. School socialization under the First Republic (1910–1926) and the *Estado Novo* (New State) (1933–1974) reinforced these currents of thought.

Portugal was also affected by the great intellectual and political movements of the turn of the century; the vision of the nation was redefined and consolidated in this period. Remote historical periods and events such as the Middle Ages were key in creating that vision of the nation and national identity. Historians invariably painted that period in heroic colors. Throughout the nineteenth and twentieth centuries, the Middle Ages and the maritime discoveries were pet themes of Portuguese writers and publicists.

The establishment of the kingdom in 1143 and the consolidation of its frontiers in the 1200s have been portrayed by nationalistic contemporary historians as epic events, permitting the early triumph of Christianity over the Moors in the western Iberian Peninsula. A recent study of medieval Portugal has interpreted this period in a new way. Because the author remains more preoccupied with the question of the nation's origins, however, his interpretation of events does not differ much from that of previous works. It is still based on the idea that "the notion of national identity, that is, the differentiation between the *regnum* as a political unity defined by monarchical power over a limited territory and its inhabitants, seems clear from the first half of the thirteenth century on."[2]

The medieval period undoubtedly left unique marks on the modern monarchy. Unlike Portugal, seventeenth-century France has recently been described as a mosaic of imperfectly united particularities and languages.[3] Portugal's kingdom, by contrast, emerged not from the integration of territorial communities but through conquest. Regional rights, provincial

institutions, strong seigneurial powers, or markedly divergent linguistic communities did not exist. Portugal had no *fueros* like those in Aragon until the period 1707–1716, and Navarre under the Spanish monarchy. Nor did it have any parliaments or provincial rights, as under the French monarchy.

It is also important to emphasize that from the middle of the eighteenth century on, Portugal had no ethnocultural minorities. During the medieval period, Moorish and Jewish communities, the *mourarias* and the *judiarias*, had been very important. With forced conversion and the expulsion decree ordered in 1496 by King Manuel I, however, their legal recognition was terminated. For more than two centuries, the main offense against the faith persecuted by the Tribunal of the Holy Offices of the Inquisition in Portugal was "judaism," the accusation directed at people suspected of practicing the Jewish religion. Converted Jews became known as New Christians, an infamous designation that their descendants inherited. During the rule of the Marquis of Pombal (1750–1777), however, the distinction between New Christians and "old Christians" was finally formally abolished.[4]

The brief period of the Catholic peninsular monarchy (1580–1640) is a key point of reference in the contemporary vision of the nation. The medieval battle of Aljubarrota, waged when dynastic union was at risk, and the regaining of independence in 1640 are still celebrated today as fundamental moments in the affirmation of national identity against the eternal Spanish enemy. It was only in reaction to proposals for Iberian union during the second half of the nineteenth century, however, that the events of 1640 "became" a "national revolution."

This interpretation of events has been directly questioned by recent historical research. Actually, the Restoration seems fundamentally to have been a reaction against attempts to impose institutional uniformity by the Count-Duke of Olivares; it was undertaken in the name of traditional institutions and not the nation. Moreover, contemporary references to the nation and to the feeling of national belonging competed with other equally important identities.[5] A combination of favorable circumstances in Europe (the alliance with Britain and rivalries between the European powers), along with the increase in income from Brazil, permitted the consolidation of the kingdom's autonomy.[6]

The Rise of Nationalism: The Liberals

The nineteenth century in Portugal was dramatically inaugurated by the invasion of French troops in 1807 and the emergence of successive nationalisms. Anti-French nationalism emerged almost immediately.[7] The period of the invasions was followed by a durable British military presence. Anti-British nationalism decisively marked the genesis of the Liberal movement in 1820. Another key political question that dominated the first Liberal triennium (1820–1823) was how to integrate Brazil by creating one nation on the basis of two kingdoms. These difficulties finally favored Brazilian independence, proclaimed in 1822.[8]

The first modern constitutional experiment was thus brought to a head. It was also during this period that a discourse based on the themes of decadence and regeneration emerged. It highlighted the grandiose period of the Middle Ages and the discoveries and the decadence of the sixteenth century, with the emergence of the Inquisition, the abandoning of productive activities, and finally the loss of independence in 1580. According to this line of thinking, the continuous process of decadence could be halted through the regenerative impulse of internal reforms, which had become necessary after the definitive loss of economic control over Brazil.

The same images predominated after the 1832–34 civil war. Even the "ultrarealist" discourse that reigned between 1828 and 1832 had a strong nationalist component.[9] Anti-British nationalism became a fundamental element of intra-liberal disputes; Liberals were divided over Portugal's position in relation to Britain.[10]

Portugal participated in the intellectual and political movement to reformulate European nationalism at the end of the nineteenth century. As Rui Ramos describes it, however,

in the case of Portugal there were neither minorities nor citizens living in neighboring States on land that could be called national territory. But it was not just for this reason that the "national question" was not the sole point of reference to explain all problems between 1890 and 1930.[11]

The decisive role played by intellectuals in the search for the historical roots of Portuguese culture is a phenomenon that antedates the nationalism of the end of the century. Decades earlier, key Romantic and Liberal writers such as Almeida Garrett and Alexandre Herculano had studied

medieval history; they had done so in the name of a "patriotism" that "still maintained the classic sense of civic love of the common good, and not the sentimental adherence to a State."[12] This patriotism was in no way incompatible with Iberianism, the belief in a common political destiny for the diverse peoples of the Iberian Peninsula, a belief shared by various mid-century intellectuals. It was the advent of widespread Iberianist sentiment, combined with vague projects for the union of peninsular dynasties, that led to the 1868 commemoration of December 1, 1640, the date of the Restoration.[13] The timidity of the celebrations, however, contrasted sharply with those of later nationalist movements.

The Generation of 1870 was also of key importance in the development of thinking on the issue of national identity. A number of important writers radically criticized the realities of "triumphant" Liberalism in Portugal. Their work was characterized by a keen national feeling. The generation of 1870 was very cosmopolitan compared with the exacerbated nationalism of the generations that followed, although some of its members later became key supporters of the more extreme form of nationalism.[14]

The Radicalization of Nationalist Thinking: The Republicans

The watershed signaling the decisive modification of Portuguese political culture occurred with the British Ultimatum of 1890.[15] Portugal had retained some African territories, but their political and symbolic importance increased when other European countries sought to gain territories in Africa in the 1880s. Britain directly opposed chimeric Portuguese projects to link Angola to Mozambique. The first large anti-British demonstration took place in 1890 to protest the Ultimatum. The Republicans capitalized on anti-British mobilization in 1890 and even organized a coup attempt in 1891. The uprising failed, but from then on, political culture was marked by an imperialist nationalism.

Ten years earlier, the Republicans had taken advantage of nationalist sentiment when the three hundredth anniversary of the death of Portugal's "national poet," Luís de Camões, was celebrated in 1880. At the beginning of that year, the Republicans proposed "three days of public holiday" to celebrate the Camões centennial and to overcome the "crisis of spirits" and promote a "national revival." They were proudly supported by their most influential positivist theorist, Teófilo Braga. The commemorative move-

ment grew, transforming the forty thousand–strong "civic" processions into protests against the Liberal monarchy and forming the basis for the Republican movement.[16]

Republican indoctrination and propaganda were decisive for Portuguese nationalism at the end of the century. Braga's Positivist Republicanism provided the movement with a coherent doctrine. The "cultural construction of the nation" was at the heart of this doctrine.[17] The Republican state was meant to represent collective beliefs, on the grounds that it was "not ideas and interests" that united the Portuguese; rather, "the basis for all social agreement lies in affective impulses," and "the affective life which is the basis for all national unity needs to be disciplined by the most powerful sociability stimulus."[18]

Braga developed a theory of the production of symbols and national rituals in a book published in 1884, *Centennials as an Affective Synthesis in Modern Societies*. In it he affirmed, "centennials of Great Men are festivals of national consecration. Each people chooses the genius who is the synthesis of the national character. . . . Without knowledge of its history no people can fight for freedom."[19] In subsequent decades, when all contemporary Portuguese national symbols were produced, these ideas took root. They bolstered the 1910 Republican triumph and combined with contemporary political currents, including the corporatist conservatism that gained power after 1926.

Portugal confronted neither ethnic and linguistic minorities nor unstable frontiers; political instability arose in the urban centers and among a politicized minority. This point has recently been used to explain the Liberal state's reduced investment in literacy programs.[20] Although some of the fundamental ingredients of contemporary nationalism were missing, the state was unable to integrate large masses of the rural population into the political system. The state had hardly any contact with this part of the population, and what contacts it had were channeled through cacique-based, clientelistic networks.[21] The Republican state project focused on overcoming multiple localisms and transforming the masses into citizens. Although it did not succeed, the integrating symbols and rituals of the nation triumphed in the long run.

The Republicans were the first political group successfully to mobilize the popular urban and middle classes, until then excluded from politics. The Republicans implemented their populist strategy in the name of a re-

generating nationalism that would overcome monarchical dependence on Britain and economic backwardness. Victorious in 1910, the Republican elite prepared for Portugal's intervention in World War I bearing the profound effects of the British Ultimatum, as well as the fear that the Allies might use the African colonies as a bargaining chip with Germany.

Portugal's participation in World War I had disastrous political and social consequences. It cannot be dissociated from the nationalist aspiration to lessen dependence on England. Portugal hoped for a place at the winners' negotiating table at all costs. More recent research has shown, however, that Portuguese military intervention in Europe also aimed to mobilize public opinion in favor of the new regime. Thus, the "fatherland in danger" was an appropriate slogan for the consolidation of the republic.[22]

Republican elites promoted a timid but radical "mass nationalization." They were always aware of the social and political stranglehold that the rural areas still had over Portuguese society. They created national symbols and undertook school socialization. They also sanctified the colonial empire, the key to Portuguese national identity. They inaugurated a national flag and anthem, created a new "civil liturgy," and declared bank holidays. Populist political mobilization and the "nationalization" of teaching accompanied the expansion of school education.[23] The anthem was antiBritish and was part of the propaganda against the British Ultimatum. The flag evoked "the two greatest moments in Portuguese history": "the foundation of the nation and the maritime epoch." Both were regarded as "the national and colonial source of historic Republicanism."[24] Initially targets of criticism, both the flag and the anthem were legitimated with participation in the war.[25]

In the postwar years, monuments to the dead and the great battles, as well as military intervention in politics, consolidated the break with the Liberal, monarchical past. Neither challenges and monarchical revolts nor the overthrow of the First Republic in 1926 eradicated the movement to link the "image of the republic with the image of the *pátria*," as well as with the nation and the "sanctified" African colonies. The Republicans linked the "national" and the "colonial" questions. This modern nationalist linkage shaped Portuguese foreign policy until the transition to democracy in the 1970s.

The Rise of Authoritarian Nationalism: The New State

Authoritarian, traditionalist, and corporatist nationalism emerged on the eve of World War I. The crisis provoked by Portugal's intervention in the war spread this vision in intellectual and military circles. Authoritarian nationalism differed from Republicanism in its anti-cosmopolitan and socially reactionary outlook. It focused on a criticism of the Liberal political system and the secularization undertaken under the Republic.

António de Oliveira Salazar's *Estado Novo* (1933–1974), Europe's most durable twentieth-century dictatorship, profoundly marked Portuguese politics.[26] Salazarism did not, however, represent a clear break with modern Portuguese nationalism.

The New State amply, coherently, and totally defined a discourse on national tradition faithful to the Positivist theoretical model, even though pursuing political objectives contrary to those of the Republican movement that preceded it in power.[27]

Salazar tenaciously consolidated and "massified" the idea of a "national regeneration."[28] It was based on the colonies, the empire and national independence, and the discoveries, which made Portugal small in Europe but large in global terms.[29] The reconciliation between traditional Catholicism and corporatism, a "national tradition" nearly destroyed by "imported" Liberalism and secularization, also became important elements of this vision.[30] Catholicism was linked with the "nation's" formation. Rituals and official discourse reinforced Portugal's medieval birth in the reconquest from the Moors. From the early 1930s on, furthermore, a process of "re-Christianization" was promoted. Corporatism aimed to "eliminate class conflict." It proposed a model of an "organic" Portugal based on medieval social organization. The *Estado Novo* thus hoped to create a society without conflict.

Under the *Estado Novo*, the movement to "reinvent the past" underwent a qualitative leap. School socialization, cultural propaganda, and a policy of national monument restoration proceeded apace. Any memory of Moorish culture and cultural diversity (already weak in any case, even in the south) was silenced. The north was upheld as the "Christian cradle of nationhood," as was Guimarães, the capital of the medieval kingdom. The preservation of national monuments led to a reconstruction of "Christian Reconquest" symbols, with the restoration of castles and military for-

tresses. The "heroes" of the nation's founding or the maritime conquests were mythologized graphically, cinematographically, and (literally) monumentally. The regime used all the propaganda of the "age of the masses" to sell this new vision of the nation.

The National Propaganda Secretariat (SPN) was founded in 1932 to promote an official political culture for the masses and the elites. The SPN restored or built most of the national monuments, and can also be credited with the introduction of "historical" popular cinema. The "reinvention" of Portuguese folklore also dates from this period. Local dance and costumed music groups were selected by the state. Official competitions for "the most Portuguese village in Portugal," for example, aimed to "develop in the Portuguese the cult of tradition." These competitions expressed the *Estado Novo*'s traditionalist nationalism. The village was seen as a microcosm of a traditional, conflict-free society, based on harmonious social relations between God-fearing individuals immune to urban vices.[31]

From the 1930s on, the official version of Portuguese history was rigidly imposed in the educational system. Although in some ways similar to the Republican nationalist vision, this version eliminated any existing pluralism. The slogan "Everything for the Nation, Nothing Against It" imposed a hegemonic cultural reality. Heroes were purged of all vices, and their perfection was gradually confirmed by "scientific research." The maritime discoveries were presented as an enterprise that had aimed exclusively to "spread the faith and the empire." The sins of positivism and of the discoveries as a "mercantile adventure" disappeared.[32]

In 1940, the *Estado Novo* organized the huge commemorative Exposition of the Portuguese World to celebrate two national mythical dates: the "founding of the nation" in 1143 and the regaining of independence, following sixty years of Spanish occupation, in 1640. The exposition took place in Lisbon when the rest of Europe was at war, and it marked the golden age of Salazarist nationalism. It sold the image of Portugal as an ancient nation with a glorious maritime past and an empire that extended from the north of Portugal to Timor.[33] The myth of empire was at the heart of the ideology of the *Estado Novo*. Efforts to create a colonial mentality through the school system also peaked in this period.

After World War II, as Salazar prepared to resist decolonization, the word *colonial* was replaced with the description "pluriracial and pluricontinental." The reevaluation of theories on the unique nature of Portuguese

colonialism dates from this period. Officially, Portuguese colonialism was not racist. The search for colonial legitimacy occurred before the emergence of African resistance and developed in tandem with important economic and social changes in Portugal.

Up to the end of the 1950s, the structure of Portuguese society suffered little change. The economically active population and the rates of urbanization remained almost stable: in 1960, 43 percent of the economically active population still worked in the primary sector, 22 percent in the secondary sector, and 34 percent in the tertiary sector.[34] Urbanization rates were low: only 23 percent of the population was urban, with the remaining 77 percent living in rural areas.[35]

Illiteracy rates were extremely high, and few children had access to what was, in any case, a very ideologically conditioned school system. Even fewer people had access to technical scientific training. In the rural areas, the Catholic Church was the most powerful socializing institution. The situation in the rural areas changed in the 1960s, however, with a wave of immigration, although the legacy of church domination lasted into the 1980s. During the 1960s, however, rural society fragmented further, shaken by modernization and rural-urban migration.

Also during the 1960s, Portugal underwent substantial economic and social change. A new wave of emigration occurred, this time headed for Europe. Economic growth was high and was accompanied by the progressive opening of the economy through membership in the European Free Trade Association (EFTA). With the expansion of the urban middle class, a new public emerged, which began to suspect the rationale for the endless colonial war.

The *Estado Novo* died in the wake of what was the last imperialistic colonial war waged by a Western European nation. Portugal was diplomatically isolated during the thirteen years of armed struggle against the African independence groups. The "imperial myth" gained strength during the 1960s, but its echo in Portuguese society was muted. Although decolonization was quick and dramatic for the thousands of Portuguese who had to abandon Africa, it did not lead to the rise of radical movements. With decolonization and the subsequent transition to democracy, furthermore, the central tenet of Portuguese nationalism came apart.[36]

After a shaky period in 1974 and 1975, the democratic parties joined together to support Portugal's European foreign policy unanimously, for

economic and, more important, political reasons. Integration with Europe was seen as a way to consolidate democracy and finally to take part in European democratic politics.[37] Despite a campaign against membership in the 1970s headed by the Communist Party, opinion polls showed high levels of support for integration into the European Economic Community (EEC).

This support was consolidated in the 1980s by accelerated social change, economic growth, and an influx of Community funds. These factors delayed the development of any isolationist nationalism in Portugal. Progressive economic integration with Europe profoundly changed the structure of the country's economic partnerships. Neighboring Spain, for example, became one of the country's most important economic partners.[38]

EEC membership has also changed domestic politics. The issue of regionalization is a good example. Before membership, a moderate but rapid project for the autonomy of Madeira and the Azores was written into the 1976 Constitution. On the mainland, debate on regionalization was sporadic, with the political parties wavering between centralism and moderate decentralization. With Portugal's entry into the European Community, however, pressures for regionalization have increased. Membership in the European Union has led to calls for the "regionalization" of what is, in reality, a small state with a centralist tradition, which has experienced no historical or culturally legitimate decentralizing pressures.

In the 1980s, Portugal underwent a second cycle of growth and social change. The movement of the population toward the coastal areas, as well as urbanization, increased again, although rates remained below the European average. More noteworthy was the acute drop (to 12 percent by 1992) in the numbers of workers actively engaged in the agricultural sector, a process that continued to break up traditional rural society in the northern and central areas of the country. Emigration was been replaced by a movement from the countryside to the cities. The growth of the middle class and the tertiary sectors was also prominent in this period. School attendance rates rose substantially.

Portuguese society in the 1990s still espouses materialist values, in contrast to other European societies, which are dominated by postmaterialist values.[39] Values associated with social well-being and the satisfaction of immediate social needs are still dominant. The value of social and politi-

cal participation, on the other hand, has not strengthened: attachment to authority is still greater in Portugal than in the rest of Europe.

Opinion polls and intellectuals agree on one point: the Portuguese are not undergoing a national identity crisis. National identity remains strong, although the expression of nationalist values and patriotism has not affected the majority's belief that European Union membership is a good thing.[40] As the negative impact of EU membership is felt, most particularly in rural areas, new opportunities for the development of a neonationalism have emerged. But the days of the colonial myth are definitely over.

Portuguese Contemporary Literature

JOÃO CAMILO DOS SANTOS

The nineteenth century in Portugal was marked by the Liberal Revolution of 1820. The democratization of political, economic, and social life gathered impetus, despite opposition, opening doors to new forms of competition and social mobility. Works of fiction and poetry from this period evoke and recount the nature of social and economic conflicts or power struggles that developed in this context, offering at least a partial view of the causes of these struggles. Amorous relations, in which marriage played a dominant but not exclusive role, are difficult to distinguish from struggles for social success. (The search for social status is one of the instruments in the battle for identity, for a place in society to serve as a refuge from the difficulties and uncertainties of existence.) The optimism of some contrasted with the frustration and despair of others. Nothing, therefore, happened without violence.

The Influence of Liberalism

In *Viagens na minha terra* (1846), Almeida Garrett (1799–1854) "invented" a new narrative form, which imitated the unpretentious spontaneity of everyday speech. He also invented the inner monologue in modern Portuguese literature.[1] He gave us the first romantic hero: a man confused by his feelings but well aware of his confusion and of the "impossibility of defining" things. Human contradiction, the insufficiency of language, of the human mind-set and vision of the world did not escape

Garrett's acute eye. Nor did he miss the inability of literature and the novel to render faithfully the inexhaustible complexity of reality.

Garrett's poetry speaks of love with a simplicity that seems almost excessive today. But *Viagens na minha terra* is unapologetically fictional, and its "literary" discourse is conscious.[2] The modernity of the mature Garrett is also apparent in the courage and clarity with which he criticizes the destruction wreaked by Liberal ideology, by the "Regime of Matter"—proof that disenchantment with the Liberal Revolution affected the more enlightened classes rather quickly. In Garrett, political clarity is mingled with linguistic, aesthetic, and literary lucidity. In *Viagens*, the story of Carlos, the hero who becomes a rich baron, is one that denounces the insoluble and tragic conflict between romantic fulfillment through love and material fulfillment through success.

Belying the claim of those who accuse Júlio Dinis (1838–1871) of writing "pink" romances, although he ingenuously expresses hope in the liberal vision of social betterment, this writer nevertheless denounces the political and social vices of the Liberal political system: the lack of scruples in the struggle for power; the cynicism, corruption, and opportunism. The scenes of violence that disturb the universe of his novels prove that Dinis, while believing in Liberalism, did not refuse to see the reality of his time. On the other hand, Dinis shows an enormous talent for psychological analysis and for description of landscapes, interiors, action scenes, family situations, and amorous intrigues. The escape from the city to the countryside in *A morgadinha dos canaviais*, for example, expresses a nostalgia for the "natural" that is obsessive in the works of his contemporaries Camilo Castelo Branco, Eça de Queirós, and Cesário Verde.

Although conscious of the limitations and vices of Liberalism, Dinis believed that the new political climate allowed individuals to pursue fulfillment and more readily to find happiness. Camilo Castelo Branco (1825–1890) had a less optimistic vision of his era. Conflicts are more acute in his novels. His characters, blinded by passion, forget their long-term interests and appear committed more to an anarchical and irrational self-destruction than to becoming a part of a promised new order. Love relationships and marriage (inseparable from social relations), struggles for social prestige, and the ambiguous notion of honor do not lead to a tranquil felicity, as in the novels of Dinis, but lie at the root of crime and tragedy. In Cas-

telo Branco, Liberalism does not offer conditions to justify the optimism that dominates Dinis's work. In Castelo Branco, the new potential for individual fulfillment does not eliminate class conflict but is instead conditioned by old notions of nobility and superiority.

The dilettantism that dominates the characters of Eça de Queirós (1845–1900) expresses an ironic vision of reality: when overbearing ambitions and grandiose projects fail, when ingenuousness, a desire to save the world, and the need to resolve the problems of existence fall flat, Eça's characters resign themselves to the modesty of their fate.

Eça died in Paris in 1900. An important part of his work was published only posthumously. The author of *A capital* (1925), *A relíquia* (1887), and *A ilustre casa de Ramires* (1900) left indelible marks on the literature and mind-set of the Portuguese, whatever the claims of his detractors. Until 1915, the year the first issue of the journal *Orpheu* came out, all important literary developments in Portugal were mere reworkings of Eça and the legacy of the nineteenth century, a parenthesis before the momentous arrival of Portuguese modernism.

The only Portuguese poet of the nineteenth century who matches the talent of the above-mentioned novelists is Cesário Verde (1855–1886). Verde's poetic vision of Portuguese reality completes the picture created by the novels of Eça. Distinctively of the nineteenth century, the works of Cesário, a poet divided between the city and the countryside, constitute the first building blocks in the edifice of modern poetry. The conflict between romanticism and realism emerges in Cesário Verde's work as a life lesson, part of the tortured life of the Self. This Self, while feeling the temptation of abandonment to the "absurd desire to suffer," imposes on itself a rigid discipline based on a realist objectivity.

The "desire to suffer," which is emphasized by Verde's antisentimentalist realism, coexists with a descriptive talent that reminds some readers of the paintings of Edvard Munch or the somber atmosphere of German expressionism. Verde also seems to express the sense of civic duty of the neorealists and reveals the existential pessimism arising from the obligation to be productive. His melancholy is repressed in the name of the "virile" obligation to maintain full control over reality, which Verde knew through his own experience (he worked with his father, who was a trader and fruit exporter) to be ruled by economic laws.

The most important contributions of António Nobre (1867–1900) to

modern poetry are his colloquial style, the simplicity with which he expresses common feelings, the ingenuousness and subtle irony of his "poetic" voice. As a student exiled in Paris, Nobre cultivated a mythical nostalgia for Portugal and for certain traditional values threatened by social change. His nostalgia is a form of conservatism, the lament of a class that has lost its privileges through the changes wrought by the Liberal Revolution. But today's readers might interpret that nostalgia as a reaction to the emergence of a liberal social order, which threatened traditional human values, as well as the ingenuous and "pure" happiness of childhood. Similarly, exacerbated competitiveness threatened individual peace. For that reason, rural places and mind-sets gradually became utopian symbols of an old, relatively peaceful existence. As was later the case with Mário de Sá-Carneiro's work, the literature of Nobre and Cesário reveals the suffering that emerges from the conflict between the need to be an exemplary, productive, and socially integrated individual and the desire to create an alternative existence based on an acute sensibility and spiritual values.

The Opening of the Twentieth Century

The republic, long announced by the conflict and disturbances that followed the Liberal Revolution of 1820, was proclaimed in 1910. The beginning of the twentieth century, while not entirely lacking in literary achievements, was clouded by nationalist ideals. The historical novel was revived or sustained, and currents that are now considered backward and conservative emerged: Neo-Garretism, Lusitanismo, and Integralismo. The *Renascença Portuguesa* and Saudosismo, as well as other currents of nationalist thought, developed an "emphasis which is markedly more rationalist, agnostic, progressive, and at times, linked with a more earthy and realistic sense of things."[3]

Teixeira de Pascoaes (1877–1952), a poet with philosophical pretensions, was the leading light of Saudosismo. He gathered around him the founders of the journal *Águia* (1910–1932) and a group of intellectuals from Oporto, the *Renascença Portuguesa*, members of which later became well known: the historian Jaime Cortesão, the philosopher Leonardo Coimbra, the poet Afonso Duarte, and the essayist António Sérgio. Mario de Sá-Carneiro and Fernando Pessoa were also briefly seduced by Saudosismo.

The *Seara Nova* journal came out in 1921 as the mouthpiece of the re-

publican ideology of progress. Members of the Lisbon National Library group were a part of it: the historian Jaime Cortesão, the writers Raul Brandão and Manuel Teixeira Gomes, the novelist Aquilino Ribeiro, the thinkers and essayists António Sérgio and Raul Proença.

The best prose of Aquilino Ribeiro (1885–1963) reflects the popular language and style of Camilo Castelo Branco. Seduced by crude and primitive customs and characters, Aquilino anticipated Miguel Torga and some of the social preoccupations of neorealism. Brutal in their passions, succumbing to primitive instincts, capable of the best and worst acts, the popular characters in Aquilino's *Terras do demo* (1919) and *Malhadinhas* (1922) allow readers to understand how Aquilino imagines a "return to the roots" and his conception of the "national soul," both of which have nothing to do with the ideal of the conservative nationalists.

Apart from his plays *O doido e a morte* (1923), *O gebo e a sombra* (1923), and *O avejão* (1929), Raul Brandão (1867–1930) wrote obsessive narrative works that are hard to classify. *A farsa* (1903), *Os pobres* (1906), and *Húmus* (1917) are extraordinary "prose poems."[4] *O pobre de pedir* (1931) is also well known. Critics have emphasized the painful preoccupation with the fate of the poor and humiliated in this writer's work; an exacerbated sense of guilt (similar to that in Tolstoy and Dostoyevsky); traces of fin de siècle decadence; an acute sensibility to the ridiculous and pathetic. The contradictions of human beings plagued him: their hypocrisy, the fate of women crushed by marriage, and the misery of individuals in bourgeois capitalist society. The pessimism in the work of Brandão presents a tragic vision of reality that reminds the reader of the works of Cesário Verde and Nobre, but that contrasts strongly with the ironic vision Eça de Queirós gives of failure and the death of illusion. The world of Raul Brandão reveals a sensibility approaching that of Antero de Quental.

The poet Florbela Espanca (1895–1930) stands out in this period for the intensity of her feminine erotic lyricism. Apart from Cesário Verde and António Nobre, however, it is the work of another important precursor of modernism, Camilo Pessanha, that deserves greater attention. Pessanha (1867–1926) lived in Macao for many years and was the author of *Clepsidra*, published in 1922. He was influenced by the French poet Paul Verlaine, and is generally considered to be the most important Portuguese symbolist. His poems express an existential pessimism born of frustration. His frustration is rooted, as would appear to be the case with Luís de Camões

(1525?–1580) and Bernardim Ribeiro (first half of the sixteenth century), in the reality of constant change: life has no sense of permanence, and travel is constant (the voyage, a metaphor for existence, is arduous). The images Pessanha used, which he claimed passed before the eye but could not be pinned down, transmit the inability to fix reality or to find in it a comfortable and stable coherence.

The difficulty or impossibility of knowing and of loving are also causes of dissatisfaction and metaphysical disquiet. Hence the poet's desire to die; death would be an end to the torments provoked by the endless changes wrought on reality and feelings and by the inability of the individual to achieve the "absolute" to which the thirst for love and knowledge is directed. The juxtaposition of the apparent and that which *was* and no longer *is* inspired in Pessanha some of his best poems. The modernity of his poetry stems largely from his questioning of the order of the world and opposing to it an unquiet subject, incapable of entering into a stable, peaceful, and happy relationship with himself and the world around him.

Three important literary movements emerged in twentieth-century Portugal: modernism, in 1915, which developed around the journal *Orpheu*; the Presença movement, based on a journal of the same name from 1927 to 1940; and neorealism, which took off in the 1930s.

Fernando Pessoa (1888–1935) and Mário de Sá-Carneiro (1890–1915) were the greatest exponents of Portuguese modernism. Almada-Negreiros (1893–1970), a writer and painter, and Santa Rita Pintor (1890–1918) were also important members of the movement. That Fernando Pessoa received a British education in South Africa, that Mário de Sá-Carneiro lived in Paris from 1913 to 1915 (when he committed suicide), and that Almada and Santa Rita also were in Paris and in touch with the most advanced artistic currents of the period may explain why Portuguese modernism represented such a decisive break with tradition. Although the modernists were influenced by futurism, the evolution of modernism in Portuguese literature was original. Along with the two numbers of *Orpheu* published in 1915, other ephemeral journals published between 1915 and 1935 were also mouthpieces for new ideas. They included *Eh real!, Centauro, Exílio, Icaro, Portugal Futurista, Contemporânea, Athena, Revista Portuguesa*, and *Sudoeste*.

Portuguese modernism irreverently attacked the dominant values of the petite bourgeoisie of the Liberal period. It should therefore be understood

as the first serious attempt to revolutionize both literature and language, as well as actual modes of living and thinking. Because it had the courage to distance itself from dominant ideologies and the values of social prestige, and because it attacked the various social manifestations of stupidity, it shocked the public and provoked a scandal.

The poetry and fiction of Sá-Carneiro includes *A confissão de Lúcio* (1914), *Céu em fogo* (1915), and *Poesias* (published posthumously, 1946). His works express a profound dissatisfaction with bourgeois life and an inability of the individual to adapt to the vulgarity of a daily life without horizons, aspiring to unreal and intangible absolutes, to unrealistic goals. excites the imagination and the senses, but the frustration of that ambition is inevitable and forces the individual to live the senselessness of an empty and mediocre daily life.

Although attracted by extreme and utopian forms of individual fulfillment, Sá-Carneiro knew how to give mystery and dignity to the pleasures of a simple daily life and its more banal moments (moments spent at a café, for example). That simplicity and its daily pleasures, however, were not sufficient to cure Sá-Carneiro of the nostalgia for absolutes or to satisfy his anxieties. Having discovered his vocation for plenitude, aware of the desire that projected him into a sensuous paradise, the poet preferred to kill himself rather than subject himself to the banal existence that bourgeois society promised.

Through Sá-Carneiro, we see that the modern city affords the most intense pleasures but falls far short of satisfying its promise. This is also what happens in *A cidade e as serras*, by Eça de Queirós; the leading character of this novel finally chooses the Portuguese mountains, which he yearns for with melancholy, over the Paris of progress. It is in the countryside that he finally feels happy.

The theme of social ascent and descent also clearly marks the work of Sá-Carneiro. It reveals the exacerbated and hysterical experience of deception already present in the work of Camilo Pessanha, Cesário Verde, and António Nobre. Above all, the poetry and suicide of Sá-Carneiro reveal an overweening pride. Instead of giving in to useless and despicable romantic laments, the author of *A confissão de lúcio* adopts provocative attitudes; the ironic self-destruction of his own image and idealized objects is expressed with a sarcastic masochism. Sá-Carneiro appropriated his own death, as it were, disdainfully and proudly rebelling against the insignificance of human destiny.

Identity crisis and the fragmentation of the self also characterize the work of Sá-Carneiro's friend Fernando Pessoa. Pessoa and his heteronyms also felt that reality was unsatisfactory. Like the characters of Eça de Queirós, Pessoa knew that romantic revolt and the sentimental exhibition of tragedy were out of place because they were useless. Pessoa's poetry and prose consist of a series of questions about and approaches to the lack of reality in reality, the absence of meaning in the world and in life.

Pessoa and his heteronyms—Alberto Caeiro, Álvaro de Campos, Ricardo Reis, and Bernardo Soares, to cite only the most important—cultivate ad nauseam a negative vision of existence; they question language and the values of what is held to be common sense in a schizophrenic manner. For them, the imperfection and the absurdity of existence are without remedy, but the fact does not deserve more than a loud laugh. It is a deception that has no hope of contradiction.

The masks of the heteronyms represent attempts to describe reality from a variety of perspectives and in a variety of styles. The masks are pure fiction, but they are also the only reality we are allowed. It is as though Pessoa, unable to believe in a single vision of reality, wanted to leave us with multiple variations on the theme of the relationship (imaginary and yet real) between man, existence, and the world. Pessoa forces us to understand the meaning of the world within us. While abandoning himself to language, literature, and life, he does not forget that everything is a game, a form of fiction. On the other hand, death inevitably transforms that game and all human activity into useless and futile passion.

If the relationship we establish with reality is arbitrary, and if that relationship is difficult to define despite linguistic pretensions to truth (everything is highly subject to questioning), how can a lucid spirit such as Pessoa's allow the reader to see, even as he wears literary masks, that he seriously suffers and lives tragically? Pessoa's lucidity prevents him from a rhetorical expression of tragedy; it is only through irony that the latter is revealed. In some ways, he seems to deny the ironic-tragic vision of life. Despite the impossibility of achieving truth and the absolute, despite the unhappy awareness that existence is gratuitous fiction, both Pessoa and Sá-Carneiro leave us with images of Lisbon and our daily lives that reconcile us to our fate.[5] Such are the contradictory consolations of literature.

Like Sá-Carneiro, Pessoa was unheroically proud and rebellious in the face of the imperfection of the world, a fictitious world Alberto Caeiro, by contrast, saw as an example of reality. Pessoa's work is far removed from

the novel of the nineteenth century. The language that describes the individual's inability to adapt to reality emerges in the form of a radical protest; it is no longer a study of the order imposed by social mechanisms. There are no more guilty and innocent classes (as neorealism would have it, in the tradition of nineteenth-century realism and naturalism). There are no longer even guilty or innocent individuals. We all become simultaneously guilty and innocent. The same fate, the same limitations explain our miseries and the conflicts we live with, just as they explain our illusions and joys. The tragic element in this vision of reality (more philosophical than historical), the helpless inability of the individual to adapt to the world, is understandably diluted by an irony that reveals an instinct for minimal communication or conversation.

The struggle, the complaint, and the reflection found in Camões's poetry reveal a Self that either accuses itself or holds others—the gods, destiny, the ruling order (the "disorder of the world")—responsible for its suffering. By finding someone or something to blame for his misfortunes, Camões can hope against hope for a change of fate. But the conflict between the individual and the world, the existential malaise that in Camões as in the nineteenth-century novel are not incompatible with hope, emerge in Pessoa as insoluble; they are accepted only with displeasure and an ironic bitterness. Pessoa already knows one can expect nothing from the gods, from others, from history, or from language and poetry.

Presença and Neorealism

The modernism of 1915 was prolonged with the posthumous publication of Pessoa's works. They brought to an end a cycle initiated with the romantic perplexities of Almeida Garrett and culminating with the theme of modern deception. For Pessoa, more so than for Sá-Carneiro, nothing is "worth it" except perhaps the narration of our disillusionment, to mark the path of hope and disappointment, leaving it very clear that we have, at last, unmasked the fiction that claimed to be reality. We cannot be fooled; we will never be fooled again. There is not even such a thing as fate; only nothing and chaos, which, in our existence, acquire the dimensions of tragic and ironic parody. But this knowledge, this lucidity, are they sufficient comfort?

After this, what could Presença and neorealism contribute to Portu-

guese society and literature? Presença's key merit consisted in its contribution to the dissemination and acceptance of the works of the modernists of 1915. It also disseminated modern French and European art of the period. Despite the influence of Proust, Gide, and Dostoyevsky, of psychoanalysis, and of French criticism, no author or group connected with Presença produced works comparable in importance to those of Pessoa, Sá-Carneiro, and the other modernists. That is why Eduardo Lourenço has, quite rightly, considered the journal *Presença* to be a clear step backward when compared with *Orpheu*.

Among Presença's exponents, João Gaspar Simões (1903–1987) left behind a vast critical oeuvre—some of it very important—on Eça, Pessoa, and the history of the novel, and he thereby accomplished an educational task that should not be belittled. José Régio (1901–1969), creator of a fascinating literary voice, wrote novels, short stories, poems, plays, and critical essays. His writings reveal a personality tortured by moral problems and gifted with a clear vocation for intellectual militancy. He allows us better to understand a certain type of Portuguese provincial mentality and its limitations. (Although he adopted a sincere attitude of protest, Régio never violated the fundamentals and limits of the order he questioned.)

Miguel Torga (1907–1995), the very embodiment of the solitary humanist, who split with the Presença group at an early stage, was a proud and intransigent enemy of Salazarism. Torga was the author of an important collection of short stories, and also a poet. His poems depict a vivid landscape, the human reality of the poor, and the isolated world of the provinces. His fictional autobiographical work, *A criação do mundo* and the *Diários*, is also the work of a great writer capable of a simultaneously austere, intimate, pained, picturesque, and moralistic tone.

Branquinho da Fonseca (1905–1974) was a talented short story writer. This is especially clear in his small masterpiece, *O barão* (1942). Adolfo Casais Monteiro (1908–1972), exiled in Brazil, later became one of Portugal's best literary critics. He was also the author of one of the most important collections of poetry published by *Presença*.

This period produced other important authors whose work was not directly related to Presença's objectives and program, although they offer an important vision of Portuguese society, especially its limitations and ills. Examples include Ferreira de Castro (1898–1959), José Rodrigues Miguéis (1901–1980), and Irene Lisboa (1892–1958). Ferreira de Castro was

self-taught, and led a difficult and adventurous life in Brazil. He gained international renown for his novel *A selva* (1930). With the publication of *Emigrantes* (1928), he developed a new form of realism, critical realism. Ferreira de Castro later published other works of fiction of a typically neo-realist nature, preoccupied chiefly with the social question, a concern he perfected with *A lã e a neve* (1947).

José Rodrigues Miguéis, who lived in exile in New York for many years, was one of the most erudite, refined, and cosmopolitan fiction writers of his generation. He also belonged to the group of authors who heralded the beginning of neorealism, although his work reveals a great variety of interests, as well as a pleasure in experimentation with new techniques and narrative genres that makes him original and difficult to classify. *Páscoa feliz* (1932) reveals an important Dostoyevskian influence. *Léah* (1958), a collection of stories and novels, inaugurates the mature phase of his career. *Uma aventura inquietante* and *Um homem corre à morte com meia cara*, both from 1959; *Escola do paraíso* (1960); and *O milagre segundo Salomé* (1975) are all from this later period.

Irene Lisboa (1892–1958) wrote both poetry and prose of great sensibility. (Her use of male pseudonyms reveals her acute awareness of the difficulties of being a woman of letters.) This writer modestly portrayed the anxieties and joys of common daily life. Her work, which lies somewhere between fiction and autobiography, portrays the difficult situation of women in society at the time, through vignettes of urban or provincial life. *Solidão* (1939) and *Voltar atrás para quê* (1956) are among her most significant works.

After Presença, the literary movement that most influenced Portuguese literature was neorealism. The neorealists took up the social preoccupations of the realist and naturalist novelists of the nineteenth century. Influenced by Marxism, however, they considered the humanism of the writers of that period insufficient and believed that only a socialist revolution could correct the vices of economic liberalism and resolve the social question. It should be noted that Presença had opposed the "objective" claims of realism and naturalism and had struggled to assert the value of a "subjective" art. The polemic between the *presencistas* and the neorealists, however, was never very deep. Essentially, the *presencistas* accused the neorealists of ignoring aesthetic values, and the neorealists accused the *presencistas* of defending art for art's sake. The neorealists stated that they aimed

to synthesize all past aesthetic currents, but that they could not understand an art disconnected from the problems and realities of their time.

Neorealism was influenced by American and Brazilian writers of the period. It developed in two phases. Critics consider the first phase, between 1938 and 1950, to be more propagandistic and doctrinaire and less aesthetically sophisticated than the second. The second phase, which developed after 1950, includes works of diverse tendencies and characteristics. It achieves aesthetic maturity but never ceases to emphasize the determining impact of social mechanisms on individual lives.

The neorealists' first and foremost enemy was Liberalism. Salazarism came only second. The novels of Carlos de Oliveira, for example, clearly show that the object of criticism was the social structure and not the power wielders of the moment.

The first notable neorealist author to achieve public recognition was Alves Redol (1911–1969). His novel *Gaibéus*, published in 1939, is the work that, according to the critics, "officially" inaugurated neorealism as a movement. In his later novels, Redol, who enjoyed great prestige in his own life, continued to narrate the stories of the humiliated and to describe social conflicts just as they occurred in various regions of the country.

Apart from Redol, the most important neorealist authors were Soeiro Pereira Gomes (1909–1949), Fernando Namora (1919–1989), Manuel da Fonseca (born 1911), and José Cardoso Pires (born 1925). Mário Dionísio (1916–1990) and later Alexandre Pinheiro Torres (born 1923) were prominent neorealist critics as well as poets and novelists. The collection *O novo cancioneiro* also revealed poets of great sensibility and talent, such as Álvaro Feijó (1916–1941) and Políbio Gomes dos Santos (1911–1959). On the margins of the movement but similarly preoccupied with social problems and politically aware were Augusto Abelaira (born 1926), one of the best Portuguese novelists of the period; Marmelo e Silva (1913–1991); Urbano Tavares Rodrigues (born 1923); and Jorge de Sena (1919–1978), the author of a vast collection of poetry, fiction, and criticism.

Soeiro Pereira Gomes wrote the novels *Esteiros* (1941) and *Engrenagem* (1951). The latter portrays class conflict in a factory, with an epic talent similar to that of the Russian filmmaker Sergei Eisenstein. Manuel da Fonseca is a talented poet, novelist, and short story writer; the Alentejo inspired him to great works of poetry. Among his best-known works are *Cerro maior* (1943) and *Seara do vento* (1958). Fernando Namora was a poet

and novelist, the author of innumerable works of great success, including *Fogo na noite escura* (1943), *Casa da malta* (1945), *O fogo e as cinzas* (1953), *Retalhos da vida de um médico* (two series, 1958 and 1963), and *O trigo e o joio* (1959).

Carlos de Oliveira (1921–1981), a poet and novelist, gained fame in both genres. As a poet, Oliveira achieved a maturity that probably makes him the most important neorealist poet. His poetry, in the collected works *Trabalho poético*, is technically sophisticated and expresses an austere seriousness. Oliveira was also one of the writers who most disturbed the *presencistas*; they recognized his talent in dealing with social issues without ignoring conflicts of conscience and matters of temperament. Oliveira's novels, *Casa na duna* (1943), *Alcateia* (1944), *Pequenos burgueses* (1948), and *Uma abelha na chuva* (1953), clearly illustrate the two phases of neorealism. They also show how Portuguese literature developed in this period, given that the author seriously reworked the first versions of his novels. *Finisterra, paisagem, e povoamento* (1978), his masterpiece, seems to express the impossibility of continued belief in the Revolution. At the same time, it poses essential questions for a neorealist and humanist (neorealism hoped to become the new humanism): the questions of private property, of law, of the possibility of knowledge, and of art.

José Cardoso Pires revealed, very early in his career, a great stylistic sophistication. He was influenced by American novelists in his short stories, published in the collections *Jogos do azar* (1963), *O anjo ancorado* (1958), and *Hóspedes de Job* (1963). *O delfim* (1968) is perhaps his most important work in the period before the Revolution of 1974. After the Revolution, the novels *Balada da praia dos cães* (1982) and *Alexandra Alpha* (1987) are understandably more direct and at ease with their criticism of social and political structures. In *A cartilha do Marialva* (1960), Pires, whose skepticism was a constant feature of his work, created a sarcastic caricature of Portuguese machismo.

Two novels published in 1979, *Sem tecto entre ruínas*, by Augusto Abelaira, and *Signo sinal*, by Vergílio Ferreira, also pessimistically reveal how the revolution that inspired the neorealists was a myth or a utopia, a product of an excessive simplification of reality.[6]

Abelaira is one of the most fascinating novelists of this generation. His preoccupation with the social question never prevents him from showing a particular sensibility about individual fulfillment through love, marriage,

and art. His characters are mostly from the urban middle classes and often intellectuals. Abelaira reveals the contradictions and sense of guilt of this class. The inability to love, a poetic vision of the Revolution, a somewhat obsessive attention to debates and ideas, and the refusal to simplify are the marks of his originality. *A cidade das flores* (1959), *Enseada Amena* (1966), and *Bolor* (1968) are among his most successful novels.

Vergílio Ferreira (1916–1996) is probably the most important novelist whose work has been published in Portugal in the second half of the twentieth century. *Para sempre* (1983), *Até ao fim* (1987), and *Em nome da terra* (1990) are examples. Ferreira began his career as a convinced neorealist, but started to question socioeconomic explanations for individual problems from *Mudança* (1969) on. He chose characters and plots that could reveal the complexity of existential malaise. It was only later, however, in novels such as *Aparição* (1959), *Alegria breve* (1965), and *Rápida a sombra* (1974), that he gained critical importance. The novels of Vergílio Ferreira can best be understood by taking his work as an essayist and his preoccupation with aesthetic and philosophical issues into account. Ferreira also produced a number of works that were deliberately provocative and polemic, such as his diary, *Conta corrente* (1980).

Urbano Tavares Rodrigues, the author of *Bastardos do sol* (1959) and *Insubmissos* (1961), worked on the margins of neorealism, producing fiction in which the criticism of the values and hypocrisy of bourgeois society is reconciled with episodes of individual fulfillment through love.

The novelist Agustina Bessa Luís (born 1929) was another important figure, but her conservative vision of reality puts her in a separate category. Luís produced a vast body of work in which fiction alternates with novelistic biography. She gained prestige with *A sibila* (1954), which sits on the margins of the neorealist code. Her politically conservative vision of the individual and society is far from optimistic, and the various forms of competition and social struggle (between the sexes, or between educated people and people from different social origins) take the place of the class struggle in neorealist works.

Also at the margins of neorealism, though certainly a left-wing intellectual, is the noteworthy figure of the eternal rebel, Jorge de Sena. He was a talented poet, novelist, short story writer, critic, and playwright, as well as the author of a vast correspondence, published posthumously by his wife, Mécia de Sena. He spent his career as a university professor in

Brazil and the United States. His *Sinais de fogo* (1979) was one of the most fevered and restless Portuguese novels to be published in this century. His short story volumes, *Andanças do demónio* (1960), *Novas andanças do demónio* (1966), and *O físico prodigioso* (1977), for example, and his poetry, from *Perseguição* (1942) to *Sobre esta praia* (1977), were vast and varied. His writing is marked by the desire for sincerity and truth in human relations, and by the same neorealist ironic critique of human vices and of the lack of ideals. Jorge de Sena also praises physical love, the body, and desire. He sees art as a superior form of intelligence and individual fulfillment; see, for example, *Arte da música* (1968).

Marmelo e Silva (1911–1991) shared with Jorge de Sena a desire for sincerity and truth in human relations that led him to attack sexual taboos. His most important works were *Sedução* (1938), a provocative novel, and *O adolescente agrilhoado* (1958).

The polemic between the *presencistas*, who defended a literature of the Self, and the neorealists, who defended a literature of the We, emerged from a difficult conflict between equally legitimate tendencies. That conflict was already apparent in Cesário Verde's poetry, which shows the poet divided between the desire to abandon himself to instinct, feeling, and "states of the soul" and the need to submit to the austere discipline of "virile" realism. António Nobre and Mário de Sá-Carneiro also lived this conflict. In a sense, even the work of Fernando Pessoa is a manifestation of the conflict between the values of the Self (his impulses, anxieties, and "states of soul") and social values (the vision and order of the dominant world). Actually, this conflict was already apparent in romanticism. It was expressed in the difference between romanticism and symbolism, on the one hand, and between nineteenth-century realism and naturalism, on the other. It is not surprising that Portuguese literature should have continued to attempt a synthesis of two apparently contradictory tendencies that were always difficult to resolve; namely, respect for individual impulses and the need to consider the order on which society is based.

Humanistic Currents

The social preoccupations of the neorealists (together with the guilty conscience that pushes revolutionary reform, with attention to the situation of the exploited and humiliated) dominated Portuguese literature

from the mid-1930s to the beginning of the 1980s. At their most advanced stage, the neorealists, while never forgetting social and economic structures, escaped their crude use, and made their characters individuals rather than just social stereotypes. In some cases, such as the novels of Carlos de Oliveira, the tendency to emphasize a Marxist explanation of life superseded the tendency to account for the profound and original subjectivity of individuals. In Oliveira's poetry, however, care and compassion for others take the form of an atemporal humanism and permit a profound meditation on reality.

In other cases, the capacity to describe the inner life and impulses of individuals attained, even in the novel, great sophistication, while retaining the "guilty conscience" or remorse about the social situation. The work of Augusto Abelaira and Jorge de Sena provides excellent examples of this tendency. The work of Agustina Bessa Luís, although apparently dominated by the author's desire to escape neorealist preoccupations with social issues, is, by contrast, a good example of the inability to give form to conscience, passion, and individual fate without ignoring the social and economic context, the constant harshness of competition and existence.

Finisterra, *Signo sinal*, and *Sem tecto entre ruínas* seem to bring neorealism to an end as a movement based on a belief in revolution seen as a goal and extraordinary event, able to solve social and individual problems. This does not mean, of course, that neorealist tendencies disappeared altogether. In the wake of nineteenth-century realism, neorealism placed great emphasis on socioeconomic, political, and social structures as factors conditioning the situation of individuals and their capacity for fulfillment. Now, however, the tendency was to express these conflicts through an individual consciousness (based on imagination, myths, fantasies, desires, illusions, and frustrations) and through human relations, which were not directly linked with the struggle for economic survival. The social question obviously remained, but revolutionary solutions ceased to appear as a possible or even correct path through which to resolve them. From the 1970s on, a new pessimism, born of this new awareness, emerged. It was accompanied by some cynicism, but it also allowed for the emergence of a new, vaguely defined hope.

The work of Almeida Faria (born 1943) illustrates this apparently eternal and insoluble conflict between the need for individual fulfillment and the inability to escape history. Faria's first book was *Rumor branco* (1962),

an experimental narrative influenced by existentialism, which seemed to oppose neorealism and which definitively introduced a new vision, tone, and style into Portuguese literature, already announced by the work of Vergílio Ferreira. In 1965, Faria published *A paixão*, probably his best novel. The social question emerges with force and surprising violence in this Faulknerian work, squarely placing this novel unmistakably in the sphere of neorealist thematic concerns. The main merit of *A paixão*, however, lies in its perfect, perfect fusion of presencista and existentialist ideals typical of the literature of the self with neorealist themes expressive of a literature of the we.

Faria's later novels (*Cortes*, 1978; *Lusitânia*, 1980; *Cavaleiro andante*, 1983; *O conquistador*, 1990) confirmed his disillusionment with the Revolution of 1974, which he considers, as others do, a failure. He thus reinforces the vision found in the novels of Carlos de Oliveira, Vergílio Ferreira, and Augusto Abelaira. The technocrats in power seem to have found a way to satisfy their ambitions and to believe, not without a dose of provincialism, in the construction of a "modern and European" Portugal; the most important novelists of the late 1970s and 1980s, on the other hand, continue to explore the "Revolution of the Carnations" and to express their disenchantment with Portuguese social, economic, and political reality.

António Lobo Antunes (b. 1942) published *Os cus de Judas* in 1979. It presents a corrosive vision of the colonial war and of Portugal in that period. He simultaneously expresses the impossibility of the protagonists' readapting to Portuguese society (or even to the values of Western civilization). In later novels, such as *Memória de elefante* (1979), *Fado alexandrino* (1983), *Auto dos danados* (1985), *Naus* (1988), and *Tratado das paixões da alma* (1990), Lobo Antunes continued to question the political, mental, and economic structures of Portuguese society. One of Lobo Antunes's merits is his ability to weave together literary and spoken languages; he does not fear swearing. His easy style emerges as a form of protest and an expression of disdain for hypocrisy and the apparent order of a bourgeois society falling into the hands of technocrats without culture, ideals, or scruples. It is also worth mentioning Luís Pacheco (b. 1926) in this context: his irreverent and literary works provocatively present themselves as socially marginal (*Exercícios de estilo*, 1971; *Literatura comestível*, 1972; and *Textos malditos*, 1977, among others).

José Saramago (b. 1922) became famous after April 25, 1974, and enormously successful in Portugal and abroad. Indeed, he became one of the most visible and discussed figures of modern Portuguese fiction. He is a virtuoso of style, and his works present a heavy, complacent irony (in the view of those who do not admire him). Saramago reflects on the real and imagined history of Portugal. Among his notable works are *Manual de pintura e caligrafia* (1977), *Memorial do convento* (1982), *O ano da morte de Ricardo Reis* (1984), *A jangada de pedra* (1986), *O cerco de Lisboa* (1989).

As noted above, José Cardoso Pires published works of fiction after the failed Revolution of 1974 that met with great success. In them, Pires draws sarcastic caricatures of social vices and the mediocrity of people without character. He presents a critique of today's society and of the failure of the April Revolution. The Revolution (not necessarily the one the neorealists had dreamed of) was finally prepared and led by the "April captains" and generals who, tired after the long years of war in the colonies, rebelled against the powers that were.[7]

The Portuguese "Revolution" is, however, one among the many more or less failed revolutions of this century. Understanding that the social question cannot be easily resolved, and that technocratic and liberal capitalism, as well as the laws of the economy, interfere tragically with the life of the individual, Portuguese writers of the last quarter of the twentieth century have produced works dominated by the great dilemmas of the Self and its inability to adapt to reality.

Having lost faith in utopian revolution, and having been forced to confront the harshness of reality, be it as agents, spectators, or witnesses, contemporary novelists in Portugal have come increasingly close to the tendency already expressed by Vergílio Ferreira. The problematic relationship of the Self with reality and with the idea of fate have been the dominant perspective adopted by contemporary novelists in their presentation and description of existence. Acceptance of the existing social order has not increased; instead, as exemplified by the protagonist of Ferreira's *Signo sinal* and the main character of *Sem tecto entre ruínas*, by Augusto Abelaira, the temptation to resolve the question of individual fulfillment in a selfish way, without the external support of social reform or utopian revolutions, has become dominant.

This tendency to emphasize individual reality, the preoccupations of the

Self, and its hidden desires has always dominated poetic works. At times, lyricism is reconciled with a vigorous, ironic, or sarcastic social critique, as in the works of Alexandre O'Neill (1924–1986), Mário Cesariny (b. 1923), and Jorge de Sena. More frequently, however, contemporary Portuguese poetry has emphasized subjective lyrical expression—which does not mean that poetry is a form of autobiographical writing. The "I" in poetry is always a mask, as well as a principle around which to organize discourse. Its "I" is as literary and fictional as that of the novel and the short story.

Two other main tendencies have prevailed in contemporary Portuguese poetry. The first, following Mallarmé, emphasizes the word and believes in the power of experimentation. It sees the poem as an object with an autonomous existence, capable of escaping the relationship with reality and thereby creating an autonomous universe. The second tendency emphasizes narration and the sentence, and focuses on the difficult relationship of the individual (and therefore of the language the person uses) with reality. This poetry of the word, on the one hand, and of the sentence, on the other, is expressed in various combinations of styles and forms, such that each tendency can only be imagined as "pure" in theory.

An essayist, the prolific and original Eduardo Lourenço (b. 1923), deserves special mention for his study of national identity and imagination in works such as *O labirinto da saudade: psicanálise mítica do destino Português* (1978) and *Nós e a Europa; ou as duas razões* (1988). Lourenço is also, and primarily, an extraordinary critic of poetry and fiction (*Poesia e metafísica*, 1983; *Fernando Rei da Nossa Baviera*, 1986; *O canto do signo, existência e literatura, 1957–1993*, 1994). He has undertaken his work without academic ambition, and has reconciled literary, historical, and philosophical culture with admirable ease.

Trends in Poetry

Although Portugal is a country of many poets, the number is significantly reduced if the criterion is that poetry be more than the expression of interesting states of the soul and more or less superficially original styles. A great part of Portuguese contemporary poetry concentrates on a narcissistic and heroic exhibitionism of a Self that delights in the contemplation of its own (imagined) capacity to seduce through the refined song of poetry. But great poetry is always, in one way or another, an expression

of the tragic condition of humanity, and has nothing to do with the love of contentment, or even with the exhibition of a personally superficial voice and style.

The number of contemporary Portuguese poets of importance is, nevertheless, too excessive to cite extensively. Apart from the poets already referred to, such as Carlos de Oliveira and Jorge de Sena, it is important to remember Ruy Belo, Eugénio de Andrade, Sophia de Mello Breyner, António Ramos Rosa, Herberto Helder, and Nuno Júdice, not only for the intrinsic value of their work but also because they can be considered representative of key tendencies.

Ruy Belo (1933–1978) published a vast body of poetry before his premature death. In his work, lyricism coexists with a disillusioned vision and a recurring bitterness in the face of reality. The mission of the poet, however, is probably to indicate why, in times of scarcity and misery, hope should be maintained. Perhaps poetry is always the product of a tragic awareness of an impossibility; namely, that of making desire and reality coincide. Poets console us because they find a way to take control of fate despite unhappiness and scarcity. Ruy Belo's work seems to confirm this vision of the mission of the poet and the function of poetry. The same can be said of the poetry of Jorge de Sena and the other poets mentioned above.

Ruy Belo's last works are long poems in which the poet ironically plays with the more formal external aspects of poetry (rhyme and an ostensibly literary vocabulary and syntax), thereby questioning the traditional conception of poetry. Belo's prolific and apparently chaotic style can be seen as a symptom of the impossibility of finding a stable place in the world, of imposing order on a reality that is complex, contradictory, and excessively rich in promise. The love of reality is so vehement in his poetry, furthermore, that the disorder through which it is represented makes the outer world emerge primarily as a symbol of passion; the same passion that made Alberto Caeiro impose a rigid antisentimentalist discipline on himself. It is also as if, unlike Cesário Verde, Ruy Belo were openly manifesting the impossibility of submitting to a rigorous reality (the rigor imposed by a liberal society centered on production) and were establishing a final, rebellious, and anarchistic rule of all the senses. It is perhaps for this reason that Belo's work bears obvious similarities to that of Mário de Sá-Carneiro. Jorge de Sena in part followed a similar course, as evident in a number of

his narrative poems, in which a provocative disdain for a traditional conception of poetry (that is, of poetic beauty and order) is expressed.

In contrast to Ruy Belo, Eugénio de Andrade (b. 1923) expresses a respect (in some senses still in the tradition of symbolism or Parnassianism) for a formally elevated conception of poetic language and form. For Andrade, the word and the verse are equally important. His poetry aspires to a classical sobriety. The expression of common feelings, however, the capturing of moments of revelation, the identification and glorification of brief and discreet instants of plenitude give Andrade's poetry a comforting modernity and freshness, despite the note of classicism and solemnity.

A laconic poet when compared with Sena and Belo, Andrade does not rebelliously contest the order of the world. At most, he bemoans it, but always finds a way to reconcile himself with reality and with his fate. In this sense, his poetry is viscerally opposed to Fernando Pessoa's poetry, which never ceased to question the meaning of existence and of words. Eugénio de Andrade is an anti-Pascoaes of sorts, knowing the limits of language and of the human tendency to expect the impossible. The value of his work lies in this capacity to reinvent reality without denying it. Sometimes bordering on the conventional, Andrade always escapes banality, using common words but giving them symbolic meaning and enriching them through an alchemical process achieved through his perfect knowledge of language. In this, he is similar to Camilo Pessanha.

António Ramos Rosa (b. 1924) represents another yet current in contemporary Portuguese poetry. Aware of the high value of poetry (about which he has also published essays), and aspiring to create the poem-object in the tradition of Mallarmé, Ramos Rosa believes that words can say what is supposedly impossible to express. He uses an elaborate syntax, avoids similarities with daily language, and privileges the value of the word as a thing in and of itself. His poetry thus gives words such as *stone*, *horse*, and *river* a mythical value. It is as though the solemnity of the poem and the privileged moment of religious or divine relationship it establishes with reality give the words it contains an aura of power and extraordinary meaning—making the reader forget that each word is only a sign indicating the object it is naming.

Words also have a mythical power to name the unnameable for both Andrade and Herberto Helder. They have the power to give daily ob-

jects and experiences sacred value. In Andrade's poetry, however, the word gains new powers and is rescued and returned to daily life, making it participate with the new qualities it has acquired. In the poetry of Helder (b. 1930), words acquire a mythical power to name what has no name. Helder's syntax, however, is not an abnormal "narrative" one. The alchemical process that gives words new meanings dictated by their context is achieved in long, narrative poems.

For Helder, words, whatever the meaning attributed to them in dictionaries or common knowledge, can always acquire new, original, and complex meanings, which are difficult to clarify. The creative activity of the poet expresses a profound disdain for the ruling linguistic order. Inherited knowledge is rebelliously and openly attacked. Helder reveals an overwhelming ambition to create an individual and original language and, in this way, to oppose order. Helder's attitude also reveals something that can be seen as an expression of the highest mission of the poet: to contest, to deny that which exists, to question the relationship between words and that which exists, to suggest new relationships and discover new senses; in sum, to reinvent reality by transfiguring it.

Although this ambition merits respect, and although it provides the reader with a fascinating experience, it must be said that Helder only partially achieves his objectives. Helder's vocabulary, syntax, and referential universe can finally be deciphered as the reader becomes more familiar with his allusions and style. Behind the new meanings given to words, we find known concepts or a vague image of those concepts, albeit with less certainty than is commonly the case. Once we understand the rules of his game, the coherence of the world and of language is reconstructed.

Helder's is a poetry of proud rebellion against the law, of rhetoric against the gods. But despite the overweening pride it ostentatiously reveals, this poetry shows the difficulty of being, the inability to achieve divinity, the modesty and emptiness of a hesitant "I" that exalts itself only because it fears that it will disappear; that its existence is uncertain. These are poems in which human vanity confronts its own limits. A certain despair infuses poems that are, superficially, mildly ironic. In the end, the poetry of Herberto Helder confesses an ontological malaise, which the poems of Fernando Pessoa and Mário de Sá-Carneiro had already proclaimed.

Herberto Helder is more than just a fascinating poet. He is also the author of *Os passos em volta* (1963), one of the best works of fiction in Portuguese literature because of its original style and its ability to speak of an inner life, of urban life, of exile, and of the frustration of modern man.

In their rigorous and refined style and the classicism apparent in explicit literary references, the poems of Sophia de Mello Breyner (b. 1919) are similar to those of Eugénio de Andrade. Breyner's poems are symbolist and Parnassian in their transformation of reality, in the way they create a "poetic reality," and in the poet's elevated idea of poetry. Breyner's poetry confronts us with high sentiments and solemnity of feeling, even though the poem starts out from an ordinary experience. Literature is deliberately literary; "poetic feeling" is opposed to the "banality" of everyday life.

In assessing these poets and their contribution to modernism, a comparison with Fernando Pessoa and Mário de Sá-Carneiro is unavoidable. It is difficult to determine how much Portuguese poetry owes to Pessoa and Sá-Carneiro. Pessoa wrote in all styles, as if to teach minor poets of his time and those of the future all the ways to write and speak about the world. Despite this heavy influence, poets such as António Ramos Rosa, Eugénio de Andrade, Carlos de Oliveira, and even Sophia de Mello Breyner seem to belong to another, more classical tradition, and what they owe to Portuguese modernism is more difficult to identify.

Portuguese modernism obviously implies *Orpheu*, the source of the only real modernism Portugal had in this century; as well as, in this precise case, Ricardo Reis, one of Pessoa's heteronyms. The classical poetic voice of these authors contrasts, in any case, with the tendency toward the dispersion or disaggregation of poetic discourse apparent in the work of Ruy Belo, Herberto Helder, and, in great part, Jorge de Sena. All of these poets can be considered disciples of Alvaro de Campos and, in part, Alberto Caeiro, rather than Ricardo Reis.

A number of younger poets fit into these two traditions, the "poetry of the word" and the "poetry of the sentence." The most serious and important of these is Nuno Júdice (b. 1949), who combines rigor with a capacity for reflection similar to that of Andrade, Breyner, Oliveira and an originality and capacity to transform reality reminiscent of Helder.

Júdice is a self-styled creator of myths, making him very similar to Helder in poetic attitude. He repeatedly reflects on the essence and technique of poetic writing. Whether he is meditating on poetry, on the act

of writing, or the Self, with its desires, ghosts, and hallucinations, Júdice always reveals the same creative energy and a capacity to give reality a seductive mystery that makes it poetic. Reality is given a symbolic value, and poetry makes it passionate. The Self, whatever suicidal temptations get lost in its mythical labyrinth, always recovers its essence. Given this permanent lucidity, a sustained pragmatic contact with reality whatever the seduction of mystery, the poetry of Nuno Judice is very original, yet it maintains clear links with other poets.

Feminist Voices

This panoramic view of Portuguese literature would be lacking if it failed to emphasize the growing importance of work by women with a particularly feminine sensibility. The publication in 1972 of *Novas cartas portuguesas*, by Maria Isabel Barreno (b. 1938), Maria Teresa Horta (b. 1937), and Maria Velho da Costa (b. 1938), had a great impact in Portugal. The book caused a scandal and became a symbol of the desire for sexual liberation of Portuguese women.

The preoccupation with the social condition of women had already emerged at the beginning of the twentieth century. The work of Florbela Espanca and Irene Lisboa staked out a position for women, albeit in different periods. Thanks to an initially favorable international situation and to the Revolution of 1974, however, the 1970s permitted that tradition to develop. Today, the number of contemporary women writers of significance in Portugal is notable, and cannot be seen in isolation from the changes in views on moral, emotional, and sexual education, changes that owe a lot to the feminist struggle for equality of rights.

The list of women fiction writers most frequently cited, in addition to those mentioned earlier, includes Teolinda Gersão (b. 1940), Maria Gabriella Llansol (b. 1931), Maria Judite de Carvalho (b. 1921), Lídia Jorge (b. 1946), Maria Ondina Braga (b. 1932), and Olga Gonçalves (b. 1929). As far as poetry is concerned, the notable women include Luísa Neto Jorge (1929–1989), Fiama Hasse Pais Brandão (b. 1938), and Maria de Lourdes Belchior Pontes (b. 1923).

Gender-based literary studies in Portugal have also been developing, such that literature by women receives the recognition of which prejudice often deprived it in the past. In some cases, women writers of modest

quality are overvalued for extraliterary reasons, which are linked to the acquisition of a new power by the triumph of the feminist perspective. The small world of studies of contemporary Portuguese literature has not escaped the logic of relations of power and of personal relations. The future, should it take an interest in us, will ensure that the dead are put in their rightful place.

Portuguese Art in the Twentieth Century

JOÃO PINHARANDA

In 1913, an international exhibition was held in New York that may be considered the first to introduce modern art to the United States. Organized by the Association of American Painters and Sculptors, the predictably scandalous Armory Show spread the news about European modernism. Amadeo de Souza Cardoso (1887–1918), a Portuguese painter resident in the French capital, was among the three hundred artists whose works were exhibited. His eight paintings were displayed along with those of the French artists Georges Braque, Henri Matisse, Marcel Duchamp, Theodore Gleizes, Paul Cézanne, Paul Gauguin, Pierre-Auguste Renoir, and Georges Seurat. Three of his paintings were sold to the collector A. J. Eddy, who reproduced them in a famous book published in 1914, titled _Cubists and Post-Impressionism_. On Eddy's death, the paintings were donated to the Art Institute of Chicago. In the same year, following Delauney's suggestion, Souza-Cardozo participated in the First Autumn Salon of Der Sturn gallery in Berlin.

Souza-Cardoso introduced modernism to Portugal. His works were among the most original and brilliant in Europe during the 1910s. It is strange, therefore, that international art history hardly refers to his work. It is even stranger that his work did not give rise to a sustained artistic movement in Portugal. The continuing ignorance of his work at both the national and international levels can be considered symptomatic of cultural and artistic development in Portugal. It is part of a social structure and "mentality" that was already evident in the nineteenth century and that has shaped the course of twentienth-century Portuguese art.

Portuguese cultural reality was influenced by the almost permanent state of political and social instability that reigned up to the 1930s, and also by a profound dependence on France. Initiated during the eighteenth century, this dependence lasted until the last quarter of the twentieth and affected all cultural groups. A comcomitant reaction against this situation of dependence, however, gave rise to a dual mode of thinking: "identity" versus "cosmopolitanism" or "isolation" versus "internationalization." This dichotomy in turn led to the emergence of viewpoints or even ideologies that were not so much articulated as set in opposition to each other.

In Portugal, literature, particularly poetry and the novel, received more public and official recognition and enjoyed higher status than the visual arts. Given the resistant nature of the factors shaping and reproducing patterns of taste, new cultural models arose only with the greatest difficulty. Naturalistic tastes thus remained dominant until the middle of the twentieth century. Modern art museums did not exist, and the lack of specialized information, critical discussion, or in-depth debate on contemporary artistic realities was apparent. This conservative climate also consolidated traditional thinking in education, helping to limit the dissemination of international modern art in Portugal and the export of Portuguese art abroad. At the same time, Portugal had no public capable of supporting contemporary art; its national elites lacked cultural sophistication and taste. A "mecenas" culture—in which banks, foundations, and the like supported the arts—did not emerge. It was virtually impossible to create a national art market, to establish pricing and trading criteria, or to launch international artistic careers.

Artists worked against the current, isolated by the ultra-conservative environment. Vanguard radicals were repeatedly forced to "sell out" as previously anti-establishment artists became part of the establishment. Thus, new tastes were delayed from taking root, and prevailing tastes survived for abnormally long periods. Conservatism permeated decision-making at all levels of Portuguese society; it penetrated political and cultural attitudes and shaped public opinion as well as the art market. Until the 1930s, it was almost impossible to crack the wall of naturalist taste. Indeed, only in the 1940s did that wall begin to crack, and from then on, only very gradually and slowly.

A dictatorial and interventionist state, excessively active in defining artistic matters, consolidated this situation. This is particularly important in a society that had a very limited capacity for individual initiative. Later,

during the 1960s and 1970s, the self-imposed absence of the state led to the intervention of a private entity, the Calouste Gulbenkian Foundation (Fundação Calouste Gulbenkian, or FCG) in the art world. The FCG changed artistic policy, but it was only in the 1980s and 1990s that a more pluralistic environment emerged.

The weakness of innovative artistic currents was also apparent in their fragile or distorted social echo. The production of art was not linked to a critical discourse with a capacity to establish a dialogue between art and the public. Artists themselves were unable to elaborate a theory of art to complement their work. Leading artists were not sufficiently committed on either an ethical or a poetic level. Finally, a historical awareness of art was conspicuously lacking. Art was often produced in ignorance of or isolation from international trends.

From Symbolism to Modernism

Amadeo Souza-Cardoso was part of a cultural movement, led by the so-called Futurist Generation, that was decisive for the advent of the modern age in Portugal. The movement emerged at a time when the national cultural climate was at a very low ebb. The establishment of the republic in 1910 did not overcome the defeatism that the financial, economic, social, and political crises of the nineteenth century had produced. The impact of the colonial and financial crises, along with the decline of the legitimacy of the monarchy, had been profound. A series of intellectuals and politicians committed suicide, among them Mouzinho de Albuquerque, a hero of the African campaigns; Soares dos Reis, the symbolist sculptor; Antero de Quental, a poet and founder of the Socialist Party; Manuel Laranjeira, a writer and close friend of Souza-Cardoso. These men became the examples and symbols of that crisis. Their deaths led Miguel Unamuno, a Spanish intellectual, to speak of the Portuguese as "a suicidal people."

Naturalism flourished in the arts (and would continue in favor for another fifty years). This style centered on José Malhoa (b. 1855), a painter who died only in 1933. A symbolism of French, rather than British or German, origins also existed and was more in touch with the age. This current, however, was very weak and, at times, only implicit, even in the works of its greatest exponents, António Carneiro (1872–1930), Soares dos Reis (1847–1889), and Columbano (1857–1929).

Souza-Cardoso and other artists of his generation turned the tide

against this intellectual climate. Their movement was centered in Lisbon, but its ideological driving force was Italian futurism. The aim of the movement was to give the Portuguese arts a sense of Europe. Literature initially predominated; the rest of the arts were affected only later. The movement's leading figures were literary men, such as Fernando Pessoa, a poet who wrote initially in the journal *Águia*; and Mário Sá Carneiro, who committed suicide in 1916. Other members had both literary and artistic careers, such as Almada Negreiros (1894–1970). Finally, there were artists who worked solely with the visual arts, such as Souza-Cardozo and another painter, Guilherme Santa-Rita (1889–1918). The magazine *Orpheu* united them, albeit only briefly, for only two issues were published, in 1915. They included important illustrations by Souza-Cardozo and Santa-Rita, however. The latter's works were practically the only examples of cubist-futurist work in Portugal, an opus the artist's family destroyed after his death.

With the exception of Pessoa, with a British cultural background, Paris was the mecca for these artists, and it was there that Souza-Cardoso's career began in 1906. The son of a well-to-do rural family from the north of Portugal, Souza-Cardoso went to Paris to study architecture, began to work as a caricaturist, and later abandoned his studies to dedicate himself entirely to painting. His social position allowed him to escape the fate of state pensioner and the obligation to submit his works to the approval of conservative Portuguese teachers.

In Paris, Souza-Cardozo met Amadeo Modigliani and became his close friend. From that relationship arose a joint exhibition held in Souza-Cardoso's luxurious studio in 1911. During this period, the two artists developed similar themes, painting stylized and decorative female figures rooted in Oriental, African, and archaic art. In Modigliani's case, this period led to the definition of a style; but in Souza-Cardoso's case, it was merely one stage in a vertiginous artistic career.

In his search for a personal style, his work expressed all the artistic references of the period. In 1912, Souza-Cardoso published an album called *XX Dessins*, which was favorably reviewed by the poet Guillaume Apollinaire, a friend of the cubists. It was probably as a result of the notoriety thus achieved that Souza-Cardoso was chosen to participate in the Armory Show. From a symbolist-inspired stylization of form and space, he went on to develop a quasi-cubist deconstruction of reality. From 1919 on, he painted abstract and chromatic landscapes that were heavily influenced by

Robert Delaunay's studies of light. He subsequently experimented with expressionism, a style he never abandoned. Souza-Cardoso thus accumulated a variety of materials and artistic references, among them futurism, synthetic cubism, and dada. These influences were not eclectic; they coincided with the European avant-garde of the time, even though they were produced in relative isolation.

World War I took Souza-Cardoso back to Portugal, where he lived until his death on the eve of his planned return to Paris. During this period, he received the exiled Sonia and Robert Delaunay in Vila do Conde, a bourgeois beach resort in the north of Portugal. They associated with Negreiros and Eduardo Viana, briefly galvanizing the narrow Portuguese art world, as well as providing new inspiration for the work of both these painters.

By then, Souza-Cardozo had already established an autonomous style. He successfully combined a depiction of Portuguese popular images with a universal language portraying the modern, mechanical world. His work was formal, both in its use of color and its themes, a rare achievement in Portuguese art. He held two exhibitions in Portugal in 1916, one in Lisbon and the other in Oporto. Both caused great scandal. His personal character, however, turned him into a giant of national modernism. An art prize was established in his name that was awarded by the state from 1935 on. Yet his work remained largely unknown in his own country until the 1950s.

A Balanced Modernism and Some Marginal Artists

The efforts of the war years faded quickly in the absence of a revolution in taste. Europe entered the so-called postwar phase of *retour à l'ordre*. The provocative voices and images of the surrealists and their First Manifesto of 1924 had only a delayed impact in this context. They gained ground later, in the 1930s, on the eve of the social and cultural disasters caused by World War II.

From a historical point of view, the 1920s and 1930s in Portugal were decades of profound crisis, just as they were for the Western world as a whole. They were characterized by a search for stabilizing political and economic solutions. In the end, a predominantly conservative society opted for a military, authoritarian remedy. The coup of May 28, 1926, led to a prolonged one-party, corporative dictatorship with a parliamentary facade, similar to other European fascist regimes.

The international isolation and censorship imposed by Prime Minis-

ter António Oliveira Salazar naturally affected the cultural world. Still, this period should not be interpreted in a linear or simplistic fashion. António Ferro, a journalist and member of the *Orpheu* group and an admirer of Mussolini, became Salazar's cultural ideologue. He persuaded the dictator to encourage modern artists' cooperation in the creation of a choreography—an image—for the *Estado Novo*, or New State, following the Italian model, which linked fascism and futurism. Through the Secretariado de Propaganda Nacional (SPN), or Secretariat for National Propaganda (later renamed the Secretariado Nacional de Informação, SNI, or National Information Secretariat), Ferro established incentives, such as competitions, prizes, subsidies, and public commissions for decorative work, posters, set designs, and clothing, which the artists of the 1910s and 1920s produced. His protegés developed a "balanced modernism" and gained national prominence. Independent of their work and life in both aesthetic and political terms, these artists remained active until the 1960s and 1970s, establishing an artistic continuity that later evolved into a new academic and conservative market taste.

The leading lights of the 1920s and 1930s in Portugal were artists who successfully captured the formal values of the European avant-garde through a formal and chromatic synthesis. The best works of these years were graphic images that appeared on magazine covers, in publicity campaigns, and on posters, as well as in the decoration of Portuguese pavilions at international exhibitions and fairs. The situation was so aesthetically fragile, however, that "modernism" in Portugal refers to something altogether different from its Western European meaning. It was assimilationist, superficial, eclectic, mundane, and cosmopolitan, an interpretation of the break with the 1910s. Portuguese modernism, moreover, was almost completely ignorant of subsequent artistic developments, such as expressionism, surrealism, and geometric abstraction. It predominated in a climate of almost total artistic consensus until the 1940s.

One of the most important representatives of this period was Almada Negreiros, a poet who wrote in *Orpheu* and a caricaturist during the 1910s. Negreiros lived in Madrid and Paris during the 1920s without ever connecting with the local avant-garde. He continually questioned the aim and mission of art in Portugal, and he transplanted the call for immediate action characteristic of the futurist age into the symbolic realm, establishing himself as a theoretician and prophet. He gave greatest importance

to the plastic arts, following Picasso's "neoclassicism." His greatest works, both of which owe much to his excellence as a sketch artist, are the murals that appear on buildings along two of Lisbon's docks, *Alcântara* (completed in 1945) and *Rocha* (1948).

The most interesting aspect of this period of "normalization," "academization," and assimilation of modernism, however, is the emergence of various marginal artists at the time. Their careers generally faded very quickly; like Souza-Cardozo, most of them became national myths, albeit less powerful ones. Most of them, furthermore, had emigrated and were disconnected from the national art world. On returning home, they remained fundamentally removed from the national scene. Most of them died young, either committing suicide or going mad.

Mario Éloy (1900–1951), for example, was schooled in Germany. He returned to Lisbon in 1932, an expressionist influenced by George Grosz and Otto Dix. His paintings and drawings expressed the violence of a radical solitude. His subsequent internment in a psychiatric hospital gave his work added meaning. Another example is Domingos Alvarez (1906–1942), from Porto. This artist developed an expressionism characterized by great economy of means, both formal and chromatic, and deformed space and figures. The strangeness of his themes permitted him to develop an oneiric and surreal naïf language. Alvarez died early from tuberculosis. Another artist of note, Júlio (1902–1969), closer to the second German expressionist movement and to surrealism, painted bold canvases of social critique. He was inconsistent, however, later developing a more figurative and lyrical style.

Of this group, only António Pedro (1909–1966) gained international fame in Paris. Like Souza-Cardozo, his economic and family situation made him independent. He was one of the vanguard of his time, and he signed the Dimensionist Manifesto of 1935, along with Duchamp, Wassily Kandinsky, Francis Picabia, Juan Arp, Joan Miró, Alexander Calder, and others. This was a document that promoted cross-pollination among all creative forms.

Maria Helena Vieira da Silva (1908–1992), a member of the Second School of Paris, and her Hungarian husband, Arpad Szenes (1899–1986), were the only other artists linking the Portuguese and international artistic worlds. The couple lived in Paris in the 1920s, but owned a studio in Lisbon and frequently stayed in Portugal throughout the 1930s. They

established a relationship with the national literary and artistic community, although they always remained peripheral as tastemakers and political outsiders. During this period, their work was a stylistic cross between expressionism and surrealism. They developed postcubist analyses of space and postimpressionist studies of light. When the dictatorship refused to naturalize Szenes, the couple opted for French citizenship and cut ties with Portugal until the reestablishment of democracy in 1974.

The relationships she established in Portugal, however, earned Vieira da Silva a place in the gallery of famous artists who became myths. Her work never had true repercussions in Portuguese art, however. Her aesthetic influence came late and weakly. In the 1970s, Portuguese art collectors finally took interest in her work and thereby popularized it. This, in turn, had political repercussions, which culminated in her renaturalization after the revolution of 1974 and also led to the establishment of a foundation in her name in Lisbon in 1994.

The Three Paths

After the Spanish Civil War and World War II, a new climate emerged that changed sociopolitical, cultural, and artistic realities in Portugal and produced a diversified but coherent artistic reality that lasted until the 1960s. The Exhibition of the Portuguese World, organized by the government in 1940 for the country's domestic and international glorification, displayed work by most of the country's contemporary artists, presenting a climactic synthesis of Portuguese modernism. António Ferro's selection of participants provoked violent reactions among the naturalists, a school still dominant in art institutions such as the Escola de Belas Artes and the Sociedade Nacional de Belas Artes (SNBA). The exhibition thus brought to light the divisions among the regime's social bases of support.

A first surrealist exhibition of the works of António Pedro and António Dacosta (1914–1990) took place the same year. It bore witness to a nascent artistic development that unfortunately did not take root. Pedro left for London, where he became a BBC announcer; Dacosta participated in official competitions and received the Amadeo Sousa-Cardozo Prize in 1942.

The emergence of socially and politically committed neorealist art further diversified art production. Neorealist literary works were published in the journal *Vértice*, inaugurated in 1940, and emerged with the novels of

Alves Redol. The school gained notoriety with the General Arts Exhibition held in Lisbon between 1945 and 1956. This exhibition was an alternative to official art salons and to abstract and surrealist artwork. It was aesthetically and ideologically based on social realism. The examples of the Mexican muralists and the Brazilian painter Candido Portinari, however, predominated over Soviet models.

Geometric abstraction first emerged in Oporto with the Independent Exhibitions of 1943, another sign of artistic renewal. Fernando Lanhas (b. 1923) was its leading light. The artistic pluralism of the 1940s was evident in the reawakening of surrealism in 1947 with the return of António Pedro, the continuing presence of Dacosta, the emergence of many young men who had originated in neorealism, and a series of exhibitions in 1949, 1950, and 1952. The artists of this decade rapidly divided into irreconcilable factions, which sustained a long dispute. One of the factions, directed by Pedro, included the critic José Augusto França, who eventually became a prominent critic and historian of the surrealist movement and of Portuguese art. The other faction, which was socially, historiographically, and museologically marginalized, was more literary. Mário Cesariny (b. 1933), one of the greatest poets of the century, became the aesthetic and ethical point of reference. From the 1950s on, Cesariny's art was based on abstract solutions and was notably free of stylistic constraints.

A debate developed between the proponents of neorealism, surrealism, and abstraction. Júlio Pomar (b. 1936), António Dacosta (b. 1914), and Lanhas are the key representatives of these tendencies. Pomar emigrated to Paris in the 1960s. Breaking away from the neorealist formula, he developed freedom of gesture, color, and theme, as well as an erotic subjectivism that drew him to Ingres and Matisse in the 1970s, to national and archaic cultural myths in the 1980s, and finally to classic and baroque traditions in the 1990s.

Dacosta also lived in Paris from the 1940s on, becoming a magnet for other artists, as Vieira da Silva had been. He abandoned painting until the end of the 1970s, although he maintained close relations with the Portuguese art world through Portuguese and Brazilian journals. His "return" to painting, however, confirmed the unparalleled quality of his surrealist canvases. An understanding of his work is indispensable for an understanding of Portuguese art in the 1980s. "Return to painting," moreover, is a doubly appropriate term in this case; it also means a return to childhood.

Dacosta depicted images based on the simple memories of a childhood spent in the Azores, or human and cultural archetypes in a melancholy style that contemplates life and death.

Lanhas never abandoned his native city, Oporto. In 1944, despite the lack of access to international art imposed by the war, Lanhas painted the first Portuguese abstract paintings. He was not prolific, nor did he undergo a clear evolution. His geometrism was based on simple lines and neutral colors. He painted free, zig-zagging, or centralized structures. Background and form coexisted in his works alongside profoundly poetic graphic games. His work always reflected his interests in palenteology, architecture, archeology, and astronomy.

The artworks and aesthetic options of the 1950s developed in a social and political climate dominated by a state whose right-wing, dictatorial nature had been further consolidated through participation in NATO's fight against communism. The state soon lost the cultural initiative, however. Salazar ceased to rely on the support of artists; the artists, in turn, became more radical. In 1950, António Ferro was removed from the SNI. Sculpture was the only medium that remained firmly under government control.

Art Deco styles, renewed during the 1930s by Canto da Maya and Leopoldo de Almeida, were surpassed by a formal modernist archaism based on a historical exploration of the overseas empire and the nation's heroes. It was in the field of sculpture that a break with the past occurred with the emergence of abstract and surrealist experimentation, albeit within the restricted circle of independent exhibitions. Jorge Vieira (b. 1922), schooled in England in the 1950s under the influence of Reg Butler and Henry Moore, depicted abstract associations and surrealist themes. In his works, human and animal forms mingle, expressing a disturbing humor and irony. Vieira worked mostly in private spaces, on a small scale, and with terracotta, although he also used iron.

Photography also emerged in this period as an autonomous artistic discipline. It had an intense social content and was driven by a desire to register reality. Vitor Palla, Costa Martins, and Sena da Silva were photography's leading exponents. Fernando Lemos (b. 1926) practiced photography as a complement to his surrealist painting.

The Pluralist Decade

The diversity of work flowering in the 1940s and 1950s led to the emergence of a new artistic climate in the 1960s. From 1960 on, the range of artists, tendencies, activities, and agents increased. The links between the national and international art worlds deepened, producing a profound alteration in national thinking. The capacity to absorb international art innovations, along with the speed of that absorption, increased during the period of pop art and dissident *nouveau realisme* and *arte povera*.

New types of initiatives emerged. First, individual initiatives were promoted by the massive emigration of artists to Europe from 1957–58 on. Second, socioprofessional initiatives were galvanized by the conquest of the SNBA in the 1960s by the new generations of artists. Third, commercial initiatives arose with the inauguration of new art galleries in Lisbon, such as the Galeria de Março, the Pórtico, and the Diário de Notícias, and later the Alvarez gallery in Oporto. Finally, private institutional initiatives were undertaken, led by the FCG and its international art grants scheme. Naturalist taste was finally surpassed, as a new generation of artists, art agents, critics, and institutional officials in the 1940s and 1950s channeled its new style through the FCG and the SNBA until the 1980s.

Emigration was decisive until the mid-1970s. It was initially an expression of aesthetic, ethical, and political rebellion and an escape from the colonial war, rather than a search for training. Later, however, it was supported by grants from the Gulbenkian, which did not submit its artists to the narrow criteria of academic evaluation. For the first time, Paris ceased to be the only mecca, although Europe remained dominant. Great Britain became a new destination, with London gaining importance from the 1970s on.

Generally speaking, works were influenced by international pop art trends. In Portugal, however, they were a creative response to the legacy of expressionism and surrealism. These styles also led surrealists to embrace nongeometric art. Most of the big names of the decade were influenced by Anglo-Saxon canons but also by French, Italian, and Spanish painters of the 1950s, and even by U.S. gesturalism. Italian *arte povera*, on the other hand, was not an important influence.

Joaquim Rodrigo (b. 1912) sought to mix formal and chromatic com-

positional values with the primitivism of Lunda, Angola, and aboriginal art. He developed contemporary themes, which were sometimes political, almost always cultural, and ever more often personal. He followed the rules of how to "paint right" with great precision. His paintings are akin to memory maps; their narrative quality and the formal archaism of the figures they depict, as well as their intimate nature, led to their rediscovery in the 1980s.

Paula Rego (b. 1935), who has worked in London since the 1950s, holds a mythical place in the history of national art similar to that of Vieira da Silva: she embodies the capacity of Portuguese artists to gain international recognition. Although Rego is married to an English painter and has adopted British citizenship, she regularly exhibits her work in Portugal, and she draws her inspiration mainly from childhood memories and popular culture. In the 1960s, she worked on explicitly political themes; subsequently, the depiction of a personal and intimate narrative delirium deepened, expressed through universal social and cultural archetypes.

Rego's painting has always conveyed an expressionist sensibility, and thus it lends continuity to the most marginal current in Portuguese art. In 1961, the display of Rego's and Rodrigo's paintings in the Second Exhibition of Plastic Arts at the FCG broke with the aesthetic currents of the 1950s, introducing a narrative structure that destroyed the linearity of an illustrationist discourse. Rego became very important in national artistic life in the 1980s, when her work began to gain international recognition. She is currently part of a group of British figurative painters who have followed Francis Bacon and Lucien Freud, but her art is distinctive in that it constructs a feminine vision of the world.

Other artists who were influenced by the British art scene are João Cutileiro (b. 1947) and Bartolomeo Cid, today one of the most important engravers in the world, based at the Slade School of Art in London. Others include Ângelo de Sousa, Alberto Carneiro (b. 1937), and Eduardo Batarda (b. 1943). Batarda set up one of the most erudite, virulent, and humorous galleries of Portuguese art between the 1960s and the 1980s. Antonio Sena (b. 1941) first explored pop art themes and later produced works reminiscent of the American Cy Twombly. Yet another example is João Vieira (b. 1934). In the 1970s, he participated in the first "happenings" ever to take place in Portugal. Sá Nogueira, Areal, Cesariny, and even younger artists such as Rui Leitão (1949–1976) are also worthy of note.

Leitão's career was dramatically short, but he undertook an extraordinary reinterpretation of pop art.

Cutileiro was the most prolific sculptor of the 1960s and went on to become the master of the new stone sculptors of the 1980s. He is an emblematic artist: he uses industrial machinery to produce images of fragmentation. His most important piece of sculpture is a statue of King Sebastião (1973), now located in Lagos. In it, he challenges official canons of representation. His obsessive productivity is at times decorative and centered on the female figure.

The KWY Group, founded in Paris (it ironically used letters that do not exist in the Portuguese alphabet), included Lourdes Castro (b. 1930), René Bertholo (b. 1935), Costa Pinheiro (b. 1932), João Vieira Escada (1934–1980), and two other (non-Portuguese) immigrants, Jan Vos and Christo. This group formulated solutions in the international context of neofigurativism, and edited a serigraphed journal featuring important European artists of the time. They dealt with the object or its absence, the mechanization of the world, the deconstruction of myths, and the visual value of words or letters. Another Paris-based artist, Jorge Martins (b. 1934), has recently undertaken publicly commissioned work for the Washington, D.C., Metro. His narrative style pursues a study of light, and of irony through constant reference to U.S. and French cinema. Manuel Baptista (b. 1936), yet another artist of this period, experiments with texture, monochromatic painting, and the shaped canvas.

This new generation of immigrants eventually returned to Portugal, becoming either isolated or regionally integrated. They lived abroad and returned, moreover, without ever taking root in the local market and gaining critical attention. Those who remained abroad forsook sales in Portugal, permitted by a growing art market. The 111 gallery in Lisbon (founded in 1964) was the decisive market in this period, and the Bucholz, an alternative gallery.

Other artists integrated with the international art scene. António Palolo (b. 1946) became a phenomenon in the art market of the 1960s. He created syntheses of pop and psychedelic culture, both alien to erudite Portuguese culture. He also worked on shaped canvases and in the minimalist style. António Charrua (b. 1945) was influenced by Robert Rauschenberg. Nikias Skapinakis (b. 1931) worked at the end of the 1960s on graphic or so-called pop figuration, using mythological as well as everyday themes.

Noronha da Costa (b. 1952) created Germanic, Romantic, and even cine-matographic paintings later in his career.

A watershed in the national art scene was reached with the emergence of a specific group of artists: António Areal (1934–1974), Álvaro Lapa (b. 1939), and Joaquim Bravo (1935–1990). All three came from a literary and surrealist background, a recurrent situation in Portugal. All became aesthetic and ethical reference points and had a decisive impact on the contradictory generations of 1980 and 1990.

Areal exerted an important tutelary influence during the 1960s and 1970s; he was one of the few Portuguese artists with a capacity for writ-ten aesthetic reflection. He initially developed informalist French and Pol-lockian paintings, later returning to the figurative style typical of the post-Rego and Rodrigo period. He focused on assemblage, derivation, and fantastic and surrealist formulas. Later he evolved from the exploration of concepts (a series of painted empty boxes in 1969) to a critical study of the figure in the history of art (*The Ideal Collector*, 1973).

Lapa's radicalism ran even deeper. The austerity and strangeness of his media, as well as his fascination with the work of Robert Motherwell and William Burroughs, gesturalism, the cut-up, and Zen led him to studies that had a decisive impact on Portuguese painting. Lapa studied the artistic method, the landscape, and the portrait; he also studied expressive visual and written techniques, fusing them in the narrative and oneiric space of the canvas. Finally, he studied the relationship between art and the viewer.

Bravo gained critical acclaim only in the 1980s. His values were more immediately visual, although still marked by literary culture. The word, as expressed in the titles within his paintings, is always present. In Bravo's work, gesture, color, and form strive to coincide; the canvas becomes a space for the presentation of synthetic and serialized gestures, which create archetypal or free forms. Bravo created a circle of intellectuals in Lagos, in the south of Portugal, bringing together various emerging artists, such as Cabrita Reis, Paulo Feliciano, and Xana, who became influential from the 1980s on.

Alberto Carneiro, a sculptor working in Oporto, has sustained a uniquely permanent capacity for renewal. Carneiro produced the first "land art," or, as he would have it, ecological art, in Portugal. His work ex-plores nature and the body—his own. His materials include exotic woods and objects from nature or popular rural culture. Also critical to his work

are the photographs he takes of his own movements in a particular land-scape. He reflects critically on the creative process and the market.

Another group of the 1960s, the Quatro Vintes, also emerged in Oporto, from a school that had been very active since the 1940s. The Lisbon school at this time was stagnant, lacking dynamic professors. The Oporto group had an important impact in market terms, but was not aesthetically influential. A key figure of this group was Ángelo de Souza (b. 1938). He produced powerful formal syntheses based on a simplication of reality, and was highly influenced by the Swiss painter Paul Klee. His syntheses are not oneiric, however. They must be understood in light of their chromatic elements. His favorite medium was drawing. His painting deepened abstract values in a study of color, light, and space, similar to the monochromatic, minimalist paintings of Robert Mangold. Jorge Pinheiro and Armando Alves, other members of the Quatro Ventes, produced shaped sculptures in painted metal, as well as three-dimensional shaped canvases.

With the rise of Marcello Caetano in 1968, a process of liberalization began. It provoked a rapid economic transformation with the opening of the market to foreign investment, the acceleration of Portuguese integration into Europe, and investment in the secondary and tertiary economic sectors. An inflationary financial cycle led to an artificial euphoria, with serious consequences for the future of an art market that had never really taken root. In sum, the 1960s were perhaps one of the most prolific decades, and certainly one of the most important, in the course of the century. The majority of the artists of that period are still alive today and fully active. They have become recognized names among the general public, art institutions, and critics.

The Emergence of Alternatives and an International Conscience

The political transformations of the mid-1970s brought about a break with Portugal's historical and cultural past. The military coup of April 1974 rapidly degenerated into social revolution, in the midst of a world economic crisis. The coup significantly altered artistic realities in Portugal. All national, social, and cultural forces began to concentrate on social and political issues. Such was the force of this trend that a new form of artistic *dirigisme* emerged, based on "culture at the service of the people." During

the revolutionary period from 1976 through 1977, the artificially sustained art market collapsed. Very few galleries survived, and there was no prospect of immediate recovery. At the same time, the state was preoccupied with the urgent questions of democratic consolidation and the elimination of the dictatorial legacy; it proved incapable of establishing coherent cultural policies.

In 1977, when art was thought of as a collective enterprise or as a field for avant-garde experimentation and subjective affirmation, an important exhibition, *Alternativa Zero*, was held in Lisbon. It was coordinated by Ernesto Sousa, a critic linked closely with neorealism. He had studied popular and erudite art, as well as cinema and literature. Sousa's opinions were always heterodox, polemical, and radical. The aim of the show was to exhibit diverse conceptualist and minimalist art, as well as the performing and video arts. Video art, a diffuse, post-pop medium, was ill defined in Portugal; it was neither institutionally embraced nor highly regarded by the public. Significantly, despite its success, it closed a cycle in Portugal's artistic life.

In 1978, the international biennial of Vila Nova de Cerveira in the north of Portugal was established. It became one of the most important exhibitions held in the nation; the 1985 installment consecrated the artists of the 1980s. That it was not held in Lisbon indicates the desire in the art world to create the conditions for cultural decentralization, an objective still to be achieved today. The Vila Nova biennial also aimed to gather, albeit without very precise criteria, a vast range of artists, both famous and unknown, at a time when the art market was inoperative. Another shift in the political climate in the 1980s, however, put an end to the project.

Other attempts to create alternatives and open new centers were made, generally by schools or by members of the performing arts, but they lacked continuity. Initiatives were undertaken in localities such as Caldas da Rainha, Torres Vedras, Almada, Oporto, and Coimbra (with the opening of the Centro de Artes Plásticas). Artists such as Julião Sarmento, Leonel Moura (b. 1949), Cerveira Pinto (b. 1942), Fernando Calhau (b. 1948), and José Barrias (b. 1946), all disciples of Ernesto Sousa, managed to keep up with world artistic developments in a steady, timely, and culturally profound fashion. They overcame existing information, communication, and circulation blocks, gaining access to foreign journals through emigration to new art centers, such as Holland (where a large community established

itself), or simply through easier travel to the United States, Germany, or Italy.

The careers consolidated in these years of crisis were those of Angelo, Lapa, Carneiro, Cutileiro, Sena, Martins, Baptista, Guimarães, Batarda, and Helena Almeida (b. 1934). These artists flourished in personal and critical terms but had little impact on the market. They renewed the studies of the 1960s and the emphasis on the (im)possibility of representation. Almeida undertook a series of different activities, including photography, drawing, painting, and collage. She became the photographic subject of her own work and created a series of "lived-in" paintings using elements of traditional art. She three-dimensionalized lines through a "horse-mane" effect, colored them with isolated brushstrokes; she dramatized her figures in space. Almeida also established one of the most solid feminine discourses in Portuguese art.

Utopias of Success

In the 1980s, the social, economic, financial, and political crises of the previous years were overcome. In artistic terms, a new period of creativity began, and new artists gained national and international fame.

The social and cultural atmosphere of the 1980s was complex. National developments paralleled international realities through the new, irreversible, democratic circulation of information. Disenchantment with revolutionary political participation was replaced by deepening individualistic cultural values, by a "fury to live" reminiscent of the liberalization of the 1960s, which Portugal had only timidly experienced. Political stabilization and the benefits of membership in the European Community promoted the development of the entrepreneurial and financial sectors, which began to channel profits into formerly unproductive areas.

Investment in the arts became a means to reinforce an often recently acquired social and political status. It was a process that paralleled the "yuppie" culture in other countries. The art galleries became part of this dynamic. They opened in unprecedented numbers, even if only in the traditional areas of Lisbon and Oporto. Art was sold at inflated prices.

The Quadrum gallery in Lisbon (1973) represented artists of the 1960s and 1970s, as well as new artists of the 1980s. It did not play a leading market role, however. The Módulo gallery in Lisbon and Porto in 1975 staked

its bets on the more "difficult" artists of the 1970s and the new names of the 1980s; it also failed in market terms. The Cómicos (now Luis Serpa) gallery was established in Lisbon in 1984. It represented artists of the transitional period between the 1970s and 1980s and many international artists of *arte povera*, as well as conceptual artists and photographers. Finally, the EMI Valetim de Carvalho gallery, today simply Valetim de Carvalho, was founded in Lisbon in 1985. It reestablished the artists of the 1960s and 1970s in the market. The 111 gallery also recovered its position of the 1960s, now as a center exhibiting consecrated artists of the 1940s and 1950s, such as Pomar, Dacosta, and Rego.

The reemergence of traditional artists with the rise of modern art auctions was accompanied by the emergence of dozens of new artists, many of whom began their professional careers while still in art school. They cultivated an irreverent attitude toward the canons of previous generations, and they rapidly gained visibility in a press responding to a public hungry for new lifestyles. This specialized press *au courant* with contemporary change did not flourish, however; and the Establishment reacted negatively to these changes. Certain newspapers, however, such as the weekly *O Expresso* and the cultural weekly *JL*, gathered an unusual amount of information on artistic activities.

A new generation of art critics had a more or less complicitous relationship with new artists; Alexandre Pomar, Alexandre Melo, and the author of this chapter are examples. A new phase of critical debate was inaugurated, although it never projected deeply enough to involve the art world as a whole because of a lack of articulation between the different interest groups and an absence of artists' associations.

Similarly, art institutions were not renewed, either in adminstrative terms or in understanding of new realities. The modern generation that had gained positions of power in these institutions during the 1950s and 1960s retained those positions in the 1980s. The Sociedade Nacional de Belas Artes, the Associação Internacional de Críticos de Arte (Portuguese Section), and the art departments of the Calouste Gulbenkian Foundation, its *escolas de ensino*, and its *colóquio artes* systematically reacted against change. Only later and in an isolated fashion did they accept and participate in the new developments.

Attempts were made to establish alternative exhibition centers and artists' associations, such as the Cooperativa Diferença (connected with

Ernesto de Sousa) and Arco (established in 1973), both in Lisbon; along with these were journals, such as *Arte Opinião*, also based in Lisbon. One of the SNBA's exhibition centers (open only to members) held important, career-launching exhibitions.

It was through an event in 1983 called *After Modernism*, involving the classic arts—architecture, fashion, dance, music, and debate—that a break with the past occurred. *After Modernism* was organized by the SNBA and promoted by artists who had been associated with Alternativa Zero. The event brought together artists with a variety of backgrounds. Indeed, it was this event that simultaneously launched and popularized concepts of and debates on postmodernism in Portugal. References to the "transvanguard," "bad painting," new expressionism, and the "return to painting" proliferated.

The establishment of a proper national museum of modern and contemporary art, however, did not occur. After April 25, 1974, two official proposals for the creation of a museum had emerged. One suggested using the Gallery of Modern Art in Lisbon, which later burned down; the other recommended the Contemporary Art Center in Oporto, where the few exhibitions of contemporary art had been held. In 1984, a private museum, annexed to the headquarters and historical museum of the Gulbenkian, was inaugurated. Unfortunately, the policy of the Centro de Arte Moderna for its first ten years was suspicious of contemporary art. The museum can be credited, nevertheless, with holding the first historical review of national modern art, exhibiting the works of Amadeo, Almada, António Pedro, Areal, and Menez, among others. It was only in 1988 that the plan for the creation of a national museum of modern art was finalized in Oporto. The Oporto museum has held numerous exhibitions of recent artwork, both national and international. The establishment of the planned Serralves Foundation, involving the construction of a building by Siza Vieira, and its cultural policy is still to come. Thus, the museum project may not become a reality until the end of the twentieth century.

The state's inability to elaborate a national art policy affected other areas. Participation in the Venice Biennale was abandoned in 1986 and taken up again only in 1995, a significant gap in time. The absence of the state placed the cultural initiative in the hands of the Gulbenkian, which organized the São Paulo Bienale. Indeed, until very recently, the Gulbenkian was the de facto Ministry of Culture. It should be noted neverthe-

less that despite the incoherence of state policies, a department of the Ministry of Culture, the Direcção Geral de Acção Cultural, supported the few important initiatives of this period. Artists such as Fernando Calhau, Julião Sarmento, Cerveira Pinto, and João Vieira worked in this department.

Participation in international art fairs was initiated with the Arco Fair in Madrid. These fairs created the best opportunties to promote the international visibility of Portuguese art. Although the Quadrum and the Módulo galleries had been important in this regard since the 1970s, it was the Arco Fair of 1984 that led to the internationalization of both the market and art criticism. The FIAT fair in Paris, as well as exhibitions in Zurich, Cologne, Los Angeles, London, and Tokyo were also important venues throughout the decade. The galleries themselves were very weak, even during the golden age of the market. They needed state and private support from the FCG and the Luso American Development Foundation (FLAD) to bear the costs of exhibiting at these fairs.

In the 1980s, an anticonceptualist reaction, the affirmation of a thematic subjectivity, and an absolute individualism, as well as the almost exclusive practice of traditional disciplines, predominated. Nevertheless, postconceptualism and subjectivism blended during this decade; the cause was the avalanche of international historical information received by Belas Artes students and the conceptual references of the transitional artists of the 1970s and 1980s—Leonel Moura, Cerveira Pinto, and Sarmento. Apart from the gallery owner Luís Serpa, all these artists were linked to the organization of the *After Modernism* exhibition.

At the beginning of their careers, artists consolidated in groups. These groups, however, did not generate programmatic and aesthetic unity; rather, they permitted unity of action and a unified provocative affirmation. From them emerged a tendency toward "deconstruction-construction," an explicit desire to deconstruct historical systems of representation and to reorganize them in a discursive, neo-Romantic, and demiurgic fashion. The exhibition *Archipelago*, organized by the SNBA in 1986, brought together artists such as Cabrita Reis (b. 1956), Pedro Calapez (b. 1953), José Pedro Croft (b. 1957), and Rui Sanches (b. 1955), who gained international recognition in the 1990s.

Among the artists who emerged immediately after that, the visual dominated over the verbal. Their work was eclectic, textured, chromatic, spatial, and decorative; alien to any literary language; and a register of absolutely

private sensibilities. As a group, these artists had no specific designation; among them were Ana Vidigal and Pedro Casqueiro (b. 1959). Other artists recovered literary values and developed a satirical or purely playful deconstruction of references and themes: the *homeostéticos* included artists such as Pedro Portugal (b. 1963), Pedro Proênça (b. 1962), and Xana (b. 1959). They were ironic, playful, and derisory; they explored language games.

Pedro Calapez depicted isolated everyday objects on a large scale. Later he developed "uninhabited paintings," based on architectural constructions or landscapes and the abrupt citation characteristic of pre-Renaissance art of the mannerist style. Pedro Casqueiro's particular style distanced him from the abstract and the figurative alike, creating a visual transcription of life experiences; speed and the unexpected nature of artistic situations dominated his work. Pedro Portugal produced ironic and playful works reminiscent of the great masters of international modernist and Portuguese painting. He portrayed a more circumstantial vision of national reality, reordering each work into great puzzles that demand deciphering. Finally, Pedro Proênça, a great sketch artist, depicted literary or erudite figures that invaded surfaces organized like architectural structures, using the complex ornamentation of baroque images to make erudite and satirical references.

Another heterogenous group gathered around the always marginal Monumental gallery. Its key artists were Miguel Branco, Manuel Sampayo, and Gonçalo Ruivo. This group took longer to establish itself, taking root only at the end of the decade. Other galleries, such as São Bento and Novo Século, embraced marginal as well as known artists. It is also important to note some autonomous careers, which, although lacking in public and commercial visibility, expressed a strong capacity for invention. The painter Hilda David (b. 1955) and the sculptor Manuel Rosa (b. 1953) are cases in point. They worked on concepts of time and myth. The sculptor Fernanda Fragateiro (b. 1962) derided constructivist values; and the sculptor Ántonio Campos Rosado (b. 1955) concentrated on the language of the body and on space.

Artists from Oporto were less important during this period than they had been in the 1960s and 1970s. They worked in relative critical and market isolation, broken only after the Bienal de Cerveira of 1985, the activity at the Roma e Pavia gallery (today the Pedro Oliveira gallery), the establishment of the Nasoni/Atlântica gallery in 1986, and the National Modern

Art Museum project in 1988. The Espaço Lusitano gallery, which opened in 1982, and the *Os Novos Primitivos* exhibition of 1984, commissioned by Bernando Pinto de Almeida, also linked these artists to the 1980s. Most of them came from the performing arts; examples include Gerardo Burmester (b. 1955), whose work initially revisited German romanticism and gradually developed a demiurgic expression. Albuquerque Mendes (b. 1955), on the other hand, used a multiplicity of styles, including a disarticulated, dadaist narrative style. Pedro Tudela (b. 1962) deployed themes and means that were truculent and typical of this decade.

Public and creative relaunching of sculpture was important in this period. This trend was reinforced by the most important artist of the decade, João Cutileiro, with whom António Campos Rosado, Pedro Rosado, and Manuel Rosa worked. Cutileiro's teaching produced a break with tradition because he worked stone mechanically rather than manually. His work, representing the body and its symbolic spatial sense, also represented a break with the foregoing conceptual trend.

Another sculptor, José Pedro Croft, reworked the symbolic sculptural forms of prehistory, ancient Egypt, and the Romantic period, which he piled up and fragmented. His work evolved toward the study of archaic, basic forms, using first stone, then plaster, and later, painted bronze. He balanced contradictory volumes and objects, such as solid geometric forms with everyday objects.

After studying in Great Britain and the United States, Rui Sanches became a leading artist of the 1980s. He was influenced by classicism and rationalism, by the French classicists Poussin and David, as well as by constructivism. He developed three-dimensional structures that comment on and upset thematic and formal references with the use of fragile materials, such as chipboard or wood agglomerates; or white paint over noble materials, such as bronze. His work reflects on the state of art; it is formally contained and conceptually weighty. A younger artist, Rui Chafes (b. 1966), showed rare and strong Germanic roots; he expressed a spirit of radical romanticism centered on the body and its ghosts, and he created closed atmospheres, using prostheses or torture objects. He also worked with untreated iron, either painted black or chromed, to accentuate the emptiness of artistic objects in relation to ideas. Xana's work lay between painting and sculpture and represented purely visual values. He painted

in strong colors, presenting bulky, ephemeral architectural structures and purely playful or decorative installations, which also comment on urban and domestic realities.

Drawing also developed during this period, in practical, critical, and commercial terms, and was exhibited in specialized galleries and exhibitions. The works of Bravo, Calapez, and Sarmento at the beginning of the 1980s, as well as Sanches, Chafes, and Gaetan, are particularly important. Gaetan (b. 1954) made his face the near-exclusive motif of his work and developed a notable series of self-portaits, which use a variety of forms and techniques.

From the mid-1980s on, photography developed, adopting the values of the plastic arts. The nomadic vision of Paulo Nozolino (b. 1956) centered on the history of photography. The inner journey of Jorge Molder (b. 1959) was more akin to the work of other photographers who accentuate the plastic languages, such as Blaufuks, Valente Alves, Augusto Alves da Silva, and Luis Campos. In the 1990s, Molder has used a large format and his own face and studio as models and background.

A shift in emigration destinations and motivations in this period, and grants to study in London and the United States, benefited artists such as Rui Sanches. António and Pedro Campos Rosado, Manuel Botelho, João Penalva, and Graça Pereira Coutinho all went to London; Manuel Castro Caldas, Martim Avilez, Paulo Feliciano, Miguel Angelo Rocha, and Pedro Sousa Vieira studied in New York. Institutional grant support from the FLAD and the Ernesto Sousa Foundation reinforced this trend. In terms of international success, Chafes, Sanches, Croft, and Proença are important; they participated in the Venice Biennale of 1980. Calapez is also notable in this regard, as are José de Guimarães, Julião Sarmento, and Cabrita Reis, who moved within stronger, albeit more disparate, circles.

José de Guimarães (b. 1949) crossed African art themes with Western art. From the 1970s on, his work followed the work of Allan Davie and pop art. He is the best-known of the group that studied abroad, for his art has been shown in Japan, Belgium, and Italy. He is also the least avant-garde. Julião Sarmento is the very embodiment of tenacity in building a U.S. and European fame. He has used the body as his theme since the 1970s. Sarmento is one of the most interesting of the postconceptualists, invoking images of film culture, photography, U.S. erotica, and police fic-

tion, and an attitude of permanent voyeurism toward the female figure, sex, violence, and pleasure.

Cabrita Reis evolved from painter to sculptor, and later to maker of installation art. His work established a strong constructive framework, which was then refined and monumentalized. He depicted powerful symbols and metaphors with poor, light-colored materials, including communicating structures such as chipboard, plaster, cloth, glass, and electrical or plumbing materials; elements of an arcane memory in a Mediterranean climate.

The international careers of these artists reflect the radical lack of synchronicity at home between official art promotion policies and individual artists. Michael Biberstein (b. 1946), a Swiss-American artist residing in Portugal since the 1980s and completely part of the Portuguese art world, adds an element of internationalism to the national scene. The difference between the "romantic" landscapes painted in Portugal and those painted in Switzerland is obvious; the thinking that accompanies these paintings has been decisive for national artistic life. Finally, the works of Dacosta, Rego, Rodrigo, Angelo, Carneiro, Lapa, Bravo, and Batarda were relaunched in the 1980s.

The Present

Since the 1980s, latent crisis once again has become explicit through national and international political, economic, and social changes: the breakdown of the Soviet Union, the fall of the Berlin Wall, the civil strife in Bosnia, the Persian Gulf War, the spread of AIDS, and the rampant hunger and genocide in Africa.

The artwork developed in this context has been characterized by a return to values rejected in the 1980s, which have been approached from a new perspective. The pomp and festivity of the 1980s are still disdained, however; and a reflection on the relationship between the creator, the work, the viewer, and the market, as well as critical consecration, has developed. The collapse of the market has facilitated this antimarket vision. In addition, there is a desire to overcome the political utopias of the conceptualists in the 1970s.

International thinking and internationally oriented art center on the

notion of the final stage of capitalism, the "spectacle society." They also reevaluate feminist discourse, exploring the body in mutation, AIDS, nationalism, and war, along with communication technologies and the recovery of nonvisual artistic languages. In Portugal, however, the debate is incomplete, as though the evolution of Portuguese society itself did not permit a natural relationship with these phenomena. This trend is akin to what has occurred in relation to pop and conceptual art. On the one hand, some artists of the 1970s and 1980s have incorporated these elements into their work. On the other hand, radical and intense power games continue to develop over the control of the few and fragile cultural institutions in existence.

This struggle divides the artists of the 1980s generation. Cerveira Pinto, who writes in the weekly *O Independente*, and Leonel Moura have set out on a separate course. In the 1980s, Moura altered his conceptualist career with an intense and militant "return to painting" based on primitive and strongly textured paintings. He has gone on to use ready-made images from other media, such as photography, or images of other artists with iconographic value nationally (Amália the fado singer, King Dom Sebastião, or the poet Pessoa) or internationally (Kant and Wittgenstein), over which he superimposes key words such as *Portugal*, *Yes*, and *Europe*. Other artists have tried to develop a new understanding of their own work through postconceptualism, language and irony games, constructivist references, or a philosophical discourse. Examples are Cerveira Moura, Pedro Portugal, Rui Sanches, and Cabrita Reis.

At the same time, new names emerge, which use their work as a true instrument for ideological rupture; an example is Paulo Feliciano. Feliciano (b. 1963) is a typical artist of the 1980s. His work has evolved from the metaphorical use of objects and recycled materials toward the construction of works based on a critical discourse that pokes fun at the relationship between art and money, art and society, and the inner creative process. His relationship with rock music as a band leader is essential to his work. A group linked to the Zero gallery, which opened in Algés in 1990, and to the review *ArtStrike* includes Paulo Mendes and Rui Serra. New artists in Oporto, such as André Magalhães, Fernando José Pereira, and Cristina Mateus, use installation art, video, and even painting to comment on society. Other independent careers of importance are those of Miguel Ângelo Rocha, Miguel Soares, José Drummond, and Francisco Tropa.

The crisis of the 1990s has not provoked the disaster of the 1970s, which proves that the art world in Portugal has gained strength. Interest in art has not declined; on the contrary, new private schools have opened and new publications have emerged. Galleries going bankrupt have been few and far between. Some galleries emerged after the earlier crisis and have maintained their leadership position. Such is the case of the Alda Cortez and Graça Fonseca galleries, both of which opened in Lisbon in 1989. These galleries are in some ways, moreover, mouthpieces for the artists.

A declining art trade, nevertheless, has led to the dispersion of initiatives through a variety of alternative centers, be they in the capital or the provinces. These centers take advantage of buildings that might be available, ranging from ruins to structures recovered by private institutions or municipalities. Examples are the Sala do Veado in the Museum of Natural History; the Mitra and Galveias museums in Lisbon; the Alfândega in Porto; the reactivated Center for Plastic Arts in Coimbra; other facilities in Beja, Lagos, and Faro; and, more recently, Vila Velha do Rodão and Almada. None of these initiatives, however, is guaranteed continuity.

On the other hand, more regular alternative events have also begun, such as Arte Pública in Lisbon (1991–94) and the Jornadas de Arte Contemporânea in Porto (1993–). The government and the large financial organizations have taken advantage of the breakdown of private initiative rethink their connection with and use of art in a more strategic way, as a means to rework their image. International events that have helped secure those links include Europália in Belgium (1992) and Lisbon, Cultural Capital, in Lisbon (1994); the inauguration of the Centro Cultural de Belém in 1994 (an architecturally excellent center but a programmatically and budgetarily undefined project); the return to the Venice Biennale in 1995; the reorganzation of some museum spaces in Lisbon, such as the Museu do Chiado and the Gare de Alcântara; the creation of a new cultural center, Culturgest, belonging to the largest public bank, the Caixa Geral de Depósitos; the organization of a collection by the FLAD presenting a coherent vision of the 1970s and 1980s in Portugal; and finally, the emergence of a large private collection, the Barardo, devoted exclusively to postwar international art. All this guarantees that museological references remain updated. What's more, a new foundation, the Fundação Oriente, permits a close relationship with Portuguese culture in Asia, India, and Macao.

Throughout the last hundred years, Portuguese art has been charac-

terized by a very strong current of individual artistic values. Yet Portugal has come to the end of the century without witnessing any change in the negative factors that have historically conditioned the nation's cultural and artistic life: the absence of an autonomous civil society, and the art world's dependence on official protection, which, in turn, demonstrates artists' continuing difficulty in achieving national and international prominence.

It seems that Portugal has arrived at a turning point. The global re-evaluation of relations between identity and cultural cosmopolitanism, and the revitalization of the cultural agents in Portuguese society, are both taking place. It is a turning point of expansion and recognition. In this context, the specific characteristics of Portuguese art, and the atomized character of its creators, may gain an international dimension. In other words, the individual nature of Portuguese art production may eventually be integrated into the world's various art networks.

Learning from the Portuguese Experience: Some Quick Conclusions About Some Long Processes

NANCY BERMEO

This lively book of essays on modern Portugal gives us an overview of a nation with a history that is both remarkable and instructive. Portugal and the Portuguese have proven remarkably resilient to the strains of dictatorship and democracy. Each of the book's chapters contains insights on the nature and the sources of the nation's achievements, and their synthesis provides the stimulus to ponder how Portugal's experience might prove instructive for other nations.

Portugal's ability to withstand the challenges of simultaneous decolonization and democratization is surely one of the greatest political accomplishments of any state in post–World War II Europe. Although Portugal's empire was thought to be an integral part of national mythic identity, and although it was given semisacred connotations in the service of national goals, the political elite that came to power in the aftermath of the 1974 Revolution engineered a surprisingly swift end to thirteen years of colonial war. In barely more than a decade, the nation was transformed from a frail and often reviled imperialist regime to a respected member of the European Community. As Nuno Severiano Teixeira puts it, Portugal changed "its place in the world" and its status in the international community almost overnight.

Portugal could not have dismantled its centuries-old empire and still maintained its new democracy without successfully meeting two other, re-

lated challenges. The first was the absorption of hundreds of thousands of ex-colonials who came flooding back to the mainland just as the nation's new democracy entered a period of economic crisis. These refugees, plus the one hundred thousand demobilized soldiers who accompanied them, might easily have provided the base for antidemocratic movements, but they were quickly channeled into the Portuguese mainstream instead. Portugal's ability to absorb a tidal wave of immigration with speed and success should be of interest to many other countries facing similar challenges today.

Portugal's ability to refashion civil-military relations in the aftermath of the 1974 Revolution constitutes another positive achievement related to decolonization. As the essays by Manuel Braga da Cruz and António Costa Pinto make clear, Portugal's revolution began as a military affair and the role the armed forces would play in the political institutions of Portugal's inchoate democracy became a hotly contested issue. Yet, on this front as on so many others, Portugal managed to avert disaster. The principle of military "subordination to civilian political power" became hegemonic by late 1975, and the 1982 constitutional reforms put an end to military participation in politics. As Maria Carrilho points out, civil-military relations in Portugal "came to resemble those of other European democracies" less than a decade after a period of radical military mobilization. The peaceful and consensual transformation of the military's role provides another lesson for students of politics elsewhere.

The subordination of a once-activist military to the authority of elected civilians marks a central component of what is, for many, the nation's most laudable achievement: the creation of a consolidated democracy. Europe's "most durable dictatorship" became a durable democracy against the odds. Despite the conditions of its birth, in the tumult of a social revolution; despite the condition of Portuguese civil society, which was thought to be poorly developed; despite meeting only a few of the "prerequisites" of democratic stability, Portugal's democratic system survived. It even went through what Braga da Cruz calls a "progressive rationalization," improving itself over time. The cabinet instability that had plagued the nation's earlier, failed democracy troubled the early years of the new democracy as well, but instability was gradually reduced. Interestingly, this reduction was not due to changes in the electoral system (which is still "not conducive to government stability") but to the electorate's willingness, as

Braga da Cruz puts it, "to correct this tendency by voting for two consecutive absolute majorities."

The electorate's willingness to eschew extremism and vote consistently for center-right and center-left parties was not always taken for granted. In the heady days of the revolution, knowledgeable and cautious scholars warned of the possibility of permanent polarization and even civil war. The essays in this volume show vividly that Portuguese political culture has undergone several dramatic and positive changes in the twentieth century, and this, too, is an achievement worth noting. Two of the cleavages that plagued the First Republic (regarding the status of religion and the monarchy) are no longer divisive. Urban-rural divisions are still troubling, although the depopulation of Portugal's rural areas may eventually lessen this strain, as well.

Although it is correct to argue that Portugal had few or none of the economic, social, and cultural requisites of a civic political culture when the First Republic was founded, this is clearly not the case today. As João Ferreira de Almeida's essay makes abundantly clear, Portugal's current political culture is not radically different from those of many other European democracies. This increasing proximity to the European cultural mainstream may explain why both João Camilo dos Santos and João Pinharanda end their respective reviews of Portugal's literature and art on notes of optimism. Despite experiencing a radical and long-lasting assault on property relations and what Virginia Ferreira calls "the widest and deepest social movement ever witnessed in postwar Europe," the people of Portugal continue to eschew antidemocratic alternatives.

People's links to the democratic system, of course, are still far from ideal. Political parties as institutions and politicians as individuals are viewed with skepticism. Social and political participation are relatively low, and class barriers to upward mobility remain formidable. But satisfaction with democracy as a political system is more than twenty percentage points above the average for the European Union as a whole, and life satisfaction is substantially above the EU average as well. The polarity of social networks and lifestyles that was once integral to the ideological divisions of the past has softened as people have combined and managed symbols and ideas with much greater "autonomy." According to Ferreira de Almeida, the increasingly dominant tendency in the political culture seems to be

"the collective internalization of the value of tolerance." Because tolerance is decreasing in many other democracies, Portugal's achievement is all the more impressive.

These positive changes in political culture are partly the result of structural changes in the nation's economy and society. As this book clearly illustrates, Portugal often struggled unsuccessfully with the challenges of a peripheral economy in the past. Today, in the postrevolutionary period, however, one notes remarkable progress on many fronts. The percentage of the active population working as salaried professionals has grown more than sevenfold since the 1960s; the number of students in universities has increased nearly fivefold; and Portugal has become a society of the middle class. Portugal's economic growth rate was harmed by the political uncertainty of the mid-1970s, but growth rates now compare favorably with those of any country in Europe.

Portugal has had to struggle to liberalize its economy to meet the demands of the EU and an increasingly globalized market of investors, but it has met these challenges without allowing its citizens to suffer the strains of rampant unemployment. Wages have remained low, but jobs have been protected. Portugal has consistently maintained one of the lowest unemployment rates on the continent. Although the costs of job maintenance have no doubt affected policymakers' ability to control inflation, the political benefits of providing steady employment to a once radicalized working class are far from inconsequential, and are closely linked to the nation's ability to consolidate its new democracy.

Portugal's ability to avoid the negative social and political consequences of rampant unemployment is even more remarkable given the role of women in the Portuguese workforce. Women are often squeezed out of the paid labor market in times of recession; yet as Virginia Ferreira notes, levels of female employment in Portugal have risen fairly steadily in the postrevolutionary period, reaching as high as 45 percent in 1994. Women's participation in paid labor has more than doubled since 1970, and an astounding 70 percent of all mothers in Portugal are part of the paid labor force. Family policy laws are extremely progressive, and although their implementation still has serious shortcomings, they might provide a focus for collective action in the future. Ferreira's essay clearly reveals the ironies and ambiguities of the social advances that Portuguese women have made

of late, but when seen in comparison with the prerevolutionary past and with many advanced industrial societies today, the improvement in the status of Portuguese women is noteworthy.

In this area, as in so many others, Portugal's historical experience offers valuable lessons to policymakers and political actors in other states. If books such as this one receive the attention they deserve, the Portuguese experience will be better known, better understood, and more often studied.

Chapter One

1. See António Costa Pinto and Xosé M. Nuñês, "Portugal and Spain," in *European Political Culture: Conflict or Convergence?* ed. Roger Eatwell (London: Routledge, 1997), 172–92.

2. See Nuno Severiano Teixeira, *O ultimatum inglês. Política externa e política interna no Portugal de 1890* (Lisbon: Alfa, 1990).

3. Hermínio Martins, "Portugal," in *Contemporary Europe: Class, Status and Power*, ed. Margaret Scotford Archer and Salvador Giner (London: Weidenfeld and Nicolson, 1971), 63.

4. See Kathleen Schwartzman, *The Social Origins of the Democratic Collapse: The First Portuguese Republic in the Global Economy* (Lawrence: University Press of Kansas, 1989).

5. See Jaime Reis, *O atraso económico português numa perspectiva histórica* (Lisbon: Imprensa Nacional, 1993).

6. Estimate, for the 1930 census transferred to the tertiary a good part of the primary sector.

7. Nicos P. Mouzelis, *Politics in the Semi-Periphery: Early Parliamentarism and Late Industrialization in the Balkans and Latin America* (New York: St. Martin's Press, 1986).

8. See Pedro Tavares de Almeida, *Eleições e caciquismo no Portugal oitocentista (1868–1890)* (Lisbon: DIFEL, 1991).

9. See Douglas L. Wheeler, *Republican Portugal: A Political History, 1910–1926* (Madison: University of Wisconsin Press, 1978), 32–47.

10. See Hermínio Martins, "The Breakdown of the Portuguese Democratic Republic" (Paper prepared for the Seventh World Congress of Sociology, Varna, 1970), 6.

11. Mattei Dogan, "Romania, 1919–1938," in *Competitive Elections and Developing Studies*, ed. Myron Weiner and Ergun Ozbudun (Durham: Duke University Press, 1987), 369–89. According to Dogan's "ideal type," a "mimic democracy" is "a political system that imitates Western competitive democracy" and is "likely to appear in societies with low degrees of urbanization and industrialization," with a strong "landed gentry" and "an immense majority of population" being rural. "The State does not penetrate in society"; the middle classes are weak; "mass communication is very limited"; "religious feeling dominates the political culture, and the State and Church support each other." "Parliament does not proceed from uni-

versal suffrage, the party in power manipulates the elections," and "the majority of citizens are not directly affected by the alternation of parties in power."

12. See Fernando Farelo Lopes, *Poder político e caciquismo na I^a República* (Lisbon: Estampa, 1994), 76.

13. See Martins, "Breakdown," 8.

14. Ibid., 6.

15. Ibid.

16. See Maria Filomena Mónica, *O movimento socialista em Portugal (1875–1934)* (Lisbon: IED, 1985).

17. Schwartzman, *Social Origins*.

18. Ibid., 132.

19. Ibid., 125.

20. See Vasco Pulido Valente, "Revoluções: A 'República Velha' (ensaio de interpretação políca)," *Análise Social* 27:115 (1992) 7–63.

21. See Nuno Severiano Teixeira, *O poder e a guerra. Objectivos nacionais e estratégias políticas em Portugal, 1914–18* (Lisbon: Estampa, 1996).

22. Nuno Severiano Teixeira, "A fome e a saudade. Os prisioneiros portugueses na grande guerra," *Penélope* 8 (1992) 91–114.

23. It should be mentioned that the Communist Party, born of a split from anarchosyndicalism and very "working class"–based in terms of its first elites, played a very insignificant role in the final crisis of the republic.

24. Schwartzman, *Social Origins*, 184.

25. See Maria Carrilho, *Forças armadas e mudança política em Portugal no séc. XX. Para uma explicação sociológica do papel dos militares* (Lisbon: Imprensa Nacional, 1985); and José Medeiros Ferreira, *O comportamento político dos militares. Forças armadas e regimes políticos em Portugal no séc. XX* (Lisbon: Estampa, 1992).

26. Wheeler, *Republican Portugal*, 193.

27. Ibid., 181.

28. Ibid., 185.

29. See António Costa Pinto, *Os camisas azuis. Ideologia, elites e movimentos fascistas em Portugal, 1914–1945* (Lisbon: Estampa, 1994).

30. See Hermínio Martins, "Portugal," in *European Fascism*, ed. Stuart Woolf (New York, 1969), 305.

31. José Pequito Rebelo, *Pela dedução à monarquia* (Lisbon: Gama, 1945), 74.

32. See Juan J. Linz and Alfred Stepan, eds., *The Breakdown of Democratic Regimes* (Baltimore: Johns Hopkins University Press, 1978), 82.

33. Ibid.

34. See Martin Blinkhorn, ed., *Fascists and Conservatives* (London: Routledge, 1990), 13.

35. See Juan J. Linz, "Political Space and Fascism as a Late-Comer," in *Who Were the Fascists? Social Roots of European Fascism*, ed. Stein Ugelvik Larsen et al. (Bergen: Universitäts Forlaget, 1980), 153–89.

36. Ibid., 164.

37. See Manuel Braga da Cruz, *O partido e o estado no salazarismo* (Lisbon: Presença, 1988).

38. See António Costa Pinto, *Salazar's Dictatorship and European Fascism: Problems of Interpretation* (New York: Social Science Monographs/Columbia University Press, 1995).

39. See Carrilho, *Forças armadas*, 423; and Ferreira, *O comportamento político dos militares*, 175–202.

40. Carrilho, *Forças armadas*, 422.

41. We are still waiting for a good biography of Salazar. Meanwhile, see the one written by one of his ministers, Franco Nogueira, *Salazar*, 6 vols. (Coimbra, 1977–85).

42. For the 1930s, see António Oliveira Salazar, *Discursos e notas políticas*, vol. 1 (Coimbra: Coimbra Editora, 1935).

43. See Juan J. Linz, "Totalitarian and Authoritarian Regimes," in *Handbook of Political Science*, vol. 3, ed. F. Greenstein and N. Polsby (Reading, 1975), 266; and Giovanni Sartori, *Parties and Party Systems: A Framework for Analysis* (Cambridge: Cambridge University Press, 1976).

44. See Shlomo Ben-Ami, *Fascism from Above: The Dictatorship of Primo de Rivera in Spain, 1923–1930* (Oxford: Oxford University Press, 1983); and José Luis Gómez Navarro, *El régimen de Primo de Rivera* (Madrid, 1991).

45. See Stanley G. Payne, *A History of Fascism* (Madison: University of Wisconsin Press, 1996).

46. See Ricardo Chueca, *El fascismo en los comienzos del régimen de Franco. Un estudio sobre la FET-JONS* (Madrid: CES, 1983), 166.

47. See Circular do Ministro do Interior aos presidentes das comissões distritais da UN, 29-12-1931, maço 452, caixa 5, Arquivo Geral do Ministério do Interior (AGMI)/Arquivo Nacional da Torre do Tombo (ANTT).

48. See AOS/CO/PC-4, ANTT.

49. Cited in Braga da Cruz, *O partido*, 140.

50. See Peter J. Williamson, *Corporatism in Perspective: An Introductory Guide to Corporatist Theory* (London: Sage, 1989).

51. See Fátima Patriarca, *A política social do salazarismo* (Lisbon: Imprensa Nacional, 1995).

52. See Victoria de Grazia, *Mass Organization of Leisure in Fascist Italy* (Cambridge: Cambridge University Press, 1981).

53. See António Costa Pinto and Nuno Afonso Ribeiro, *A Acção Escolar Vanguarda (1933–1936)* (Lisbon: História Crítica, 1980).

54. See Simon Kuin, "Mocidade Portuguesa: 'Mobilization' of Youth During the Portuguese Estado Novo Regime (1936–1974)" (Mimeograph, Florence, 1991).

55. See Luís Nuno Rodrigues, *A Legião Portuguesa* (Lisbon: Estampa, 1996).

56. Ibid., 10.

57. See Artur Portela, *Salazarismo e artes plásticas* (Lisbon: Bertrand, 1982); and Jorge do ó, "Salazarismo e cultura," in *Nova história de Portugal*, ed. Joel Serrão and A. H. Oliveira Marques, vol. 12, *Portugal e o Estado Novo*, ed. Fernando Rosas (Lisbon: Presença, 1992), 391–454.

58. See Christian Faure, *Le projet culturel de Vichy: folklore et révolution nationale, 1940–1944* (Lyon: CNRS, 1989), 7. For a detailed description of the reinvention of tradition, see chapter 11 in this book. On Ferro's recruiting of artists, see chapter 13.

59. Salazar, *Discursos e notas políticas*, 1:259.

60. Quoted in Arlindo Caldeira, "Heróes e vilões na mitologia salazarista," *Penélope* 15 (1995) 121–39.

61. See Manuel Braga da Cruz, "As relações entre o estado e a igreja," in Serrão and Oliveira Marques, *Nova história*, 12:211.

62. Ibid.

63. See Maria Inácia Rezola, "Breve panorama da situação da igreja católica em Portugal, 1930–1960," ibid., 12:238.

64. Quoted by João Medina, *Salazar em França* (Lisbon: Bertrand, 1977), 50.

65. See Stanley G. Payne, "Authoritarianism in the Smaller States of Southern Europe," in *Politics, Society, and Democracy, Comparative Studies: Essays in Honor of Juan J. Linz*, ed. H. E. Chehabi and Alfred Stepan (Boulder: Westview Press, 1995).

66. See Nuno Severiano Teixeira, "From Neutrality to Alignment: Portugal in the Foundation of the Atlantic Pact," EUI Working Paper HEC no. 9/91 (Florence, 1991).

67. António José Telo, "Portugal, 1958–1974: sociedade em mudança," in *Portugal y España en el cambio político (1958–1978)*, ed. Hipólito de la Torre Gomez (Mérida: Universidad National de Educación a Distancia, 1989), 88.

68. Salazar, *Discursos e notas políticas*, vol. 6 (Coimbra: Coimbra Editora, 1965).

69. See Philippe C. Schmitter, "Liberation by *Golpe*: Retrospective Thoughts on the Demise of Authoritarian Rule in Portugal," *Armed Forces and Society* 2:1 (November 1975) 5–33; and Kenneth Maxwell, *The Making of Portuguese Democracy* (Cambridge: Cambridge University Press, 1995).

Chapter Two

1. Eduardo da Costa, *Estudo sobre a administração civil das nossas possessões africanas* (Lisbon: Imprensa Nacional, 1903), 8–13, 37–39, and 57–86.

2. René Pelissier, *História das campanhas de Angola* (Lisbon: Estampa, 1986), 1:294, 2:79.

3. Malyn Newitt, *Portugal in Africa: The Last Hundred Years* (London: C. Hurst, 1981), 61.

4. René Pélissier, *História de Moçambique* (Lisbon: Estampa, 1987), 1:205–7, 2:278–83.

5. Cf. Pélissier, *História das campanhas de Angola*, 1:233–35, 2:234–50; *História de Moçambique*, 1:211–12.

6. Norton de Matos, *A província de Angola* (Porto: Editora de Maranus, 1926), 15, 262.

7. See Decree Law 77, Dec. 9, 1921.

8. Matos, *A província de Angola*, 117.

9. Ibid., 42.

10. Decree Laws 40 and 41, August 3, 1921.

11. Matos, *A província de Angola*, 305–11.

12. For the latter two acts, see Decree Laws 23.228 and 23.229, Nov. 15, 1933.

13. Organic Charter of the Portuguese Colonial Empire [*Carta orgânica*], articles 227 and 228.

14. Decree Law 27.552, Mar. 5, 1937, quoted in Joana Pereira Leite, *La formation de l'économie coloniale au Mozambique* (Paris: Ecole des Hautes Etudes en Sciences Sociales, 1989), 192.

15. Gervase Clarence-Smith, *The Third Portuguese Empire, 1825–1975* (Manchester: Manchester University Press, 1985), appendix 3, figs. 1, 2.

16. Ibid., 150–51 and appendix 3; Fernando Rosas, *O Estado Novo nos anos trinta, 1928–1938* (Lisbon: Estampa, 1986), 141–42.

17. Rosas, *O Estado Novo nos anos trinta*, 158–59.

18. Ibid., 143.

19. F. Ribeiro Salgado, *A evolução do comércio especial ultramarino* (Lisbon: AGC, 1939), map 44.

20. Leroy Vail and Landeg White, *Capitalism and Colonialism in Mozambique* (London: Heinemann, 1980), 272.

21. Fernando Rosas, *Portugal entre a paz e a guerra, 1939–1945* (Lisbon: Estampa, 1990), 239.

22. Ibid., 265–67.

23. Fernando Rosas, *O Estado Novo (1926–1974)*, vol. 7 of *História de Portugal*, ed. José Mattoso (Lisbon: Círculo de Leitores, 1994), 489.

24. Pereira Leite, *Formation de l'économie coloniale*, 298.

25. Edgar Rocha, "Portugal, anos 60: crescimento económico e relações com as colónias," *Análise Social* 13 (1977–83) 593–617.

26. Measures taken by Marcelo Caetano compiled in *Providências legislativas* (Lisbon: AGC, 1945).

27. Gilberto Freire, *Masters and the Slaves* (New York: Alfred A. Knopf, 1946).

28. Decree Law 43.896, June 9, 1961.

29. Decree Law 43.730, June 12, 1961; and Law 2.119, June 24, 1963.

Chapter Three

1. Valentim Alexandre, *Origens do colonialismo português moderno* (Lisbon: Sá da Costa, 1979); Gervase Clarence-Smith, *The Third Portuguese Empire, 1825–1975* (Manchester: Manchester University Press, 1985); José Medeiros Ferreira, "Características históricas da política externa portuguesa," *Política Internacional* 6 (Spring 1993) 113–56; Richard Langhorn, "Anglo-German Negotiation Concerning the Future of the Portuguese Colonies," *Historical Journal* (1973), 2:361–87.

2. Enders Armelle, *Histoire de l'Afrique lusophone* (Paris: Chandeigne, 1994); Marcello Caetano, *Portugal e a internacionalização dos problemas africanos* (Lisbon: Atica, 1971); Jean Derou, *Les Relations Franco-Portugaises, 1910–1926* (Paris: Publications de la Sorbonne, 1986); José Medeiros Ferreira, *Um Século de problemas — As Relações luso-espanholas da União Ibérica à Comunidade Europeia* (Lisbon: Horizonte, 1989); Nuno Severiano Teixeira, *O Poder e a guerra 1914–1918* (Lisbon: Estampa, 1996); Hipólito de la Torre Gómez, *Conspiração contra Portugal, 1910–1912* (Lisbon: Estampa, 1978); John D. Vincent-Smith, *As Relações políticas luso-britânicas, 1910–1916* (Lisbon: Horizonte, 1975).

3. José Freire Antunes, *Kennedy e Salazar-o leão e a raposa* (Lisbon: D. Quixote, 1991); Alberto Franco Nogueira, *As Nações Unidas e Portugal* (Lisbon: Atica, 1962); César Oliveira, *Salazar e a guerra civil de Espanha* (Lisbon: O Jornal, 1987); Maria Fernanda Rollo, *Portugal e o Plano Marshall* (Lisbon: Estampa, 1994); Fernando Rosas, *Portugal entre a Paz e a Guerra 1939–1945* (Lisbon: Estampa, 1990); Glyn Stone, *The Oldest Ally: Britain and the Portuguese Connection, 1936–1941* (Suffolk and New York: Boydell Press, 1994); Nuno Severiano Teixeira, *From Neutrality to Alignment: Portugal in the Foundation of the Atlantic Pact* (Florence: EUI Working Paper n° 9/91, 1991); António José Telo, *Portugal na Segunda Guerra Mundial, 1941–1945*, 2 vols. (Lisbon: Vega, 1990–91).

4. José Medeiros Ferreira, "Portugal," *Dicionário de política internacional* (Lisbon: D. Quixote, 1990), 438–44; idem, "Political Costs and Benefits for Portugal Arising from Membership in the European Community," in *Portugal and E.C. Membership Evaluated*, ed. José da Silva Lopes (London and New York: Pinder Publishers, 1993), 173–81; Scott B. Macdonald, *European Destiny, Atlantic Transformations: Portuguese Foreign Policy Under the Second Republic, 1974–1992* (London: Transaction Books, 1993); Kenneth Maxwell, *The Making of Portuguese Democracy* (Cambridge: Cambridge University Press, 1995).

Chapter Four

1. Fernando Rosas, "O pensamento reformista no século XX em Portugal," in *Actas do encontro ibérico de história do pensamento económico em Portugal*, ed. CISEP (Lisbon: Centro de Estudas de Economia Portuguesa, 1992), 357.

2. José N. Ferreira Dias Júnior, *Linha de rumo. Notas de economia portuguesa* (Lisbon: Livraria Clássica, 1945).

3. José Maria Brandão de Brito, *Corporativismo e industrialização: elementos para o estudo do condicionamento industrial* (Lisbon: Dom Quixote, 1989), 343.

4. Idem, "Os engenheiros e o pensamento económico do Estado Novo," in CISEP, *Actas do encontro*, 211.

5. Fernando Rosas, *Portugal entre a paz e a guerra, 1939–1945* (Lisbon: Estampa, 1990), 193.

6. José Ferreira Dias, speech, December 21, 1943, *Boletim da Direcção Geral da Industria* 329, p. 181.

7. Fernando Rosas, *O Estado Novo nos anos trinta, 1928–1938* (Lisbon: Estampa, 1986), 185.

8. Ferreira Dias, *Linha de rumo*, 1:170.

9. Rosas, *O Estado Novo nos anos trinta*, 210.

10. L. Prados de la Escosure and Vera Zamagni, eds., *El desarrollo económico en la Europa del sur: España y Italia en perspectiva histórica* (Barcelona: Alianza Editorial, 1992).

11. Jaime Reis, *O atraso económico português em perspectiva comparada*, Working Paper 20 (Faculdade de Economia da Universidade Nova de Lisboa, 1984), 7–28.

12. Rosas, *O Estado Novo nos anos trinta*, 58.

13. Reis, *O atraso económico*, 7–28.

14. Fernando Rosas, "Rafael Duque e a política agrária do *Estado Novo*," *Análise Social* 111–13 (1991), 771; Luciano do Amaral, "O país que nós perdemos: politica agrária, grupos de pressão e evolução da agricultura portuguesa entre 1950 e 1973" (Mimeograph, Lisbon, 1993); Joaquim Oliveira Martins, *Fomento rural e emigração* (Lisbon: Guimarães, 1956).

15. Miriam Halpern Pereira, *Política e economia: Portugal nos séculos XIX e XX* (Lisbon: Livros Horizonte, 1979), 31.

Chapter Five

1. See chapter 4.

2. Ana Bela Nunes and Nuno Valério, "A lei de reconstituição económica e a sua execução: um exemplo dos projectos e realizações da política económica do Estado Novo," *Estudos de Economia* 3 (April–June 1983), 331–59.

3. José Maria Brandão de Brito, *A industrialização portuguesa no pós-guerra (1948–1965): o condicionamento industrial* (Lisbon: Dom Quixote, 1989), 128.

4. Francisco Pereira de Moura, *Por onde vai a economia portuguesa?* (Lisbon: Dom Quixote, 1969), 19; José Nascimento Ferreira Dias Júnior, *Linha de rumo. Notas de economia portuguesa* (Lisbon: Livraria Clássica, 1945), 1:170.

5. Ferreira Dias was undersecretary of state for commerce and industry from

1940 to 1944 and minister of the economy from 1958 to 1962. He was the author of the National Electrification Law and the Law of Industrial Reorganization and Support, both passed during the war years; and his seminal book, *Linha de rumo*, was published at the end of that period.

6. Fernanda Rollo, *Portugal e o plano Marshall. Da rejeição às solicitação da ajuda financeira norte americana (1947–1952)* (Lisbon: Estampa, 1994); José Maria Brandão de Brito, "The Portuguese Response to the Marshall Plan," *Estudos de Economia* 10:4 (July–September 1990), 415–21.

7. Presidência do Conselho, Inspecção Superior do Plano de Fomento, Relatório final da execução do plano de fomento (1953–1958) (Lisbon: Imprensa Nacional, 1959), 11.

8. Parecer da Câmara Corporativa, no. 36/V, Plano de Fomento, pt. 1 (continente e ilhas), Projecto de Proposta de Lei no. 519, in *Pareceres da Câmara Corporativa (V Legislatura)*, ano de 1952 (Lisbon: Assembleia Nacional, 1953), 2:232.

9. *II Congresso dos Economistas Portugueses*, INE (Lisbon: Centro de Estudos Económicos, 1957); *II Congresso da Indústria Portuguesa*, vols. 1–9 (Lisbon: Associação Industrial Portuguesa, 1957).

10. J. Calvet de Magalhães, "Portugal e a integração europeia," *Estratégia* (Lisbon) 4 (1977–88), 33.

11. Marcello Caetano, "Discurso inaugural do Congressos dos Economistas e da Indústria Portuguesa," *Discursos, Conclusão*; idem, *Estudo sobre a economia portuguesa* (Lisbon: Associação Industrial Portuguesa, 1957).

12. Edgar Rocha, "Crescimento económico em Portugal nos anos de 1960–1973: alguns aspectos," *Análise Social* 20:4 (1984), 621.

13. Manuela Silva, "O planeamento em Portugal: lições da experiência e perspectivas de futuro," in *O planeamento económico em Portugal: lições da experiência*, ed. A.A.V.V. (Lisbon: Livraria Sá da Costa, 1984), 19.

14. Ibid., p. 21.

15. *III Plano de fomento*, vol. 1 (Lisbon: Secretaria Geral da Assembleia Nacional, 1967), 30.

16. Américo Ramos dos Santos, "Abertura e bloqueamento da economia portuguesa," in *Portugal contemporâneo*, ed. A.A.V.V. (Lisbon: Alfa, 1990), 5:109–50.

17. Rogerio Martins, *Caminho de país novo* (Lisbon: Gris, 1970).

18. José Maria Brandão de Brito et al., "Portugal: Economic Developments and Eighteen Months' Intervention by the International Monetary Fund" (Paper prepared for the South-North Conference on the International Monetary System and the New International Order, Lisbon, January 1980).

Chapter Six

1. Decree Laws 621-A/74 and 621-C/74, 1974.

2. Article 116-5 and Article 115, Constitution of 1976.

3. See Marcelo Rebelo de Sousa, *Os partidos políticos no direito constitucional português* (Braga: Cruz, 1983), 555.

4. The phrase comes from Adriano Moreira, "O regime: presidencialismo do primeiro ministro," in *Portugal. O sistema político e constitucional, 1974–1987*, ed. Mario Baptista Coelho (Lisbon: ICS, 1989).

5. MFA program, sections B-3-C and C-1, in *Textos históricos da revolução*, vol. 1 (Lisbon: Diabril, 1975), 45.

6. José Medeiros Ferreira, "25 de Abril de 1974: uma revolução imperfeita," *Revista de História das Idéias* 7 (1985), 391–426.

7. André Gonçalves Pereira, *O semipresidencialismo em Portugal* (Lisbon: Atica, 1984), 42–43.

8. José Miguel Alarcão Júdice, "O bonapartismo impossível?" in *Portugal à deriva* (Lisbon: Tempo, 1978), 68.

9. Jorge Campinos, "Le cas portugais de 1979 a 1983: le président opposé à la majorité," in *Les régimes semipresidentiels*, ed. Maurice Duverger (Paris: PUF, 1986), 221.

10. Ibid., 213.

11. Marcelo Rebelo de Sousa, *O sistema de governo português, antes e depois da revisão constitucional* (Lisbon: Cognito, 1984), 86.

12. Gonçalves Pereira, *O semipresidencialismo*, 61.

13. Joaquim Aguiar, *A ilusão do poder. Análise do sistema partidário português, 1976–1982* (Lisbon: Dom Quixote, 1983).

14. Jorge Oliveira, "O veto presidencial e a continencia presidencial," *Expresso* (Lisbon), May 28, 1988. For the response by Alfredo Barroso, see "O presidente da república e o veto político," *Expresso*, May 21, 1988.

15. Antonio Barreto, interview, *Jornal* (Lisbon), February 16, 1990.

16. Mario Soares, *Intervenções* 2 (Lisbon: Imprensa Nacional, 1988), 15–17.

17. Mario Soares, interview, *Público*, March 9, 1990.

18. Soares, interview, *Público*, March 10, 1990.

19. This was particularly true after Lucas Pires, leader of the Social Democratic Center, decided not to compete in the race because of a lack of political support in the PSD.

20. See Soares, *Intervenções* 5 (Lisbon: Imprensa Nacional, 1991), 17–18.

21. See Hugues Portelli, "La présidentialisation des partis français," *Pouvoir* 14 (1980), 97.

22. Moreira, "O regime."

23. Maurice Duverger, "Le concept de régime semipresidentiel," in *Les régimes semipresidentiels*, 23–35; idem, *Xeque Mate. Analise comparativa dos sistemas politicos semipresidenciais* (Lisbon: Rolim, 1979), 122.

Chapter Seven

1. This chapter is the result of research leading to the publication of a book by the author, *Democracia e defesa* (Lisbon: Dom Quixote, 1994). A detailed bibliography and sources can be found in that volume.

2. Samuel P. Huntington, *The Third Wave: Democratization in the Late Twentieth Century* (Norman: University of Oklahoma Press, 1993), 3. Huntington writes, "The third wave of democratization in the modern world began . . . at twenty-five minutes after midnight, Thursday, April 25, 1974, in Lisbon, Portugal, when a radio station played the song "Grandola Vila Morena." P. 3.

3. *Movimento* 1 (1975), 3.

4. Carrilho, *Democracia e defesa*, 62–63.

5. Law of National Defense, Law 29/82, 1982, Article 44.

6. Ministerio da Defesa Nacional, *A defesa de Portugal* (Lisbon, 1994) 38.

7. This approach to public opinion consultation was proposed by the author, and she presently directs the program. Since 1991, a national inquiry has been conducted each year, alternately by personal or telephone interview. See Maria Carrilho, *A nação e as questões de segurança e defesa*, 4 vols. (Lisbon: Instituto de Defesa Nacional, 1991–94). At the end of each volume is a condensed version in English.

Chapter Eight

1. A settlement of two thousand people, albeit a relatively arbitrary benchmark, is considered here to constitute an urban population.

2. João Ferreira de Almeida, *Valores e representações sociais* (Lisbon: Fundação Calouste Gulbenkian, 1990).

3. This is not easily subject to verification because of the intervention of other variables.

4. The class variable takes into account professional categories, as well as the distribution of economic, cultural, and educational capital.

5. João Ferreira de Almeida, António Firmino da Costa, and Fernando Luís Machado, "Evoluções recentes e valores na sociedade," in *Portugal Hoje*, ed. Eduardo Sousa Ferreira (Lisbon: Instituto Nacional de Administracão, 1995), 43–65.

6. Luís de França, ed., *Portugal, valores europeus, identidade cultural* (Lisbon: Instituto de Estdos para O desenvolvimento, 1993).

Chapter Nine

1. Quoted in Lia Viegas, *A constituição e a condição da mulher* (Lisbon: Diabril, 1977), 43.

2. Maria José de Magalhães, "O discurso feminista sobre a educação em Por-

tugal nos anos 70 e 80" (Master's thesis, Faculdade de Psicologia e Ciências da Educação, Porto), 20.

3. Pedro Hespanha, "Vers une société-providence simultanément pré- et post-moderne" (Mimeograph, Oficina do CES 38, Coimbra, 1993). See also Fortunata Piselli, *Medio Occidente: una periferia d'Europa tra politica e transformazione* (Venice: Marsilio, 1991).

4. Innumerable studies point out that this distance is one of the essential characteristics of Portuguese society. Two of the most recent examples are Boaventura de Sousa Santos, *Pela mão de Alice: o social e o político na pós-modernidade* (Porto: Afrontamento, 1994); Manuel Villaverde Cabral, "Portugal e a Europa: diferenças e semelhanças," *Análise Social* 27:118–19 (1992), 943–54.

5. João Ferreira de Almeida, António Firmino da Costa, and Fernando Luís Machado, "Recomposição socioprofissional e novos protagonismos," in *Portugal: 20 anos de democracia*, ed. António Reis (Lisbon: Círculo de Leitores, 1993), 318.

6. The decline in fertility rates over the last twenty years puts Portugal among the countries with the lowest fertility rates in the world: 1,518 children per woman in 1993. The only other countries with similar rates are two others in southern Europe, Spain and Italy, which are also member states of the European Union.

7. Helena Araujo arrived at this same conclusion regarding women's entry into the educational system until 1993. See Araujo, "The Construction of Primary Teaching as Womens' Work in Portugal (1870–1933)" (Ph.D. diss., Open University, London, 1993), chap. 5.

8. I am referring here to the lifting of the ban on marriage for teachers and nurses before the 1960s and, more important, to the passage of legislation reflecting the principle of "equal wage for equal work" in 1969. Legislation limiting or prohibiting women from working in activities considered dangerous to their reproductive health was also passed. Working groups were set up, such as the Working Group on the Participation of Women in Economic and Social Life, which were charged with the study of social and legal discrimination against women. These groups made recommendations to eliminate sources of discrimination in public and private law, particularly in family law and legislation on women's employment. None of the recommendations, however, was ever put into practice; the initiatives were never more than rhetorical. One example is the "right to an equal wage for equal labor," which today is still not effectively fulfilled in Portugal.

9. Virginia Ferreira, "Women's Employment in the European Semiperipheral Countries: Analysis of the Portuguese Case," *Women's Studies International Forum* 17:2/3 (1994), 141–55.

10. A detailed description of this process can be found in Audrey Brassloff, "Portuguese Women Between Revolution and Recession: Gender in Decision Making and Employment," *Journal of Area Studies* 6 (Spring 1995), 83–95.

11. Data from the General Population Census. The surveys undertaken by the

census are self-administered. For this reason, the figures regarding the active population are always inferior to those obtained by the Employment Survey, which is indirectly administered. Given that it is women who are generally considered as not being active, particularly when they are unremunerated domestic workers, the census data indicate lower levels of femininization than the data from the Employment Survey, in which the interviewer determines the interviewee's activity and then proceeds to classify it. According to the Employment Survey data, the femininization of the labor force in 1994 stood at 45 percent. This is the third-highest value among the twelve member states of the European Union in 1994, following Denmark and Great Britain. It is above the European Community average (41 percent). See *Eurostat. Estatísticas de base da comunidade* (Brussels and Luxemburg: CECA-CEE-CEEA, 1994), 132.

12. See Maria João Rodrigues, *O sistema de emprego em Portugal: crises e mutações* (Lisbon: Dom Quixote, 1988), 85.

13. See Boaventura de Sousa Santos, José Reis, and Maria Manuel Leitão Marques, "O estado e as transformações recentes da relação salarial: a transição para um novo modelo de regulação da economia," in *O comportamento dos agentes económicos e a reorientação da política económica*, vol. 2 (Lisbon: CISEP, 1986), 589–628.

14. See Grupo de Peritos, "As mulheres e o emprego," in *As mulheres em empregos atípicos* (Lisbon: CISEP/CCE, 1988).

15. In 1991, approximately 20 percent of work contracts were time-limited, and the portion of wages in total remuneration reached 88 percent, the lowest level in the European Union. See Marinús Pires de Lima, "Relações de trabalho, estratégias sindicais e emprego (1974–90)," *Análise Social* 26:114 (1991), 905–43; Wolfgang Brassloff, "Emprego e desemprego em Portugal no contexto europeu (1973–1991), II," *Brotéria* 135:6 (1992), 508–34.

16. A general rule pointed out by Isabella Bakker, e.g. See "Women's Employment in Comparative Perspective," in *Feminization of the Labour Force: Paradoxes and Promises*, ed. Jane Jenson, Elisabeth Hagen, and Ceallaigh Reddy (Cambridge: Polity Press, 1988), 17–44.

17. See Ferreira, "Women's Employment."

18. These figures are based on a calculation of indices of dissimilarity; in other words, the total difference between the structure of female and male employment. The formula to calculate the difference is the following:

$$I(t) = \frac{1}{2} \, | \, m(i,t) - f(i,t) \, |$$

in which $m(i,t)$ is the percentage of total male labor that, at time t, is employed in the sector of profession i, and $f(i,t)$ is the percentage of total female labor that, at time t, is employed in the sector or profession i. These indices give the proportion of women who should change employment or sector in order to end employment segregation. For this formula, see Karen C. Holden and W. Lee Hansen, "Part-

Time Work, Full-Time Work, and Occupational Segregation," in *Gender in the Workplace*, ed. Clair Brown and Joseph A. Pechman (Washington, D.C.: Brookings Institution, 1987), 217–46.

19. See Ferreira, "Women's Employment," 142.

20. Data for 1992. See *Eurostat. Estatísticas de base da comunidade*, 134–37.

21. See European Communities Directorate-General for Employment, Industrial Relations and Social Affairs, *Bulletin on Women and Employment in the EC* 3 (October 1993), 2.

22. In 1991, only 10 percent of children between infancy and 2 years of age were at official or state-subsidized institutions, and only 47.7 percent of those between the ages of 3 and 6 were at such institutions, little more than half the average for the twelve countries of the European Economic Community at the time (between 70 percent and 80 percent). See Comissão para a Igualdade e para os Direitos das Mulheres, *Portugal: situação das mulheres, 1994* (Lisbon: CIDM, 1994).

23. A recent issue of one of the major scientific journals includes a debate on whether the more advanced countries give more opportunities to women scientists. See Marcia Barinaga, "Surprises Across the Cultural Divide," *Science* 263 (March 1994), 1468–72; Mary Osborn, "Status and Prospects of Women in Science in Europe," ibid., 1389–91.

24. *Estatísticas da educação* (Lisbon: Instituto Nacional de Estatística, 1991).

25. The argument put forward to explain this phenomenon is the relatively retarded psychological development of boys during adolescence, a period crucial for school performance and university admission. The higher rate of graduation among women, on the other hand, shows that the problem arises because boys do not value school as much as girls. Boys reject school, intellectual work, and the behavioral norms imposed at school. The construction of male identity is based more on the search for work and economic independence. Girls place more faith in school as a means to gain access to certain professions that will allow them to escape domestic work, a model they reject.

26. Ferreira, "Women's Employment," 147.

27. Ibid., 148. We arrive at the same conclusion if we pay attention to political developments in semiperipheral countries. In this light, we can understand why many women become prime ministers and presidents of their countries through the inheritance of political positions. There are innumerable examples of this in all continents, so it cannot be said that it is a cultural phenomenon. See, for example, Nicaragua, the Philippines, India, and Pakistan.

28. Virginia Ferreira, "Office Work, Gender, and Technological Change: The Portuguese Case," in *The New Division of Labour: Emerging Forms of Work Organisation in International Perspective*, ed. Wolfgang Littek and Tony Charles (Berlin: Walter de Gruyter, 1995), chap. 14.

29. See, for example, Max Haller and Franz Hoellinger, "Female Employment

and the Change of Gender Roles: The Conflictual Relationship Between Participation and Attitudes in International Comparison," *International Sociology* 9:1 (1994), 87–112.

30. The absence of the Salic law meant that queens ruled Portugal in the eighteenth and nineteenth centuries. Portuguese women were never barred from holding property, furthermore, and men's legal rights over that property were never more than administrative. Where property owned by women was concerned, any action that affected it required the express consent of the owner.

31. An example of this policy can be found at the level of primary education. As Araujo has shown, the state attempted to keep the best places for male professors during the First Republic, passing legislation that imposed sexual parity for the occupation of posts and pushed women into the primary education sector. Araujo, "Construction of Primary Teaching."

32. In her analysis of the incorporation of women into the medical profession, Judith Lorber refers to this as the "Salieri phenomenon." She bases this term on the play *Amadeus*, by Peter Schaffer, in which Salieri, the official court composer, recommends to the emperor that Mozart be given a secondary position in the court, thereby showing Mozart that he is receiving fair recognition but does not deserve better. Judith Lorber, "Women as Colleagues: The Matthew Effect and the Salieri Phenomenon" (Paper presented at the Annual Meeting of the American Sociological Association, Detroit, August 1993). See also Cynthia Epstein, *Deceptive Distinctions: Sex, Gender, and the Social Order* (New Haven and New York: Yale University Press/Russell Sage Foundation, 1988), 156.

33. Michael Harsgor, *Portugal in Revolution* (Beverly Hills: Sage, 1976), 4; Constitution of 1933, Article 5.

34. See *Mulheres, direito, crime, ou a perplexidade de Cassandra* (Lisbon: Faculdade de Direito da Universidade de Lisboa, 1993), 176.

35. The list of forbidden authors included Karl Marx, D. H. Lawrence, Simone de Beauvoir, and Colette.

36. Gosta Esping-Andersen, "Orçamentos e democracia: o estado-providência em Espanha e Portugal, 1960–1989," *Análise Social* 28:122 (1993), 589–606, esp. 598.

37. See Boaventura de Sousa Santos, "A crise e a reconstituição do estado em Portugal (1974–1984)," *Revista Crítica de Ciências Sociais* 14 (November 1984), 7–29, esp. 17.

38. Ibid., 18.

39. An expression coined by Vital Moreira. See "A edificação do novo sistema institucional democrático," in *Portugal contemporâneo, 1974–1992*, ed. António Reis (Lisbon: Alfa, 1992), 6:81–116.

40. "A German paper hailed it as 'the most progressive in all of Europe.'" Gisela Kaplan, *Contemporary Western European Feminism* (London: UCL Press/Unwin, 1992), 185.

41. Legislation was changed. It should be noted that it was only on June 16,

1976, with the approval of the new constitution, that the violation of women's correspondence by husbands was forbidden. The revision of the main legal codes was completed only in 1983, when the New Penal Code was introduced. This code made important changes regarding violence between married couples. The revised Civil Code, which profoundly changed family and inheritance law, had already come into force in 1978. For a good summary of the legal changes that occurred, see Moreira, "A edificação do novo sistema."

42. This lack of flexibility is also apparent in other constitutions resulting from similar processes of democratization in southern Europe, such as those of Greece and Spain. This is why Gisela Kaplan talks about the "Mediterranean constitutional model." See *Contemporary Western European Feminism*, 258–59.

43. Spain underwent a similar process, but its transition did not occur through rupture with the previous regime or through a revolutionary crisis. The constitutional referendum met with serious opposition from women who had to mobilize in its defense despite their mixed feelings about the new constitutional text.

44. Except for the legalization of abortion. The law passed in 1984 provided for abortion in cases of deformity, rape, or health risks for the mother (including psychological health). This law could have been positive, had the medical profession been willing to apply it or had the state created the necessary clinical infrastructure for its application. Neither of the two has occurred, so that few women have had legal abortions in Portugal. A survey undertaken by the Association for Family Planning in 1991 shows that of the 52 hospitals surveyed, only 17 practiced abortions; and of the 10 central hospitals, only 5 practiced abortions. Since the law took effect in 1990, only 397 legal abortions have been undertaken. Thus the overwhelming majority of abortions are undertaken illegally.

45. The Pro-Divorce Movement, which emerged in the mid-1960s, was led by middle- and upper-class individuals whose marriages had failed and who could not legalize their second marriages or the "illegitimate" children born under those second unions. Only two months after the revolution of April 1974, the Pro-Divorce Movement promoted one of the first large demonstrations undertaken, to force the new political authorities to revise the law.

46. See *Diário da Assembleia Constituinte* no. 34, Quinta-feira, August 21, 1975, p. 908.

47. See interview with Secretary of State for Social Security, *Marie Claire* (May 1994), 123.

48. Catherine A. Mackinnon, *Feminism Unmodified: Discourses on Life and Law* (Cambridge: Harvard University Press, 1987).

49. Constitution of 1976, Article 68 (1/89 of July 8, 1989).

50. According to a recent survey, between 74 percent (when the respondent was a man) and 97 percent (when the respondent was a woman) of the respondents declared that women did the cooking, washing up, ironing, tidying, and cleaning, with the help of their daughters. See *Expresso*, July 16, 1994.

51. Hespanha, "Vers une société-providence"; Piselli, *Medio Occidente*.

52. See Sousa Santos, "A crise e a reconstituição," 21.

53. Ibid., 22.

54. See Sousa Santos, *Pela mão de Alice*, 62.

55. R (90), January 2, 15, 1990.

56. Law 61/91 of August 8, 1991.

57. Decision of judges Vasco Tinoco, Lopes de Melo, Ferreira Vidigal, and Ferreira Dias. Women's access to judicial careers began in 1974 and has gradually increased. In 1991, 19 percent of judges were women. The 59 judges of the Supreme Court, however, are all men.

58. See Beleza, *Mulheres, direito, crime*, 555.

59. Philippe C. Schmitter, "Public Opinion and the 'Quality' of Democracy in Portugal" (Paper presented to the "Colóquio sobre Sociedade, Valores Culturais e Desenvolvimento," Fundação Luso Americana para o Desenvolvimento [FLAD], Lisbon, May 23–24, 1991).

60. Cabral, "Portugal e a Europa," 950.

61. "Portugal has never had a women's movement comparable to any of the [Western European] countries." Kaplan, *Contemporary Western European Feminism*, 189.

62. Maria José Magalhães, "O discurso feminista," 32. Madalena Barbosa also maintains that Portugal had a feminist movement, even before the Campaign for Abortion: "Unlike the movement in other countries, it was centralized (in Lisbon) and its composition was very heterogeneous. . . . It had not as yet developed a collective consciousness or defined a common objective. It was characterized more by a common awareness of the oppression of women in everyday life." "Women in Portugal," *Women's Studies International Forum* 4:4 (1981), 478.

63. The book's title refers to a famous collection of love letters from the seventeenth century, *Portuguese Letters*, written by a nun, Maria Alcoforado, to a French cavalier. In *Novas cartas portuguesas*, the authors discuss issues of feminine sensuality and sexuality and the relations between men and women. The dictatorship considered the book pornographic and held back its publication; the authors were arrested by the political police, the PIDE. This gave rise to a wave of protest and solidarity on the part of feminist organizations, particularly those in Britain, France, and North America. Internal reaction was minimal, given that censorship prevented the agitation of public opinion. A few Portuguese writers were mobilized, but that was all. During the authors' trial, which took place after the regime had collapsed, the accusations were withdrawn. The book is published in various languages. See, for example, the English version, *New Portuguese Letters*, trans. Helen R. Lane, Faith Gillespie, and Suzette Macedo (London: Paladin, 1975).

64. *New Portuguese Letters*, 188.

65. This is an allusion to the revolutionary slogan, "The People United Shall Never Be Defeated."

66. Maria Velho da Costa, "Portuguese Letter from Myself Alone to the People Still United," *Diário de Lisboa*, May 16, 1974.

67. "O mito da queima," *Marie Claire* (May 1994), 95–99.

68. One of those interviewed by Maria José Magalhães said that when the MLW asked the DWM what its position on abortion was, the DWM stated, "abortion does not help to liberate the country." Another interviewee recounted that in 1978, at one of the events promoted by the Women's Unitary Commissions in Oporto, she was "pushed by the stewards" for distributing pamphlets on the abortion issue. Ibid. However, working-class women were precisely those who suffered most from the prohibition of abortion, because they did not have the means to pay for an illegal abortion in private clinics with medical support to ensure the best sanitary and health conditions, or to go abroad, as wealthier women could do. Moreover, working-class women have always contributed most to deaths resulting from abortion. Even today, the Portuguese Communist Party sustains this policy on social relations between the sexes. Although all the women deputies and former deputies of the various political parties participated in a study currently being undertaken on women's participation in political life, centering on the question of the nature of discrimination suffered by women in their political careers, the female deputies of the Communist Party refused to respond to the survey, doubtless in the name of "party unity."

69. The Socialist Party also had a women's section, but it was never activated. In 1987, this section was replaced by the Association of Socialist Women, founded by a group of Socialist women who were independent from the party. In other countries, similar difficulties were experienced in the formation of these kinds of organizations. See "The Women's Movement in Spain," *New Left Review* 151 (May–June 1985), 44–73; Eleni Varikas, "Les femmes grecques face à la modernisation institutionnelle: un féminisme difficile," *Les Temps Modernes* 473 (December 1985), 918–34; Olive Banks, *Faces of Feminism* (Oxford: Basil Blackwell, 1986).

70. More specifically, the Aliança Povo Unido (APU), a coalition between the Communist Party and a number of small, satellite groups, gained 19 percent of the vote in the interim parliamentary elections, thus gaining more than a million votes. Since then, its electoral weight has halved. See António Reis, "O poder central," in Reis, *Portugal: 20 anos de democracia*, 74–89.

71. On the subordination of trade union activity to political objectives, see Lima, "Relações de trabalho," 914, 923.

72. *Expresso*, November 26, 1994.

73. This corresponds to what Boaventura de Sousa Santos calls the "re-creation of civil society by the state," the latter having an intimate relationship with the former. See "Estado e sociedade na semiperiferia do sistema mundial. O caso português," *Análise Social* 21:87/88/89 (1985), 869–901. See also Juan Mozzicafreddo, "Concertação social e exclusão social," *Organizações e Trabalho* 12 (October 1994), 97–119.

74. Portugal, Commission for Equality and Womens Rights, "Portugal: situa-ção das mulheres, 1994," 91.

75. The growth rate of the private sector has been consistently high since 1986–87, and especially since 1988–89, with the passage of the Basic Law on Private and Cooperative Education of 1988. In the 1990–91 academic year, less than one-fourth of the students attending institutions of higher education were matriculated at private schools (out of a total of 156,878 from both private and public sectors); in 1993–94, approximately one-third of a total of 253,026 were martriculated at private universities. See *Estatísticas da educação*.

76. Neil J. Smelser, *Theory of Collective Behavior* (New York: Free Press, 1963).

77. The movement in Spain has been characterized by Lidia Falcón, one of its most prominent figures, as "the most aggressive, explosive, and brilliant feminist movements in all of Europe." Quoted in Kaplan, *Contemporary Western European Feminism*, 261. A recent and interesting theoretical volume by Italian feminists is Paola Bono and Sandra Kemp, *Italian Feminist Thought: A Reader* (Oxford: Basil Blackwell, 1991). Kaplan states that the Italian movement was "the most impressive, politically active, and far-reaching women's movement of the '70s." *Contemporary Western European Feminism*, 229. This author's interpretation is not entirely convincing, however. Her references to the Portuguese case are quite solid, and can be considered a good source of information for English speakers. They are at times distorted, however, because of her reliance on sources close to the Movimento Democrático de Mulheres (MDM). Accordingly, she states that the situation of the working classes worsened after April 1974! This observation seems to serve the sole purpose of proving the seesaw effect in Portuguese society, with improvement in some areas and stagnation or regression in others.

78. Alain Touraine, *The Voice and the Eye: An Analysis of Social Movements* (Cambridge: Cambridge University Press, 1981).

79. Monica Threlfall, "The Women's Movement in Spain," *New Left Review* 151 (May–June 1985), 54.

Chapter Ten

1. The following discussion draws heavily on four publications by Maria I. B. Baganha: "Portuguese Emigration: Current Characteristics and Trends" (Portuguese Report to COST A2 conference "Migration: Europe's Integration and the Labor Force," Leuven, 1991); "As correntes emigratórias portuguesas no século XX e o seu impacto na economia nacional" (Paper presented to the 2d Encontro de História Económica Portuguesa, Curia, 1993); "Principais características e tendências da emigração portuguesa," in *Estruturas sociais e desenvolvimento: actas do II Congresso Portugues de Sociologia* (Lisbon: Fragmentos, 1994), 819–35; "The Market, the State, and the Migrants: Portuguese Emigration Under the Corporative

Regime" (Paper presented to the ESF Conference "Migration and Development," Crete, 1994).

2. France, Office Nationale d'Immigration (ONI) for the given years, in M. L. Marinho Antunes, "A emigração portuguesa desde 1950: dados e comentários," in *Cadernos GIS* 7 (Lisbon: GIS, 1973), 73, 109.

3. See Luís Miguel Seruya, "Determinantes e características da emigração portuguesa, 1960–1979," in *Perspectivas da emigração portuguesa para a CEE, 1980–1990*, ed. Heinz-Michael Stahl et al. (Lisbon: Moraes Editores/I.E.D., 1982), 37–64; Mary M. Kritz, Charles B. Keely, and Silvano M. Tomasi, eds., *Global Trends in Migration: Theory and Research on International Population Movement*, 3d ed. (Staten Island, N.Y.: Center for Migration Studies, 1983); W. R. Böhning, *Studies in International Labour Migration* (London: Macmillan, 1984); Jorge P. Branco, *A estrutura da comunidade portuguesa em França* (Porto: Secretaria de Estado das Comunidades Portuguesas/Centro de Estudos, 1986).

4. In the early 1980s, for example, the portion of unskilled workers was 45 percent among the Portuguese immigrant labor force in France, similar to other foreign groups but much higher than among natives. The share of unskilled laborers in the French active population was 29 percent. Branco, *A estrutura*, 70–71.

5. F. G. Cassola Ribeiro, *Emigração portuguesa. Aspectos relevantes às políticas adoptadas no domínio da emigração portuguesa, desde a última guerra mundial. Contribuição para o seu estudo* (Porto: Secretaria de Estado das Comunidades Portuguesas/Centro de Estudos, 1986), 41–42.

6. Proposta de lei sobre política de emigração, in *Actas da Câmara Corporativa* 142 (February 23, 1973). See also Ribeiro, *Emigração portuguesa*, 95–110.

7. The figure does not include the 105,000 special legalizations performed by the Emigration Bureau between 1963 and 1969. See Antunes, "A emigração portuguesa," 13–15.

8. The estimate includes 975,000 arrivals to France and 212,000 arrivals to Germany, respectively.

9. Some 777,000 arrivals to France and Germany are not accounted for in the Portuguese official statistics. More specifically, comparing the French and Portuguese sources indicates that for the period 1960–69, 48 percent of emigration to France went unregistered by Portuguese sources, and 81 percent for 1970–79. For Germany, the Portuguese migratory flow is unregistered by 27 percent for 1962–69 and by 42 percent in 1970–79 (see Table 10.6). Previous works considered only illegal emigration to France. The totals are therefore different from the ones presented in this paper. See, e.g., J. C. Ferreira de Almeida, "A emigração portuguesa para a França: alguns aspectos quantitativos," *Análise Social* 2:7/8 (1964), 599–622; M. L. Marinho Antunes, "Migrações, mobilidade social e identidade cultural: factos e hipóteses sobre o caso português," ibid. 19:65 (1981), 17–37; Stahl, *Perspectivas da emigração*.

10. The last annual *Boletim* available from the Secretaria de Estado das Comunidades Portuguesas is for 1988.

11. Although important, the movement to Germany never attained the same intensity. Still, between 1970 and 1974 it represented 19 percent of the global total.

12. See William S. Bernard, "History of U.S. Immigration Policy," in *Immigration*, by R. Easterlin et al. (Cambridge: Harvard University Press, 1982), 103.

13. France, Office Nationale d'Immigration, quoted by Seruya, "Determinantes e características," 52; and OECD, *SOPEMI Reports*, 1985, 1988, and 1990 (Paris: OECD).

14. Caroline Brettell, *Men Who Migrate, Women Who Wait: Population and History in a Portuguese Parish* (Princeton: Princeton University Press, 1986).

15. Ibid., 68.

16. The most relevant works are Manuela Silva et al., *Retorno, emigração e desenvolvimento regional em Portugal* (Lisbon: Instituto de Estudos para o Desenvolvimento, 1984); Eduardo S. Ferreira, *Reintegração dos emigrantes portugueses: integração na CEE e desenvolvimento económico* (Lisbon: CEDEP/AE ISE), 1984; Amadeu Paiva, *Portugal e a Europa. O fim de um ciclo migratório* (Lisbon: IED-CEDEP, 1985); Michel Poinard, "Emigrantes portuguese: o regresso," *Análise Social* 19:75 (1983), 29–56.

17. After the mid-1980s, the information available points to a decrease in the level of returns. At the end of the decade, returns were between 25,000 and 26,000.

18. Poinard's study, "Emigrantes portuguese: o regresso," based on 3,792 documents and files on Portuguese processes for aid return presented to French authorities in 1978, gives a slightly different portrait of the migrants returning from France. The mean duration of the stay in France was 9.5 years.

19. Employment was quite different in France and Germany. In France, 49 percent of the returnees worked in construction and 25 percent in manufacturing; in Germany, 13 percent worked in construction and 60 percent in manufacturing.

20. The most frequent reasons for return were missing the family and native land and concern with the children's education, 35 percent; and health, retirement, and labor accidents, 26 percent.

21. See SECP, *Boletim anual* 1988:83. For returns see Silva, *Retorno, emigração e desenvolvimento*, 49–52; Stahl, *Perspectivas da emigração*, 17.

22. Alfredo M. Pereira, "Trade-Off Between Emigration and Remittances in the Portuguese Economy," Faculdade de Economia–Universidade Nova de Lisboa Working Paper 129, 1989.

23. A. Sedas Nunes, "Portugal: sociedade dualista em evolução," *Análise Social* 2:7/8 (1964), 407–62; Carlos Almeida and António Barreto, *Capitalismo e emigração em Portugal*, 3d ed. (Lisbon: Prelo, 1976); Joel Serrão, *A emigração portuguesa: sondagem histórica*, 3d ed. (Lisbon: Livros Horizonte, 1977); Vitorino Magalhães Godinho, *A estrutura da antigua sociedade portuguesa* (Lisbon: Arcádia, 1978).

24. Eduardo S. Ferreira, *Origens e formas da emigração* (Lisbon: Iniciativas Editoriais, 1976); José P. Barosa and Pedro T. Pereira, "Economic Integration and Labour Flows: The European Single Act and Its Consequences," FE-UNL Working Paper 123, 1988; A. M. Pereira, "Trade-Off Between Emigration and Remittances."

25. Barosa and Pereira, "Economic Integration and Labour Flows," 8.

26. Stahl, *Perspectivas da emigração*; I. J. Seccombe and R. J. Lawless, "Some New Trends in Mediterranean Labour Migration: The Middle East Connection," *International Migration* 23:1 (1985), 123–48; Barosa and Pereira, "Economic Integration and Labour Flows."

27. Barosa and Pereira, "Economic Integration and Labour Flows," 13.

28. Amadeu Paiva, *Portugal e a Europa. O fim de um ciclo migratório* (Lisbon: IED–CEDEP, 1985).

29. See the publications by Baganha cited in note 1; and Baganha and João Peixoto, "Trends in the '90s: The Portuguese Migratory Experience" (Paper presented to the Cost A2 Workshop "Immigration in Southern Europe," Coimbra, 1994).

Chapter Eleven

1. E. J. Hobsbawm, *Nations and Nationalism Since 1780* (Cambridge: Cambridge University Press, 1990).

2. José Mattoso, *Identificação de um país. Ensaio sobre as origens de Portugal, 1096–1325*, vol. 2 (Lisbon: Estampa, 1985), 211.

3. Jacques Revel, *A invenção da sociedade* (Lisbon: Difel, 1990), 192.

4. Francisco Bethencourt, *História das inquisições. Portugal, Espanha, e Itália* (Lisbon: Círculo de Leitores), 1995.

5. A. C. Silva and A. M. Hespanha, "A identidade portuguesa," in *História de Portugal. O antigo regime (1620–1807)*, ed. José Mattoso (Lisbon: Estampa, 1994). See also Francisco Bethencourt, "Sociogénese do sentimento nacional," in *A memória da nação: coloquio do Gabinete de Estudos de Simbologia realizado na Fundação Calouste Gulbenkian, 7–9 outubro, 1987*, ed. Bethencourt and Diogo Ramada Curto (Lisbon: Sá da Costa), 1991.

6. See Kenneth Maxwell, *Pombal: Paradox of the Enlightenment* (Cambridge: Cambridge University Press, 1995).

7. Contrary to what happened in Spain, this movement was dominated by the conservative, antiliberal forces.

8. Valentim Alexandre, *Os sentidos do império: questão nacional e questão colonial na crise do antigo regime português* (Oporto: Afrontamento, 1993).

9. Maria Alexandre Lousada, "Nacionalismo e contra-revolução em Portugal: o episódio miguelista," *Luso-Brazilian Review* 29 (1992), 63–70.

10. See Maria de Fátima Bonifácio, *Seis estudos sobre o liberalismo português* (Lis-

bon: Estampa, 1991). On the pretext of policing slave trafficking, Britain continuously oversaw Portugal's African territories. See Valentim Alexandre, "Portugal e a abolição do tráfego de escravos (1834–1851)," *Análise Social* 26:111 (1991), 293–337.

11. Rui Ramos, "A segunda fundação (1890–1926)," in *História de Portugal*, vol. 4, ed. José Mattoso (Lisbon: Estampa, 1994), 30–38.

12. Ibid., 65.

13. Luís Reis Torgal, "A restauração nas ideologias e na história," in *História e ideologia* (Coimbra: Livraria Minerva, 1989), 43.

14. Ramos, "A segunda fundação"; idem, "A formação da *intelligentsia* portuguesa (1860–1880)," *Análise Social* 27:116–17 (1992), 483–528.

15. Nuno Severiano Teixeira, *O ultimatum inglês. Política externa e política interna no Portugal de 1890* (Lisbon: Alfa, 1990).

16. See Alexandre Cabral, *Notas oitocentistas* (Lisbon: Portugália, 1973).

17. Teófilo Braga, *Os centenários como síntese afectiva nas sociedades modernas* (Oporto, 1884), 227.

18. Quoted in Ramos, "A segunda fundação," 65.

19. Ibid., pp. 5–20.

20. See Jaime Reis, *O atraso económico português, 1850–1930* (Lisbon: ICS/INCM, 1993), 227–53.

21. Pedro Tavares de Almeida, *Eleições e caciquismo no Portugal oitocentista (1868–1890)* (Lisbon: Difel, 1991).

22. Nuno Severiano Teixeira, *O poder e a guerra, 1914–1918* (Lisbon: Estampa, 1996).

23. Sérgio Campos Matos, *História, mitologia, imaginário nacional. A história no curso dos liceus (1885–1939)* (Lisbon: Horizonte, 1990).

24. Nuno Severiano Teixeira, "Do azul e branco ao verde rubro. A simbólica da bandeira nacional," in Bethencourt and Curto, *A memória da nação*, 335.

25. Ibid., 337.

26. António Costa Pinto, *Salazar's Dictatorship and European Fascism: Problems of Interpretation* (New York: Social Science Monographs/Columbia University Press, 1995).

27. Fernando Marques da Costa, "Imaginário histórico, imaginário político," *Nação e Defesa* 46 (April–June 1988), 11.

28. On this topic, see Ronald W. Sousa, *The Rediscoverers: Major Writers in the Portuguese Literature of National Regeneration* (University Park: Pennsylvania State University Press, 1981).

29. Valentim Alexandre, "Ideologia, economia, e política. A questão colonial na implantação do Estado Novo," *Análise Social* 28:123–24 (1993), 1117–36.

30. Manuel Braga da Cruz, *O partido e o estado no salazarismo* (Lisbon: Presença, 1988).

31. Joaquim Pais de Brito, "O Estado Novo e a aldeia mais portuguesa de Portugal," in *O fascismo em Portugal*, by the AAVV (Lisbon: A Regra do Jogo, 1992), 508.

32. Maria Filomena Mónica, *Educação e sociedade no Portugal de Salazar* (Lisbon: Presença, 1978), 303.

33. Jorge Ramos do Ó, "Modernidade e tradição: algumas reflexões em torno da Exposição do Mundo Português," in *O Estado Novo. Das origens ao fim da autarcia, 1926–1956*, by the AAVV (Lisbon: Fragmentos, 1987), 177–85.

34. António José Telo, "Portugal, 1958–1974: sociedade em mudança," in *Portugal y España en el cambio político (1958–1978)*, ed. Hipólito de la Torre Gomez (Mérida: Universidad National de Educación a Distancia, 1989), 74.

35. Urban is defined here as population centers with more than ten thousand inhabitants.

36. See Kenneth Maxwell, *The Making of Portuguese Democracy* (Cambridge: Cambridge University Press, 1995).

37. See Paul Manuel, *The Challenges of Democratic Consolidation in Portugal* (Westport: Praeger, 1996).

38. António Costa Pinto and Xosé M. Nuñéz Seixas, "Portugal and Spain," in *European Political Culture: Conflict or Convergence?* ed. Roger Eatwell (London: Routledge, 1996).

39. See Jorge Vala, "Valores sociopolíticos," in *Portugal: valores europeus, identidade cultural*, ed. Luís de França (Lisbon: Instituto de Estudos para o Desenvolvimento, 1993), 221–59.

40. See Mario Bacalhau, *Atitudes, opiniões e comportamentos políticos dos portugueses, 1973–1993* (Lisbon: FLAD, 1994), 265–72.

Chapter Twelve

1. See João Camilo Santos: "Formas de corrente de consciência em algumas narrativas do século XIX: os exemplos precursores de Alexandre Herculano e Almeida Garrett," *Arquivos do Centro Cultural Português* (Fundação Calouste Gulbenkian, Lisbon-Paris) 32 (1993), 195–234.

2. To consider the novel about the nightingale girl the only truly accomplished work of this author, as some critics have suggested, is to ignore abusively Garrett's texts as a coherent whole and Garrett's experimental courage.

3. António José Saraiva and Oscar Lopes, *História da literatura portuguesa*, 16th ed. (Porto: Porto Editora, 1992), 1004.

4. Ibid., 1027.

5. The way Eça de Queirós and Fernando Pessoa portray Lisbon, its neighborhoods and streets, its colors, its skies, the geometry of its houses, and the views it affords over the River Tagus take on mythical qualities; the city is evoked with an extraordinary sensibility.

6. See João Camilo dos Santos, "Augusto Abelaira e Vergílio Ferreira: plenitudes breves e absolutos adiados," *Arquivos do Centro Cultural Português* (Paris) 19 (1983), 413–68. See also idem, "Tendances du roman contemporain au Portugal:

du néo-réalisme à l'actualité," in *L'Enseignement et l'expansion de la littérature portugaise en France* (Paris: Fondation Calouste Gulbenkian, 1986), 197–239.

Chapter Thirteen

1. José Augusto França, *A Arte em Portugal no século XX* (Lisbon: Bertrand, 1974).

2. Mário Cesariny de Vasconcelos, *A Intervenção surrealista em Portugal* (Lisbon: Artis, 1966).

3. José Augusto França, *A Pintura surrealista em Portugal* (Lisbon: Artis, 1966).

4. Rui Mario Gonçalves, *100 Pintores portugueses do século XX* (Lisbon: Alfa, 1986); José Augusto França, *A Pintura abstracta portuguesa* (Lisbon: Artis, 1960).

5. Rui Mario Gonçalves, *Pintura e escultura em Portugal* (Lisbon: Instituto de Cultura, 1984).

6. Alexandre Melo and João Pinharanda, *A Arte Portuguesa contemporânea* (Lisbon: Perspectivas, 1986).

7. Paulo Pereira, ed., *Arte portuguesa* (Lisbon: Círculo dos Leitores, 1995).